TURNER AND CONSTABLE

TURNER AND CONSTABLE

Art, Life, Landscape

NICOLA MOORBY

YALE UNIVERSITY PRESS
NEW HAVEN AND LONDON

For information about this and other Yale University Press publications,
please contact:
U.S. Office: sales.press@yale.edu yalebooks.com
Europe Office: sales@yaleup.co.uk yalebooks.co.uk

Set in Sabon and Trajan Pro by IDSUK (DataConnection) Ltd
Printed in China

Library of Congress Control Number: 2024945271

ISBN 978-0-300-26648-1

A catalogue record for this book is available from the British Library.

10 9 8 7 6 5 4 3 2 1

For David Moorby (1946–1998)

CONTENTS

ACKNOWLEDGEMENTS

THE LITERATURE ON Turner and Constable is vast and I am indebted to all the art historians, curators and conservators whose research and scholarship have paved the way and made studying the two artists the rich, accessible experience it is today. During my time at Tate I had the privilege and good fortune of working with inspirational colleagues and benefiting from their expertise and passion at first hand. I would particularly like to thank the following, from whom I learned so much over the years: Thomas Ardill, Peter Bower, David Blayney Brown, Matthew Gale, James Hamilton, the late Robin Hamlyn, David Hill, Matthew Imms, David Fraser Jenkins, Jennifer Mundy, Martin Myrone, Catherine Parry-Wingfield, Cecilia and Nick Powell, Christine Riding, the late Eric Shanes, Alison Smith, Sarah Taft, the late Rosalind Tennent, Joyce Townsend, Piers Townshend, Robert Upstone and Andrew Wilton. A special debt of gratitude is owed to Heather Birchall, who generously read and commented upon the manuscript, and to Anne Lyles and Ian Warrell whose matchless knowledge of Constable and Turner has underpinned the entire process. I thank all three for their expertise, as well as their kind support and friendship.

For further help and advice, grateful thanks are due to Mark Bills, Emma Boyd, Amy Concannon, Sarah Cove, Mark Hallett, Val and Sascha Constable, Sophie Lambert, Andy Loukes, Pieter van der Merwe, Mark Pomeroy, Anne Puetz, Jacqueline Riding, Kirsty Rodda and Caroline Shenton. I also extend my thanks to everyone who has taken my Courtauld Spring and Summer School courses in the past and contributed stimulating thoughts and ideas to our discussions on the two artists.

I would like to extend my sincere thanks to the peer reviewers and to all the team at Yale University Press – Lucy Buchan, Robert Davies, Rachael Lonsdale, Suzannah Stone. I am especially grateful to the commissioning editor, Sophie Neve, who encouraged me to write this book and has patiently and expertly guided me through every stage.

Finally, I offer my love and thanks to family and friends for their encouragement and for gifting me space and time to write: Stephanie Ashmore; the seven ladies of the 'Hive Mother' – Natasha Bloxham, Rachael Jolley, Sascha Koszarek-Prowse, Jaisica Lapsiwala, Julia Sharpe, Maxine Slate and Zoe Whicheloe (though, in fairness, I might have got the job done quicker without you tempting me out on occasion); Jenny Moorby; Dorothy and Ted Reynolds; and Emmie, Andy, Evie and Elise Ward. Special mention to my husband, Andy, and my children, Charlie and Rosa, who have been putting up with Turner and Constable for as long as they've known me. The book is dedicated to my father and fellow lover of history, David Moorby. How I wish he were around to read it.

INTRODUCTION

'FINE PICTURES NEITHER want nor will bear comparison,' John Constable is reported to have said.[1] Despite his dislike of the practice, comparison can make for a compelling story. It provides the starting point for this book – a study of two well-known artists whose works were judged together during their lifetimes, and have been studied in parallel, as well as in isolation, ever since. Indeed, the act of comparing these painters has come to dominate our understanding of the period. In different ways, Constable and J.M.W. Turner are now widely remembered as a contrasting pair – the twin pillars of nineteenth-century British landscape.

Look at their portraits, painted at a proximate point at the turn of the century (figs 1 and 2). At first glance, there doesn't seem much to choose between them. Here are two young men in their early twenties, close in age and attire, poised to make their marks upon the world. Delve beyond the surface, however, and it doesn't take long to realise that these are two very different souls. Contemporaries they may have been, but in all the other character-forming things that count they were unalike. Poles apart in temperament, background, beliefs and vision, these individuals painted pictures as dissimilar as their personalities. With one only just at the start of his career, and the other already well on his way, their fame was not a foregone conclusion. Between them they would go on to change the face of British art.

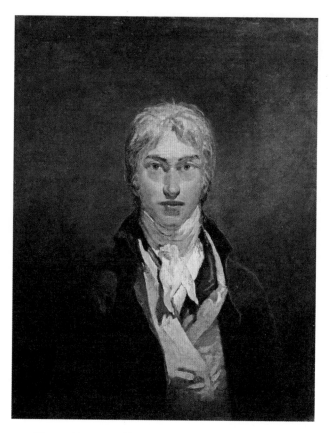

Fig. 1. Turner, *Self-Portrait*, c.1799, oil on canvas.

Sometimes art history evolves as a story, albeit one rooted in reality. Like any historical figures, artists accrue a measure of myth, and this is what has happened to Turner and Constable. Over the centuries, the way they have been chronicled has embellished known facts with layers of fiction. Both were the subjects of biographies soon after their deaths – Turner's written by an unreliable journalist, Walter Thornbury, and Constable's by his close friend and fellow painter, Charles Robert Leslie. These texts, and those that followed, established records of varying accuracy. As their contemporary Napoleon Bonaparte (allegedly) said, 'History is a set of lies agreed upon.' We don't reproduce the past, we recreate it, fleshing out what we know with things we imagine, even things we hope and want.

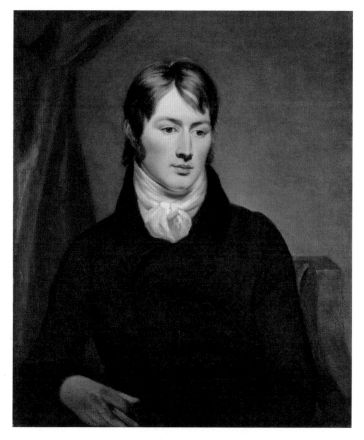

Fig. 2. Ramsay Richard Reinagle, *John Constable*, c.1799, oil on canvas.

Due in no small part to the fact that there were two of them, our understanding of the art of Turner and Constable has traditionally been shaped through the idea of conflict. It has been commonplace to pitch them together as rivals operating within the same professional arena, an exercise only exacerbated by their personal differences. Celebrity thrives on contest, and when people with equal but distinct strengths are vying towards the same goals, comparison becomes inevitable. They have routinely been placed diametrically, even by their peers: the urban Londoner versus the country boy; the traveller and the stay-at-home artist; airy heat and earthy coolness; golden visions and silvery realism . . . the list of contradictions goes on.

The thing about rivalry is that it can be so easily manufactured. It builds upon partisan preferences, falsely encouraging observers to pick a side. It demands winners and losers, supporters and naysayers, and encourages overly simplistic readings. Had the personalities and private lives of these two men not been quite so different, the sense of dualism might not have found quite so much traction. But it was persuasive then, and has only grown in strength after their deaths.

The aim of this book is to revisit their pairing from a different perspective. By placing them side by side, instead of face to face, we can challenge the usual narrative and bring both into sharper focus as a result. Like a jigsaw, the picture is clearer and more complete when the pieces are fitted together. Turner's life and works are an illuminating guide to Constable's, and vice versa. The one naturally provides effective points of reference for interpreting the other. Even a speculative reading of the material uncovers new resonances which help to offer corrective insights and more fully comprehend the scale of their respective achievements.

No question there were competitive moments. But ultimately it is more helpful to see these men in unison. As colleagues from the same generation their intersecting biographies reveal patterns of symmetry and connection, rather than conflict and contrast. Children of the late eighteenth century, they faced challenges and opportunities universal to the era: political unrest, social upheaval, scientific discoveries and cultural developments. As visual commentators, they bore witness to a similar sense of transience – Constable as a preserver of the past, Turner as an augur of change – setting up, in the process, prevailing mythologies about Britain and Britishness that persist to this day. Above all, they shared common cause as champions of their chosen specialism. Between them their achievements pushed the boundaries in different directions, ensuring a depth and breadth that helped cement Britain's standing as an artistic nation. This is not just a tale of two artists; it is the story of the rise of landscape painting as the genre most relevant to the Romantic age.

CHAPTER 1

BACKGROUND AND BEGINNINGS

L IKE MANY STORIES, this one begins with a birth.

In late spring 1775, a boy was born in the Covent Garden district of London. No official birthdate was recorded, but on 14 May the child's parents, William and Mary, took him to be baptised. They walked from their home in dark, narrow Maiden Lane to nearby St Paul's church and christened him Joseph Mallord William Turner.

Georgian children often inherited family names as a mark of continuity and legacy, and this hefty four-part title reflected both strands of the boy's relatively humble social lineage. William Turner was, like his father before him, a barber from Devon, only recently set up in London. The more unusual second given name was bestowed in deference to the baby's mother. Mary's people were butchers – a long line of Joseph 'Mallards' going back to the seventeenth century, and the homely duck-like appellation had eventually evolved with her grandfather into the more distinguished 'Mallord'. Most recently it had been given to her younger brother, Joseph Mallord William Marshall, with whom it is likely that Mary lived as a spinster housekeeper for many years. By the time she became a wife in 1773, she was thirty-seven years old (although she claimed to be younger). Her marriage at such a mature age (for the eighteenth century) and to a man nine years her junior was probably unexpected, and motherhood two years later perhaps even more so.

In their wildest dreams, Turner's parents could never have antici-pated that this child from their late union would go on to become one of the best-known names in British cultural life. Their name would even take on the status of an eponymous adjective. Years later, simply invoking the word 'Turner' would become enough to conjure up images of dazzling colour, stormy seas or flamboyant sunsets, and the emotional intensity humans feel when they witness nature at its most dramatic.

Approximately fourteen months later and sixty-five miles away, another baby boy made his entrance into the world under different circumstances. His name too would eventually go down in legend. John Constable was born on 11 June 1776, the fourth child of Ann and Golding Constable of East Bergholt, a village in rural East Anglia, near the Essex/Suffolk border. Unlike the Turners, who had only recently established themselves in central London, the Constables were not newcomers to the area. Rather they had been there for generations, as farmers, millers and merchants, people tied to the seasonal cycle of agriculture. Aged twenty-five, Golding Constable had inherited a flour-milling business from a childless uncle, and three years later had married the eighteen-year-old Ann, the daughter of a prosperous London barrel-maker. This profitable commercial background led to more of the same. By the time John was born, Golding was running an extensive and multi-faceted business. Not only was he a successful mill owner, he was also firmly established as a landowning farmer and grain exporter, transporting goods in and out of the region by barge and ship. In Suffolk at least, the Constable name already had significant presence and meaning. It was synonymous with power, prosperity and the surrounding countryside. For as long as anyone could remember there had been Constables resident in this part of the world. Even though, as the second son, John might not initially have been considered the heir-apparent to the family business, he would have been known by everyone he met as a 'Constable of East Bergholt'. From birth that name would have come with certain expectations and assumptions, none of which at that point revolved around painting.

Yet ultimately it was by turning his back on those expectations that Constable forever bound the family name with the county of his birth. More than his farming antecedents and descendants, it was he who wedded 'Constable' with 'country' and preserved the

landscape for generations to come. His name was immortalised not only in Suffolk. It became a byword for nostalgia, tradition and quintessential English countryside.

Two infants then, with two distinct roads ahead of them. As they set out upon their appointed journeys, how far were the fates of this pair shaped by their personal histories or by the wider world in which they both lived? How much of their future destinies was mapped out by their backgrounds and beginnings?

Growing up in late eighteenth-century England, it would be hard to imagine two more distinct milieus than that of Covent Garden and East Bergholt. They exemplified the division between city and country and the gulf of experience between the two. Whilst one in ten of the population was estimated to live in London, the majority of the rest were still based in predominantly rural areas. The fundamental differences between the two spheres can be gauged by the houses in which Turner and Constable grew up (figs 3 and 4). Neither property now survives but their appearances are recorded in various images and even a quick glance immediately throws up the disparity. How could two babies raised in such different settings not have turned out very differently?

Maiden Lane, the street where Turner lived for the first twenty-four years of his life, runs parallel with the Strand in central London. A Victorian watercolour by John Wykeham Archer (fig. 3) transports us back in time to number 26, the lodgings to which the Turner family moved when he was not quite one year old. The terraced house looms directly up from the street, hemmed in by neighbouring properties. A shadow cast by the buildings on the opposite side falls across the facade, and attests to the narrowness of the thoroughfare. Natural light would have rarely penetrated further than the uppermost floors. A figure with a lamp stands inside the dark archway entrance to Hand Court – a small enclosed courtyard at the far end of the lane, only passable on foot. The general feeling of metropolitan claustrophobia is heightened by the small slice of night sky visible at the top. If the top-hatted figure walking past the front door wanted to look up at the stars, he would have to step out into the road and crane his neck to an uncomfortable angle. Far easier instead to peer in nosily through the street-level windows, suggesting that privacy and quiet too would have been in short supply. There is not a hint

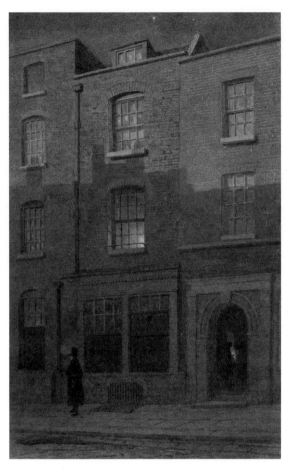

Fig. 3. John Wykeham, *26 Maiden Lane, London, J.M.W. Turner's birthplace*, 1852, watercolour on paper. Despite the traditional title, the artist was in fact born at 21 Maiden Lane. The family moved across the road to number 26 in 1776 and Turner lived here until 1799.

of green in sight and one can imagine the bad air rising from the pavement grille, adding to the general stench from the puddle of dirty water (or worse) in the gutter outside.

Turner's mother was presumably used to the city's sights and smells, but for William Turner the metropolis must have seemed like a different world from South Molton, the small market town near Exmoor from which he hailed. Although perhaps he relished the change. At the very least, Maiden Lane would have been an

excellent place to run a business – any kind of business – because everything was for sale in Covent Garden: food, alcohol, coffee, flowers, clothes, jewellery, entertainment and, not least, sex. Maiden Lane may have originally been named for a statue of the Virgin Mary that once stood on the street (although a twisting of 'Midden Lane' has also been suggested – a midden is an old word for a heap of human waste) but it quickly acquired a tongue-in-cheek meaning for the sex workers who plied their trade here. In Turner's day, the basement of the rented accommodation where he'd been born hosted a notorious drinking den and brothel, the Cider Cellars (small wonder that the family with their newborn chose to move across the road). What is more, dotted all around the district were the listed addresses of prostitutes and courtesans published in the infamous *Harris's List of Covent Garden Ladies* (1757–95). It was a busy, bustling and cosmopolitan neighbourhood, and the high footfall and mixed clientele would have made it a perfect spot for a barber's shop, servicing fashionable London gentlemen and *hoi polloi* alike with wigs and hairstyles, powders and perfumes, shaves and trims.

The other area of commerce that the Turners could not have failed to be aware of was art. Covent Garden was a vibrant hub of creativity with an unusually high concentration of painters located within a small vicinity, not to mention miniaturists, printmakers, printsellers, salesrooms, frame-makers and colourmen (suppliers of artists' materials). Even Maiden Lane had its artistic denizens. The respected watercolourist Thomas Hearne called it home for a time, whilst at number 21 was John Moreing's Great Auction Room. Perhaps the rapidity with which objects were dispatched and sold at this art warehouse across the street awakened Turner senior to the possibilities of a new stream of income within his own establishment. In pale imitation of the numerous print shops found all over the city he began to display drawings in his shop window – probably that very window pictured in Archer's image – executed in watercolour by none other than his own son. When customers having their hair curled idly questioned the proprietor and would-be art dealer about his child prodigy, William Turner is cheerfully said to have replied, 'It's all settled, sir; *William is going to be a painter!*'[1] He even charged his clients a shilling for a closer look – an outrageous sum when one considers the same amount would enable you to visit

the prestigious annual Exhibition of the Royal Academy just a few minutes' stroll away.

Which came first: an awareness of the lucrative possibilities of the art market or the realisation that his boy was a natural talent? According to accounts, which vary in reliability and authenticity, Turner's precocious gift emerged whilst he was tracing a finger in spilled milk, by graffitiing walls with chalk drawings of chickens or through precisely copying a coat of arms at a silversmith's house whilst his father dressed the client's hair. Whatever the circumstances, it is the father who has been credited with encouraging his son along a path that would lead him above and beyond his low-born station.

Turner was apparently very like his father to look at, particularly with regard to the nose – a prominent feature which can be seen in a characterful portrait sketch of the elder William Turner by John Linnell.[2] The sketch consciously draws attention to his profession; a pencilled annotation reveals that he is wearing a 'wig', presumably one of his own hairpieces. Written descriptions of him meanwhile comfortably fit the profile of the stereotypical Georgian barber. He is described as being short, thin and spare, chatty and cheerful with 'tonsorial loquacity', but with the unsettling habit of 'nervously jumping up on his toes every two or three minutes'.[3] There is no reason at all to suppose that Turner of Maiden Lane was not a competent operator but barbers were stock figures of fun in satirical prints of the time and it was commonplace to picture them so engrossed in conversation that they remained oblivious to chaos unfolding within their premises or to the injuries they were inflicting upon their unfortunate clientele.[4] He can easily be imagined as the energetic, razor-wielding fellow undertaking a shave on the far right of Rowlandson and Bunbury's cartoon *A Barber's Shop*, so busy talking that he's unaware of the discomfort caused by his ministrations, or the fact that he has nicked the chin of his previous customer.[5] The image also perpetuates another cliché: that gentlemen's cutters were generally vulgarian figures with pretensions to urbane gentility and worldliness. The barber's shop is imagined as a place for indulging in the idle reading of newspapers and for mingling with the upper classes.

This, therefore, was the backdrop to Turner's childhood. Whether his father was a social climber or not, the boy was brought up in an establishment catering to the needs of a wealthier and better-educated

class of individual. As a small business owner, William Turner introduced his son to market economics and the ability to deal with his social superiors. He also bequeathed him a strong work ethic and an awareness of the value of money. 'Dad never praised me for anything but saving a halfpenny!' Turner would later claim.[6] It was 'Dad' who pushed and encouraged him, enabled and supported, and who even ultimately gave up his own profession in order to place himself at the service of his son's artistic vocation. He was in all respects a positive paternal presence and the two seem to have had a comfortable, sympathetic and affectionate relationship, choosing to live together until William's death in 1829.

Turner's mother, on the other hand, looms large in his biography for all the wrong reasons. Based upon the known facts alone, she is a shadowy and elusive figure. We cannot say for sure what she looked like, although a small number of likenesses have been speculatively attributed as depicting her.[7] There is reference to a missing portrait in which she is described as having a strong likeness to her son with blue eyes, an aquiline nose and below-average height. The description goes on: 'Her hair was well frizzed – for which she might have been indebted to her husband's professional skill – and it was surmountd by a cap with large flappers [lappets].'[8] It isn't much to go on. Nor do we ever hear her voice, or ascertain how Turner really felt about her. He almost never spoke of her. We certainly never hear her side of the story. Yet whereas his father is generally positioned as a force for good, the silent, faceless Mary Turner is credited only with the bad. To her influence are ascribed all the perceived flaws in Turner's mature character: his taciturn, secretive personality; his inability to express himself emotionally; his belligerence and ruthlessness in matters of business; and his unwillingness as an adult to tie himself down to conventional (at least by Victorian standards) domestic arrangements.

All this centres upon his mother and the two stark, sad facts we know about her. The first is that she was fated to become a mother bereaved. In 1783, the Turners' only other child, a little girl named Mary Ann, died aged four. Infant mortality was commonplace in the eighteenth century and Turner's sister was perhaps a victim of 'the urban penalty', the terrible cost of living in reduced circumstances amidst the dirt and pollution of a crowded city.[9] This family tragedy must surely have been a contributing factor to the other known truth

about Mary, which is that she suffered from some form of psychiatric illness. Whether her instability was triggered by grief or whether the loss of her daughter simply exacerbated a pre-existing condition is not known. But it seems that in the months and years following Mary Ann's demise, Mrs Turner's mental state deteriorated. She is unsympathetically, even misogynistically, described by Thornbury as having a 'masculine, not to say fierce' aspect, and as being a person of 'ungovernable temper' who 'led her husband a sad life'.[10]

If Mr Turner's life was sad, then presumably so also was that of his surviving son, whose childhood was marred by the trauma of illness and loss. It seems within the grieving and damaged household, things began to go wrong. The young Turner began to spend intermittent periods away from the home environment. Was this to remove him from the unhealthy urban setting that had contributed to his sister's death? Or was it to try and shield him from the worst excesses of his mother's behaviour? Mary's 'temper' got worse, perhaps manifesting itself as emotional neglect, verbal abuse or even physical aggression. Between the ages of ten and thirteen the boy was sent away for months at a time, first staying with an uncle in New Brentford, Middlesex, and later with friends, the Trimmers, in the seaside town of Margate. Even when he returned to the capital, and embarked upon his artistic education, Turner still frequently left Maiden Lane to visit family or friends: the Nixons of Foots Cray, Kent; the Wells family, also in Kent; or the Narraways in his father's home county of Devon. These sojourns smack of escape – interludes of respite from the unhappy situation at home – and Turner became used to associating absence from London with a sense of freedom and release. Many of his earliest drawings and watercolours are not of his immediate Covent Garden vicinity, but of places further afield, havens of calm and inspiration – the sea and harbour around the Isle of Thanet, the green fields of Oxfordshire and the Avon Gorge in Bristol. The emotional and creative benefits of these rural expeditions instilled within him a deep love of the natural world and a wanderlust that would remain undiminished throughout his life.

Poor mad Mary, therefore, has traditionally been understood as representing a dysfunctional element within the artist's childhood. Clara Wells, who knew Turner as an adolescent, believed he would have been a very different man had not he suffered from the emotional damage caused by what she circumspectly described as

'many domestic trials, too sacred to touch upon'.[11] Yet can it really be assumed Mary Turner played no positive part in her son's life whatsoever? Her illness does not preclude the existence or display of love, or an awareness or satisfaction in his talents. The fact that she apparently gifted his earliest known watercolours of Margate, painted c.1784, to an acquaintance in Derbyshire, hints at periods of lucidity, social interaction and an actively proud engagement with his juvenile achievements.[12] But clearly the situation in the Maiden Lane home was at times desperate. There was also no satisfactory solution. This was an age when disorders of the mind were neither well understood nor well treated. Evidently the challenge, or shame, of dealing with Mrs Turner eventually became too much and husband and son turned to the alternative of public 'care'. In 1799, Mary was committed, temporarily, to St Luke's Hospital for Lunatics in Old Street. A year later, she was moved permanently to the long-term 'Incurable' ward at Bethlem Hospital, in Moorfields.

'Bedlam', as the institution notoriously became known, was not a place of civilised comfort. From the outside it resembled an opulent estate, but the grand facade belied a dilapidated interior. As she passed through the front gates, Mary Turner would have seen looming above her a horrifying premonition of what was to come; two life-size figures in Portland stone by Caius Gabriel Cibber, representing the twin faces of mental illness as it was then understood.[13] To the left, a sculpture, *Melancholy Madness*, showed a reclining man with a vacant expression slumped in hopeless apathy. However, it would have been the right-hand statue that chimed more powerfully with the Turners. Entitled *Raving*, this contorted sufferer is bound in chains, his psychotic energy restrained and his mouth open in an endless fixed wail of agony. As gratuitous as this effigy of manic insanity might seem, in its essentials, this reflected the reality of the conditions inside Bethlem. Inmates *were* kept in cells lined with straw. Violent or aggressive patients *were* kept chained to the wall, sometimes in solitary confinement, but sometimes in the same wards as their non-violent counterparts. Following the Galenic system of medicine, many were subjected to debilitating and inhumane treatments such as purging, bloodletting and cold-water bathing.[14] In his early twenties, as his professional life was just taking off, this was the fate Turner chose for his own mother. Her incarceration

lasted the best part of five years, and she died in 1804, hidden away from view, all but forgotten by the world at large.

From a modern perspective the actions of the Turner men seem heartless, or even cruel. But in many ways, they were simply acting in accordance with contemporary thinking. As unlikely as it may seem, patients placed in Bethlem were sent there under the precept of recovery; the admissions criteria were defined as 'raving and furious and capable of cure'.[15] Confusingly, even those deemed 'Incurable' were taken in with the hope that they would improve with treatment. Contrary to popular belief, fuelled by the memorable visions of William Hogarth, there is evidence to suggest that some inmates at least were adequately fed and watered, and, as far as the orderlies could manage it, kept clean and well clothed.[16] True, the Turners might have opted for private care, but it is likely they were acting on professional advice. They may well have been persuaded to institutionalise Mary following the recommendation of none other than the principal physician at the hospital, one Dr Thomas Monro.

Monro is a significant figure in the backstory of Turner's early artistic life. A member of a dynasty of practitioners, he had followed in the footsteps of both his father and grandfather and inherited his position at Bethlem in 1792. Around the same time, the doctor, who was an enthusiastic and gifted amateur watercolourist, had also begun to establish himself as a patron and supporter of the arts. It appears his eye was caught by two bright new talents within the growing field of British watercolour. From 1794, Turner and his equally precocious friend Thomas Girtin could regularly be found undertaking the short walk from Maiden Lane to spend Friday evenings at the doctor's home in nearby Adelphi Terrace. The incentive to attend these candlelit soirees was the art and the private club-like ambience of the gatherings.[17] In a time before easy public access to pictures, Monro was like a one-man print room, providing a conducive space for the close study of his extensive collection of modern and Old Master drawings. He exacted no price for this privilege, but rather paid them. Together they were given materials and money (half a crown or two shillings and sixpence), as well as their supper (sustenance was offered in the form of oysters), in return for copying selected works from the collection. Girtin sketched out the outlines before passing the composition on to Turner, who washed in the effects with colour.[18]

TURNER AND CONSTABLE

The work would have been menial and the money largely beside the point. It was the opportunity to get their hands on pictures that was so invaluable: to analyse, compare and discuss works by some of the best-known masters of the day – Edward Dayes, Thomas Hearne, Paul Sandby, as well as dozens by a private patient of the doctor's, the painter John Robert Cozens. As both a watercolourist and a topographer, Cozens was one of the most talented and inspiring hands in the business and enormously influential upon the generation of landscapists to follow. Scores of up-and-coming painters, including Turner, would admire his expressive touch and romanticising of location, and John Constable would later describe him as 'the greatest genius that ever touched landscape'.[19] By opening his doors to this wonderful collection, Monro fostered a grassroots community of artistic talent that materially benefited the development of landscape and watercolour painting in Britain. At least as far as the young artists of London were concerned, he was a thoroughly decent person. Turner, whose association with him lasted for several years, called him the 'good Doctor'.[20]

Monro was not a good doctor. He may have gone down in history as a benevolent mentor but this extracurricular altruism came at the expense of his medical practice; he was much more interested in painting than he was in treating patients. There can be little doubt that Mary Turner's last years must have been miserable. In 1815, a government inquiry into the practices of the Bethlem hospital uncovered a litany of horrors. Behind its doors, appalled investigators found evidence of abuse and neglect, including the 'disgusting idiocy' of some female patients found cold and naked in fetid cells, long-term 'violent' inmates kept chained behind bars, and one particular unfortunate permanently shackled by the neck to an iron bar. Unsurprisingly much of the blame was laid squarely at the door of its chief medical man. A Commons committee accused Dr Monro of absenteeism and of employing cruel, outdated practices.[21] The sad truth was that, even as he was feeding, financing and fussing over the future stars of the British art world, Monro was neglecting his professional responsibilities and wilfully ignoring the basic needs and welfare of the vulnerable patients under his care. His actions were condemned as utterly 'wanting in humanity' and the scandal finished his career. He was forced to resign his position.

To what extent did all this background biography really shape Turner's art? Can we detect the miasma of Georgian muck and madness within his works? John Ruskin certainly thought so. In *Modern Painters*, the Victorian critic and Turner superfan devoted a chapter to a comparison of Turner's boyhood with that of the Renaissance master Giorgione, stipulating (with great naivety and idealism), that the beauty and elegance of Giorgione's native Venice ensured that he never painted anything foul.[22] By contrast, he argued, Turner's background had desensitised him to ugliness so that throughout his life anything 'fishy and muddy . . . had great attraction for him'. He was not only inured to dirt and litter; he actively sought it out, 'like Covent Garden wreck after the market'. According to Ruskin it was early exposure to London grit that fostered Turner's taste for illustrating the 'effects of dinginess, smoke, soot, dust, and dusty texture; old sides of boats, weedy roadside vegetation, dung-hills, straw-yards, and all the soilings and stains of every common labour'.[23] Ultimately though, Ruskin believed that the greatest impact Maiden Lane had upon Turner was to repel him with its squalor, inducing him to rise above the vulgarity of his upbringing and to seek out subjects like 'fair English hills, the rocks, and fields, and trickling brooks, and soft, white clouds of heaven'. Certainly, Turner does seem to have continued to seek inspiration outside his home territory. For the rest of his life, London remained a place of commerce and industry, education and enterprise, but not one he associated with health and happiness. Rarely did he use the city as a subject within his painting and although several (related) images of his boyhood home exist, none of them are by the artist himself. Despite living there until he was an established professional, Turner had no interest in creating a visual record of the place that had nurtured him from birth. Maiden Lane, described as 'small and ill calculated for a painter', was somewhere for him to leave behind.[24] His painting represented freedom and upward mobility. The two were mutually exclusive.

John Constable, by contrast, painted his family home often, and compared with Turner's inner-city environment, these pictorial records are like a welcome breath of fresh air: an escape to the country with an abundance of green fields, trees and clear skies (fig. 4). The open acres of East Bergholt immediately look like a more conducive place in which to bring up children than the streets of Covent Garden.

Indeed, Constable's father, a native son of the Stour Valley, could barely tolerate even occasional business trips to London. Like a canary down a mine, he could 'perceive a difference in the air' when he came within seven miles of the city, and 'it became more and more oppressive as he advanced towards the Metropolis'.[25] He wouldn't risk staying in the capital, even for a day, for fear of severe risk to his health. Certainly, he would never have dreamed of relocating there as William Turner had done, and raising a family in its filthy atmosphere. Instead, it was Constable's mother, Ann, who exchanged town for country and grew to share her husband's intense love for the 'beauty of the Langham, Dedham and Bergholt Vales' of East Anglia, 'so rich & delightful'.[26]

East Bergholt may have been a small country village but historically it owed its prosperity to the medieval cloth and wool trade. A number of high-status manors were located in the vicinity. Initially Golding Constable inhabited the modest mill house he had inherited by the river in Flatford, but in 1774 he moved into a newly built, impressively proportioned house, fashioned on the model of other local but more historic mansions. Financed by the profits from his lucrative business, 'East Bergholt House' stood directly opposite the green on the main thoroughfare between the parish church and the centre of the pleasant village after which it was named. Here, in the words of a fellow miller, industrious Golding Constable lived 'like a country squire'.[27] Described as incorporating 'every convenience that can be thought of', the three-storey property included four 'excellent sleeping rooms', a 'spacious entrance hall', 'light closets & spacious landing', four attics, a 'capital' cellar and wine vault, offices, stables for eight horses, a coach house, a garden and a shrubbery, as well as thirty-seven acres of very good pasture and arable land.[28] There was, in short, ample space, both for a family increasing in size, and for these growing young people to run around and play comfortably and safely within the clean air and gentle pace of Suffolk village life. It was an upbringing of well-being and security. John, the first child to be born at East Bergholt House, had not been expected to live and was so sickly that the local reverend had been urgently summoned to baptise him on the day of his birth. Yet all six of the Constable children not only survived infancy but thrived into adulthood, testament to the prosperous and healthful

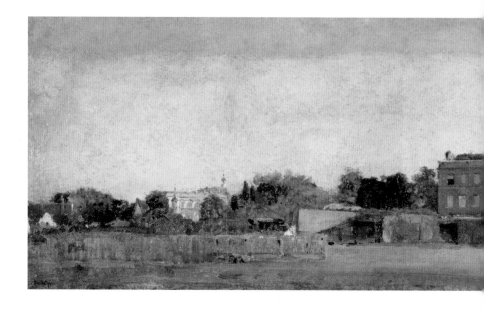

circumstances in which they were raised. There were the occasional squabbles and irritations common amongst even the fondest of relations, but the family represented an affectionate and close-knit unit. Parents and siblings alike were supportive and solicitous of one another and there was also an extensive, extended network of aunts, uncles, cousins and in-laws.

Suffolk was everything for the young Constable, and his early biography suggests that he exhibited little desire to venture beyond the boundaries of his father's purview. His childhood world was triangulated around the fixed points of East Bergholt House and the mills at Flatford and nearby Dedham, two miles in each direction. An experiment had been attempted to send him to school in Lavenham, sixteen miles away, but this had not been a happy experience and the boy was swiftly brought back into the family fold. He was enrolled instead in Dedham Grammar School, a more sympathetic educational facility. The headmaster, Rev. Dr Thomas Grimwood, tolerated young John's tendency to daydream about art whilst neglecting his Latin and literature. 'Oh, I see you are in your painting room,' he would quip.[29] Even at this early stage, Constable was thinking about pictures, and about the beauties of the countryside through which he walked each day. His daily commute took thirty to

Fig. 4. Constable, *Golding Constable's House, East Bergholt*, c.1811, oil on millboard laid on panel.

forty minutes or so, along a route that sloped gently downhill from East Bergholt church before following the meandering River Stour, towards Dedham itself. More than a village, but no longer quite a town, Dedham too had been a centre for the wool-cloth trade, and it was money from the fifteenth-century clothiers and merchants which had built the large parish church of St Mary the Virgin with its impressively high tower. Just along the high street from the church was the grammar school where generations of pupils scored their names into the red brick around the doors and windows. Amongst the dozens of scratched marks can still be seen the names and dates of boys who must have been Constable's classmates. There are even the initials 'JC', but whether this is Constable's handiwork cannot be proved. However, he graffitied his presence elsewhere. In 1792, the sixteen-year-old incised a sketch of a windmill, along with his signature and the date, into the wood of East Bergholt mill.[30] This crude but accurate carving represents one of Constable's earliest known productions and few pieces of artistic juvenilia. The impulse to create something graphic out of the fabric of the Constable chattels was strong, and this would be only the first of many occasions when he would turn his hand to an accurate representation of the buildings and territories that made up his father's domain.

That same mill can be seen in the background of views taken from the back of East Bergholt House during the 1810s.[31] Looking out of an upper-storey window Constable surveyed his father's rural kingdom. Everything as far as the eye could see was part of his bailiwick: the gardens, the barns and outhouses, the fields beyond, enclosed by hedges, the livestock and the labourers and, in the far distance, the most important status symbol of all, the windmill.[32] By this time the adult John had long since left home and moved to London. Yet despite broadening his horizons, he was still returning to the place of his birth and making a visual touchstone of the landscape of his childhood. Within this fertile, well-maintained and man-made territory is encapsulated a personal philosophy of social and economic stability, grounded in the harnessing of nature and cultivation of the land. The source of the family's wealth became the cradle for his artistic vision and Suffolk remained indelibly fixed in his mind as the site of familial love, domesticity and security. In a letter which has gone down in art history as a profound statement of artistic intent Constable famously acknowledged the foundation of his individualistic world view. In 1821 he wrote:

> I should paint my own places best – Painting is but another word for feeling. I associate my 'careless boyhood' to all that lies on the banks of the *Stour*. They made me a painter (& I am grateful) that is I had often thought of pictures before I had ever touched a pencil.[33]

This in a nutshell is Constable's 'origin story', told in his own words. If we choose to psychologise Turner as using art as a way to transcend his roots, then similarly we can understand Constable's childhood remembrances as rooting and shaping his subsequent artistic vision. For many years, he sought to use his painting as a way to articulate his feelings in public about the place he would always consider in his heart to be home.

That 'home' still exists for us today, not just through Constable's landscape paintings but also through his portraits and his writings. So much of how we think about him comes directly from the horse's mouth, as it were. We know what his parents looked like because *he* painted them and these paintings remain for all to see. And whilst

Turner's extant correspondence exists in the form of one slim publication, Constable's surviving letters run to several substantial volumes.[34] It is thanks to this extensive mass of writings that, unlike the uneven patchwork of Turner's formative years, the backdrop to Constable's life is like a rich, colourful tapestry, woven from the multitude of words sent to and from those who knew him best. Dipping into his correspondence is like picking up a direct telephone line to bygone Bergholt, so whilst Turner's immediate family appear to us now as little more than picaresque caricatures, the Constable clan are like the ensemble cast in a novel by Jane Austen. We can not only gaze upon their faces but also listen to their voices, sharing in their thoughts and mannerisms, idiosyncrasies and in-jokes. Constable's portrait of his mother, Ann, for example, reveals her to be a neat, bright-eyed woman with a matronly face and a tender manner (she cuddles a spaniel on her lap).[35] How different from the harsh and potentially spurious description of Mary Turner's masculine fierceness. Flesh is added to these bones by Mrs Constable's letters. They are charming, chatty affairs, full of titbits of family and local gossip, and within them she comes across as everything Turner's mother was allegedly not – a devoted wife, a caring mother and a busy and active body, utterly absorbed in the day-to-day doings of her small corner of the world. She has a nice turn of phrase and fills her reports with observations about the village, the weather and the favourability, or otherwise, of the harvest. In the main, her existence is defined by well-meaning worries about her family. She fusses over their health and their prospects, their well-being and their wardrobes (in one particularly endearing letter to John she frets about the size of the cambric frills on some shirts she has made him and whether they are fashionable enough; on another occasion she tells him to bring his mending home).[36] She frequently accompanies her missives to him with small gifts of money or food and copious homely advice, and invariably signs herself 'your affectionate Mother'.[37] In fact her fond, motherly concern seems to underline all that is missing from accounts of Turner's early life: the trappings of family life which he must have yearned for as a child, but which (as we shall see) he seems to have turned his back on as an adult.

It wasn't that illness and disability didn't exist for the Constables. John's elder brother, Golding, two years his senior, was prone to fits

which left him, in the words of his brother Abram, 'far from right' with his mind so 'contracted' that he was unable to maintain focus and empathy.[38] He was described as 'apathetic' and unable to assume his natural responsibility as the next in line to the family business. Had *he* been considered for admittance to hospital his ailment (probably a learning difficulty compounded by epilepsy) would presumably have more readily accorded with Bedlam's 'melancholy' diagnosis. But whereas poor Mary Turner's condition escalated to the point where her nearest and dearest were no longer willing or able to care for her, 'good-tempered' Golding Constable junior remained ever in the bosom of his family.[39] He was allotted simple tasks commensurate with his capabilities, such as his handiness with a shotgun, and he was eventually given the position of gamekeeper for a local estate (a role John found for him). After the death of his parents, he remained happily with his siblings, sharing a cottage in East Bergholt with his eldest (and rather eccentric) sister, Ann (generally referred to as Nancy). Indeed, the Constables' neighbourhood remained always just that. Youngest brother Abram took over the running of the business and relocated to Flatford Mill with another sister, animal-lover Mary, and although the remaining sibling, Martha (known as Patty), married a London cheesemonger, Nathaniel Whalley, and lived in East Ham for a few years, she too eventually returned to the area, settling opposite the mill owned by the Constables at Dedham. So of all Ann and Golding's offspring, it was only John who permanently moved away and established himself elsewhere.

Leaving Suffolk hadn't been the easiest of things to accomplish. That comfortable, privileged existence came with a heavy burden of expectation. Golding Junior's disadvantages meant that Golding Senior automatically looked to his second son, John, to follow him in the business. 'It's all settled,' he would have flatly told anyone who had enquired, 'John is going to be . . . my successor.' Although perhaps the question had not even needed to be asked. The idea of the heir of Golding Constable, wealthy merchant and miller, becoming something as outlandish as a painter would never have entered anyone's mind. Pictures were a precarious line of work. Most artists were considered little more than artisans and very few managed anywhere near the level of income that the Constable business brought in. What use was a painter when there were mills to be managed? Constable's portrait

of his father depicts an affluent man with a broad, ruddy face.[40] Like William Turner, he wears a wig, which perhaps makes him seem more youthful and vigorous than his years, but there can be no doubt that this is a man of consequence and standing, with a commanding presence and a steady, no-nonsense gaze. Also like William, Golding tried to teach his children the value of money. Compared to his wife he was an infrequent correspondent, but when he did put pen to paper it was usually to impart practical information concerning matters of business or to lecture John, with affectionate sternness, about his finances. He was not a man used to being gainsaid, 'the *resolution* of a Constable' being a thing which was noted.[41] Ignoring his teenage son's wistful preference for drawing over all things, he set him to work, training him up with the skills and experience he would need to take over the business. For seven years, John's life was mostly accounts, machinery and warehouses, as he grappled with the complexities of milling flour and transporting it by barge and sea from East Anglia to London. All the while, however, his mind was still wandering elsewhere. Constable was still thinking about pictures.

Exposure to art would have been harder to come by in East Bergholt than in Covent Garden, but even in the Stour Valley it was possible to connect with other people interested in painting. As he dutifully went through the motions of his day job, John Constable became blessed with two such acquaintances from very different sides of the Suffolk social divide. The first of these was John Dunthorne, a near neighbour and the local handyman, who shared Constable's enthusiasm for the landscape. In their hours of leisure, the two went out into the fields with easels and painting equipment where they would work side by side whilst the light lasted. The Constables were not so grand that they wouldn't associate with someone who made his living mending windows and roofs (although his mother later had misgivings about the wisdom of the connection). However, neither were they so lowly that they weren't able to mix with the gentry. At the opposite end of the social scale from John Dunthorne was Sir George Beaumont, a baronet and Tory MP, who had houses in London and Leicestershire, but whose dowager mother lived in Dedham High Street. Beaumont had been taught painting at Eton College by Alexander Cozens, the father of the aforementioned John Robert Cozens. This awakened in him an insatiable appetite

for making and buying art and by the end of the eighteenth century he had become a major influence within London's artistic circles. A well-thought-of amateur and connoisseur, he regularly exhibited at the Royal Academy, and was gradually building up a valuable collection of Old Master works. In 1795, Mrs Constable engineered an introduction for her artistically minded son and, just as Turner was doing at Dr Monro's during the same period, nineteen-year-old Constable gratefully seized upon this valuable opportunity to study and copy from the greats. It was an electrifying experience. Sir George's personal treasure trove, which would later go on to form a founding gift for the National Gallery in London, was notable for its major examples of French, Flemish and Dutch art. He also owned select modern productions, including watercolours by Thomas Girtin, Turner's friend and collaborator at the 'Monro School'.

In particular, Constable was struck by Beaumont's all-time favourite work, a small oil titled *Landscape with Hagar and the Angel*, by the seventeenth-century French master Claude Lorrain.[42] So great was Sir George's love for this picture – the importance of which for Constable we will later return to – that he took it with him wherever he went, carrying it in a bespoke travelling cabinet, like a talisman. To Turner, who already knew many artists and collectors, and whose own early encounter with Claude's work moved him to tears, such ardent and demonstrative behaviour would not have seemed anything particularly out of the ordinary. But no one else in Constable's sphere at this time would have exhibited such passionate devotion to Art. Thus an awareness of the 'art world' – a predominantly urban system in which Turner was already fully immersed – began gradually by degrees to insinuate itself into Constable's country existence. By spending time in Beaumont's company, he was offered a glimpse into an alternative reality where art was not merely a peripheral, spare-time pursuit, but rather an all-consuming way of life of the utmost value and importance. He was filled with a new desire to become a permanent part of it. To do so, he realised, he would have to escape from Suffolk and completely extricate himself from the family business.

Golding Constable was reluctant to say the least. There was a last-ditch attempt to keep John on track by sending him to gain business experience at his uncle's brewery in Edmonton, north of London. The move, however, backfired. The temporary transfer

brought Constable within the orbit of more artistic and intellectual types, such as the engraver John Thomas Smith and the painter John Cranch, and only served to further whet his appetite for broader horizons and more intellectual circles. Ultimately, the battle was lost. Constable was never going to assume the preordained role set out for him by his parents. Fortunately, help arrived in the form of the youngest member of the family, Abram, who, as soon as he was able, stepped into the breach and shouldered the responsibility neither of his brothers had been able to take on. In 1799, the year Abram turned sixteen, the go-ahead, if not quite the blessing, was finally given. Despite his reservations about the viability of painting as a career, and his fears that his boy was 'pursuing a shadow', Golding Constable awarded him an allowance and permitted him to move out of home.[43] The now twenty-three-year-old John Constable headed to the capital with a single aim: to become a full-time art student.

Unbeknownst to him he was following in the footsteps of his near-contemporary Turner. The latter's formal art education had begun ten years earlier in 1789. But despite their divergent backgrounds and the decade's difference in getting started, the paths of these two young men were about to converge. In order to become a professional artist at this time there was really only one place to be: the Royal Academy, in London.

CHAPTER 2

THE ROYAL ACADEMY

As the year 1789 drew to a close, fourteen-year-old William Turner left his Maiden Lane house and walked the third of a mile down the Strand to a much grander building, his new place of study.[1] Turning right near Aldwych and the church of St Mary le Strand, he would have entered the grand neoclassical colonnade of the former royal residence of Somerset House and proudly looked up at the architectural decoration of the vestibule. Glancing to his left, he would have seen an alcove containing a bust of the English mathematician Sir Isaac Newton, which told visitors they were looking at the entrance to the Royal Society, the national academy of sciences, founded in 1660. Turner, however, would have turned his back on Newton and moved instead towards the opposite doorway, surmounted by the head of Michelangelo. In crossing the threshold beneath the Renaissance master, Turner would have entered the Royal Academy of Arts, an institution dedicated to upholding the advancement of the arts in all three major fields – painting, sculpture and architecture.

Founded in 1768, the Academy dominated artistic taste and identity to an extent that would never be repeated in Britain. At the time it offered the only official endorsement of professional status and its functions were twofold: exhibition and teaching. It was the sole body in the country to offer centralised formal art education, and that was why Turner was there. He had already been taking private

lessons with various local professionals, notably the topographical artist Thomas Malton the Younger. But as invaluable as this early tuition was – particularly for mastery of architectural subjects – Turner's aptitude was something exceptional to behold, matched only by his ambition. 'Tom Malton of Long Acre' was never going to help him reach his full potential. His purpose for undertaking the Academy studentship was to embark upon a career track which, if one worked hard, was the surest path to success. Fame and fortune were the goals, along with the right to append the celebrated letters 'RA' to his name.

At the beginning of 1799, John Constable, only recently arrived from Suffolk, was determined to follow that same track and began to manoeuvre himself into position accordingly. He took lodgings in Cecil Street, a road off the Strand about as close to the Royal Academy as it was possible to be (barely a stone's throw from Maiden Lane), and chose to cohabit with another artist, Ramsay Richard Reinagle, who just so happened to be the son of an Associate of the Academy, the painter Philip Reinagle. Armed with a letter of introduction from a Suffolk acquaintance, he promptly called upon one of the most prominent members of the Academy's community, the painter Joseph Farington, RA, casually dropping into the conversation the names of Sir George Beaumont and Thomas Gainsborough, whose work he knew through an art-collecting uncle, David Pike Watts.[2] This was a smart tactical move. If you wanted to make headway at the Academy it was politic to pay homage at the court of Farington, an average artist but a master networker and power broker. His good opinion and influence were widely acknowledged to be indispensable. In this respect Constable was quicker off the mark than Turner. Whilst Farington was well aware of Turner as a precocious talent, there was the matter of class between them. Despite being, by now, a long-standing contributor to Academy life, Turner was not the sort of personage with whom Farington would habitually socialise. In fact, he called upon Farington for the first time in September 1798, barely five months before Constable, and then specifically to canvass his support for election as Associate in November.[3] But whilst Turner had to rely on talent to recommend him, the more affluent and well-connected Constable naturally felt more comfortable about securing Farington as a social ally.

The very next day after his first visit Constable called again to show the older artist a few 'sketches of landscapes' he had made in the 'neigh-berhoud [sic] of Dedham', and to ask his advice about applying to the Schools.[4] On being told he would have to 'prepare a figure', Constable got straight to work and returned four days later with a drawing of a classical 'torso'.[5] This was a study of a plaster cast of the *Belvedere Torso* – a textbook exercise, invariably undertaken by all aspiring artists at some point (including Turner).[6] Farington rewarded him with a letter of introduction to Joseph Wilton, the Keeper of the Royal Academy and superintendent of the Schools. Constable did not waste a moment to use it. With all the impatience of one whose heart's desire has been long deferred, he immediately hastened with his 'torso' along the Strand and, like Turner had done a decade earlier, passed through the doorway beneath Michelangelo and offered up his work for approval. On 4 March he was able to write in triumph to John Dunthorne, 'I am this morning admitted a student at the Royal Academy.'[7]

So it was that the Royal Academy became the crucial backdrop to the lives of both Turner and Constable. In the chronology of their shared existence it is the place where we first, and then most frequently, catch sight of them together. It hosted the majority of their known encounters and became the stage set for their reputed rivalry. To begin with, their movements barely overlapped. As time went on, they met more often, drawn together by professional cir-cumstance and institutional loyalty.

It has often been supposed that Constable was old to embark upon artistic training, casting him in the role of a late starter. Certainly at twenty-three, he would have seemed mature compared to some of his compatriots, notably the most famous alumnus of his student years, William Mulready, who, like Turner, gained admittance to the schools when he was fourteen, and had a similarly swift rise to success. However, Constable was a relative youngster compared to others from his intake, such as twenty-nine-year-old William Daniell or thirty-one-year-old J.F. De Cort. Amongst the June 1800 list of qualifying probationers, the average age was in fact twenty.[8] As an institution where attendees were expected to apply to the Schools with their artistic abilities already well advanced, it was less common to see adolescents like Turner, and far more usual for students to arrive, like Constable, in their late teens or early twenties.

Despite the ten-year interval between their arrivals, Constable's academic training at the turn of the century differed very little from that of Turner's during the 1790s, and was specifically geared towards study of the human figure. Having passed their probationary periods, both subsequently embarked upon the mandatory two-tier curriculum of practical instruction, beginning by drawing from plaster casts of statues in the 'Antique Academy', before graduating to the flesh-and-blood models of the 'Life' class.[9] No painting was taught, and it is perhaps hard to see the bearing this intense focus on mastery of the human figure had for two young men already leaning towards specialisms in landscape. But a comparison of their respective student studies reveals that they both came through the process with a thorough grounding in draughtsmanship and a useful competency with anatomy. There were also valuable lessons absorbed about subject and design. A rota of supervising Academicians known as Visitors set the nude sitters in stances reminiscent of classical statuary or Old Master paintings, often favouring dramatic poses. Hence the contorted attitude of a naked male drawn by Turner, perhaps based upon one of the Niobid sculptures in the Uffizi Gallery, Florence, is echoed years later by the bent-back musculature derived from Michelangelo's Jonah in the Sistine Chapel as copied by Constable.[10] The intention was to encourage an awareness of narrative emotion and reaction, and its introduction through the use of line, light and shade.

In addition to the practical syllabus, both young men would have attended evening lectures in subjects including anatomy, architecture, painting and perspective, and here the authority of art-historical precedent would have further been reinforced. True, in the intervening decade between Turner's freshman year and Constable's, the faces of the professors might have changed – James Barry was succeeded as professor of painting in 1799 by Henry Fuseli. But there was little change in the pedagogic ethos. In particular, Turner's student days had coincided with the final years of the first president of the Royal Academy, Sir Joshua Reynolds, and Turner had therefore almost certainly been present on 10 December 1790, to hear the revered portraitist deliver a lecture on Michelangelo. This represented the fifteenth and final instalment in his famous series, the *Discourses on Art*, an intellectual articulation of the founding principles of the

Academy.[11] Based upon his belief in the supremacy of the Old Masters, Reynolds had identified the essence of grandeur in art and theorised how best to achieve it. The most influential of his ideas was that of the 'grand manner' or 'grand style', which advocated the idealisation of nature through application of the classical ideal. This proved to be a brilliantly flexible notion. Essentially elevating aspects of an artwork through reference to Greek, Roman and Renaissance art, it could readily be applied to different genres and media, not to mention the cultural advancement of the British School. Anyone striving for Academician status was wise to heed its lessons. Reynolds delivered his lectures with an erudition and flair that led to the *Discourses* attaining canonical status; even students not lucky enough to hear him speak in person would have been thoroughly inculcated with his teachings. By the time Constable joined the Academy, Reynolds was long gone – a seventeen-year-old Turner had participated in his funeral procession in March 1792 – but like all his peers, he was intensely familiar with the *Discourses* in their published form and was often known to quote their wisdom.

Reynolds' doctrine not only regulated the educative system at the Royal Academy; it also underpinned its exhibition activity. Even before the statutory six-year period of study in the Schools was completed (increased to seven years in 1792, and ten years by the time Constable was there), students would have been looking to achieve one of their first significant career goals: to have a work accepted into the annual Exhibition.[12] The prestige of this yearly extravaganza of contemporary practice can be inferred from its perennial capitalisation; there were many London 'exhibitions', but there was only one 'Exhibition'. Held between late spring and early summer, it was not only the central fixture of the Royal Academy's calendar but was also scheduled to coincide with the royal family's residence in the capital and the related events of the 'Season' for the aristocracy and landed gentry. This made it the most well-attended platform for display and artistic self-promotion.

The Academy relied on ticket sales to fund all its activities, including the Schools. With an entrance fee of one shilling (and an additional sixpence for the catalogue), the Academy could confidently expect a genteel crowd of thousands.[13] A shilling represented the same admission price as for other accessible urban entertainments – seats in the

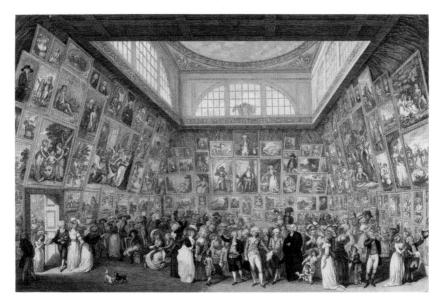

Fig. 5. Johann Heinrich Ramberg, engraved by Pietro Antonio Martini, *The Exhibition of the Royal Academy 1787*, published 1787, hand-coloured etching and engraving.

cheapest tier at the theatre, for example, or entry to the Vauxhall Pleasure Gardens – and although this placed it well beyond the reach of the working classes (a shilling was a day's work for the average labourer), it would have been comfortably affordable to those for whom leisure was a regular habit.[14] Take a look at the public assembly in the foreground of J.H. Ramberg's famous view of the 1787 Exhibition (fig. 5). All of Georgian society is here. Prominent in the centre is the red-coated personage of George, Prince of Wales, and dancing attendance next to him with his ear trumpet is the art world's equivalent of royalty, the Academy's president, Sir Joshua Reynolds. All around them is a chattering cross-section of affluent, privileged Londoners, both young and old: from dignified clergymen and sober scholars to fashionable bucks and flirtatious young misses, elegant matrons and even a fidgeting babe-in-arms, reaching out to try and grab the miniatures. Just as varied are the pictures, hung in a condensed chequerboard, from floor to ceiling. From high-end to

low, there would have been something here for everyone: works to suit all tastes and budgets, but, like the visitors themselves, crammed closely together in a manner that must have been overwhelming for the senses. No wonder it was known as the 'Great Spectacle'.

In terms of the exhibitors the event was (and still is) open to anyone on a meritocratic basis. All comers, whether professional or amateur, male or female, were invited to submit their efforts for anonymous consideration. The miscellany of successful contenders (several hundred of them) was then sifted into a loose curatorial arrangement by the hanging committee for that year and displayed throughout the various spaces of Somerset House. In theory it was possible for unknown dilettantes to find their daubings hanging cheek by jowl with masterpieces by some of the most acclaimed artists of the day. In reality, however, the works were broadly assigned a location according to an assessment of their perceived artistic values. The criteria upon which those judgements were based linked directly back to the intellectual agenda and the educative programme instigated by Sir Joshua Reynolds. It was all about hierarchy and the way that was choreographed by the architecture of the building.

Essentially, as a visitor to the Royal Academy, the higher you climbed, the nearer you found yourself to artistic greatness. The exhibition spaces at Somerset House were spread across three storeys and hierarchical ascendancy had been hardwired into their design by the architect, Sir William Chambers. In mounting the famously steep spiral staircase, visitors' expectations were guided by the neoclassical ornamentation, moving on each successive level through the classical orders of architecture, with the simplest (Doric) at the bottom and the most complex (Corinthian) at the top. Exhibition goers who made it to the top of the staircase, out of breath from the physical effort of the climb, were symbolically rewarded in their quest for artistic illumination by daylight emanating from a circular window set into the roof. Another visual signpost could be found in the antechamber beyond the stairs. Here a floating Greek inscription picked out in gold warned 'Let no stranger to the Muses enter', inviting the enlightened art lover to progress through to the most exalted space of all, the so-called 'Great Room'. This grand chamber – the one depicted in Ramberg's print – had been purpose-built to showcase large numbers of pictures. It offered state-of-the-art display conditions for oil paintings

in particular, including natural lighting from four large Diocletian windows at the top and hanging screens that could be brought forward off the vertical to facilitate viewing of the uppermost canvases. It also boasted 'the line' – a wooden moulding that ran around the room at the optimum height of about eight feet. This feature helped to demarcate the upper and lower portions of the space and to impose some kind of visual order upon the tessellated hodgepodge of exhibits. Prized pictures were selected to hang 'on the line' – directly above or below it, depending on the size of the production (full-length portraits, for example, naturally extended above the line) – and the prime position was considered to be in the centre of a wall.

There was also a theoretical pecking order assigned to the subjects on display. Following on from principles entrenched within Western art since the Renaissance, genres were assigned a notional ranking based upon their perceived cultural value. Within this system, the mostly highly thought-of fields were those believed to require the greatest imaginative effort on the part of the artist (generally those centred around dramatic depiction of the human figure). Thus, in descending scale of intellectual content, the putative art charts ranked: in top spot, history painting – themes drawn from mythology, history or literature; secondly, portraiture; and thirdly, genre pictures (narrative scenes of everyday life). Real-life subject matter such as real-world landscapes, animals and still-life motifs was considered less cerebral and therefore rated lower.

Artworks from all these categories could be found in abundance at the Exhibition, as well as numerous examples of sub- and hybrid genres such as marine painting, historical portraiture and historical landscape. However, even a very quick glance around the Great Room would have been enough to note the precedence given to the higher classifications, either by square footage (a disproportionate amount of space was taken up by a relatively small number of very large-scale history paintings), or by the sheer numbers (portraits were by far and away the most numerous of the exhibits – comprising around 40 per cent of the entries in the Great Room in 1799). Aside from the genre hierarchy, there was also media bias whereby oil painting took precedence over watercolours, drawings and prints. With the honourable exception of miniatures – grouped together en masse over the fireplace – it was rare to find works on paper in

the Great Room. Instead they ended up, with the lesser oils, either in the adjacent anteroom (or 'Anti-Room'), or in the smaller and less impressive rooms on the first and ground floors. Sculptures and architectural models were also largely confined to the lower levels.

As a general rule, the most elevated paintings were grouped together in the Great Room. This meant, in effect, that it was often dominated by oils produced from within the Academy – firstly, by the Royal Academicians, an elite membership of forty individuals elected by their peers. RAs were afforded the right to exhibit works without going through the process of selection by jury. Also heavily represented were up to twenty Associates (ARAs), intermediate artists who had been formally recognised by the favoured forty and were well on their way to attaining Academician status (although progression to the full honour was by no means guaranteed). There was also an indeterminate number of honorary members: non-professional but influential practitioners such as Constable's mentor, Sir George Beaumont. Lastly, the Great Room regularly featured up-and-coming young talents – the cream of the crop from the Schools, for example, or new prodigies moving in from the provinces. Nearly all these exhibitors were men (although it's unlikely that this gender discrepancy would have struck Turner, Constable or any other male artist from the time as anything other than the natural order of things).

As alumni of the Academy Schools, Turner and Constable would have been attuned to the legacy of Reynolds and to the protocols of the Exhibition. Keen to achieve professional recognition, they directed their efforts towards launching themselves from within its walls. As self-professed landscapists, however, they were faced with the challenge of negotiating the bias towards history painting and portraiture. They had no choice but to be mindful of the pervading culture and spatial arrangements, and from the outset this directly impacted what they painted, how they painted it and how successful they were. By mapping the timeline of their corresponding Academy movements we can clearly chart the efficacy of their individual approaches and compare the discrepancy in their progress. Thanks to their differing choices they encountered varying degrees of success.

In 1790, Turner had become one of the youngest artists since the Academy's foundation to make the grade for the Exhibition. His first

exhibit was a topographical watercolour entitled *The Archbishop's Palace in Lambeth*, accepted for the Twenty-Second Exhibition when he was just fifteen years old.[15] This was a giant leap up from the barber's shop window. The Latin motto chosen for the catalogue that year was from Virgil: 'In tenui labor', meaning 'the labour is light'. Going forwards Turner certainly made light work of conquering the Academy. From this moment on he consistently made it through the open submission process, and not just with one painting, but often with multiple works at a time. Initially he presented himself as a watercolour specialist – one of a growing band of artists exploiting the special qualities of the medium for topographical landscapes of picturesque locations. Year in, year out, his appetite for travel provided him with endless opportunities for new material and, off the back of expeditions to Kent, Wales and the counties of the north, he treated the Academy to a dazzling array of castles, cottages and cathedrals. Each selection was more impressive and sophisticated than the last, until it was clear Turner was no longer emulating his elders, but surpassing them in technical virtuosity and inventiveness. In 1792, he sold an antiquarian view of the ruins of Malmesbury Abbey to a buyer directly off the walls of the Exhibition.[16] To put that achievement into context we might remember that the only thing Constable is remembered for creating in the same year is a childish windmill crudely carved into the timbers of the mill in East Bergholt.

By 1794 Turner's watercolours had received their first public notices in the newspapers, and from 1795 he had become a regular fixture in the Council Room, a newly designated space given over to the best of the medium. This room proved to be immensely popular with the general public. Their enthusiasm for modern watercolour was gradually forcing the Academy to re-evaluate its validity as an academic rather than merely an artisanal pursuit, and as one of the most accomplished hands in the business there is no doubt that Turner's contributions formed a material part of that shift. What is more, the examples he showed at exhibition represented only a very small percentage of his overall output. Master of the commercial and exhibition watercolour alike, he generated a creditable income from sales of this side of his oeuvre.

Driven as he was by financial rewards, the status-seeking Turner was not satisfied by money alone. He had his sights set on more

illustrious goals. As things stood, it was not yet possible to become an Academician by confining oneself exclusively to watercolour. An outdated rule from 1772 stated that 'Persons who only exhibit Drawings [i.e. watercolours] cannot be admitted as Candidates for Associates'. If you couldn't become an Associate, by definition you would never make it to RA. Despite his undisputed genius with watercolour, for example, Thomas Girtin failed to (or perhaps chose not to) branch out into oils and consequently advanced no further along the Academy route. Turner was taking no such chances. From 1796, alongside his watercolour work, he sought to diversify his practice and seriously began to market himself as a painter in oils.

Bigger, glossier and more expensive, oil paintings were inevitably more impactful in an exhibition scenario. They were also more highly esteemed by connoisseurs and art aficionados. Whereas watercolour was trying to redefine itself as a sparkling new contemporary art form, oil maintained the illustrious gravitas of centuries of European art history and carried with it a greater sense of permanence and precedent. It was considered to be a more suitable vehicle for subjects at the more intellectual end of the spectrum – the society portraits, classical fantasies, naval battles and large literary or historical productions – in other words, the staple fare of the Royal Academy. Its potential for skilful textural effect meant that the presence of the artist could be almost entirely concealed in favour of mimetic illusion, yet its expressive capabilities made it the ideal medium for allusion and allegory – the visual equivalent of poetry. For Turner, it naturally fed into his penchant for dramatic sensation and effect, and facilitated his transition into more elevated pictorial categories.

It also, for the first time, projected him into the more prominent zones of the Exhibition. His maiden oil, *Fishermen at Sea*, 1796, was placed in the anteroom, but the following year an atmospheric night-time view of the River Thames, *Moonlight: A Study at Millbank*, gained him a spot in the Great Room.[17] A second and larger canvas, *Fishermen Coming at Shore at Sun Set, Previous to a Gale* (also known as *The Mildmay Sea Piece*) was due to join it, but was displaced at a late stage in favour of a portrait by a Royal Academician, Sir Francis Bourgeois, and relegated next door.[18] This kind of pictorial jockeying was a regular feature of the Exhibition's installation and it would not be the last time Turner experienced the

frustration of a last-minute swap. But he suffered no real harm from the demotion. The critics waxed lyrical about the picture, commending Turner's departure from his watercolour practice and praising its originality and poetic qualities. 'We never beheld a piece of the kind possessing more imagination or exciting more awe and sympathy in the spectators,' gushed *The Times*.[19] By branching out into oil Turner had vastly boosted his representation within the Academy, and automatically placed himself in contention for a greater share of attention and plaudits.

This was just the opening salvo in Turner's energetic campaign for academic approbation. At the Exhibition of 1798, he came out strong again with ten exhibits: double the number of oils, two of which were placed in the Great Room; and six watercolours, one of which was lauded by the newspapers as 'the best Landscape in the present Exhibition' and 'possessing the 'force and harmony of an oil painting'.[20] Small wonder that he came away from the show feeling confident. The buzz within the Academy confirmed his star was in the ascendant and even though he was still technically a year below the age limit, Turner made his first pitch for Associate status, a process which involved physically adding your name to a list posted in the Great Room and then gaining a majority of votes by the existing Academicians. He was unsuccessful, but he hadn't missed by much. Out of the twenty-seven candidates vying for two positions (all of whom were his senior), Turner achieved unlucky third place. Never mind. This was only a temporary stumbling block. The gossip was that it was only a matter of time and there was always next year.

Although no proof exists, it may be confidently assumed that amongst the visitors to the Exhibition the following year was John Constable. The show opened on 26 April 1799, just a month after he had been admitted to the Schools as a probationer, and it's hard to believe that he wouldn't have taken the opportunity to attend. As a layman with a keen interest in art, it is possible that he may have visited in the past, but this was the first time he would have viewed the show with the assessing eye of one aiming to break in as a contributor. An interested bystander now to the way the Academy worked, he would have swept an interested gaze over the physical arrangements of the rooms and their contents, daring perhaps to project himself forward in time and daydream about the moment

when he might see his own work installed upon the walls. Surely amidst the more than a thousand exhibits on offer he cannot have failed to notice, or have pointed out to him, the eleven works by 'William Turner of Hand Court'. There were actually three other exhibitors by the name of Turner that year: Honorary Member Reverend Charles Turner, a Daniel Turner and a George Turner. But the one everyone was talking about was Turner of Maiden Lane, the artist widely predicted to become the next Associate.[21]

Just how high Turner was riding can be judged by comparing the case of another artist throwing his hat into the ring for Associateship at that time: Constable's roommate, Ramsay Richard Reinagle. Three weeks into the Exhibition's run, Constable accompanied Reinagle on a house call to lobby Joseph Farington. On paper he was a strong candidate. Exactly the same age as Turner, he had been successfully exhibiting at the Royal Academy even longer, since he was thirteen years old. What is more, he exhibited portraits and animal pictures as well as landscapes, in both watercolour and oil, and he had the benefit of a father in the business. But despite these advantages, Farington gave him a decidedly ambivalent reply. In his diary for 17 May he noted:

> Reinagle expressed his intention of putting down his name as Candidate to be Associate. – I told him he was right in doing so, – but that He must not be surprised if all the vacancies are not filled as the Academy have considered it prudent to keep vacancies open, as stimulus for those who are not members. – I said His pictures have been properly noticed and approved by the Academicians.[22]

This lukewarm response was very different from that given to Turner just ten days later. Farington's diary entry for 27 May tells us: 'Turner called. I told him there could be no doubt of his being elected an Associate if He put His name down. – He expressed himself anxious to be a member of the Academy.'[23]

Come the November elections, Turner was indeed successful and was duly confirmed an Associate of the Royal Academy. For Reinagle, it would take another fifteen years (almost but not quite as long as it would ultimately take Constable).

TURNER AND CONSTABLE

Not only was Farington unequivocal in reassuring Turner about his prospects at the Academy, he was also, with typical nosiness, fascinated by his astonishingly successful commercial activities. During the same visit Turner casually revealed that he was in the midst of business transactions with not one but three influential patrons: marine insurer John Julius Angerstein; author and collector William Beckford, the richest man in England; and baronet and antiquarian Sir Richard Colt Hoare of Stourhead in Wiltshire.[24] This was a client list to be envied and shows that Turner was managing the business side of his career as successfully as the academic, wooing some of the most munificent collectors of the period. He told Farington that he had more commissions than he was able to handle, and was earning more money than he expended. The previous month he had even turned down the opportunity to accompany Lord Elgin as his personal artist and assistant on a trip to Greece and Turkey because the salary was too low. It was an astute decision. The individual who did eventually take the job, Giovanni Battista Lusieri, was an exceptionally gifted watercolourist but found his role for Elgin largely involved shipping antiquities from Greece, including, of course, the now controversial removal of the Parthenon marbles. This left him limited time for painting. Lusieri always maintained his art would have been much better known had he not spent so much time acting as an agent for Elgin. Turner was right to remain the master of his own destiny.

How was Turner so successful in these early years? To answer that question we need only look at the pictures he submitted for the 1799 Exhibition – a bumper crop of four oils and seven watercolours – within which we see him self-consciously pitching for academic status and astutely checking all the right boxes for virtuosity, versatility and scholarly allusion. As he had learned from Sir Joshua Reynolds and the *Discourses*, a sure way to prove your intellect was to deliberately reference the art of the past. Turner therefore deliberately styled himself as the heir-apparent: the British answer to all the best bits of the European landscape tradition. Two of his oil paintings were visually striking Welsh scenes, very different in appearance and mood, which forcibly reminded viewers of the historical landscapes of Richard Wilson. A founder member of the Royal Academy, the Welsh painter Wilson was one of the most distinguished artists of

recent years and had made his name through painting his native countryside according to the ennobling conventions of Italianate landscape. He was a role model for anyone seeking to bring landscape into the forefront of academic practice. Indeed one of the first exercises Constable set himself after meeting Wilson's former pupil, Farington, was to copy from memory a painting by Wilson which he had seen in Beaumont's collection.[25]

Another historical emulation by Turner was *The Battle of the Nile*, a modern marine piece showcasing Nelson's naval victory of the previous year. Maritime painting (as opposed to simply views featuring the sea) was a distinguished form of image-making with a pedigree rooted in the Dutch and Flemish traditions of the seventeenth century. It concerned itself with the sea as a site of national biography. Turner was thereby presenting himself as a contemporary history painter. In the catalogue he provided evidence of his literary prowess by pairing his titles with extracts from well-known poets, including John Milton.

No less impressive were the watercolours. Turner cleverly exhibited works which had already earned their keep through commercial sales: a pair of architecturally complex and impeccably executed views of Salisbury Cathedral, part of the Sir Richard Colt Hoare commission mentioned to Farington; some beautifully staged river landscapes whose compositional harmony and lighting effects contained all the drama and impact of oil on canvas; and a watercolour entitled *Sunny Morning*. For the latter, Turner had strategically (and from an artistic point of view, completely unnecessarily) enlisted the help of an existing Academician, the animal painter Sawrey Gilpin, ostensibly to complete the cattle in the foreground but in reality to forge an alliance and prove his ability to collaborate within the Academy fraternity. Finally, there was the pièce de résistance – a truly spectacular vision of Caernarvon Castle, which Turner had couched in terms of the golden grandeur of the landscape artist most beloved by the British cognoscenti, Claude Lorrain. By presenting the Welsh fortress as though it were a classical seaport, Turner harnessed an aesthetic redolent with connotations of imaginative perfection and provided a superlative demonstration of the transformative power of light and colour in landscape. The critic for the *Lloyd's Evening Post* described it as 'a drawing that Claude might have been proud

to own'. In reality, the lucky owner was John Julius Angerstein. He purchased the watercolour for forty guineas and it joined his formidable assemblage of Old Master paintings, including superlative examples of the genuine article by Claude.[26]

One of Angerstein's most prized pictures was the magnificent large oil *Seaport with the Embarkation of St Ursula* by Claude (now in the National Gallery, London). According to Thornbury, this painting had reportedly once caused the young Turner to shed tears, despairing, 'I shall never be able to paint any thing like that picture.'[27] It seems likely that this unreliable anecdote may have become muddled with the emotion Turner displayed on a more securely documented occasion. Coincidentally, at the same time as the 1799 Exhibition was open, the opportunity arose to see further examples of Claude's work in London. Another of Turner's patrons, William Beckford, had recently purchased a supreme pair of canvases known as the 'Altieri Claudes', and on 8 May he welcomed a party of artists to a private viewing at his house in Grosvenor Square.[28] According to Farington, Turner was visibly moved – 'both pleased & unhappy'. Claude's genius 'seemed to be beyond the power of imitation'.[29] In fact, by exhibiting a Claude-inspired watercolour at the Academy, and one owned by one of the best-known connoisseurs in London, Turner was providing timely proof of his artistic credentials and was publicly demonstrating that he was, in fact, capable of achieving the most powerful of imitative paintings.

Constable had also gone to see the Altieri Claudes, visiting the day after Turner. Now immersed in the thick of the London art scene, he was starting out on his journey towards professional status and it's fair to say his path was not as meteoric or direct as Turner's. However, just as it isn't true to describe him as a late starter at the Academy, neither is it quite accurate to describe his progress as slow – at least not to begin with. For someone with considerably less experience than Turner had by the time he was twenty-three, Constable's progress in the Schools was actually remarkably rapid. Whereas Turner remained in the Antique Academy for two and a half years before advancing to the Life (perhaps as much to do with his age as his ability), Constable made the move more swiftly. He was an exceptionally gifted draughtsman and qualified for the Life class after fewer than eleven months drawing from plaster casts.[30]

Similarly, although Turner was one of the youngest ever exhibitors at the annual Exhibition, it took another six years before he was sufficiently accomplished to have an oil painting accepted, and seven until a work by him was finally hung in the Great Room. Constable made it straight into the Great Room with his very first exhibit, an unidentified landscape oil in 1802.[31] Around this same time his social connections led to his first offer of a salaried position, the situation of drawing master at Marlow Military Academy. These events marked a level of vindication for Constable. Only three years after his big life change, he was managing the progression from student to professional. It looked as though there was every hope for the future. Even Golding Constable was optimistic. John Dunthorne reported from East Bergholt that he had several times seen 'your Father' and 'I am glad to hear him speak of your painting in quite a different way to what he formerly did.'[32]

The year 1802 became a crossroads moment for Constable. Like Turner's veto of Lord Elgin's offer in 1799 the Marlow job became the road *not* taken, because as he explained to John Dunthorne, 'Had I accepted the situation offered it would have been a death blow to all my prospects of perfection in the Art I love.'[33] But whereas Turner was able to turn down a job because he was earning considerably more under his own steam, Constable was not, as yet, making his painting pay. He was still reliant on the allowance given to him by his father. Turner, who had no such safety blanket and no choice but to be incentivised by money, was always mindful of the market for certain types of image. Constable took the opposite tack. His private source of income gave him sufficient freedom to be able to deprioritise financial gain for the time being and instead to give deep and serious consideration to how his individualistic worldview could be applied to the pursuit of 'excellence' in art. The answer, he felt, was not to go to Marlow, but neither now was it to be found exclusively in London. In a much-quoted letter, he explained himself more fully to Dunthorne (and by doing so, one senses, also clarified things for himself):

For these few weeks past I beleive [sic] I have thought more seriously on my profession than at any other time of my life – that is, which is the shurest way to real excellence. And this morning I am the more inclined to mention the subject having just returned

from a visit to Sir G. Beaumont's pictures. – I am returned with a deep conviction of the truth of Sir Joshua Reynolds's observation that 'there is no *easy* way of becoming a good painter'. It can only be obtained by long contemplation and incessant labour in the executive part.

And however one's mind may be elevated, and kept up to what is excellent, by the works of the Great Masters – still Nature is the fountain's head, the source from whence all originality must spring – and should an artist continue his practice without refering [sic] to nature he must soon form a *manner* . . . For these past two years I have been running after pictures and seeking the truth at second hand . . . I am come to a determination to make no idle visits this summer or to give up my time to common place people. I shall shortly return to Bergholt where I shall make some laborious studies from nature – and I shall endeavour to get a pure and unaffected representation of the scenes that may employ me with respect to colour particularly and any thing else – drawing I am pretty well master of.

There is little or nothing in the exhibition worth looking up to – there is room enough for a natural painture. The great vice of the present day is *bravura*, an attempt at something beyond the truth . . . *Truth* (in all things) only will last and can have just claims on posterity.[34]

From the outset, Constable's motivation was not money or even the judgement of his peers, but rather a high-minded determination to find an original artistic voice – an expression of the truth of nature through means he did not believe, as yet, to exist. He described this search for a new sensibility as the quest for 'natural painture' (sometimes varying the spelling – 'peinture'). And even as his father's land continued to nurture him financially, he turned to the same landscape for creative enrichment.

For at least the next fourteen years, Constable's personal mantra remained 'back to Bergholt'. Summer after summer he returned to Suffolk and devoted himself to sketching and painting his home territory. His father bought him a small cottage in the village for use as a studio but his real atelier was the great outdoors – the fields, woods and lanes in and around the Vale of Dedham, where he set himself the task of responding to the specifics of the countryside in his

preferred medium of oil. One of his earliest exercises, a small canvas of the view looking across the Stour Valley towards Dedham church (fig. 6), shows him grappling with a solution to the problem of 'pure and unaffected representation'. One of his favourite neighbourhood subjects and a motif to which he would return repeatedly over the

Fig. 6. Constable, *Dedham Vale*, 1802, oil on canvas.

years, it was painted at least in part 'from nature', i.e. on the spot; it is unashamedly intuitive. With a multitude of small undisguised brushstrokes interspersed with unpainted patches of ground, the painting's simplicity suited the unpretentious character of the subject and was the first step towards attaining a pictorial language that could convey Constable's depth of feeling about the view.

The timing of this revelation is interesting. In the run-up to this moment, the one artist Constable *cannot* have failed to be aware of was Turner. Since becoming Associate in 1799, Turner had gone from strength to strength with pictures that imaginatively and overtly referenced the European canon of Old Masters. At the 1800 Exhibition he had contrebuted *The Fifth Plague of Egypt*, a grandiose biblical subject in the manner of Nicolas Poussin, as well as another Claudean-style watercolour of Caernarvon Castle. There was also a moody Welsh oil, *Dolbadern Castle*, heavily reminiscent of the dark and sublime landscapes of Salvator Rosa, which the Academy selected as his diploma picture (a work chosen by the institution for its permanent collection). Then, in 1801, he had taken the Academy by storm with *Dutch Boats in a Gale: Fishermen Endeavouring to Put Their Fish on Board* (later known as *The Bridgewater Sea Piece*), a painting commissioned by the Duke of Bridgewater to hang as a pendant with a sea piece by the Dutch marine painter Willem van de Velde the Younger.[35] This picture, which drew heavily upon the style, subject and composition of Van de Velde's original, was hung in the Great Room in prime position – on the line, in the centre, opposite the doorway. It had been so widely admired by the Academy and art world elite – the president, Benjamin West; the professor of painting, Henry Fuseli; even Sir George Beaumont, not generally a fan of Turner's – that it had directly led to his election the following February as full Royal Academician, the youngest artist ever to achieve the honour.[36] He celebrated his new status with a reincarnation of his professional name in the Exhibition catalogue, abandoning 'William Turner' for the grander-sounding 'J.M.W. Turner, RA'.

So, at least as far as his Royal Academy status was concerned, Turner defined himself as an artist with reference to canonical European art. His friend Henry Scott Trimmer remembered an occasion when Turner had picked up a mezzotint after Van de Velde, and emotionally exclaimed that it had 'made me a painter'.[37]

Whether Turner meant that early exposure to that particular image had inspired his calling, or whether he was crediting the fact that *Dutch Boats in a Gale* had been directly instrumental in his election as Royal Academician, isn't clear.[38] But what is fascinating is his claim that he was 'made' by the Old Masters. If one brought together all of Turner's key Great Room pictures across the half a century and more he exhibited, the majority would appear at first glance like a gallery devoted to the history of Western art. From his very first marine oil in 1796 to his last Claudean picture cycle in 1850, hardly a year went by when his Academy offerings did not include a homage, pastiche or nod to some European master or other. He systematically worked his way through the Italian, French, Dutch and Flemish schools of painting, in order to validate landscape as an intellectual and academic genre and to position himself as the leading modern equivalent. This, of course, represents the antithesis to Constable who, in his own retrospective words, claimed he was 'made' a painter not by other artists, but by the natural scenery of the banks of the Stour.

Constable's first inclusion within the Exhibition in 1802 was coincidentally the first time that Turner *hadn't* had to go through the process of committee approval. RAs received guaranteed display entitlements. Taking full advantage of the fact, Turner chose to continue what he considered to be his winning formula, by exhibiting several more paintings inspired by the past, notably two more Dutch-style marine oils, another large Poussinesque Egyptian plague and *Jason*, a Greek literary subject which once again channelled the flair and flavour of Salvator Rosa.[39] So when, in his 1802 missive to Dunthorne, Constable dismissed en masse the collective tenor of the Academy's Exhibition, and denounced such habits as 'manner', 'bravura' and excessive reference to the 'Great Masters', one of the artists he *had* to have been thinking about was Turner, the very epitome of someone who could be said to have made a virtue of 'running after pictures'.

Constable made no bones about publicly critiquing his contemporary. In 1801 he had told Farington that he thought 'highly' of Turner's *Dutch Boats* but that he knew the picture by Van de Velde upon which it was formed – as though that somehow depreciated its value.[40] Perhaps, from Constable's rather envious standpoint, Turner seemed to have achieved fame very quickly and easily – too quickly,

without the long period of 'labour' Constable felt was mandatory. Despite the fact that Turner had set a shining precedent for the way a landscapist could navigate the Academy's bias against the genre, Constable at this point deliberately turned his back upon this exemplar and, with almost pious righteousness, set himself upon a different path, entrusting the next stage of his artistic development to the intensive study of Nature in the field, rather than nature in the art gallery.

For all his disingenuous insistence upon empiricism as his true source of instruction, Constable's understanding of the underlying principles of painting owed a great deal to his training and formal education. What is more, he continued to develop his knowledge through scholarly reading: Reynolds's *Discourses*, or the writing of Swiss artist and author Salomon Gessner.[41] And he continued to meditate upon the Old Masters. Despite his avowed abstention from referencing other artists, his 1802 study of Dedham Vale obviously owed its compositional formula to another picture: Claude's *Hagar and the Angel*, the little painting owned by Beaumont which had so enchanted Constable a few years earlier. Although he wasn't interested in engaging with the biblical narrative, or with turning the view into a classical subject (in the way that Turner had done with Caernarvon Castle, for example), he nevertheless recast the valley according to Claudean principles: the upright format; the framing trees situated exactly according to the rule of thirds; and zigzagging forms such as the meandering river and cloud shapes. All of these devices help to create the picture's sense of recessional depth and lend the lowly landscape a quiet, understated elegance. The result was an epiphany. Constable had found a new clarity of purpose – the pursuit of a painting style that was steeped in the teachings of *Art*, yet entirely *artless* in appearance.

Turner too was having his own revelatory moment, and one which, in sharp contrast to Constable, was unashamedly based upon 'running after pictures'. Whilst Constable was earnestly summering in Suffolk, Turner was on quite a different pilgrimage – taking advantage of the fact that, for the first time in his life, it was possible for him to journey abroad. For the past nine years the French Revolutionary Wars had prevented Continental tourism, but in 1802, a treaty known as the Peace of Amiens suspended hostilities and opened up mainland Europe for the eager traveller. Along

with large numbers of British citizens (including many of his fellow artists) Turner crossed the Channel in July and embarked upon his first European expedition, one of the most formative episodes of his career. It was a considerably more perilous venture than journeying to East Anglia. The three-month tour kicked off with a terrifying near-drowning incident in the stormy seas of Calais harbour where his boat was 'nearly swampt'. After that there was the ongoing challenge of bad roads and poor accommodation;[42] and Turner suffered 'much fatigue from walking' and a 'bilious' constitution from the acidic foreign wines. But for all that, the dividends were more than worth it. Everything on this trip was exciting and stimulating.

One of Turner's key objectives was the art collections of Paris. The Louvre at that time was stuffed full of objects looted by Napoleon from across Europe and the young painter gorged himself on the greatest and finest assembly of artistic treasures he'd ever had the opportunity to see in one place. Farington, who was there at the same time, spotted him drawing in the Grande Galerie, filling a sketchbook with copies, notes, observations and thoughts on works by Italian, Dutch and French artists.[43] He also visited the studio of the pre-eminent neoclassical painter Jacques-Louis David and saw the French master's iconic portrait *Napoleon on the St Bernard Pass* (c.1800), a heroic image commemorating Bonaparte's recent crossing of the Alps.[44] There was even the possibility he might have caught sight of the legendary commander himself. Farington had seen Napoleon twice during his stay in Paris, including at the Tuileries Palace, just two days after bumping into Turner in the Louvre.[45] For someone fascinated by the historical ramifications of geography and the way that echoes of the past could be made to resonate for a modern audience, it was all vital grist for the mill.

As well as visiting the galleries, Turner also spent weeks touring more extreme terrain. Whilst Constable was rambling amidst the gentle declivities and shady lanes of the Stour Valley, Turner was intrepidly hiking through gorges and across glaciers in the French and Swiss Alps. It was the most exhilarating experience. Revelling in the 'fragments and precipes very romantic and strikingly grand' and 'very fine Thunderstorms amidst the mountains', Turner was deeply inspired and this physical encounter with the scenery gave his understanding of landscape the most enormous shot in the arm.[46] The majestic peaks, deep ravines

and plunging waterfalls provided a huge injection of empirical data that first met with, and then exceeded, his expectations about the 'sublime' – the philosophy of intense feelings triggered by perilous environments. Originating within the writings of the eighteenth-century philosopher Edmund Burke, the concept of the sublime celebrated the disorder and wildness present within the natural world, and the corresponding emotional impact upon the individual.[47]

Turner returned to London with his sketchbooks full and his brain whirling with ideas about elemental forces, the fragility of man and the way landscape could be used as a vehicle for dramatic metaphor. The fruits of his tour immediately began to make their way into his work. At the next Royal Academy Exhibition he showed several Alpine views – eye-catching productions in both oil and watercolour that captured all the elevated sensations and heightened emotions of his mountain adventures. There was also a Claudean-inspired river landscape, a Raphaelesque 'Holy Family' and a large stormy marine picture, *Calais Pier*, which cleverly conflated the dangers of sea travel with topical anxieties about the political situation in Europe.

Constable, who could not have been less interested in going abroad, professed himself unimpressed. In discussion with a crowd of some of the younger painters at the Academy, who all thought Turner's pictures of 'a very superior order', Constable stood out as the sole voice of dissent, saying he did not think them 'true to Nature' or anywhere near as fine as the artistic antecedents they were so frequently compared with.[48] He commented to Farington that Turner was becoming 'more & more extravagant, and less attentive to nature' and that he thought the Swiss views were 'fine subjects but treated in such a way that the objects appear as if made of some brittle material'.[49]

Constable's comments reflect, to a large extent, the opinions of the people whom he considered mentors and friends – Farington and Beaumont. The latter loathed Turner's modern versions of Claude and was not reticent about airing his opinions. Farington's diary is full of his fault-finding diatribes, overheard at numerous dinners and meetings amongst his artistically minded social clique. Ostensibly, Beaumont's objections were stylistic, though in truth they owed much to class prejudice.[50] His cavils spread like a virus, condemning the younger painter's artistic crudeness and his appropriation of the

Old Masters. They were widely echoed amidst some of the older Academicians of Beaumont's circle: men such as Northcote, Nollekens, Smirke and Daniell, who condemned what they felt was a pernicious new influence within the Academy. Turner's works, they groused, were 'too much made up from pictures' and 'not enough of original observation of nature'. They 'consisted of parts gathered together from various works of eminent Masters' and 'too little of nature'.[51] Such comments appear remarkably close to Constable's self-professed mission to cease 'running after pictures' at this time. This is not to say that the painting habits of these men stood in alignment with Constable's, or that Constable had formulated his position based upon the views of others, but rather that, at a time when Constable was searching for personal clarity and direction, certain bits of advice chimed with ideas upon which he was already fulminating. The anti-Turner rhetoric he was being exposed to simply confirmed his resolve to follow a very different path. Professional jealousy aside, he wasn't pitching himself directly against Turner as an individual. Instead he was consciously setting himself in opposition to a way of painting which, at that time, Turner appeared to embody.

Constable had not set himself an easy task. At the 1803 Exhibition he had four landscapes on display, including, it seems likely, some of the small Dedham studies painted from nature which he'd taken to show to Farington a few weeks earlier.[52] One may well have been the *Dedham Vale* study, modelled on Claude's *Hagar and the Angel* (fig. 6).[53] Whether contemporaries perceived Constable's underlying reference to the French master or not, his modest concept would have paled into insignificance beside Turner's resplendent homage from the same year, *The Festival upon the Opening of the Vintage of Macon* (fig. 7). In this large painting, Turner had also given a modern river landscape a recognisably Claudean transformation. But instead of hiding its origins, the composition trumpeted its allegiance. It revelled in all the imaginative grandeur and improbable fantasy which Constable had deliberately sought to exorcise from the Vale of Dedham. It is not difficult to intuit which was more highly rated. *Macon* was variously described as 'perhaps the finest work in the room', 'an object of peculiar attraction' and one that had 'even surpassed the master [Claude] in the richness and forms of some parts'.[54] Nothing whatsoever was said about the Constable.

Fig. 7. Turner, *The Festival upon the Opening of the Vintage of Macon*, 1803, oil on canvas.

This became the story of Constable's early Academy years. Despite his promising start, he struggled to achieve notice and approval, being outshone and overshadowed by other landscapists, especially Turner. He might have tried to exhibit some of his portraits. He took a decent likeness – largely to make a bit of money and keep his family happy. However, his heart wasn't really in it, and in any case, he felt there were too many portraits at the Exhibition.[55] It was landscape where his true loyalties lay. Constable was passionate, even evangelical, about the natural, truthful pictures he wanted to paint. The problem was persuading others of their value. At least to begin with, his particular line in understated picturesque naturalism was just not that noticeable. By choosing to focus on real, everyday scenery he had ruled himself out of the higher academic categories, and in the crowded confusion of the hang, small-sized studies of humbly local scenery were easily overlooked. Their intellectual qualities were not immediately apparent and their visual impact was drowned out by pictures that were bigger, brighter and blatantly more highbrow.

Disheartened, Constable abstained from the 1804 Exhibition altogether. He told Farington that nothing could be gained by putting his pictures 'in competition with works which are extravagant in

colour & bad taste wanting truth'.[56] 'How inferior a production made upon a picture is', he remarked, 'to one that is founded on original observation of nature.'[57] This last comment referred directly to a Rubenesque imitation he'd seen by another artist, James Ward, but the sentiment could just as easily have applied to Turner, whose influence was credited as becoming pervasive. And whilst Constable continued to define his own position as distinct from the model offered by his counterpart, for many years, he remained at a disadvantage because of it. Although from the outset, he was indirectly comparing himself to Turner, it would be a long time before anybody else was.

CHAPTER 3

UPS AND DOWNS

A T THE TURN of the century, the disparity between Turner's and Constable's respective standings was enormous, but Turner wasn't having it all his own way at the top. Whilst Constable was battling to make the transition from gentleman amateur, Turner was simply struggling to pass as a gentleman, facing challenges that would never be a problem for his more well-heeled colleagues. His Maiden Lane mien had begun to grate upon the more patrician members of the establishment and he found himself up against hostility of the socially snobbish kind. There were complaints from several quarters about his 'presumptive and arrogant' manners:[1] 'more like those of a groom than anything else', sneered somebody.[2] Farington rebuked him at a Council meeting for his lack of deference, and he was publicly called a 'little Reptile' by Sir Francis Bourgeois.[3] He even had to suffer ongoing indignities with his change of name, being erroneously credited in the Exhibition catalogues with an unfortunate stream of typos which successively labelled him 'James Mallord William Turner' (1803), 'John Mallord William Turner' (1805 and 1806) and 'Joseph William Mallord Turner' (1807, 1808 and 1809).

Disparaging comments were also made about Turner's mercenary tendencies – his high prices (described as 'beyond comparison'), the escalation of his rates and the way that he charged extra for framing costs.[4] There was a sense that the young arriviste had got above himself. True, Turner did sometimes raise his costs. In spring 1803,

Sir John Leicester had offered 250 guineas for *The Festival upon the Opening of the Vintage of Macon* but Turner wanted 300 guineas, increasing the price to 400 the following year.[5] This was so far above the two or three guineas Constable was then charging to paint portraits of Suffolk farmers in 1804 (the price increased if hands were included) that it hardly makes sense to draw a parallel, but it was expensive compared to other leading painters.[6] Thomas Lawrence, for example, charged 200 guineas around this time for a similar-sized canvas (i.e. a whole-length portrait).[7] Be that as it may, in the long term, Turner's prices remained remarkably steady. During the 1830s he was still quoting 200 guineas for a standard-sized canvas of three by four feet (36 by 48 inches), the same tariff he had been charging in 1809 (though this varied according to the client and the commission).[8]

One of Turner's most consistent detractors continued to be Sir George Beaumont. It may have been Beaumont, for instance, who instigated the trend for mocking Turner's handling of the sea. In 1803 he had criticised the depiction of the water in *Calais Pier* as looking 'like the veins on a marble slab'.[9] He returned to the theme again in 1804, describing the sea in *Dutch Boats* as 'like pease soup' and eventually coining the phrase 'white painter' as a pejorative term.[10] His influence seems to have provoked comments from other Academicians. At the 1804 Exhibition (the one Constable missed), Turner was anxious about the hanging of his most recent sea piece, *Boats Carrying Out Anchors and Cables to Dutch Men of War, in 1665*, objecting to its positioning underneath a portrait by John Singleton Copley featuring a sitter in a white dress. His fears seem to have been justified. The prominent white of the drapery called unwanted attention to the painterly white spume of his churning waves and it was variously denigrated by fellow Academicians as looking like a '*Turnpike Road* over the Sea' (John Opie) and like the work of someone who 'had never seen the Sea' (James Northcote).[11] Not all the discourse in the press was now positive either. Whether acting independently or swayed by influencers such as Beaumont, some critics had also begun to lay into Turner's bold paint-handling and 'indistinctness'. His 'figures are very indifferently formed', wrote the *Sun*, 'and the *Sea* seems to have been painted with *birch-broom* and *whitening*'.[12] Turner was dissatisfied enough that he removed the picture before the end of the Exhibition's run. Thoroughly disenchanted

with the Academy and its cohort, he absented himself from all Council meetings for the rest of his tenure and the following year it was he, not Constable, who boycotted the Exhibition.

Constable's veto of the Academy had meant that he was effectively invisible for a year. Turner, however, was not materially harmed by cold-shouldering the Exhibition because he had a viable alternative. He had created his own gallery. At the end of 1799 he had moved out of the cramped quarters in Maiden Lane to a more upmarket address, 64 Harley Street. By 1804, he and his father had taken over the entire property and converted an outhouse into a narrow display space. This functioned as a permanent showroom and Turner also used it to host an annual one-man show, an autonomous alternative to the Royal Academy. Acting as his own curator, he could circumvent the strictures and pitfalls of the Academy and present a seasonal edit of hand-picked pieces entirely upon his own terms. For over a decade 'Turner's Gallery' became a regular feature of the London exhibition season. It was a bold statement of financial and creative independence. At a time when Constable was still struggling to find his true metier, Turner was the very epitome of self-assurance and personal confidence.

Nowhere is the gulf between their respective positions more apparent during this period than in their artistic responses to the defining event of 1805, the Battle of Trafalgar. On 21 October of that year Britain had engaged the French and Spanish fleets off the coast of Cádiz. The decisive naval victory, and Lord Nelson's death in action, was a topical gift for British marine artists and Turner leapt at the chance to produce something memorable in time for the following spring. On learning that Nelson's body was to be brought back in his flagship, the *Victory*, he made a trip to the Thames Estuary at the end of December in order to see the famous vessel with his own eyes. Hungry for the details only first-hand fieldwork could supply, he was like an investigative journalist, researching not only the appearance of the ship, but also the lived experience of the battle. His on-the-spot sketches show him drawing the *Victory* from multiple angles, but also reveal that he got on board and interviewed serving crew members.[13] These encounters helped to clarify his understanding of the engagement, the positions of the key protagonists involved in relation to the *Victory* and the details of on-board casualties. They

sharpened his awareness of what it must have been like to be immersed in the thick of the action. The boatswain, William Willet, recalled for him the traumatic moment when a ship with a 'white Lion head raked the Vic[tory]' with broadside fire. Another unnamed seaman described how the severely wounded Flag-Lieutenant John Pascoe was carried down the gangway to safety by four marines.[14] One wonders what these hardened veterans, many of them younger than Turner but fresh from the horrors of campaign, thought of the odd little civilian, scrambling over their ship and scribbling away in a slim sketchbook. Did any of them later follow up to see how this extraordinary visitor had immortalised their testimony in paint?

Turner's research resulted in a large oil painting – *The Battle of Trafalgar, as Seen from the Mizen* [sic] *Starboard Shrouds of the Victory* – which provided a complete assault on the senses (fig. 8).[15] As the title suggests, the imagined viewpoint is the rigging on the right-hand rear of the ship (the mizzen is the mast near the stern) and this lofty position captures a bird's-eye view of the battle. It also vividly

Fig. 8. Turner, *The Battle of Trafalgar, as Seen from the Mizen Starboard Shrouds of the Victory*, 1806, reworked 1808, oil on canvas.

TURNER AND CONSTABLE

sets the scene for the human experience down below. The oppressive lack of open sea and sky creates an impression of claustrophobia and vulnerability that would have seemed even more overwhelming within the private confines of Turner's narrow gallery. Here, in 1806, he was able to place the painting alongside a handwritten description and a numbered legend identifying the featured individuals, many of whom, such as Lieutenant Edward Williams (5 foot 8, with a 'Small rather pointed nose') and Midshipman Thomas Robins (5 foot 9, 'young Dark Eyes' and 'rather small, good teeth'), he had spoken to in person.[16] This key would have helped visitors look past the immersive sense of confusion that the picture imparts – the chaos of entangled masts and sails, the smoke, the teeming mass of sailors swarming over the quarterdeck – and zone in on moments of action and consequence, such as the slumped figure of Nelson with Captain Hardy bending over him and the enemy sniper who has fired the fatal shot. Farington thought it a 'very crude, unfinished performance, the figures miserably bad' but Turner later reworked it and re-exhibited at the British Institution (a society in Pall Mall run by a consortium of private connoisseurs including Beaumont).[17] There, in 1808, it was praised in the highest terms as a 'British epic picture, the *first* picture of the kind'. 'Mr Turner . . . has detailed the death of *his* hero' wrote the *Repository of Arts*, but also 'suggested the whole of a great naval victory, which we believe has never before been successfully accomplished if it has been before attempted, in a single picture'.[18]

It would not be the last. Epic paintings of national import would go on to become one of Turner's trademarks and *The Battle of Trafalgar* explores themes of tribute and pathos to which the artist would repeatedly return in future works, most notably in *The Fighting Temeraire*.

Constable too had seen the *Victory* at first hand, although his glimpse of her had come a couple of years earlier, during a sightseeing voyage in spring 1803. Taking advantage of his father's friendship with the captain of an East Indiaman called the *Coutts*, Constable had joined the ship for a month as she skimmed along the Kentish coast, prior to leaving for China. There he had spotted the *Victory*, docked amongst the great numbers of men-of-war at Chatham. Even then, she stood out as something special. Constable waxed lyrical about the sight in a letter to Dunthorne, telling him:

I sketched the 'Victory' in three views, She was the flower of the flock, a three decker of (some say) 112 guns. She looked very beautifull, fresh out of Dock and newly painted. When I saw her they were bending the sails – which circumstance, added to a very fine evening, made a charming effect.[19]

Remembrance of this 'charming effect' gained new resonance after Trafalgar and Constable dug out his earlier sketches to see what could be made of them. According to Leslie he was inspired to paint a *Victory* picture after hearing an account of the battle from a Suffolk man, but Constable would hardly have needed anyone to tell him how marketable the subject was or how fitting for the Royal Academy's next Exhibition.[20]

What is interesting is that Constable chose to produce his tribute in watercolour, a medium with which he had hitherto limited experience. Over the last few years the sales and status of watercolour had risen exponentially in direct response to the levels of sophistication and energy emanating from a wave of specialist practitioners. These included Richard Westall, who had pushed the boundaries to produce history pictures in the medium, Thomas Girtin (who had tragically died in 1802) and, of course, the 'magician' himself – Turner. Just recently, in 1805, a newly formed group, the Society of Painters in Watercolours, had hosted its first exhibition to large attendance and rave reviews. Even the Academy was noticing the change; the dedicated watercolour room was frequently the one most popular with the general public. Constable was therefore not only jumping on the Nelson/Trafalgar bandwagon but also the watercolour one.

Maybe he didn't have time to paint the subject in oil. Or perhaps he felt that watercolour was more suited to his memories of the fine sight of the *Victory* with its sails being attached, the evening sunlight sparking on the water. Certainly his subsequent effort, *His Majesty's Ship 'Victory', Capt. E. Harvey, in the Memorable Battle of Trafalgar, between Two French Ships of the Line*, is a more serene image than the turmoil of Turner's *Trafalgar* but also a more static one (fig. 9).[21] The composition employs a convention drawn from the traditions of marine painting and sets the viewer at a safe remove from the battle, with the full starboard side of the *Victory* framed by enemy ships. Despite the evident signs of conflict – the

Fig. 9. Constable, *His Majesty's Ship 'Victory', Capt. E. Harvey, in the Memorable Battle of Trafalgar, between Two French Ships of the Line*, 1806, watercolour on paper.

ship's sails have been strafed into tattered holes – the watercolour lends the scene a meditative, celebratory quality. In wash, the smoke of battle looks more like benign, billowing cloud than the smothering acrid discharge enveloping Turner's warships. In short, Constable's modest piece lacks the drama and jeopardy of Turner's monumental canvas. In fact it resembles other more prosaic commemorative pictures by Turner which depict the *Victory* returning after the battle in apparently undamaged splendour.[22]

Constable's flirtation with watercolour and with marine painting is typical of the lack of conviction apparent in much of his public output during the first years of the nineteenth century. As he strove to find his artistic feet, he vacillated between different kinds of practice – landscape, portraiture and even the odd religious altarpiece. The *Victory* was his only entry at the 1806 Exhibition and it received his most disappointing placement to date, being hung to disadvantage, not in the Council Chamber with the best of the watercolours (including a Welsh landscape by Turner) but in the dark Model Room, a mixed

jumble of leftovers – works on paper, sculpture, wax models, architectural designs and second-rate canvases. In an unfamiliar line of business, with a medium to which he was not intrinsically suited, Constable seemed as far from his personal and professional goals as he was ever likely to be. Henceforth he would not use watercolour at exhibition again for another quarter of a century.

It wasn't that he abandoned the possibilities of the medium altogether, though. In the autumn of 1806 he was offered the chance to tour the Lake District. The trip was funded by his maternal uncle, David Pike Watts, a merchant and sometime art collector who tried to steer his nephew towards profitable outcomes for his practice. Since the region was established territory for picturesque and romantic view-making it seemed logical that someone who professed an interest in landscape should be encouraged to go there and take his watercolours with him. Portable and compact, watercolour was, after all, the favoured tool of the itinerant artist and conceptually linked to the representation of natural phenomena – lakes, rivers, skies and weather. Constable responded to the impressive scenery with heavily tonal pencil drawings but he also made dozens of watercolour sketches. In this sense he was once again following in the footsteps of Turner, whose own tour of the Lakes had taken place nine years earlier. Like his travelling counterpart, who was famously doughty in the field, Constable went out in all weathers and kept up an indomitable pace, producing nearly thirty studies in three weeks in and around the peaks and valleys of Borrowdale.[23]

There the similarities ended. Unlike Turner's relentless travel habit, this would be Constable's only dedicated sketching tour. Moreover, for anyone accustomed to Turner's extraordinary facility with watercolour, Constable's Lake District studies can appear, at first sight, rather awkward.[24] Whereas Turner's forte was evocation of mood through subtly layered passages of wash, Constable's natural predisposition was to use paint gesturally. An instinctive oil painter, he had a tendency towards categorical marks rather than softly blended colours. His watercolour surfaces therefore sometimes appear somewhat laboured and the relationship between positive and negative forms unconvincing. It also takes a measure of mental adjustment to equate the dark valleys and looming mountains with the strongly accepted view of Constable as a painter of bucolic countryside. C.R. Leslie

perpetuated the idea in his *Memoirs*, claiming that the Cumbrian landscape repelled rather than inspired Constable: 'I have heard him say that the solitude of mountains oppressed his spirits. His nature was peculiarly social and could not feel satisfied with scenery, however grand in itself, that did not abound in human associations.'[25]

Since we have been schooled to understand that painting equates to feeling with Constable, the implication is that he was uncomfortably depressed within this kind of habitat and therefore the importance of his Lake District period has historically been disregarded as an anomaly.[26] However, the sojourn in the Lakes represented a genuine shift of focus and one that was more than a passing fancy. After all, it came about when Constable was thirty, hardly a callow youth. Far from the terrain being disagreeable to him, he actually relished it, describing it as 'the finest scenery that ever was'.[27] Over the next three years he exhibited no fewer than ten Lakeland subjects at the Academy, marking a return to the Great Room, as well his debut at the British Institution.

Unsurprisingly this renewed sense of purpose came about in oil and on a scale that echoed some of Turner's earlier mountain views (Farington described a scene of Borrowdale that was five-feet wide).[28] The tactic was a successful one, garnering Constable his first mention in the press. In 1807, the *St James's Chronicle*, a tri-weekly London newspaper, which had also first reviewed Turner's work, commented: 'This Artist seems to pay great attention of Nature, and in this picture has produced a bold effect. We are not quite so well pleased with the colouring of 98, *Keswick Lake*, by the same, in which the mountains are discriminated with too hard an outline.'[29]

He was also, for the first time, approached about the possibility of putting his name down for Associate.[30] What a boost! True, the hope was peremptorily squashed by Joseph Farington, who felt he was nowhere near ready. Nevertheless, a seed had been planted and, slowly but surely, Constable began to feel he was finally making progress. His pace may have been glacial but it was finally picking up.

Whilst Constable, to a small extent, was emulating Turner, Turner too was taking his art in a different direction in response to a new sensation emerging at the Royal Academy. Turner had already proved his willingness to take on the painters of yesteryear, but now for the first time he pitched himself head to head with a contemporary, a young Scots painter called David Wilkie. In 1806 Wilkie had

delighted the Academy with *Village Politicians*, a lively modern take on the seventeenth-century Flemish peasant-genre tradition of David Teniers the Younger. As an artist who had made a speciality of stylistically synthesising the Old Masters within his landscapes, Turner was loath for someone else's example to go unchallenged. None too subtly, he entered the 1807 Academy with an everyday narrative subject of his own entitled *A Country Blacksmith Disputing upon the Price of Iron, and the Price Charged to the Butcher for Shoeing his Poney* (Turner never worried about keeping his titles short and snappy).

This was like the art-world equivalent of starting a brawl in the playground. To add further piquancy to the situation, it was well known that Wilkie's painting had been purchased in advance by Turner's nemesis, Sir George Beaumont, and the Academicians on the selection committee for the year gleefully anticipated the showdown. They might as well have been chanting 'Fight, fight, fight!', deliberately positioning Turner's picture close to Wilkie's latest offering, *The Blind Fiddler*, so 'as to invite and provoke comparison'.[31] For the press the chance to weigh in on behalf of one side or the other was too much to resist, and although there was some praise for Turner, most commentators came down in favour of Wilkie. Turner, it was felt, was not someone suited to the 'genre' genre. 'In Landscapes and Sea-views he appears to great advantage,' declaimed the *Sun*, 'but his pencil is much too rough and negligent for familiar scenes of domestic enjoyment.'[32]

Undeterred, Turner returned the following year for round two and the year after that for round three, with yet more pictorial attempts at anecdotal storytelling. In 1808 he exhibited *The Unpaid Bill, or The Dentist Reproving his Son's Prodigality*, a work that this time had the backing of his own connoisseurial champion, Richard Payne Knight. Knight had commissioned him to paint the piece as a pendant to a celebrated work he owned by Rembrandt but again, Turner used the moment to try and unseat Wilkie. Once more, the rivalry was ramped up in the Great Room, and *The Unpaid Bill* was hung close to Wilkie's *The Card Players*, a painting so popular that there was a half-hour queue to see it. This was purely for the purposes of playing 'Who did it better?'. On this occasion the general consensus was for a Wilkie win. The verdict was that Turner was 'wast[ing] his powers' and should stick to what he knew best.[33]

TURNER AND CONSTABLE

This 'war' with Wilkie is a fascinating example of Turner's combative exhibition strategy but it is also an interesting precursor of better-known battles to come. It typecasts Turner in the role of a territorial prize-fighter and also demonstrates the part knowingly played by other artists and art journalists in engineering competitive skirmishes. The idea of the Academy as a gladiatorial arena was a compelling fiction and would have a later bearing in his perceived subsequent rivalry with Constable.

However, all of that was still far in the future. The closest Constable got to being part of the action in the 1800s was as a mild, inconsequential critic of Turner and a peripheral supporter of David Wilkie, whose company he enjoyed. In a moment of crossover, common amongst the incestuous threads linking the web of the Georgian art world, Constable sat as a model for Wilkie in May 1808, appearing as the handsome head of a doctor in a picture entitled *A Sick Lady Visited by Her Physician.*[34] A few weeks later the two men visited the Exhibition together and surely must have enjoyed seeing and discussing Turner's *The Unpaid Bill* compared to Wilkie's *The Card Players.*[35] It's fun to speculate what Constable, a regular martyr to toothache, thought of Turner's painting with its dentist's surgery cluttered with forceps, extractors and other tools of the trade. And by further odd coincidence, at the very same time, Constable was at the mercy of his own unpaid bills. He wasn't a prodigal spendthrift, like the protagonist of Turner's picture, but he had been living beyond his means and this led to an uncomfortable encounter with his father. In early summer he was forced to go cap in hand to Golding for funds, a regrettable experience since it seemed to confirm his father's fears about his career; he still thought his son was 'following a shadow'.[36] Thanks to tactful handling by his mother and younger brother, Golding was persuaded to clear his son's debts. The episode only serves to underline Constable's continued reliance on his family. They provided material support, but also a psychological foundation for his endeavours, so that consciously or unconsciously, his deep-seated connection with 'home' always seemed to be humming away in the background, like the key note of a chord, underpinning his every move.

We already know that Suffolk dominated his thoughts on landscape, but for years the majority of Constable's paid work, in whatever form that took, emanated from the region in one way or another. Mostly

these were portrait commissions undertaken for friends and acquaint-ances of the Constable network: George Bridges, for example, who like Golding Constable dealt in goods being shipped in and out of Mistley; or the Masons of Colchester (solicitor William Mason was married to Constable's first cousin, Anne Parmenter). From 1807 he was regularly employed on various jobs for Wilbraham Tollemache, the Earl of Dysart, a Suffolk landowner introduced to him by a Dedham solicitor. There was even an unexpected foray into religious painting which came about courtesy of an aunt who commissioned an altarpiece, *Christ Blessing the Bread and Wine*, for her local church, St James's in Nayland, eight miles from East Bergholt.[37] Unlike Turner, who regularly instigated his own workload, Constable was painfully aware that he owed the majority of his employment 'to the kindness of friends'.[38]

So, whilst the Lake District had provided a temporary new direc-tion, Suffolk exerted an irresistible pull on Constable's consciousness and remained the cornerstone of his artistic identity. It was inevitable the compass needle would eventually swing back to Bergholt and from 1809, the idea of painting his 'own places best' reinserted itself firmly back into his landscape practice. At the 1810 Academy he exhibited his most personal picture to date, a small oil of St Mary the Virgin's church in East Bergholt, a place that Constable knew intimately and which in reality could be found just yards away from his parents' front doorstep (fig. 10).

A village church from a remote parish in Suffolk might seem like an unlikely subject to have made it to the Great Room of the Royal Academy, but Constable was careful to give his modest little painting enough symbolic content to satisfy the intellectual expectations of his metropolitan audience. The painting shows the view from the east of the churchyard looking towards the fourteenth-century church with late-afternoon sunlight illuminating the pale stonework of the south porch and the protruding gnomon of a sundial above the entrance. The eye of the viewer, however, is drawn by a bright splash of a red cloak to a group of figures in the foreground: an old man, a woman and a young girl seated amongst the tombstones. Educated contemporaries would have immediately intuited the literary reference here: Thomas Gray's melancholy 'Elegy in a Country Churchyard', published in 1751, one of the most popular poems of the eighteenth century and a famous, lyrical meditation upon mortality.

TURNER AND CONSTABLE

Fig. 10. Constable, *The Church Porch, East Bergholt*, 1810, oil on canvas.

Gray's 'Elegy' was so universally beloved that it had become the progenitor of a visual tradition of picturesque graveyard scenes. Turner had used a similar motif of children playing on tombstones in an early watercolour of Llandaff Cathedral to suggest the passing of time and the inevitability of death.[39] But the particular relevance for Constable was Gray's country setting and the focus on the

passing of ordinary men and women. He was immediately able to tap into the poignancy of the theme, precisely because of his profound understanding of rural life and his own intimate connection with the graveyard of East Bergholt, a place where the memorialising of the local dead held significance only to those who came from the village itself. Gray's lines: 'Beneath those rugged elms, that yew-tree's shade / Where heaves the turf in many a mould'ring heap / Each in his narrow cell for ever laid / The rude forefathers of the hamlet sleep' would have chimed with the artist's own awareness of his Suffolk forebears. He had grown up as a regular attender of St Mary's. His father was a churchwarden, and from 1787 the family had their own pew. His great-uncle and aunt, Abram and Isabella Constable (the branch of the family from whom Golding Constable had inherited Flatford Mill), had even been interred beneath a slab within the main aisle.[40] Outside in the churchyard too, the names on the gravestones would have been as familiar to him as those of his next-door neighbours: the interconnected families and households whose bloodlines he knew almost as well as his own. And in musing upon those who had gone before, it is equally likely that he pondered those who were to come – people of the village who would never leave their tight-knit community. Constable knew that this was where his parents would likely one day lie in peace, and perhaps other members of his family too. The painting therefore is the first glimpse of the sense of timeless continuity that would become the defining characteristic of Constable's Suffolk paintings – a consequence of his uniquely intense connection with place.

As a tangential aside, the same view in St Mary's churchyard can still be seen today but there are many more grave markers than when Constable depicted it in 1809. As he might have predicted, they do indeed bear the names of people well known to him during his life: the Folkard family, for example, whose graves came to occupy the space where the three figures sit in Constable's painting, including those of Sarah Folkard and her two daughters who tragically all died within months of one another in 1829. Another member of the Folkard clan, Francis, married John Dunthorne's daughter, Hannah. She too lies in the churchyard, amidst a cluster of Dunthorne stones, now found just left of Constable's view. These include that of John Dunthorne himself – Constable's Bergholt painting partner whose

aspirations never got much further than touching up the face of the church sundial. Immediately to the right of the painting's standpoint, meanwhile, is situated the grave of William (Willy) Lott, who passed away in 1849 aged eighty-eight having lived his whole life in the cottage opposite Flatford Mill. And in the far north-east corner of the churchyard is the Constable family tomb itself. Neighbours in death as well as in life. Meanwhile, the two eighteenth-century red-brick chest tombs that appear so prominently in the foreground of Constable's little painting still stand, their surfaces so worn and covered with lichen that most of the lettering carved is obscured. Whilst Constable surely knew the identities of the individuals buried therein, they are now lost to living memory (although ironically there is a strong chance one is the final resting place of a Susan Turner, who died in 1747).

Judging by the catalogue numbering, A Church-Yard (as it was titled at the 1810 Exhibition) must have been hung very close to a larger painting by Turner, one of a pair depicting Lowther Castle, Westmorland, the seat of the Earl of Lonsdale. Unsurprisingly, given its modest size and subject matter, the church porch seems to have gone completely unnoticed and it was Constable's other exhibit that year, A Landscape, which garnered his first public notices for three years. The generic title makes positive identification a challenge, but it is possible it was a view of Malvern Hall, the Warwickshire estate of Henry Greswolde Lewis, which Constable had visited and painted in 1809.[41] (As the brother-in-law of his aforementioned patron, the Earl of Dysart, Lewis was yet another sponsor who had come indirectly courtesy of East Anglia.) If so, it brought Turner and Constable into a kind of unconscious alignment, both producing landscapes related to the tradition of country-house portraiture and the patronage of aristocratic clients, albeit with very different sensibilities.

In addition to his two paintings of Lowther Castle, one at midday and one at sunset, Turner was exhibiting a sunrise view of Petworth House, the Sussex home of the Earl of Egremont.[42] Together, the trio formed a showcase of sunlight at different times of day. The colourful light effects, achieved by applying paint directly onto a white ground, proved more striking than the architectural subjects. Many of the critics commented on what they perceived to be the unusual results. Whilst the Morning Post praised the 'clearness of tone, richness and harmony of colour, disposition of object, and aerial

hue', the *Repository of Arts* deplored the 'slovenly and indistinct' execution and described the sky of the midday scene as 'rather dirty, owing to a profusion of Naples or patent yellow'.[43] This is one of the earliest critiques of Turner's predilection for yellow, a rebuke that would become commonplace in the future. Constable's picture by contrast was described as 'a fresh and spirited view of an enclosed fishpond', and by the *Examiner* as 'a chaste, silver toned picture'.[44] As we shall see, the comparison of the golden heat and colour of Turner with the cool, silvery freshness of Constable would become a recurrent trope in years to come.

By Constable's standards, the 1810 Exhibition had been a triumph. Proudly he shared his public notices with his family back home and, desperate to prove himself to his father, put his name forward for Associateship for the first time. He was on 'tiptoe both for fame and emolument'.[45] Yet in reality these were small steps, inconsequential to anyone outside his inner circle. Anyone measuring his progress according to Turner would have found the comparison laughable. The older artist was currently swamped with commissions in both oil and watercolour, and he was also working on his self-generated print project, the *Liber Studiorum*. He was easing more comfortably into his Academy existence and in 1808 had strengthened his standing by applying for, and obtaining, the job of professor of perspective, a role that placed him firmly amongst the most visible and influential members of the institution. Constable, by comparison, was nowhere. Come the ARA elections in November he hadn't received a single vote of support in his favour and although he'd been 'overjoyed' at the subsequent sale of his exhibition landscape to Lord Dysart, the earl had purchased his picture for thirty guineas, a pocket-money price that Turner would hardly have considered worthwhile even for a watercolour at this time. Turner's sales, on the other hand, were so frequent and reliable that he had begun to charge standard rates for his work calculated according to size.[46] His financial portfolio was now extensive enough that he had found it helpful to take stock in a sketchbook, and calculate the net worth of his self-made fortune – a figure he estimated to be around £12,000–13,000.[47] He was well able to afford the extensions and improvements he deemed appropriate to his new gallery in Queen Anne Street, as well as the suburban villa he was planning to build on land

he'd purchased in Twickenham. Constable, meanwhile, still reliant on his parents at the age of thirty-four, had also moved addresses to yet another set of temporary lodgings (his fourth since Cecil Street), this time in Frith Street. His mother felt they weren't respectable enough and nagged him to look for something better at less cost.[48]

Given the pendulum swings of his reputation, and the pressure he felt from his well-meaning but interfering family, it is small wonder that Constable began a battle with his mental health. Alongside the emotional turmoil now creeping into his private life (see Chapter 4), the artist began to be plagued by worry and self-doubt about his career. At the 1811 Exhibition he sent in *Dedham Vale: Morning*, a picture which had 'cost him more anxiety than any work of his before or since', so much so 'he had even said his prayers before it'.[49] He bemoaned the painting's low placement in the ante-room, and fretted that he thought he had 'fallen in the opinion of the members of the Academy'.[50] It didn't seem to matter that his other painting, *Twilight*, was more favourably positioned in the Great Room. The successive catalogue numbering again indicates that it must have been situated very close to Turner's *Mercury and Herse*, another classical subject which was so well received that it was even referenced by the Prince Regent in his Royal Academy banquet speech as a landscape 'which Claude would have admired'.[51] Turner was sufficiently thrilled by his newspaper reviews to copy one of them by hand into his sketchbook and personally wrote to thank the author.[52] Constable, by contrast, was left 'in much uneasiness of mind'. There were no honourable mentions, no reviews, hardly any sales and, yet again, no votes for him to become Associate. As the months went by he suffered low spirits, loneliness and a sequence of niggling ailments that bordered on hypochondria.

It goes too far to suggest that Constable was constantly evaluating his life according to Turner's. There was too much else on his mind, and in any case, Turner wasn't the only contemporary to be envied. Richard Westmacott, David Wilkie and William Mulready were all streaking ahead of him. Another painter doing very well was Augustus Wall Callcott. A specialist in atmospheric marine views, Callcott was often favourably compared to Turner and mentioned alongside him as the greatest hope for British landscape. He had been made an ARA in 1806 and an RA in 1810. However, there was

just no avoiding Turner. He was the most openly competitive artist on the scene, and the one who most strongly incited public opinion. Whilst he was apparently indifferent to Constable, Constable could not help but keep tabs on Turner. At every turn of the Academy year he was confronted by new proof of his fellow artist's public profile and prowess, leading to private feelings of inferiority and resentment. It cannot have helped his morale to hear the acclaim heaped upon Turner whilst he himself languished in obscurity.

Had a contemporary then been inclined to give serious thought to the two men's differing approaches (an unlikely eventuality at this point), the starkest and most enlightening comparisons would have been to juxtapose Constable's paintings of Suffolk scenery with some of the overtly dramatic paintings by Turner that *hadn't* appeared at the Academy: *Fall of an Avalanche in the Grisons*, exhibited at his gallery in 1810, for instance, or *The Wreck of a Transport Ship*, privately purchased by the son of the Earl of Yarborough.[53] Turner's disaster pictures were direct expressions of the sublime, an idea that had gained prominence in Europe as an exploration of the awe-inspiring power of Nature. In art, this became a form of visual thrill-seeking, where the dangers of primitive forces such as earthquakes, thunderstorms or rough seas could be experienced vicariously, through the safety of the painted scene. Constable's paintings, on the other hand, broadly owed their philosophical framework to the theory of the picturesque. Originating in Britain in the mid- to late eighteenth century, this was a way of identifying and appreciating the qualities of local or native landscape. Arising as an alternative to the sublime and another aesthetic, the 'beautiful' (the classical ideal of symmetry and balance), it had been popularised within the writings of Reverend William Gilpin. During a time of rising domestic tourism, Gilpin's travel guides instructed readers in the 'picture-like' elements to look for within rural and historic regions of Britain. Picturesque landscape had to offer *contrast* – variation of colour, tone and form in a pleasing arrangement. Nothing should be artificially smooth, straight or balanced, but rather should be naturally rough, contrasting and irregular. A picturesque site might inspire feelings of contemplation and reverie, possibly a thoughtful meditation on past and present and man's relationship with nature – but not the awe and emotion of a sublime spectacle.

Some of Turner's most visually arresting pictures were those ener-gised with dramatic sublime features – with movement, spectacle and a narrative where man was pitted against nature. It was an effective way of injecting power and imaginative content into a scene and of articulating fatalistic ideas about the human condition. In *The Fall of an Avalanche in the Grisons* (also known as *Cottage Destroyed by an Avalanche*), Turner depicted the devastation of a snowslide at the moment of impact – the crushing weight of the avalanche replicated by the tangible presence of textured white oil paint. In *The Wreck of a Transport Ship,* that extreme physicality was taken even further – the surface of the sea became a heaving, frothing mass of pigment so that the paint itself appears to be writhing and swirling, dragging at the foundering boats and swallowing drown-ing figures. Like *The Church Porch, East Bergholt*, both of these images are ostensibly about the inevitability of death, but in size, spirit and sensation nothing could be further from the quiet calm of Constable's churchyard than Turner's chaotic canvases, several times larger and seething with fractured forms. Unlike Constable, Turner was master of many different categories of landscape, purposely varying his practice to demonstrate his versatility across the board of European aesthetics. More used to seeing his classical and pastoral landscapes, the critic of the *Sun* believed this not to be Turner's usual style.[54] But to a generalised extent, the opposing doctrines of calm and commotion are one way to weigh up their intellectual camps at this time: Constable's homely and homespun picturesque versus the stormy sublimity of Turner's grand-manner landscapes, so often articulated with wider references to European culture.

We can see that dynamic within the artists' principal pictures at the Royal Academy Exhibition of 1812: Turner's *Snow Storm: Hannibal Crossing the Alps* (fig. 11) and Constable's *Flatford Mill from the Lock*. During 'two hasty visits to the exhibition' Constable had taken particular note of Turner's offering, a vast canvas over seven feet wide, in which Turner had matched grandiose scale to a grandiose subject. This was the historical traversing of the Alps in 218 BC by the Carthaginian general, Hannibal Barca, during the Second Punic War. It is a dramatic and memorable painting, in which the menacing mass of an encroaching storm engulfs the sky like the encircling wings of a bird of prey about to strike. Even Constable

Fig. 11. Turner, *Snow Storm: Hannibal Crossing the Alps*, 1812, oil on canvas.

couldn't fail to be impressed. He thought the work 'so ambiguous as to be scarcely intelligible in many parts (and those the principal), yet as a whole it is novel and affecting'.[55]

It is interesting that Constable found the work unintelligible in places. Unlike the straightforward premises of his own everyday scenes, Turner's historical landscapes invariably contained a complex relationship between the figurative elements and their environment, and, beyond the visual impact of the snowstorm, *Hannibal Crossing the Alps* is a composition that demands a level of intellectual engagement from the viewer. As was his wont, Turner had accompanied the painting with a poetical epigraph inserted into the catalogue. Perhaps, given the fleeting nature of his visits, Constable had simply not had the time or inclination to absorb the implications of the composition, as the artist intended, in parallel with the following lines of blank verse, composed on this occasion by himself from a 'manuscript' titled 'Fallacies of Hope':

Craft, treachery, and fraud – Salassian force,
Hung on the fainting rear! then Plunder seiz'd
The victor and the captive, – Saguntum's spoil,
Alike, became their prey; still the chief advanc'd,

TURNER AND CONSTABLE

Look'd on the sun with hope; – low, broad, and wan;
While the fierce archer of the downward year
Stains Italy's blanch'd barrier with storms.
In vain each pass, ensanguin'd deep with dead,
Or rocky fragments, wide destruction roll'd.
Still on Campania's fertile plains – he thought,
But the loud breeze sob'd, 'Capua's joys beware!'[56]

For those with the patience and wherewithal to unravel them, Turner's verses help make sense of the more confusing parts of his picture – the varied array of figures. On the right of the composition can be seen the massed ranks of Hannibal's army who are not only besieged by the elements but are also under attack from a local 'Salassian force' (the Salassi were the Roman-age inhabitants of the Little St Bernard Pass in the present-day Aosta Valley). Just visible in the far distance, thrown into silhouette by the 'wan' sun, is the 'chief', Hannibal, mounted on an African war elephant, and implacably pressing onwards to invade Italy. The 'fallacy' of the situation is that although Hannibal's crossing of the Alps was a strategic triumph, in the long run he was defeated by the Roman forces of Scipio Africanus and all the bloodshed was ultimately in vain.[57]

It's fair to say Turner's dense and rather affected verse fills the average twenty-first-century reader with a kind of dull horror. It is not an easy read and even a nineteenth-century contemporary might have been dismayed by the convoluted language and abstruse references. However, Turner had a profoundly literary sensibility and given the scarcity of other written memoranda from him (certainly in comparison to Constable), it is worth paying attention to his poetry. Calculated to justify the associative faculties of his painting, it represents a relatively rare and valuable personal explanation of his work. As has been frequently pointed out, the style bears a strong resemblance to that of the Scottish poet James Thomson.[58] Another very popular and influential writer of the eighteenth century, albeit infrequently read today, Thomson was one of the first exponents of nature poetry. He combined impassioned moralistic commentary with vivid descriptions of the natural world and his four-part poem cycle *The Seasons* (1726–30) was an important stimulus to many luminaries during the Romantic period including Haydn,

Beethoven and Wordsworth. Both Turner and Constable made frequent reference to it. So, just as the well-read gallery-goer would have easily picked up on Constable's graveyard allusion to Gray's 'Elegy', many contemporaries, including Constable himself, would have readily recognised Turner's linguistic patterns and phraseology as derivative of Thomson. They would have inferred that *Hannibal Crossing the Alps* was a 'poetical' painting with intellectual aspirations.

Even without knowing the historical context, a nineteenth-century viewer would have been forcibly struck by the symbolism of the storm and its pertinence to the current fraught political situation in Europe. The Alpine setting and the story of Hannibal would have brought to mind Napoleon's celebrated crossing of the Great St Bernard Pass in 1800, the one immortalised in the iconic equestrian portrait by David, seen by Turner in Paris in 1802. The French artist had cast Napoleon as a modern-day Hannibal (the link had been made explicit by an inscription on a foreground rock). But where David had portrayed the commander as a mighty colossus, imposing his dominion upon the landscape, Turner's painting achieved a complete inversion of scale, reducing the human element to ant-like proportions and heroicising Nature's battle between sun and storm. Turner may even have intended a subtle visual echo of David's image – the swirling maelstrom of the blizzard recalls the billowing, almost muscular folds of Napoleon's cloak and the curving forelegs of his rearing horse. Never before had weather seemed so epic and Turner's ability to conjure such a powerful visual tempest earned him the title of 'Prospero of the graphic arts'.[59]

Fittingly enough, *Snow Storm: Hannibal Crossing the Alps* caused its own storm in a teacup during the organisation of the 1812 Exhibition. Turner was on the hanging committee that year but must have been assigned the installation of the watercolours because the group organising the premier oils comprised George Dance, Robert Smirke and Joseph Farington, the latter of whom chronicled the ensuing kerfuffle.[60] Initially the three men had placed Turner's large canvas over the door in the Great Room. However, upon good authority that the artist wanted it hung 'below the line' they had experimented with a new position, low down on the opposite side. Here they concluded it 'appeared to the greatest disadvantage; – a scene of confusion and injuring the effect of the whole of that part of the arrangement'.

TURNER AND CONSTABLE

The trio duly returned the work to its original elevated spot and congratulated themselves on a job well done. They had not counted upon the stubbornness of the creator. Turner was already dissatisfied with the distribution of some of his other exhibits in 'situations . . . as unfortunate as could possibly be allotted them'.[61] He was adamant that *Snow Storm* needed a low viewing point. Digging in his heels, he issued his colleagues an ultimatum: unless his demands were met he would withdraw the work altogether. Eventually a compromise was reached. The painting *was* hung low, but in the Inner Room, not the Great Room, and Turner conceded the downgrade, provided he wasn't the only Academician represented in that space.

Turner's curatorial obduracy cannot have endeared him to his colleagues but he may have been vindicated in his instincts. *Snow Storm* attracted far more attention than any of his other works that year, receiving glowing reviews and almost universal approbation from critics and colleagues alike. Ironically, its location may actually have hindered its full visual impact. Constable's future biographer, the eighteen-year-old Charles Robert Leslie, had tried to get near Turner's 'grand Landscape', but regretted that as it was 'placed very low, I could not see it at the proper distance, owing to the crowd of people'.[62]

In an unexpected see-sawing of fate, Constable was very pleased with the 'excellent situations' of his landscapes this year, none of which, as it happened, were hanging in the same room as *Hannibal*. His 'best performance', and the one most diametrically opposed to Turner's showy snow piece, was *A Water-Mill*, now known as *Flatford Mill from the Lock* (see the related sketch – fig. 13), a calm, quotidian subject based upon a true slice of life. Nothing is idealised or improved upon. There is no historical narrative or symbolic subtext, no cross-referencing to literary matter and no onus upon the viewer to unravel arcane implications. Instead the scene speaks simply and directly to the eye, quietly telling of everyday things: the basic mechanism of a lock gate; sunlight on grass; trees waving in the breeze; gentle ripples playing upon the surface of water. The receding diagonals of the River Stour, converging at the pair of poplar trees in the centre of the composition, create a strong and satisfying visual perspective. The real aesthetic appeal, however, lies with the textbook pleasures of the picturesque – in the contrast and variety of rugged forms and rough textures, of

dappled light and mottled colours. Unlike Turner's sensational saga of snow and storms, Constable's painting is a sonnet to sandy earth and weathered wood. Just like the later Stour subjects which it presages it is unmistakably Flatford (the viewpoint for *The Hay Wain* is immediately to the other side of the buildings on the left), though as a visual idea of the countryside it is generic enough to be anywhere. The specificity of the details seems utterly convincing, yet for all that, it has a timeless, universal quality that makes it instantly accessible.

Flatford Mill from the Lock became Constable's most acclaimed work to date. What Turner thought of it was anyone's guess, but other Academy colleagues were impressed and Constable was thrilled when the president, Benjamin West, stopped to speak to him in the street. West told him 'it had given him much pleasure and that he was glad to find I was the painter of it. I wished to know if he considered that mode of study as laying the foundation of real excellence. "Sir" (said he) "I consider that you have attained it." '[63] The picture also brought him a level of recognition he'd never before experienced in the press. Despite reservations about the 'crudeness of effect', he was singled out for his 'originality and vigour of style'.[64] There was even a pun made upon his name. 'If the artist proceeds with the success [*A Water Mill*] indicates,' quipped the *London Chronicle*, 'there will soon be few artists in the same line who will *outrun the Constable*.'[65] It was news to the subject of the joke that he *had* a 'line' to be outrun in, but it was good news. Constable had finally found his voice and for the first time amidst the clamour of the Exhibition was making himself heard. He reflected on his success: 'I have every reason to be satisfied with myself – especially when I consider how the last twelve or eighteen months have passed with me – but we must not think on troubles which I hope are past, but look forward to brighter prospects.'[66]

The future did indeed look more hopeful. In the summer there was another breakthrough. In an article reflecting on the current 'State of the Arts' in Britain, the *Examiner* namechecked the top talent amongst 'our best Landscape Painters'. Headlining the roll call were Turner and Callcott, but alongside the best of the rest there, listed for the very first time, was Constable. This was official proof that he was considered one of the stalwarts of the British art world, and was contributing something unique and valuable to the national story.[67]

CHAPTER 4

LABOURS OF LOVE

FAME AND FORTUNE are not the only ways to measure a life. Even if posterity judges genius according to achievements, most people define personal success according to family and friendship. Thus another way to assess the similarities and differences between Turner and Constable is to consider their private lives. They may be remembered as great artists, but first and foremost they were men, with feelings, foibles and private passions, not all of them connected with painting. Like everyone else, their day-to-day existence could be complicated, messy with love and loss, and peppered with the everyday irritations and burdens typical of the human experience. In this aspect of their lives, as in so much else, the two men could not have been more different. Turner kept his public persona separate from his private self. Constable's was more closely aligned – sometimes even one and the same. And, whilst a league table of professional attainment might tend to rank Turner on top, at least to begin with, an assessment of their intimate relationships might result in a different outcome altogether.

Let us therefore leave the Royal Academy for a while and instead follow the pair as they go about their daily affairs. Let us take a peek at them as they work and also, as far as they will permit, visit them at home, sharing in their unguarded moments. In the absence of journals or diaries, the best way to do that is to look through their letters and sketchbooks. These accumulations of paper, with

their casual scribblings of ink or pencil, represent a direct record of sight and thought, through which we gain a privileged insight into the artists' ideas and feelings. They are like postcards from the past – dispatches of routine occurrence and random incident. Putting these things alongside their paintings widens the lens of our gaze and deepens our understanding.

Both artists sketched, and both men wrote letters. However, due in part to the nature of the individuals involved, we have huge numbers of sketchbooks used by Turner, but a greater volume of surviving letters relating to Constable. This means, as a rule, we 'see' more through the former's eyes, but 'hear' more of the latter's thoughts. We are privy to Constable's inner world whereas Turner's is more reliant on conjecture and anecdote.

As far as mainstream nineteenth-century society was concerned, Turner did not follow the expected conventions of wedlock and monogamy. It's striking when looking at his only mature self-portrait how much it reveals, but also how much it hides (fig. 1). Painted around 1799, the individual that stares out from the canvas is a confident, self-made career artist. The gaze is direct, as though the sitter has nothing to hide, and the implication is that 'what you see is what you get' – an intense, slightly odd-looking young man, somewhat unpolished and rough around the edges, but unapologetic in his self-sufficiency. Yet the more one looks, the more guarded Turner's expression appears. The way the light falls upon his face creates a shadow masking his eyes, and his unsmiling demeanour sets up a sense of distance, as though the subject is holding himself back from the viewer. His portrait does not at all suggest the inner workings of a mind capable of great flights of fancy and intellect. He ruefully admitted this himself: 'People will say such a little fellow as this can never draw,' he used to contend.[1] And from the beginning, Turner kept his professional activities segregated from his personal life. None of the colleagues who congratulated him upon his elevation to Associate Royal Academician in November 1799 would have had an inkling that he had a mentally disturbed mother whom he had just moved into institutional care. Nor would they have been aware that he had recently become involved with a woman.

Turner's lover was called Sarah Danby, and she lived in a neighbouring street in Covent Garden. She was at least nine years his

senior – a curious echo of the age gap between Mary and William Turner – and she was a widow. She was also a mother, with four living children, all girls. She was not necessarily the obvious choice of partner for a young man set on independence and upward mobility. Despite their liaison lasting in some capacity or other for at least twelve years, very little is known about it beyond the fact that Sarah had two more daughters, presumed to be Turner's: the first, Evelina, born in 1801, and the second, Georgiana, in 1811. Just like Mary Turner, they remain largely out of sight, their voices absent from the record.

Was this just a physical affair or was there genuine love and feeling there? How did Turner feel about becoming a father? Did he participate in the upbringing of his children? Did the Turner men cohabit with the Danby females? To each and every question there is only one answer: we simply don't know. We can only speculate, and over the years that speculation has been rife. Various theories have been mooted, ranging from the probable to the prurient: that in his youth Turner had been embittered by a broken engagement to a girl in Margate; that there was a second disappointment later in his thirties from a female relation of the Trimmers; that Sarah chose not to marry Turner to avoid losing her widow's pension; that images of Sarah posing nude can be found in Turner's sketchbook; that it was Turner's father, William, who had sired Evelina; that there were other illegitimate children, including a son; and even the suggestion that it was not Sarah but her young niece, the housekeeper, Hannah Danby, who had given birth to Georgiana. In the end, all we know for sure is that the relationship between the artist and Sarah Danby was never formalised, and the children were not legitimised. One wonders whether Turner's attraction to an older woman was a subconscious desire for maternal affection, but, scarred by his father's experiences with his mother, he remained wary of matrimony and family ties. He later bequeathed the 'natural daughters' of Sarah Danby money in his will (though in the event Georgiana predeceased him), but he seems to have had little parental involvement. Instead he freed himself to live and work as he pleased. 'I hate married men,' he once told an associate, 'they never make any sacrifice to the Arts, but are always thinking of their duty to their wives and families, or some rubbish of that sort.'[2] On the subject of love he is almost

entirely silent. It seems simply not to be a topic up for discussion, at least as far as his own feelings are concerned. His energies were reserved for painting.

Ironically, whilst we are kept in the dark about Turner's views on love, we actually know a great deal more about his sex life. Although he forswore matrimony, he didn't abstain from physical relations and interspersed through his sketchbooks are many drawings of a deeply intimate nature.[3] Sometimes hazy, sometimes explicit, these sketched or painted memoranda visually corroborate the existence of active heterosexual desires and hint at real or imagined sexual encounters at various times in his life. Certainly not all can relate to Sarah Danby. In 1802, what resembles a snapshot taken in watercolour appears to flaunt the post-coital afterglow of a dalliance abroad.[4] Turner was travelling in Switzerland with a male companion, Newbey Lowson. Since Sarah was presumably in London with his baby daughter, the one or more naked figures reclining on the bed are highly unlikely to be her. And long after he had broken off his attachment to Sarah, the contents of his sketchbooks continue to throw up suggestive odds and ends: unclothed women who are more sexualised than one would expect from a life model, or shadowy bedroom interiors complete with tangled limbs and rumpled bedsheets.[5] Some sketches are downright erotic, leading to insinuations that the artist frequented brothels (though whether to sketch or sleep with the girls isn't known). There were nineteenth-century reports of him wallowing with sailors' women in Wapping or Rotherhithe.[6] Sometime around 1813 he wrote out a cure for gonorrhoea; he probably wasn't asking for a friend.[7]

Whilst none of these things would have been considered extraordinary behaviour for an eighteenth-century male, or indeed for a modern individual (though they shocked the Victorians), with regard to Turner it is their unwitting exposure that is so interesting. The optics of an image such as an embracing couple cocooned within the shadows of a curtained bed seem to confirm our perceptions of a man who preferred to keep his private life swathed in mystery, yet simultaneously fling open the bedroom door to reveal himself at his most exposed.[8] Surely intended for Turner's eyes only, the so-called 'erotica' of his sketches exists as a vulnerable chink in the armour of secrecy which the artist so carefully adopted.

TURNER AND CONSTABLE

Compared to the apparent Georgian romp of Turner's sex life, John Constable's story is a more decorous affair, a real-life Regency romance, told through correspondence with the object of his affections, Maria Bicknell. We never see or hear anything improper, but it is an emotional rollercoaster. Jane Austen herself, born in the December between Turner and Constable, would not have been ashamed to have penned its twists and turns. For just like the famous couples in her novels, published during these very years of courtship, theirs was a relationship complicated by financial and social considerations.

Unsurprisingly for Constable, love had blossomed in the emotional epicentre of his existence, Bergholt. In fact, when he painted *The Church Porch* in 1810, it's likely he was dwelling upon personal developments from the previous year. Take another look at the figures in the foreground of the picture (fig. 10). The clerical-looking gentleman in black might easily represent the rector of St Mary's church, a proud and prickly character called the Reverend Dr Durand Rhudde. This wealthy doctor of divinity was a person of considerable stature in the area, not only as the pastor for two neighbourhood parishes but also as chaplain-in-ordinary to the king. He bore the status of a local dignitary; the 'grand Caesar', some people called him. His East Bergholt rectory could be seen across the fields from the back of Golding Constable's property, and the two

Detail of fig. 10, Constable, *The Church Porch, East Bergholt*, 1810.

households were well known to one another. If this elderly grandee does indeed depict the septuagenarian rector, then the girls seated on either side could feasibly represent two of his granddaughters visiting from London: the youngest figure on the right, perhaps nine-year-old Elizabeth, and on the left, her elder grown-up sister, Maria. Daughters of his daughter, Maria, and her lawyer husband, Charles Bicknell, the genteel Miss Bicknells had stayed with Dr Rhudde in Bergholt during the late summer of 1809. In line with the courtesies due to their distinguished grandfather, they had been invited to take tea with the Constables at East Bergholt House. And just as the red cloak of the young lady in the graveyard picture catches the gaze of the viewer, twenty-one-year-old Maria Bicknell caught and held the attention of a love-struck John Constable.

In Austenian terms, the dynamic between Maria and John was a little like Emma Woodhouse and Mr Knightley. She was pretty and privileged, and had known him since she was a girl. He was kind, gentlemanly and more than a decade her senior. He had not thought of Maria in a romantic way before, but suddenly there she was, all grown up, a dark-haired beauty with soulful eyes and a gentle disposition. The attraction was mutual. Unlike Turner, Constable was very good-looking, admired by the Bergholt girls for his muscular form and fresh complexion: the tall, dark and 'handsome miller'.[9] A portrait by Reinagle from 1799 (fig. 2) depicts him as Maria would have first encountered him – a fine fellow in his early twenties; 'so finished a model of what is reckoned manly beauty', gushed another young lady.[10] A later self-portrait shows that by his thirties he'd lost none of his looks: a countenance worthy of Raphael according to the ladies, 'with dark hair and eyes, a Roman nose, and a pleasing expression'.[11] The pair took long walks together in the fields and discovered a shared passion for poetry. They fell in love. They were meant to be together. It was as simple as that.

Except that it wasn't. 'It is a truth universally acknowledged', Austen famously wrote, 'that a single man in possession of a good fortune, must be in want of a wife.'[12] Constable was a single man, and he wanted Maria to be his wife, but unfortunately he was *not* in possession of a good fortune and therein lay the problem. Middle-class marriage was contingent on money and John didn't have enough of it. As their attachment deepened, the two families weighed in with

their reservations. The Constables were not opposed to the match per se but worried about John saddling himself with dependants before his career had really taken off. Maria's family was openly reluctant. Her father, Charles Bicknell, was an eminent man – solicitor to the Admiralty and legal adviser to the royal family. He was not at all thrilled by a suitor whose profession was not considered entirely reputable, and whose income was not enough to support a wife of his daughter's status. Another obstacle was Dr Rhudde. His influence stemmed from the fact that Maria stood to inherit a substantial amount after his death. The family was wary of crossing him. And whilst the rector was happy enough with the Constables as neighbours he thought himself well above them socially. Certainly he objected to his favoured granddaughter aligning herself with an artist whose family background was in trade. Arguably Constable could have been earning as much as Turner at this point and Dr Rhudde would still have disapproved.

Well-bred young ladies didn't defy their parents (or overbearing grandparents) lightly and Maria was pragmatic enough to have her own doubts, declaring it impossible to live without 'that necessary article Cash'.[13] She had been brought up to expect a certain standard of living and could not conceive of managing on less than £400 a year (four times Constable's current allowance).[14] 'We should both of us be bad subjects for poverty, should we not?' she admitted. 'Even Painting would go on badly, it could not survive in domestic worry.'[15] By the end of 1811, convinced the situation was hopeless and that she was acting in everyone's best interest, she did her utmost to break off the relationship.[16] But like the hero at the finale of a romantic movie Constable dashed to her side. Tracking her down at her step-sister's house in Worcester, he convinced her that he couldn't live without her. They had but to hold steady until such time as 'it shall please providence to bring us together – which must be sooner or later, for I shall think that I am leaving this world when I think for a moment to the contrary'.[17]

In the end it was later, and not sooner, that love won through. Unwilling to part, but unable to unite, the pair were forced into a prolonged period of separation and for the next five years they had to endure the challenge of a long-distance relationship conducted almost entirely by post. It was a testing time and one can read all

about it in their weekly letters back and forth.[18] In these exchanges Maria's and John's voices carry on a near-unbroken conversation, and whilst their diction dates from a bygone era, the emotion is as relatable as any couple in love today. There were frequent joys. John revelled in ardent and eloquent declarations of feeling. Maria was his 'beloved', his 'dearest Love'; he told her, 'I lament every moment of my life the absence of your society and feel the loss of it on my mind and heart.'[19] But with the highs came the lows – the insecurities, the crossed wires and the lovers' tiffs. At the root of the tensions between them sat painting. 'It is a subject on which I cannot write to you with any pleasure,' lamented Constable. 'It seems to be our greatest enemy but nevertheless I love it more and more dayly.'[20]

Maria was keenly aware her happiness lay at the mercy of Constable's career. The fact he was an artist was the greatest barrier to their marriage, but at the same time their best hope for the future. We can sense her frustration with the predicament. Unable to obtain money herself by any means other than inheritance, she was forced to bide her time, a passive spectator to her beloved's professional struggles. Constable at this time was often demotivated, blaming his distracted mind on his inability to work.[21] Forbidden to call on Maria by her father, he tried to engineer ways for them to meet. On one miserable occasion he loitered in her street for hours, so intent upon catching sight of her that he forgot to wear a coat, even though it was December and very cold.[22] When she failed to spot him he returned to mope dejectedly in his studio. Maria became exasperated. She urged him to be 'getting on with [his] profession upon which so much depends' and declared she'd rather he was exerting his talents for the 'ensuing Exhibition' than 'on a *stolen march* with me round the Park'.[23] 'It is certainly paying me a very ill compliment,' she snapped when he neglected his labours. 'If you like to remain single it will do very well.'[24] It is impossible to imagine Turner behaving in such a moony fashion, wasting the daylight when he could be painting.

On other occasions Maria felt she was competing for Constable's love – a tug of war between herself and his work. 'I wonder which you have thought of most this summer,' she half-joked in 1813, 'landscape or me? (am I not a sad jealous creature?).'[25] And note

that she says *landscape*, not painting more generally. His family were pressurising him to properly 'marry' himself to portrait work and he dutifully went through the motions, fulfilling the commissions they insisted on putting his way. Maria, though, knew where John's true affections lay. It was landscape that was his 'mistress', and that meant Suffolk.[26] He pined for 'dear Suffolk' almost as much as for her and found comfort and solace in Bergholt, 'that dear spot' to which 'I always turn as a safe and calm retreat'.[27] He had, he told her, 'a divided heart'. '[M]ake yourself easy & don't be greedy,' he tried to reassure her: 'you have by far the greatest half.'[28] But despite his pledge Maria often felt she was playing second fiddle to a county. Even though she wanted him to work, she begrudged his time away and reprimanded him if she felt he was neglecting her. By 1815 she was desperately fed up. 'How I do dislike pictures, I cannot bear the sight of them,' she wrote waspishly; 'you may spare yourself telling me I am very unreasonable for I know it already, but I cannot be reconciled to your spending month, after month in the country.'[29]

What was it that John was doing during those months in the country? The answer is sketching, sketching and more sketching. His love for Bergholt now had the added sweetener of associations with Maria, and if anything, his fond childhood memories had taken on even greater emotional significance than before. So he took the quest for 'natural painture' back home. It was not a quick process. As we know, Constable subscribed to Reynolds's belief that 'there is no easy way of becoming a good painter. It can only be obtained by long contemplation and incessant labour.'[30] In other words, practice makes perfect. (Though he lacked the same eloquence, Turner would have agreed with this sentiment. When once asked what the key to being a successful artist was, he replied, 'The only secret I have is damned hard work.') Constable later characterised it as like driving in a nail with a hammer – something that required repeated effort and perseverance.[31] His whole being became focused on reaching goals that only time and patience could achieve: how to reveal the poetry and grandeur in everyday landscape; how to apply paint to a surface so that it conveyed the specifics of time and place; how to be with Maria. Starting in around 1809 and continuing until 1816, he mused upon these problems within hundreds of sketches in and around the Bergholt–Flatford–Dedham area, sometimes in pencil or

watercolour but mostly in oil. The Bicknell years therefore – those long years of waiting, pining and biding his time – coincided with his most intensive period of sustained creative development.

Sketching is not a 'one-size-fits-all' activity. It is a personalised process according to individual motivations and circumstances. Whilst it can pave the way for more finished pieces, it is usually a 'behind-the-scenes' occupation, and constitutes the way an artist works out their conceptual or technical path. In the main, Constable's approach to sketching was very different from Turner's, and the contrast is instructive. The way the two men instinctively observed and responded to the world reveals much about their wider outlook and beliefs, and helps us to understand the very substance of their landscape vision. We can see the broad distinction if we compare examples of their respective fieldwork during the summers of this period.

The overwhelming majority of Turner's sketches relate to travel – fact-finding, data-gathering expeditions which laid the groundwork for studio painting. During the early 1810s these trips mostly arose from commissions – a succession of substantial watercolour/print series featuring picturesque British scenery. Hence he headed wherever the money dictated – the West Country in 1811, 1813 and 1814, Sussex in 1815 and the north of England in 1816. The more unfamiliar the surroundings, the greater the compulsion to record, and the most expedient way to do this was with a pencil. Employing a medium graphite pencil and an unfussy linear style, Turner filled portable pocket-sized sketchbooks with swift, successive jottings. It was a simple, effective approach that enabled him to keep pace with the novelty passing before him. He might be standing up or sitting down, knee-deep in mud or clambering over rocks, inside a carriage or even afloat on water, but wherever he went, and however he got there, a sketchbook in the hand suited all terrain and all weathers. The turning of the pages mirrored the passing of the miles, the blink of his eye or the agile switch of his gaze – from the distant horizon to objects right under his nose. During the course of his lifetime, Turner used nearly 300 individual sketchbooks, over 80 per cent of which relate to journeys made away from London.

Work pressures notwithstanding, travel was a liberating experience for Turner. He was a single man, financially secure, unencumbered

by domestic responsibilities, and in mind, body and spirit, his preference was to be free as a bird. As early as 1809 and as late as 1847 he marked the start of many a journey by declaring himself 'on the wing'. In one undated letter he even accompanied his signature with a duck-like bird in flight, a play perhaps on his name.[32] Sketchbooks suited his itinerant personality, facilitating a creative as well as a physical freedom. When he used them for painting he tended to prefer quick-drying media, such as watercolour or ink, which fostered an element of spontaneity. But mostly he considered outdoor painting a waste of time; he reckoned he could make fifteen pencil sketches for every one coloured with wash.[33] The truth was that Turner had no need to lay down a scene in colour: the briefest pencil memorandum was enough to trigger his incredible visual memory. What is more, he was never a slavish copyist of nature. He could rarely resist translating the things he had seen according to his imagination. Oil paints were therefore generally reserved for studio work. Far more useful to him were his sketchbooks, the best repository for his quick hand, his constantly roving eye and his greedily curious way of surveying the world.

Whilst Turner was gallivanting around the country during the 1810s, Constable was for the most part a home bird, hunkered down in Bergholt. He too went out and about on foot. But since he was revisiting scenery that was already intensely familiar to him, he didn't need to fix its topography for reference. His focus was not upon establishing the layout of fleeting locations, but capturing the fleeting moment within a fixed location. With a sensitivity most acute in places that he already knew well, he sketched to navigate his deeply felt perceptions – the instances of light, colour, sound and feeling that flickered across his best-loved locations. Unlike Turner's rapid reportage, his eye was leisurely and lingering, and his use of materials reflected the intensity of an unhurried gaze. And whilst it was Turner's habit to fill in the atmospheric blanks using his memory and imagination, it was not in Constable's disposition to do so. Not only did he lack the same powers of visual recall, but he had also made a conscious avowal to pursue fidelity in the natural world. In his quest to close the gap between nature and art he rooted his practice in oil paint.

Messy, sticky, slow-drying – oils are not intrinsically suited to outdoor use. They did not pair well with Turner's nomadic movements

at all. But Constable was a more sedentary character and his proximity to a permanent painting room mitigated many of the immediate impracticalities. Thanks to the small studio his father had rented for him in Bergholt, storing his equipment was easy and his familiarity with the terrain meant that he could pre-select the best times and locations for painting, without journeying for hours between destinations. He could dive for cover if the weather turned bad and return to the same spot at a more convenient moment. For forays further afield he used a sketching box, a hinged wooden container with compartments for paints, brushes and other media. When furnished with millboard or pre-primed paper pinned inside the open lid, this indispensable piece of kit contained everything the artist needed for a short burst of focused activity – paintbox, palette and easel in one. It could even be closed up with a still-wet sketch safely preserved inside. Sitting with the box balanced upon his knees, Constable could indulge in a contemplative form of looking. Once he sat so still a mouse crept into his pocket.

Oil allowed Constable to revel in the tangible qualities of land-scape, varying the handling of paint according to his impressions of colour, texture and substance. And he wasn't only describing what he could see. Fixated upon detail and sensation, he sought to convey the range of his senses – sound, scent, movement and temperature. Looking at a sketch by Turner, we can often recreate what a place looked like – revisiting the historical accuracy of features long since vanished. But looking at an oil sketch by Constable, we comprehend what the scene *felt* like – you can almost hear the rushing water, feel the freshness of the breeze and smell the earthy bouquet of leaf mulch and petrichor (fig. 12).

This is not to suggest that Constable only sketched in oil, or that Turner never did. Both were inventive, versatile artists, prone to adapting their practice under different circumstances. In 1813, prompted by the loan of pre-prepared equipment from a local acquaintance, Turner tried his hand at al fresco oil painting.[34] These studies of the countryside around the Plym estuary are lively and fresh, and sit alongside the sketchbook material from his wider Devonshire tours. Constable, meanwhile, often turned to graphite. That same summer, he was wandering around Bergholt with a sketchbook making what

Fig. 12. Constable, *Flatford Mill from a Lock on the Stour*, c.1811,
oil on paper laid on canvas.

he called a 'journal' of 'little scraps of trees, plants, ferns, distances
&c' in pencil.[35]

As a general rule, however, Constable's sketchbook use was not
nearly so intensive as Turner's. Most of his sketchbooks have at
some point been dismembered and the contents dispersed, but it
has been estimated that overall he used about forty-five across his
career.[36] Even taking into account his shorter lifespan (he predeceased
the older artist by fifteen years), this is still many fewer than the
hundreds of volumes accumulated by Turner, and the disparity can
be accounted for by the very different tenor of their practice. Even
when done quickly, Constable's sketches tend to be more carefully
considered than Turner's, the views more selectively composed and
individual objects more meticulously observed. His handling of the
pencil also leans towards the textural, employing softly worked
masses to create rich contrasts in light and shade.[37]

During the years of his Suffolk sketching period, Constable's tonal
pencil work often betrays an emotional resonance that is absent

from Turner's detached outlines. For him, shadows were indicative of the evanescence of life – a fact he was reminded of every time he walked past the sundial mounted on Dr Rhudde's church, with its Latin motto: 'ut umbra sic vita' ('life is like a shadow').[38] The phrase seemed to mock his current impasse. Two small studies on a page in an 1814 sketchbook use East Bergholt House as a motif for exploring the inversion of contrasts between night and day. Respectively inscribed 2 and 3 October, they reveal an aesthetic interest in sunlight and moonlight. Yet the subdivided page also seems to symbolise Constable's personal life – the split between work and love, the long separation from Maria and the sense of time being lost.[39] Every sunset marked another day of waiting. On the very same day as he started his sketch Constable wrote a heartfelt letter to Maria, articulating his mental conflict:

> It is my peculiar happiness to have an object to pursue, that occupies my time and mind so much – a mind that must otherwise have fallen a prey to itself. God knows my beloved Maria (when I consider the accumulation of untoward circumstances that keep us apart, and deprive me of the only person I ever loved), how sincerely thankfull I am for so great a blessing – as I have always found my profession to be under all its anxieties.[40]

It is hardly a surprise that two such distinct personalities should have evolved different methods of working. But there is something profoundly revealing about the working approaches of Turner and Constable at this period. There could hardly be a greater contrast: the confident, clinical sketches that document Turner's 'on the wing' momentum; and the soulful studies arising from Constable's introspective stasis.

Whilst direct comparison can help us to appreciate their artistic differences, there are equally times when the private worlds inhabited by Turner and Constable overlap and add an unexpected layer of insight into each other's paintings. A good example of this is their respective exhibits at the Royal Academy in the spring of 1813.

Constable's picture was another view of Flatford Lock, this time facing in the opposite direction, towards Flatford Bridge.[41] Once again it was unmistakably local and true to life: the northern lock

gate with water trickling through a gap in the weathered timbers and falling into the pound chamber; the distinctive wooden bridge with its single handrail and central support; and nearby Bridge Cottage, a thatched and timber-framed dwelling, inhabited on occasions by tenants of Golding Constable. Full of maternal pride, Ann Constable came up to town to see the painting for herself.[42] How it must have tickled her to find her home turf immortalised on canvas. Here were all the humble sights and sounds of her husband's hamlet, displayed for the entertainment and edification of London society. Perhaps as a concession to metropolitan taste, Constable generically titled the painting after the central figurative element: *Landscape: Boys Fishing*.

As ever, there is no way of knowing how much notice Turner took of Constable's picture, hung this year in the Inner Room, but he perhaps enjoyed the reference to a pastime which, as it happened, was very dear to his own heart; fishing. In his own words, Turner was an enthusiastic 'tormentor' of 'the finny race'.[43] Casting a line into the clear waters of a peaceful river was one of his few recreational pleasures, and he regularly packed his fishing tackle alongside his art equipment. Sometimes in company and sometimes in solitude, he fished in waterways up and down the country – in the Thames, the Dee, the Brent and elsewhere – chasing tench, perch, trout and freshwater eels. He took advantage of the well-stocked lakes of wealthy friends and patrons – Walter Fawkes at Farnley; Lord Egremont of Petworth House; James Holworthy in Derbyshire; Sir John Soane at Pitzhanger Manor in Ealing; and Sir John Fleming Leicester of Tabley Hall, Cheshire (where he spent more time fishing than painting) – and even installed his own small trout pond in the garden at Sandycombe Lodge. As a hobby enjoyed by rich and poor alike, fishing would have been an accessible way for Turner to connect socially with his more well-heeled acquaintances – a levelling activity not dependent on income or education. We can imagine him sitting in the sunshine on a sandy riverbank with his rod and 'a can to catch trout', enjoying long moments of stillness interspersed with the sudden flurry and excitement of a bite.[44]

Turner apparently 'fished with the enjoyment of a boy', and something of these simple delights is captured within the watercolour design for *Young Anglers*, a plate published in 1811, as part of the landscape print series the *Liber Studiorum* (see Chapter 8).[45]

Set in the tea gardens of a public house near Turner's premises in Marylebone, the still waters and pollarded willows are reminiscent of the river scenery of the Stour, and the central motif of two kneeling boys, eagerly examining their catch, is endearingly like the pair similarly absorbed in the middle distance of Constable's painting. Turner's composition is a consciously constructed example of the 'pastoral' category of landscape, an idealised rural setting where people are pictured harvesting or utilising the land in harmony with their surroundings. However, there are enough authentic everyday details – the characterful body language of the figures, the boys' bare legs and rolled-up breeches, the watering can storing their fish and the contemporary urban buildings in the background – to confer a sense of lived realism upon the scene, suggesting that even Turner's troubled youth had carefree moments which he could recall with pleasure as an adult.

Of course Constable shared Turner's love of fishing. Living near a river, it would naturally have been a regular feature of his upbringing and a pastime he automatically associated with the innocent, idle hours of youth. Indeed it was casual mention of an angling trip described by his friend – the appropriately named John Fisher – which prompted his famous, oft-quoted meditation upon his 'careless' boyhood and its role in making him a painter. In 1821 Fisher reported to Constable that he'd been thinking of him whilst fishing for pike 'in a fine, deep, broad river, with mills, roaring backwaters, withy beds . . . as happy as when I was "a careless boy"'. In reply, Constable ran with the theme, channelling cherished memories of his own: 'How much I can Imagine myself with you on your fishing excursion in the new forest,' he wrote. 'But the sound of water escaping from mill dams . . . Willows, Old rotten Banks, slimy posts, & brickwork. I love such things . . . As long as I do paint, I shall never cease to paint such Places. They have always been my delight – & I should indeed have delighted in seeing what you describe in your company.'[46]

Whilst later paintings such as *Stratford Mill* and *The Hay Wain* include anglers as a convincing feature of the scenery, the two figures in *Landscape: Boys Fishing* introduce a conventional, sentimental note, softening the realism into more of a pastoral cliché. Maybe Constable was attempting to make his homespun brand of East Anglian countryside a little more palatable and commercially

appealing for his middle-class urban exhibition audience. If so, the strategy paid off. In early 1814 the picture was bought from the British Institution by a London bookseller called James Carpenter, for twenty guineas and a payment-in-kind of books. This was a significant breakthrough – it was the first time Constable had ever sold a work to a stranger – but it was a very modest sum. It was a long way from the standard 200 guineas Turner charged for a similarly sized canvas, and immeasurably beyond the 850 guineas he was asking for his large Claudean pastiche, *Appulia in Search of Appullus*, at the same exhibition.[47]

If Constable had hoped 1813 would be the moment his rural tableaux would take the Academy by storm, he had picked the wrong year. Many of the most talked-about pictures in the Forty-Fifth Exhibition featured rustic subjects: the humorous antics of simple country folk in David Wilkie's *Blind-man's Buff*,[48] or Edward Bird's series of six canvases illustrating the punishment and redemption of a rural poacher. And unfortunately for Constable, there too was Turner, who was not only exhibiting a grand biblical subject,[49] but had also chosen to tackle a contemporary countryside scene which became one of the sensations of the year.

Titled *Frosty Morning*, Turner's painting was a pitch-perfect rendition of the effects of cold weather upon an agricultural landscape (fig. 13). Bleak and cheerless, the emptiness of the sky is echoed by the desolate barrenness of the land; the viewer can almost feel the biting chill of the air. Two men are digging at the side of the frozen, rutted road. They look like labourers clearing a ditch but there is something disturbingly funereal about them. With their hearse-like cart it is as though they are engaged upon a sad and lonely internment. A further note of morbidity is introduced by the watching man, his head bent as if in respect, leaning on a gun. The animal he has just shot is draped around the shoulders of a young girl like a macabre tippet.

At the beginning of the nineteenth century, Britain was still in the grip of a period of climate change known as the 'Little Ice Age'. The decade from 1810 to 1819 was the coldest in England since the 1690s. Severe snow and white Christmases were common, and even the legendary frost fairs, held when the Thames iced over in central London, were not as yet a thing of the past (the last one would take place in February 1814). Hard winters posed significant

Fig. 13. Turner, *Frosty Morning*, 1813, oil on canvas.

challenges to health and living conditions, and would have been felt more harshly in the country than in the towns. Constable rarely, if ever, depicted the colder months of the year. His Suffolk pictures celebrate spring and summer, not the autumn or winter, and he said he disliked the 'sad ravage' of the snow upon trees, equating it to the damage wrought by battle.[50] Indeed, all the Constable family feared cold weather. This genuine sense of threat can be sensed within the Constable correspondence and lends a humanised perspective to Turner's frost painting.

Constable's mother, in particular, dreaded winter like a mortal enemy. She fretted constantly in her letters about the dangers to life and limb, being terrified by coughs, colds and chilblains almost as much as the perils of transport and travel. It didn't matter that John was a grown man, well into his thirties; she fussed about him going from the 'warmth of the Academy room, smoke from lamps or many candles, & then coming into the air & streets of London'.[51] She urged him to take care walking upon the streets in the 'very sharp evenings', to keep his feet warm and dry so as to avoid 'sore throat, inflammation of the lungs and tooth ache', and to keep a

TURNER AND CONSTABLE

good fire, even sending him money for coal.[52] Her greatest concern, though, was always her husband, whose breathing was adversely affected by 'keen frosty air' and agitations over the business.[53] In January 1811 her letters were full of the weather:

> Thank God – your Father is full as well as I expect he will be during the Winter, better in his breathing than usual in severe frosty air which we now experience . . . Pray take care of cold. Within the two days last past, the barges are frozen in at Cattawa[de] & the Telegraph [Golding Constable's seagoing vessel], Captain Francis at Mistley, so you may know it is severe.[54]

She also reported on the havoc wreaked in Suffolk due to the intense cold and drifted snow:

> The roads for two or three days last past have been impassable by the thaw & in chief of the narrow roads. Mr & Mrs Addison were completely over turned returning from Sudbury to Wenham Hall in a post chaise on Saturday . . . the Mail Coach on Saturday night . . . got sadly entangled in snow . . . one of the horses fell and the hook of the pole run into it. Poor animal – it is yet alive.

In short, there was little Ann Constable feared more than wintry weather and her aversion was shared by the rest of the household. When she herself experienced a fatal 'giddiness' (almost certainly a stroke) in the garden of East Bergholt House a few years later, her family blamed the severe cold.[55]

Whilst there is no way of knowing whether Constable's mother definitely saw Turner's *Frosty Morning*, surely John would have guided her around the Exhibition, pointing out the highlights and famous names for her amusement and edification. One can't help but wonder what she made of the painting. We can imagine her instinctively recoiling at the austere naturalism, drawing her wrapper tighter around herself and turning away with a shiver. Her accounts of the cold help us empathise anew with the vulnerability of the living beings in the painting, compelling us to reconsider the dangers of a nineteenth-century winter, in a way that is easily lost in our age of insulated homes and central heating. They reinforce the frailty

implicit within the frost. Whilst at first glance the agrarian setting and naturalistic effects might appear to be close to Constable's picturesque territory, in its own way the painting is as doom-laden as some of Turner's more overtly sublime productions.

Unusually for Turner, *Frosty Morning* is believed to contain certain personal visual tie-ins. He was not above the inclusion of whimsical or witty pictorial puns, but unlike Constable, his pictures were generally not self-referential. As a storyteller he tended to try to generate or replicate extreme, broadly felt emotions rather than nuanced feelings indicative of his inner life. Yet according to received wisdom, the 'Frost Piece' was one of his favourite pictures and this may be because specific details were directly derived from his private reality.

Firstly, the two horses were apparently modelled upon a genuine working animal, an 'old crop-eared bay' which Turner owned to pull his gig on sketching expeditions, including to the West Country in 1811.[56] The source of this information was the son of Henry Scott Trimmer, whose reminiscences were recorded by Thornbury without any reason to doubt their veracity. Less anatomically convincing than some of Constable's painted equines (in *The White Horse*, *The Hay Wain* or *The Leaping Horse*), Turner's beasts are nevertheless full of individual character. The horse pulling the cart does indeed have short docked ears and a stocky appearance, capturing 'the stiffness of old Crop-Ear's fore legs' and the fact it was 'a cross between a horse and a pony'.[57]

Secondly, and perhaps speciously, the girl with the hare over her shoulders is assumed to have been modelled upon the elder of Turner's daughters, Evelina, around twelve years old at the time *Frosty Morning* was painted. Trimmer asserted that the child 'reminded him of a young girl whom he occasionally saw at Queen Anne-street, and whom, from her resemblance to Turner, he thought a relation. The same female figure appears in his "Crossing the Brook".'[58]

This is exactly the kind of tenuous fragment to which we have to cling in order to glean anything about Turner's private affairs. But can it really be supposed that someone so aspirationally motivated, not to mention secretive to the point of obsession, put proof that he had an illegitimate daughter in plain sight within a canvas destined for the walls of the Royal Academy? If Turner did base the figure upon Evelina, her looks are utterly generic. It is an absurd

　　　　　　　　　　　　TURNER AND CONSTABLE

truth that we can be surer about the appearance of his pony than we can about his children (or indeed any of the important women in his life – his mother, Sarah Danby, Hannah Danby or his later companion Mrs Booth).[59]

The third link relates to one of Turner's most important friendships, with the Yorkshire landowner and erstwhile liberal MP Walter Fawkes, a congenial patron who had become one of his closest friends. Again according to Trimmer, Turner had experienced *Frosty Morning*'s wintry conditions whilst travelling by stagecoach near Fawkes's home, Farnley Hall in Otley.[60] During his thirties and forties, the artist was often in that neck of the woods and it wouldn't have been the first time a Yorkshire sky had made it into one of his oil paintings. The storm that inspired *Hannibal Crossing the Alps* had apparently been seen in the company of Fawkes's son, Hawkesworth, over the hills near Wharfedale. If so, it might be recent events in Fawkes's life which explain the pervading melancholy of the picture. In November 1811 and again in 1812, Turner had stayed at Farnley during a period of family mourning.[61] Tragically, Fawkes's eldest son had killed himself. The sixteen-year-old, also called Walter, had committed suicide by throwing himself into the Grand Union Canal at Denham, Buckinghamshire, where he had been attending school.

It's unlikely that the figures represent Fawkes or his family. Instead it is the land which serves as a proxy: the melancholy stillness of the dawn is indicative of Fawkes's world, frozen in grief. Turner had been accustomed to using Farnley as a get-away from work, taking pleasure in the familial domesticity (Fawkes had eleven children in total), and in country pursuits such as grouse-shooting and fishing. For such a trauma to befall this happy household must have complicated his feelings and perhaps, too, underlined his personal beliefs about the fragility of love and human relationships. Yet if Turner painted *Frosty Morning* in recognition of Fawkes's recent loss, he incorporated a sliver of comfort. The picture was accompanied in the catalogue by a line of verse, once again taken from Thomson's *The Seasons* – 'The rigid hoar frost melts before his beam'. Apparently much brighter in 1813 than it appears in the present day, it is the breaking dawn light which provides a hint of hope; the sun delicately warms and thaws the icy landscape in the same way as the passing of time gently eases the sorrow of loss.

Whether read in conjunction with Thomson's poetry or the letters of Ann Constable, and whether interrelated to Fawkes's fatherhood or his own, Turner's painting is a tour de force of natural realism. It seems to contain the kind of associative naturalism that Constable was still striving to achieve within his Suffolk landscapes. Though this would become a successful feature of his mature exhibition paintings, in 1813 it was not yet quite there. As an essay in natural painture, *Landscape: Boys Fishing* was still a work in progress, and compared to the example put forward by Turner, it fell short of the mark. This at least was the verdict of Constable's best friend, clergyman John Fisher (later an archdeacon). Like Fawkes for Turner, Fisher was both patron and companion – someone with whom the artist felt comfortably at ease. Indirectly he was yet another offshoot from the Suffolk network. Fisher's uncle (another John Fisher) had been rector of Langham, the neighbouring village to Dedham, and was one of Constable's earliest patrons. Like Dr Rhudde, Fisher senior also fulfilled ecclesiastical roles for the royal family, not least as tutor to the young Princess Charlotte, and in 1807 he had been made Bishop of Salisbury. It was at the bishop's palace in 1811 that Constable first met the younger John Fisher, and the two became lifelong friends. Constable derived much support from their regular exchange of confidences. But whilst Fisher was unfailingly encouraging, he could also be straight-talking, frank and prone to a spot of good-natured teasing. In June 1813 he wrote to Constable:

> I have just heard your great picture [i.e. *Landscape: Boys Fishing*] spoken of here by no inferior judge as one of the best in the exhibition. It is a great thing for *one* man to say this. It is by units that popularity is gained – I only like one better & that is a picture of pictures – the Frost of Turner. But then you need not repine at this decision of mine; you are a great man like Bonaparte & are only beat by a frost.[62]

The last line is a jocular reference to Napoleon's retreat from Moscow in 1812, a disastrous rout hampered by the freezing Russian winter. The defeat had been widely reported in the English press and gleefully seized upon by satirists.[63] As was the case with *Snow Storm: Hannibal Crossing the Alps*, Turner had previously been described

as an artist able to command the power of the weather. So for Fisher to characterise Constable as Bonaparte beaten by the 'frost' of Turner was a pointed topical witticism and was in danger of hitting a little too close to the mark. It was testament to the relaxed camaraderie that existed between them that Constable seems to have taken the comment in good part, relating the anecdote in his next letter to Maria. In the same letter he also had other news to convey concerning Turner.

Up until this moment, Turner and Constable had apparently never met. For well over a decade they had been frequenting the same places and mixing with many of the same people but narrowly skirting around one another. The previous month alone there had been at least two near misses. On 8 May they had both been at a royal banquet marking a retrospective exhibition of the work of Sir Joshua Reynolds at the British Institution. A couple of weeks later Constable, accompanied by Joseph Farington, had gone to see Turner's latest show of paintings at his Queen Anne Street gallery. They were greeted by Turner's gallery attendant, his father. Still chatty and chipper at sixty-eight years old, 'Old Dad' had long since hung up his strop and razor, and was now working as his son's assistant. He impressed the pair with his energy, cheerfully telling them 'that He had walked from Twickenham this morn'g eleven miles; . . . In two days [during] the last week He s[ai] d He had walked 50 miles.'[64] But whilst they enjoyed the encounter with Turner senior, Turner junior was not in residence. Rather than having a conversation with the man himself, Constable had to be satisfied with discussing the exhibits with Reinagle, who happened to be there at the same time.

Such was life amidst the London culturati. It was a small world, and the microcosm of the Royal Academy was even smaller. Life at Somerset House followed a set rotation of activity, and it was inevitable that Turner and Constable, as regular participants, would eventually encounter one another. That moment came just a fortnight after Fisher declared Constable 'beaten by the Frost of Turner'. On Monday 28 June 1813, the two men came face to face at one of the perennial social fixtures: the king's birthday dinner, an annual meal hosted solely for artists, in honour of the monarch.

Tickets for the dinner, held in the Council Chamber at Somerset House, cost twenty shillings a head and the catering was outsourced to

a local tavern. If it was anything like the anniversary dinner (another yearly event, held in memory of Reynolds), it was a convivial affair, consisting of 'a handsome and plentiful first course' (turtle soup was a favourite), a main course of 'removers' (a group of dishes that could be replaced for something different partway through) and a dessert, all served with the best wines, port, sherry, madeira, claret, champagne or punch.[65] Each Royal Academician had the privilege of introducing one invited guest. In 1813, there were sixteen RAs in attendance with sixteen corresponding visitors (Associates and other contributors to that year's Exhibition). It is not known which Academician had invited Constable (although 'dear old' Thomas Stothard, the only member so far to vote for him, seems the most likely possibility), but the seating plan, as recorded by Farington, shows that he had been placed directly next to Turner.[66] For Constable at least this was extremely noteworthy. He was seated to the left of someone whose career he had closely followed for over a decade, and who, from the moment he had arrived in London, had represented the very definition of success.

A couple of days later Constable regaled Maria with a short but memorable account of the dinner: 'The day passed off very well. I sat next to Turner, and opposite M. [Benjamin] West and [Thomas] Lawrence – I was a good deal entertained with Turner. I always expected to find him what I did – he is uncouth but has a wonderfull range of mind.'[67]

What a pithy record of such a historically momentous meeting. Constable's evaluation is astute, and not at all the account of someone overawed or starstruck by celebrity (note that he doesn't have to explain who Turner is to Maria. He is enough of a household name that his reputation precedes him, or perhaps John has mentioned him to her before). But as tantalising as his insights are, questions abound. Constable 'expected' to find Turner 'uncouth', but what did he mean by that? Was he reacting to the other man's 'lower-class' London accent (though he himself might have spoken with the 'yod-dropping' burr of East Anglian English), or was Turner slurping his soup and belching over the wine?[68] Perhaps Constable found him a social curiosity compared to the more gentlemanly and conservative type of Academician he was used to dealing with. His preconceptions had been shaped in part by men like Farington and

TURNER AND CONSTABLE

Beaumont, who considered Turner rather rough and ready. James Hamilton has suggested that the term was not meant to be an insult but rather intended to imply someone who was 'odd' or 'unusual'.[69]

Above all, what, in turn, did Turner make of Constable, someone so far beneath his professional notice that he'd barely given him any thought at all before now? They were unlike in so many ways: family, background, politics (Constable was a staunch supporter of the Tories; Turner, as far as we can gather, tended towards a more liberal outlook) and temperament. Yet for all their differences, they also had a lot in common, and not only because they were both painters. They were a pair of intelligent, similarly aged, middle-class men, unmarried, alumni of the same art school and self-consciously committed towards raising the status of landscape art. Even casual small talk would have revealed many interests and passions alike. And if Constable is to be believed, the conversation was not superficial but entertaining, full of interest and depth. What 'wonderful range' of topics did they talk about and what common ground did they discover?[70]

Art must definitely have been on the list. As contemporary landscape specialists they shared an ardent admiration for the historic masters who had paved the way, even to the point of studying or copying the same examples. The same Gainsborough landscapes that made Constable cry, for example, had likewise been examined by Turner, so intensely he hurt his eyes.[71] Other heroes included Wilson, Ruisdael and Claude. There was also the love of poetry – Thomson, in particular – and a shared belief in the poetics of landscape. Perhaps these things were discussed in relation to the relative merits of regional scenery, with each man explaining the dividends of landscape unfamiliar to the other, Constable of course expounding upon his love of Suffolk and Turner talking about his forthcoming return to Devon. They also had various people and places in common: the Lake District for one, or Salisbury and Stourhead. It's unlikely Turner would have been so impolitic as to complain about Constable's mentor Beaumont, although he was much disgusted with him at that time, blaming him for a campaign of slander that was directly hindering sales.[72] But it's possible they touched upon the doings of other mutual acquaintances – the arrogant Benjamin Robert Haydon, for example. And Constable presumably mentioned that he had recently visited Turner's

gallery and met his father. Other possible subjects could have been architecture (Turner sharing design features from his new house near the Thames), current affairs (Constable had cousins fighting in the British army), Turner's perspective lectures (which Constable must have heard) or their mutual interest in science. Their exhibits might have sparked some light-hearted conversation, pleasantries about their shared love of fishing or a self-deprecating retelling of Fisher's preference for the Frost Piece.

All this is conjecture. However, there is one topic we can deduce must have come up: Constable's Academy prospects. The younger man should have had every reason to be feeling hopeful. Both West and Farington had approved his recent work, reporting that the Council had thought he'd made a 'great advance'. To have a dinner placement next to Turner was proof in itself of progress. Farington had urged him to put himself forward for Associateship, a process which involved adding one's name to a handwritten list pinned up in Somerset House. This had to be done by the end of May so that the candidates' work could be examined before the Exhibition closed in June. In 1813, the day of scrutiny had been fixed at 28 June, immediately prior to the king's birthday dinner.[73] In other words, Turner, along with the rest of the General Assembly of Academicians, had spent that very morning looking at paintings by prospective ARAs. For whatever reason, Constable's landscapes had been found wanting. The next day, Constable glumly told Farington he had 'but little expectation of being elected an Associate in November next'.[74] Was it a coincidence that this pessimistic plunge in spirits followed an evening spent in conversation with Turner? Either under Constable's probing Turner had fed back the general consensus of the Academic body (unlikely – Turner was noted for his discretion), or Constable had simply become disillusioned by comparing his situation to his more famous counterpart's. Whether kindly, maliciously, pragmatically or unintentionally, the established star of the Academy had scuppered the aspirant Associate's current hopes and left him feeling discouraged.

Today, the 1813 dinner represents a fateful meeting of minds between the two greatest English artists of the age. At the time, this would have surprised both of them. Whilst the fame of one was already assured, the other's was non-existent. If the man from

TURNER AND CONSTABLE

Suffolk had not lived beyond this point he would now be remembered as an inconsequential regional painter, little more than a footnote in the history of British art. But the next few years would see that situation change. Turner didn't know it as yet, but he was about to see and hear a good deal more of John Constable.

CHAPTER 5

RIVERS OF ENGLAND

A COMPELLING WAY of comparing Constable's maturation with Turner's is to consider the rivers that provided the backdrop to their respective biographies. They each had waterways intertwined through their lives and landscapes: Turner's Thames and Constable's Stour. From cradle to grave, these rivers of England wound through the course of their careers as constantly evolving relationships. They honed the two artists' receptiveness to nature and came to form a public part of their identities. Whether on their waters or beside their banks, these rivers guided them towards ways of understanding and picturing the nation, its social and cultural heritage and its contemporary happenings. But people and places evolve over time. As the ancient saying goes, 'No man ever steps into the same river twice for it is not the same river and he is not the same man.'[1]

Viewed together, Constable's intense connection with the Stour and Turner's lifelong fascination with the Thames become a fascinating exercise in counterpoint. Their river work represents their most consistently revisited and overlapping theme. Comparison provides flashes of coincidence – moments when, by chance or design, we find the two artists at their closest, carried by the same current. Inevitably, however, it also flags up their differences and the way that rivers meant very different things to them at different points in their lives.

Take the year 1814. Turner painted a picture – *Dido and Aeneas* – which used the Thames as the starting point for an imagined,

mythological past. The painting derived its subject from Virgil's epic poem the *Aeneid*, but owed its compositional source to a watercolour made on the Thames nearly a decade earlier.² The wooded landscape was reconfigured as the sylvan realm of Carthage, the setting for the tragic love story between Queen Dido and the Trojan hero Aeneas. With its weighty themes of duty, doom and destiny it was a fittingly scholarly subject for exhibition and it impressed his Royal Academy peers with its intellectual properties and accessibly naturalistic effects.

One colleague who wasn't enamoured was John Constable. *Dido and Aeneas* was a far cry from the local views he was exhibiting at the same time: a small landscape, *Ploughing Scene in Suffolk*, and an upright view of Flatford titled *The Ferry*. He simply could not countenance Turner's creative licence and lack of authenticity, writing disparagingly to Maria:

> It is an amusing Exhibition on the whole. A large landscape of Turner's [*Dido and Aeneas*] seems to attract much attention. Should we ever have the happiness to meet again it may afford us some conversation. My own opinion was decided the moment I saw it, which I find differs from that of Lawrence and many others entirely – but I may tell you (because you know that I am not such a vain fool) that I would rather be the author of my landscape with the ploughmen than the picture in question.³

Despite his insistence that he'd rather paint like himself than Turner, Constable was still struggling to translate his Stour sketches into something that successfully conformed to public expectations. *The Ferry* of 1814 was a classic example of the problem. The painting was based upon studies the artist had made of Flatford millpond and the cottage of Willy Lott. Contrary to the spontaneous naturalism he so prized in his on-the-spot sketches, however, the final painting had a sort of fussy quality about it, appearing mannered, unconvincing and overworked. What was even worse, the painting was heavily criticised at the Academy for its lack of finish. Essentially, therefore, it was failing on both fronts – as an exhibition piece and as an essay in natural painture.

A radical change of practice was required. In the summer of 1814, whilst Turner was using river sketches as the departure point for

powerful flights of fancy, Constable went in completely the other direction. He returned to East Anglia and, pencil in hand, scanned the landscape for pictures. Like Turner's earlier Thames sketchbook, his sketchbook includes a number of germinal studies – nascent compositions in Bergholt, Dedham and Flatford – that formed the basis for subsequent pictures. But whereas Turner's ideas erupted from his mind, Constable's were firmly rooted in reality. Carefully and deliberately, he selected subjects on the spot, composing and framing with aesthetic precision. He didn't want to go travelling, even in his imagination, and his ideas, like his feet, remained firmly by the banks of the Stour.

Constable, as we know, was a son of the Stour. The river forms much of the natural boundary between Suffolk and Essex, with tributaries fanning out on both sides. Pronunciation of the name can rhyme with 'tour' or 'tower', according to whether one hails from the east or west of the region. From the early eighteenth century its strategic importance lay with the eastern stretch that passes through the Vale of Dedham. In 1705, an Act of Parliament had made this part of the river navigable, turning it into the main artery for trade and transportation between London and East Anglia. Over twenty miles of canals, locks, sluice gates and towpaths were constructed, enabling barges to convey goods from the market town of Sudbury to the sea, a journey of two days. The boom period – the years when 'the Navigation' was busiest and most profitable – almost exactly spanned Constable's lifetime, from the 1770s until the coming of the railways in the 1840s.

Right at the centre of this economic system sat Golding Constable. He was one of the Navigation's key operatives, owning a number of barges (known as lighters) and three dry docks for building and repair. Working in pairs (gangs) pulled by barge horses, the lighters carried the grain from the mills, as well as other materials such as Suffolk bricks and chalk, to Mistley Wharf in the Stour estuary. From there goods were loaded onto sailing vessels known as sloops (also owned by Golding) and transported onward by sea to London. To capitalise the profits, cargo was also conveyed on the return trip, bringing coal, oil and other domestic staples into the area. This was a large and successful enterprise, a fundamental part of the infrastructure and commerce in that part of the country.

To top it all, Golding Constable was also one of the Navigation's appointed commissioners. Since 1780, he had held responsibility for the maintenance and governance of the network, ordering repairs and negotiating with landowners to keep the length of the watercourse running smoothly. If the Stour was the lifeblood of the area, Golding Constable was like its vital, beating heart. And though John had technically abandoned his position as heir to the Constable business, he was knowledgeable enough to appear in his father's stead before the Commissioners of the Stour Navigation. In 1808, long after he'd left for London, he was still familiar enough with the workings of the system to confidently 'report and complain of the tow-paths, locks, gates'; exactly those things that would become his most famous subjects.[4]

Constable's relationship with the Stour was not therefore merely that of a near neighbour. It was a deep-seated and emotional bond, more akin to that of a blood relation. He loved the river in much the same way as he loved his parents, for the role it had played in his upbringing. When he painted the Stour it was like capturing the likeness of a family member. He claimed, as we know, that it was the banks of the Stour that 'made' him a painter, and by this he meant not only that it was these river scenes which brought him professional approbation, but also that his whole approach to landscape was forged through a long and intense dialogue with the specifics of the Suffolk river.

Various chroniclers over the years have likewise divined the source of Turner's art as the Thames. Ruskin was the first, claiming that Turner loved to draw and paint anything resembling the Thames shore: 'anything fishy and muddy . . . black barges, patched sails, and every possible condition of fog, dinginess, smoke and soot, dirty sides of boats, weeds, dung-hills, straw-yards and all the soilings and stains of every common labour'[5] – a sentiment that recalls Constable's declaration of love for 'old rotten banks' and 'slimy posts'. Thornbury took up the thread, writing of how 'on the banks of the Thames – our dear, dirty old river – Turner began his art; and on the banks of the Thames he lay down to die.'[6] Similarly, he quoted the river as Turner's first destination for sketching trips and his first subject for an oil painting.[7] Certainly, with the exception of the sea, no other single geographical feature appears so consistently within Turner's

work. He was enchanted by its various views and moods, and its aesthetic and symbolic potential. And whilst Constable's Stour, or at least the painted Stour of his childhood, amounts to a short localised section barely two miles long, Turner's Thames was a mighty entity, stretching over 200 miles. From Oxfordshire to the estuary between Essex and Kent, Turner's engagement with the river was a lifelong dialogue, consciously exploiting its multilayered identities in order to serve his evolving professional agenda.

Unlike the Stour, the Thames during this period was already a national symbol. Turner's history with it started in central London, with its most well-known section – the lower reaches that run through the heart of the city. During the eighteenth century, the river was the main artery for trade and transport, and for much of his first two decades, Turner's daily proximity to it was even closer than Constable's to the Stour. East Bergholt lay out of sight of the river, at least several minutes' walk away. Maiden Lane was almost right beside it. Today it takes approximately five minutes to reach the river on foot, but in former times it was much nearer. Just a hundred yards from Turner's doorstep was the Strand, which derives from an Old English word meaning 'shore of the river'. Prior to the construction of the Thames Embankment in the mid-nineteenth century, the river bordered the Strand's southern side, and from Charing Cross to Fleet Street it ran adjacent to and parallel with the great thoroughfare. Turner's childhood was therefore dominated by the Thames. Many of the district's stately mansion buildings had direct water access, including of course Somerset House, the home of the Royal Academy. There was also grime amidst the grandeur. Even at an early stage Turner was fascinated by contrasts between old and new, the dignified and the dirty, and the Thames was full of these contradictions. Coal wharves, timber yards, foundries and tanneries lined both sides of the river and the skyline bristled with chimneys and cranes. One such jarring juxtaposition was the excessively ornamental baroque erection of the York Watergate, situated cheek-by-jowl with a seventy-foot-tall wooden tower belonging to the steam-powered waterworks. Turner had painted this odd architectural pairing in around 1795.[8]

The Thames had also hosted Turner's first exposure to greener, more natural scenery. From the age of ten he had lived for a time in

Brentford, the home of his mother's brother, Joseph Mallord William Marshall (and, coincidentally, the birthplace of John Fisher). Situated to the west of London, where the Thames flows into its tributary, the Brent, this was the first of the sanctuaries to which Turner was sent away from the family troubles at home. A busy hub for manufacturing and market gardening, Brentford was nonetheless considerably more rural than Westminster and the displaced young boy formed a deep-seated attachment to the area. Although his boyhood could never be characterised, like Constable's, as 'careless', it was this part of the Thames that provided valuable moments of respite during his formative years – so much so that Turner re-established his connection to it as an adult. From 1804 he retraced his steps to the leafy environs west of the capital and used it as the location for a string of second homes. First in Isleworth, then at Hammersmith, and finally in Twickenham, he occupied a series of houses on or close to the Thames. The river helped him to relax and indulge in his love of water-based recreations – fishing and boating. He also had good friends in the area – Henry Scott Trimmer at Heston, and John Soane at Pitzhanger Manor in Ealing. Indeed, in so far as he had one, it was this stretch of river – Brentford to the Thames Valley – that became Turner's closest equivalent to Constable's Stour Valley. Just as for his contemporary, the river represented consistency and security, harking back at least in part to a mellow, nostalgic past.

In the years following his election as Royal Academician, this part of the Thames had also nurtured the next phase in Turner's artistic development: a remarkable period of self-fashioning. An important year had been 1805. From a rented water-facing property in Isleworth, Turner had given himself over to a summer-long sketching spree. From Syon Ferry House – his lodgings, happily situated on the Middlesex (north) bank between the edge of the Duke of Northumberland's Syon Park estate and Isleworth church – he had undertaken a dedicated but speculative exploration of the Thames. Sometimes on foot, sometimes by boat, and sometimes directly from his doorstep, Turner had indulged in a flurry of sightseeing, covering miles and miles of riverbank. Interconnected journeys took him from Kew through Walton, Windsor and Reading all the way to the outskirts of Oxford. He had also made a separate expedition, along the Wey Navigation into Surrey as far as Newark Priory, Guilford

and Godalming. Later in the year, he completed his Thames education by charting the river all the way in the opposite direction as far as the estuary.

As ever, it is the sketchbooks which most clearly show the workings of Turner's mind at this time. Dipping into them appraises us of his movements and motivations as clearly as if he had written them down. The first thing to note is the observational content: pages and pages filled with trees, foliage, barges, bridges, churches and clouds. Switching between pencil, pen and paint as the mood suited him, Turner's eye took in everything the river had to offer: the light and shade; the placid comings and goings of boats; the local specificity of fluvial flora and fauna – in short, the same kinds of preoccupations that Constable was so ardently and patiently to study on the Stour. Similarly to Constable, immersion within a tranquilly familiar river environment sparked a heightened awareness of the effects of nature. Working largely outside, Turner sketched with reactive boldness, seeking visually apt ways to describe what he saw before him.

Like Constable's outdoor oil sketches, Turner's Thames sketches are things of freshness and immediacy, characterised by realistic colours and a liberated looseness of effect. But where Constable sought to replicate nature's sensations in considered touches of oil, Turner's most intuitive medium proved to be watercolour. Particularly around Isleworth, Kew and Richmond, he made a series of coloured studies, responding to weather and water with improvisational brushwork. Sprightly sweeps of wash mimic the vigour of wind and flickering light. In one notable example, a broad pass of the paintbrush perfectly conveys the bracing gust of an incoming shower, its motion captured within the very speed and direction of the marks (fig. 14). Elsewhere on the same sheet, drier strokes dragged unevenly across the paper simulate gleams of sunlight dancing on the surface of the river. Turner has even broken up the integrity of the colour with the pad of his finger or thumb, the furrows of the impression leaving ripple-like imprints within the paint. These kinds of experimental marks evolved from a reflexive response to the source material; they simply would not have originated within the sterile confines of the studio.

Despite all his wandering up- and downstream, Turner was actually relatively settled during this summer, uncharacteristically anchored by his base at Isleworth: less an artist 'on the wing' and more like a duck

Fig. 14. Turner, *The River Thames with Isleworth Ferry*, 1805, pencil and water-colour on paper.

paddling around in a backwater. His time in situ inspired an atypical flirtation with outdoor oil, not a regular feature of his practice. Turner produced a handful of long, low Thames views, speedily blocking in the impression of the scene on portable sections of unprimed wooden panel.[9] These bear striking correlation with some of Constable's Stour sketches: stylistic quirks of colour, stroke and texture that are a natural consequence of having to adjust to painting in the open air.[10] Despite the disparity in size and format there are similarities in the loose, lush physicality of the brushwork, the smudgy softness of the textures and the simplification of forms and figures. The simpler something is, the harder it can be to do well, but both Turner and Constable were exceptionally skilful at representing living, moving things with painterly abbreviations, distilling the essence of the physical world into a matrix of gestural brushstrokes.

Whilst to the modern eye, the sensory qualities of these things are utterly convincing, these kinds of sketches were private, not public-facing productions. Such cursory handling would have struck

a contemporary exhibition audience as underdeveloped and illegible. Turner and Constable, however, would have had no difficulties understanding each other's visual idioms. In watercolour and especially in oil, they were essentially conversant in the same dialect, if not the same language, and each would have immediately comprehended what the other was trying to do. In 1799, Constable had talked about his time being more taken up with 'seeing' than painting, so that he might better qualify himself to paint the leaves on the trees.[11] Turner's Thames sketches share the same affinity between hand and eye. As one writer has put it, it seems as though he was 'not so much looking in order to paint, but painting in order to look'.[12] Indeed, it is hard to think of another moment where Turner drifted so closely towards Constable's ethos. Intimately concerned with truth, and intensely connected to place, they represent his purest and most experimental expressions of naturalism. Constable would have immediately recognised them as things created from the 'fountain's head' of nature, close to what he himself was aiming for with his 'natural painture'.

Any emulation was inadvertent. Already a mature professional, Turner would not have known about Constable's self-professed quest to study from nature, any more than the younger man would have been aware of what Turner was doing within the privacy of his sketchbooks. Although Constable's epiphany first occurred in 1802, Turner's 1805 stay in Isleworth pre-dates the main campaign of Suffolk sketching, which didn't properly gain momentum until after 1808. However, it is an interesting example of two ostensibly very different artists briefly moving in parallel. The vogue for outdoor oil sketching had been spreading through artistic circles for a while. Contrary to popular art history, which tends to cite *plein-airism* as a modern invention, the practice actually dated back to the seventeenth century. In Britain, it had suddenly come to the fore during the late eighteenth century.[13] An indelible link had emerged between looking, painting and understanding the natural world, in a way that was newly representative of its time – Romantic subjectivity combined with the principles of scientific observation. Particularly during the years of wartime alienation from Europe, the variability of Britain's climate and geography became seen as an exceptional artistic resource, and gradually, almost by osmosis, an informal

TURNER AND CONSTABLE

movement had arisen of outdoor sketchers, united in the broadest terms by how and where they painted.

Seen within this context, the sketches of Turner and Constable are part of the rule, rather than the exception, of early nineteenth-century landscape art. Whether they knew it or not, their river work places them loosely in company with other, less well-remembered artists of the time – William Havell, William Delamotte and John Varley. The latter was an influential tutor who took pupils, including William Henry Hunt and John Linnell, on outdoor painting expeditions from his home in Twickenham. Varley's didactic motto was 'Go to Nature for everything', circumstantial evidence that Constable's mission for 'natural painture' had not emerged out of a vacuum.[14] As evangelical as he was about it, the basic fact of Constable's idea wasn't all that unusual. It was the length and strength of his crusade that was extraordinary.

Turner found sketching liberating but it wasn't a commercially viable end in itself. He was always on the lookout for saleable subjects, and what fundamentally distinguishes his waterborne explorations from Constable's is the sheer scope of his different lines of enquiry. From the Thames Valley to the Thames Estuary, his river journeys spanned a marvellous breadth of scenery, and this in turn triggered his innate compulsion to invent. Returning to his sketchbooks, we find them teeming not just with observations, but with ideas. Sketches of the real world are so readily interspersed with imaginative ones that the abrupt change of pace can take one by surprise. On one page Turner can be standing opposite the Syon Park estate, fascinated enough by the dense vegetation lining the riverbank to pick up a real leaf and press it within his book (where it remains to this day).[15] The next moment, his mind's eye has wandered in time and space, and he is sketching an ancient seaport – complete with colonnaded buildings and a historical fleet – as convincing as if he stood directly before it. At times there is even a synthesis of observation and imagination – a curious blending between fact and fiction, where the Thames takes on the aspect of an antique Arcadia, and classical scenarios bear more than a passing resemblance to the outskirts of west London.

So intense was the imaginative burst of energy sparked by the river that, within a relatively short time, Turner had generated enough

material to fertilise his art for years to come. For the next five or six exhibition seasons he produced a whole sequence of river-themed paintings, pitched for broad market appeal and displayed, not sporadically at the Academy, but en masse, on the walls of the Turner Gallery in Queen Anne Street. Some years the whole exhibition space was dominated by the river in various different guises. There were topographical images showcasing the elegant quietude of historic bridges, castles, palaces and abbeys, alongside scenes of rural pastoralism, with cows or horses standing placidly by wooded riverbanks. Some were maritime pieces with a patriotic flavour, displaying a topical array of shipping in the estuary, whilst others drew attention to the changing face of urban London. A few were unexpectedly ordinary, depicting the drudgery of agricultural life with a realism to rival Constable's, *Ploughing up Turnips, near Slough* being one such title that unapologetically flaunts its mundanity. Others tapped into the river's cultural heritage. *Pope's Villa at Twickenham* of 1808 lamented the destruction of one its most illustrious residences, the house of the renowned poet Alexander Pope. With options straddling the range of his landscape repertoire, visitors to Turner's private gallery could have found a Thames to suit all tastes.

As well as establishing the Thames as one of his trademark subjects, Turner cemented his loyalty to the river by living near it. In 1807 he purchased a plot of land in Twickenham, half a mile from Richmond Bridge. By 1809 plans for a property designed by him were beginning to take shape. That same year he painted *Thomson's Aeolian Harp*, a majestic tableau featuring one of the most celebrated vistas of Georgian Britain: the curving bend of the Thames as seen from Richmond Hill. This lofty viewpoint had been made famous by Reynolds, Pope and Thomson, and in this instance Turner paid specific homage to the latter.[16] Painted as though seen through Claude-tinted spectacles, the picture fused the local with the ideal, and drew improving parallels between painting and its literary sister art, poetry. Turner portrayed Richmond Hill like a dreamlike vision inhabited by the Muses – female deities from classical mythology who were said to inspire creativity in poetry, music, history and the arts. Remember the Greek motto above the entrance to the Academy's Great Room, 'Let no Stranger to the Muses enter'? Here Turner

was intimating he was indeed no stranger. The goddesses dance in the foreground of the very riverscape within which he was, at that time, building himself a house.

This, therefore, was the background to Turner's fanciful way of looking at the Thames as though it were a site of antiquity. *Dido and Aeneas* in 1814 was only the first in a sequence of pictures which utilised his earlier river material. Through reference to his 1805 sketchbooks, he revisited his mental musings of make-believe ships in a classical harbour, and spun them into further large historical extravaganzas. In 1815 he painted *Dido Building Carthage; or The Rise of the Carthaginian Empire*, another portentous celebration of Claude Lorrain, integrated with Turner's more naturalistic approach.[17] Few recognised the modest waters of the Thames within the magnificent seaport. But Turner's friend and Thames neighbour Henry Scott Trimmer spotted them, later telling his son that it was Richmond scenery that had inspired the scene.[18]

For Constable, meanwhile, naturalism remained front and centre. The same year as *Dido Building Carthage*, he exhibited two Stour paintings which had evolved directly out of his Suffolk stay the previous year. Unlike Turner's classicising fantasies these were scenes embedded within reality. The first was a distant view of Dedham from the road between Bergholt and Flatford, looking down across the fields with the river meandering past Fen Bridge. Originating as a commission, the painting was later exhibited under the title *The Stour Valley and Dedham Village*.[19] The most astonishing thing about the work is its earthy foreground, dominated by, of all things, a dunghill – a heap of farmyard refuse set to dry by the roadside, before being shovelled into a cart and taken to fertilise the fields. Even for Constable this was a bold level of verisimilitude. It was a very different landscape from what most people would expect from a serious painter – much more radical, for example, than Turner's domesticated classicism. It's one thing to dress up your neighbourhood as though it is a mythological site. It's quite another not to bother to dress it up at all and simply to show it ordure and all. When it came to pursuing veracity, Constable was capable of mulish obstinacy. He had already set himself a difficult furrow to plough with his insistence upon the beauty of such humdrum territory. It would have been a huge ask for most contemporaries to appreciate

the picturesque qualities of an enormous pile of manure, and it is testament to Constable's stubborn commitment that, in spite of the challenge, he remained true to the spirit of his landscape mission.

In Suffolk, Constable had worked upon *The Stour Valley* in the mornings but in the afternoons he had moved to a different position, walking down the valley and setting up his easel directly beside the Stour. He had narrowed down a motif within his sketchbook – the building of a barge in the small boatyard at Flatford – and proceeded to complete the oil in situ. From beginning to end he painted in the open air, timing his daily sessions to fit in with the work patterns of the local labourers. It was a radical departure from precedent. Not only was the subject derived directly from the real world, it was painted entirely *within* the real world. *Boat-Building* was therefore Constable's first solution to the exhibition problem. In an attempt to transpose the visual effectiveness of 'natural painture' into a format fit for public exposure, he cut out the studio altogether and completed an exhibition picture outside on the spot.

Despite their mutual interest in naturalism, Constable's 1815 pictures shared almost no common ground with Turner's whatsoever. In fact, the comparison is almost an exercise in bathos, from the profound to the prosaic, from the universal to the local. In *Dido Building Carthage*, the sunlight is an emotional force, throwing some things into highlights, and casting others into shadow according to their narrative purpose. In *Boat-Building* the sunlight provides no greater effect than the pleasant sight of sparkles on the water. And whilst Turner transports the viewer hundreds of miles and thousands of years away, inspiring meditations upon the meaning of life, Constable takes one no further back than the Suffolk of his childhood. The only empire that occupied his thoughts was the milling and transport business owned by his father; the only fleet he was interested in was the lighters that transported grain; and the only creations, the barges under construction in the dry dock beside the Stour. Whereas Turner implies the inevitability of change, Constable fixes an image of an enduring way of life he hopes never to alter.

Change *was* coming, however. For years, Constable had been marking time – waiting to fulfil his artistic potential, waiting to marry Maria. Gradually, during the long Suffolk summers, the realisation grew that, even whilst he painted the continuity of life beside the

Stour, he was actually witnessing the gradual decline of his parents. Illness and old age were incrementally taking their toll. Each winter there was great anxiety over Golding's health, though in the end it was Ann who passed first. She witnessed her son working on *Boat-Building* in the summer of 1814 but did not live to see it displayed at exhibition, dying after a short illness in March 1815. For Constable, spending as much time as he could in Bergholt, it was clear his father would not be too far behind. In the event, he outlived his wife by just over a year, dying in May 1816.

These were odd and unsettling months, and not just for the Constable family. The country too was experiencing upheaval. Napoleon had escaped from exile in Elba and there was disquiet across the nation. On the Thames in Twickenham, Turner gained a new neighbour, Louis-Philippe, the Duke of Orleans, ousted from France along with other members of the Bourbon dynasty. Britain marched to war and the entire country waited with bated breath. Even whilst he wrote to update his brother about their dying mother, Abram Constable couldn't help but reflect on wider issues, noting, 'These are awful times big with extraordinary matter, indeed all Europe, I may say the world is in an unsettled state, only think of that scoundrel Bonaparte being at *large* again.'[20] At East Bergholt House they had more reason to be anxious than most. Amongst the troops who fought at the Battle of Waterloo in June were two of Ann Constable's nephews. Eventually, alongside the reports of Wellington's victory came the terrible news that their cousin, Captain James Gubbins, was amongst the fatalities. Already in mourning for their mother, Constable and his siblings were 'very much affected'.[21]

There were troubles at home too. Far from ushering in stability, the shift from war to peacetime was characterised by economic downturn and civil unrest. The Tory government's divisive Corn Laws had artificially inflated the price of grain. Whilst intended to be beneficial to farmers and landowners like the Constables, it was a disastrous policy for the working poor, who struggled to buy bread, and had an adverse knock-on effect on manufacturing too. Riots ensued in London and elsewhere. There were fears about revolution and reform; Abram anxiously mentioned the 'mobs'.

Even the weather was topsy-turvy. Shortly after Golding Constable's death, 1816 developed into the 'Year without a Summer'. A massive

volcanic eruption of Mount Tambora in Indonesia had caused severe atmospheric abnormalities across most of the northern hemisphere, and Britain experienced unusually low summer temperatures, heavy rain and even snow. Farmers everywhere despaired, including Abram Constable. Now in charge of the family business, he lamented the worrying impact on the harvest. 'The weather is very unfortunate,' John reported to Maria. 'We cannot get up our hay which is at least a month later than usual, and the corn backward in proportion.'[22] He entreated her to take care of herself amidst 'these horrid, black, cold, raw, easterly winds'.[23] Turner meanwhile was trudging around Yorkshire, in the same conditions. 'Weather miserably wet,' he reported resignedly to his friend Holworthy. 'I shall be web-footed like a drake, except the curled feather.'[24] The splashes on the pages of his sketchbook testify to the sodden conditions.[25] Now the war in Europe had ended, he had entertained hopes of travelling abroad but found himself defeated by the weather. 'Rain, Rain, Rain, day after day,' he complained. 'Italy deluged, Switzerland a wash-pot . . . All chance of getting over the Simplon or any of the passes *now* vanished like the morning mist.'[26] It was the end of an era, but what did the future hold?

Turner, who was always sensitive to the ramifications of current events, produced a follow-up pendant to *Dido Building Carthage*, *The Decline of the Carthaginian Empire*.[27] Exhibited at the Royal Academy in 1817, the painting depicted the sun setting on the ancient city, diminished in its defeat by Rome. A metaphor for the inevitable rise and fall of civilisations, it drew allegorical links to the recent downfall of Napoleon. Turner understood the country was witnessing the conclusion of a chapter in history, but his melancholic painting offered up a warning against hubris. With his innate belief in the ebb and flow of human fate, he avoided bombastic triumphalism and captured instead the national mood of unease and unrest.

Constable, on the other hand, omitted all reference to the state of the nation. He too exhibited paintings born from change, but unlike Turner's act of universal reflection, the only history he was referencing was his own. For so long his heart had been divided between London and Bergholt, but during his parents' decline, the idea had formed of Suffolk as a distinct period, slowly dwindling to a close. With the death of his father, that end was made final. His

siblings moved out of the family home. The property was sold, gently dissolving Constable's domestic ties to the village. Henceforth, East Bergholt life as he had known it would never be the same.

Even as he sensed the transition, Constable sought to negotiate it in paint. During the summer of 1816, he began work on a new canvas – *Flatford Mill ('Scene on a Navigable River')*, his largest open-air scene to date. Executed mostly on the spot, the picture was not only a triumph of naturalism, it was also an intimate portrait of the working life of the river, so accurate the painted details can be read almost like an instruction manual on the mechanics of the Navigation. Constable depicted a moment he would have witnessed hundreds of times: a chained pair of lighters, travelling upstream from Flatford Lock. The horse that has been pulling them along the towpath has stopped, and stands patiently waiting whilst it is unhitched – the slackened tow rope trailing in the water, one barge drifting right, the rear one scissoring left, as they are carried by the momentum of the current. On the foremost vessel, a bargehand pushes a pole against the riverbank, straining to create enough force to propel the 'gang' underneath Flatford Bridge, the timbers of which are just visible in the left-hand corner. And the river is not only powering the economic reality of this part of the world; it also comes across as the life force of Constable's art. The way he painted the little stream to the right is the very definition of 'natural painture': the clarity of the light sparkling on clear water, the freshness of varied greens, the changing colours and tones within the sunlit bank, the rough texture of the wooden posts. Constable seemed to sense he had achieved a vocational breakthrough. By signing the picture with a flowing cursive script, prominently placed in the foreground as though he had scratched it into the dirt with a stick, he drew attention to the realism of the scene but also to his role within it. It was the first time he could truly say he had negotiated the gap between outdoor sketch and exhibitable product.

It has often been suggested that by visualising the river kingdom established by his father, the picture pays symbolic tribute to Golding Constable. The artist is projecting his identity onto the figure of the young rider, as though he is a boy recalling the river of his childhood. Yet in many ways *Flatford Mill* is more an acknowledgement of the durability of place than the passing of an individual. Following

Golding's death, it was John's brother Abram who assumed his father's mantle. He moved into Flatford, visible here in the background, and took over the management of the business on behalf of his brothers and sisters, allotting Constable £400 per annum as his share of the profits. In his safe hands, life on the Stour went on in the same way it always had. The painting makes evident the seamless succession of productivity, unimpeded by the recent change in ownership. Children, like the boy riding the tow horse, were as much a part of its daily rhythm as the adults. They would grow up to take over the reins from their elders, just as Abram had done. *Flatford Mill* does not so much represent the end of an era, therefore, as an affirmation of continuity. People come and go but the Stour remained, continuing to support Constable both artistically and financially. It was the same river from his youth – the mainstay of his existence – even if by this point, he was no longer the same man.

One door closed and another one opened. Thanks to his brother, Constable was now more comfortably off, and by the time he exhibited *Flatford Mill* at the Royal Academy, two major life changes had occurred. The first was that he had got married. After seven long years of waiting, he had finally been able to tie the knot with Maria. The ceremony took place in October 1816, and after honeymooning in Dorset, the newlyweds settled down happily to married life in London. From this point forward Constable's identity became whole and complete. He would intermittently visit the family at Flatford and Dedham but never again would he split his work life between Suffolk and the city.

The second development was a natural consequence of the first. By the spring another event was imminent – Constable was about to become a father. Maria had suffered a miscarriage at the beginning of 1817, but by the time the Exhibition opened in April, she was pregnant again, and on 4 December their first child was born – a boy, baptised John Charles. He was followed in 1819 by a little girl, Maria Louisa (known as Minna), a second boy, Charles Golding (Charley), in 1821, and a second girl, Isabel, in 1822. Eventually there would be seven Constable babies, born between 1817 and 1828.

Fatherhood suited Constable in a way that was never the case for Turner. As a matter of fact, around the same time as Constable became a father, Turner became a grandfather. In 1817, Evelina, now sixteen, married a civil servant, Joseph Dupuis, twelve years

her elder. Like Maria, she went on to have seven children within a similar timeframe (although only four would survive infancy). But, not only did Turner not attend his daughter's wedding, he seems to have been even less involved as a grandparent than he had been as a parent. In all fairness, the Dupuises moved to Kumasi in Africa (part of modern-day Ghana). But there is no indication that Turner played any further part in the life of any of his descendants. He continued to keep his professional identity at arm's length from his personal affairs and his children were no more connected with his fame than if they were strangers.

Constable, by contrast, was the very model of paternal love – involved, affectionate and doting. According to Leslie, his babies might be seen as often in his arms as in those of the nurse or Maria, and when he wasn't cuddling them he was often sketching them – tender, sweet little remembrances of sleeping infants and growing toddlers.[28] He had always associated his art with his childhood, but now in his mind it seems to have become conceptually linked with his offspring. Almost as though they were blessings bestowed upon him by the Stour, he used river endearments as pet names for his loved ones: Maria was his darling 'Fish', and the children were the 'little fishes' or his dear, sweet 'ducks'. And he often referred to his paintings as 'his children'. At the same time as he became a father, Constable came into his own as an artist. Now a breadwinner and role model, he was desperate to make a success of his landscape. To do so, he returned to the idea of the river.

Just as Turner had consolidated his landscape supremacy by establishing himself as *the* painter of the Thames, Constable set about confirming his reputation as an equally monumental painter of the Stour. Though he rejected the Turnerian tendency to turn water into wine (as it were), there was one tactic he emulated. Desperate to improve his visibility at the Academy, Constable followed one aspect of Turner's exhibition practice: he decided to go big. In *Flatford Mill*, he had brought together a number of ingredients: the narrative potential of the workings of river life; painterly handling; largeness of scale. Going forward he resurrected those elements, but now fine-tuned them into a formula that suited his new circumstances and ambitions. As his household grew in size, so did his paintings. Following on from the four-foot width of *Flatford Mill*, Constable

came up with a new kind of exhibition landscape which he called the 'six-footer' – four-foot by six-foot (or thereabouts) canvases, painted in his vernacular, 'natural painture' style. He unveiled the first of these at the Exhibition in 1819. Originally titled *A Scene on the River Stour*, thanks to its grey tow-pony being ferried across the water in a barge it soon became known as *The White Horse* (fig. 15).

One of the most significant works of his entire career, *The White Horse* made a big splash at the Academy. Striking and impactful, the marriage of size and substance proved to be a successful strategy. As Charles Robert Leslie observed, they were simply 'too large to remain unnoticed' attracting 'more attention than anything he had before exhibited'.[29] Most importantly, it gained him the approval of the Academic body. Having striven for so long, and been disappointed on so many previous occasions, it was *The White Horse* which finally tipped the balance in his favour and directly led to his election that November, as an Associate of the Royal Academy. The six-foot format was Constable's answer to the problem of making his landscapes academic. His confirmation as ARA was swift vindication

Fig. 15. Constable, *The White Horse*, 1819, oil on canvas.

TURNER AND CONSTABLE

and henceforth the six-footers became his standard way of pitching for public recognition.

It wasn't that six feet was an unprecedented size for a picture. Oil paintings regularly reached much greater dimensions in width or height. Turner's two pictures at the same Exhibition in 1819 were substantially longer – one eight feet and one ten feet. The novelty lay with the scaling up of the subject matter. It was an unwritten rule that magnitude was commonly associated with grandeur. Anything in the region of six feet and over was more likely to be reserved for imaginative themes, noble subjects or rarefied treatments. Existing Turner 'six-footers', for example, included a Poussinesque biblical history painting; a dramatic sea piece in the tradition of seventeenth-century Dutch maritime art; and *Sun Rising through Vapour*, an imaginative rendering of a fishing scene, with explicit visual references to the Dutch and Flemish traditions.[30] All of these featured a distinctly 'artistic' treatment – Turner's aggrandisement of landscape according to the tenets of European art history. *The White Horse* represented something different. For the first time, an artist was using *extra*-ordinary proportions for the most ordinary of English scenes. What is more, Constable wasn't trying to gild its ordinariness, as Turner was wont to do. He was unmasking beauty *within* the banal, using naturalism to underscore authenticity and truthfulness. He reproduced familiarity along monumental lines, augmenting the homely details without compromising any of his singularity of style.

Just like *Flatford Mill*, the narrative of *The White Horse* is a low-key bit of river life in graphic and believable detail. As improbable as the spectacle of a horse standing in a boat might appear today, in fact it was a regular occurrence peculiar to the Stour Navigation. When the towpaths had been built, they hadn't maintained a single unbroken passage along the canal but instead repeatedly transferred from one bank to the other. From Sudbury to Manningtree, the path switched sides more than thirty times, according to changing land ownership or obstacles in the way. Horses had to be trained to step on and off the barges, and to calmly accept the crossing of the river as part of their daily duties. Had Constable reproduced it on a smaller scale, this Stour custom would probably have appeared mundane and incidental – a charming piece of rustic trivia. Scaled up, however, a horse crossing the Stour took on all the gravitas of

Hannibal crossing the Alps. By supersizing the scene and the setting, Constable automatically elevated the action, investing it with a sense of dignity and grace, worthy of the greatest historical events. He also forced the viewer to look closely at the detail, obliging them to observe the aesthetic qualities of trees, plants, wood and water. It was as if he were suggesting that for true meaning and import, one need look no further than the banks of a rural English river.

Whilst Constable was glorifying one small corner of England, at the same Exhibition Turner was showing *England: Richmond Hill, on the Prince Regent's Birthday*, a painting that sought to encapsulate ideas about the entire nation (fig. 16). A complex and multilayered production, it is almost as though Turner was looking through the opposite end of a telescope from Constable, switching perspective from the close-up intimacy of the Stour to a wide, sweeping panorama of the Thames seen from afar. As in *Thomson's Aeolian Harp*, the view depicted was the same iconic prospect seen from the heights of Richmond Hill, and once again this magnificent viewpoint was the setting for outdoor revelry. Rather than giving it a historical twist, this time Turner brought the view right up to date, albeit with the light-hearted overtones of a Rococo *fête galante* by Watteau. Instead of mythological maidens, the figures disporting themselves in the foreground are Georgian contemporaries in recognisably modern dress. The event too is a plausible, if spurious, one, a picnic in honour of the birthday of the Prince Regent. A little like Constable's *The White Horse*, Turner presents the view as though it is a microcosm of England itself, but whilst Constable's country is underpinned by quiet labour, Turner's is redolent of privilege and prosperity. The river appears in the distance like a spine – the backbone of civilised society – an amalgam of peacetime stability, leisured wealth and patriotic royalism.

At ten feet long, the picture is large – far larger than *The White Horse*: an epic size for an epic view. And it is interesting to query Turner's motivations for producing his largest exhibition oil to date. One incentive that can be discounted is rivalry with Constable. Whilst it would have been quite typical of Turner's competitive nature to try to up the ante on a fellow artist, especially one on the ascendant, it is extremely unlikely that Turner would have known, or cared, what Constable was working on prior to 1819. In the years that followed, Turner would keep more of a weather eye on Constable's progress,

Fig. 16. Turner, *England: Richmond Hill, on the Prince Regent's Birthday*, 1819, oil on canvas.

but at the moment he was still only concerned with more celebrated colleagues – Augustus Wall Callcott, for example, or Thomas Stothard, who had also exhibited a Watteau pastiche in 1817.[31]

The more likely explanation for *Richmond Hill*'s immense size is that whilst Constable was still trying to gain the favour of the Royal Academy, Turner's sights were fixed even higher. Not too many art collectors could house such a vast canvas. As far as his commercial pictures went, Turner tended to prefer a smaller stretcher, three feet by four. Even six feet was bigger than many middle-class customers could easily accommodate in their home. The illustrious patron Turner had in mind, however, would have had no difficulty giving such an impressive landscape house room. What is more, that patron was not very subtly name-checked within the title and subject matter of the work – the Prince Regent. The Richmond landscape was intended as a flattering metaphor about the beneficent blessings of the crown on English society and the arts.

In truth, *Richmond Hill* is as much a halcyon fiction as *The White Horse*. Far from the well-ordered world presented by both painters, 1819 was a year of political and social unrest, culminating in the horror of the Peterloo Massacre, the bloody suppression of a crowd gathered to protest government reform in Manchester. One need

only read Percy Bysshe Shelley's sonnet 'England in 1819' to divine the true state of the nation according to the liberal left. The poem, which opens with 'An old, mad, blind, despised, and dying king' and 'Princes, the dregs of their dull race', contrasts the corpulent greed of those in power with the forlorn existence of the labouring classes 'starved and stabbed in the untilled field'.[32] But whilst Turner's sympathies often appeared to lie with the 'everyman' he also curried favour with his social superiors. This work, with its veneration of the Prince Regent, was the first of a number of paintings deliberately intended to hook the most desirable clientele of all. Sadly for Turner, regal consideration would always elude him. His only royal commission, a painting of the Battle of Trafalgar, was ultimately rejected and no work by him would enter the Royal Collection. From George III through to Victoria, the artist's unique painting style and esoteric subjects (as well as, doubtless, his lowly social beginnings) failed to appeal to any members of the royal family, and unlike many Academicians of equal (or even lesser standing), Turner would never be knighted.

By 1812, Turner had finished building Sandycombe Lodge, his modest two-storey villa in Twickenham. The property served as an occasional retreat from London, as well as a permanent home for his father. If one were to pinpoint Sandycombe's position within the view from *Richmond Hill*, it would be found slightly off centre, immediately beneath the lowermost bough of the tree bearing the Royal Standard. The leafy branch gently curves towards it like a gesturing finger. In later years, when *England: Richmond Hill, on the Prince Regent's Birthday* remained in Turner's possession, dominating the end wall of his gallery like an enormous picture window, he and his father must have taken great delight in pointing out to visitors the situation of their Twickenham bachelor pad.

This blurring of public and private associations is fascinating. Whether or not Turner seriously expected the Prince Regent to buy the work, he was clearly making a statement about the personal meaning of the landscape. It was at Sandycombe that Turner entertained guests and hosted feasts and boating parties by the banks of the Thames. On 7 July 1819, just four days after the Exhibition including *England: Richmond Hill* closed, there was a meeting of the 'Pic-nic-Academical Club', an informal artists' social group. Participants including Turner dined at the

Eel Pie House in Twickenham, before rowing back along the Thames by moonlight. According to Farington 'Everything went off most agreeably' and 'Turner and [Richard] Westmacott were very loquacious in the way back.'[33] The next time the club met, it was hosted by 'Secretary' Turner, at Sandycombe itself.[34] It is a measure of Turner's aspirational ambition that he visualised a royal event in full swing overlooking an elegant landscape within which he himself regularly picnicked. What is more, the Prince Regent's actual birthday was in August but his official birthday was celebrated on 23 April – Shakespeare's birthdate, St George's day and the date Turner claimed as his own arrival in the world. The Thames of his middle years therefore was as close as Turner would come to laying claim to a landscape as one of *his* 'own places'. He tied his identity to the great river like a fixed point of reference, almost as thoroughly as Constable's to the Stour, but as an indication of where he had got to, rather than where he had come from.

Turner was on the Committee of Arrangement for the 1819 Exhibition, although it is not known which rooms he was responsible for hanging. Whether as a result of his decisions or not, *his* paintings, including *England: Richmond Hill*, were installed in the Great Room, but *The White Horse* was not. Consequently it was not possible to directly compare Constable's Stour with Turner's Thames, or indeed his other exhibit, a sea piece, *Entrance of the Meuse: Orange-Merchant on the Bar*.[35] Nonetheless, for the very first time, comparison was happening. Constable told Farington that he had 'heard a good report of his picture in the Exhibition', and he related to Maria it was 'much admired & doing me much credit'.[36] Amongst the positive reviews one writer commended the 'truth of nature'. Another exclaimed, 'What a grasp of every thing beautiful in rural scenery!', and one even likened his approach to the Dutch landscape masters Ruisdael and Hobbema.[37] Perhaps the most telltale marker of his new success was that for the first time, Constable's name was linked in the press with Turner's. Robert Hunt, the art critic of a liberal weekly publication, the *Examiner*, wrote a lengthy and sensitive critique, drawing parallels between the two artists' similarities and differences:

Of a very different style [than *Richmond Hill*], though equally successful of its kind, is Mr CONSTABLE's, who though he also

is still far from pencilling with Nature's precision, gives her more contracted features, such as a wood or a windmill on a river, with more of her aspect. He does not give a sentiment, a soul to the exterior of Nature, as Mr TURNER does; he does not at all exalt the spectator's mind, which Mr TURNER eminently does, but he gives her outward look, her complexion and physical countenance, with more exactness. He has none of the poetry of Nature like Mr TURNER, but he has more of her portraiture. His *Scene on the River Stour* is indeed more approaching to the outward lineament and look of trees, water, boats, &c., than any of our landscape painters.[38]

Constable would surely have disagreed that he didn't impart emotion and 'soul', but he must have been delighted with this assessment of his work as something valuable and distinct. Never before had the art press judged his work worthy as measurable to Turner's, never mind elucidated its qualities in terms of dissimilarity. And by praising the 'portraiture' of Nature – the ability to reveal the true face of the natural world – as something of equal value to Turner's imaginative 'poetry', Hunt was establishing a precedent that would become a critical commonplace. It was the first time the two were thrown into complementary but contrasting roles, but it would certainly not be the last. Finally, he was gaining ground – becoming a viable contender for the title of leading landscapist. A new decade was dawning: one that would witness the rise of John Constable.

CHAPTER 6

FOREIGN FIELDS

ALL RIVERS LEAD to the sea. They flow on until they reach the ocean, their waters changing and broadening, and eventually become part of something bigger as they join the wider world. So it was with the lives of Turner and Constable. The Thames and the Stour remained important in their art, but as a new decade dawned, new pathways opened up. For the first time in years, Europe beckoned and its siren call carried them both onward, extending the thread of their personal and professional narratives, and pulling them into wider contexts during the 1820s. And if there is one thing that illustrates the two artists' histories as a tale of opposites, it is the story of their relationships with Europe. They were like either side of the same coin – a coin which in the post-Napoleonic era was sent spinning. Peace set in motion new opportunities and outcomes, and the pair responded in ways that were by turns predictable and unexpected. One travelled abroad and one stayed at home. One produced European landscapes and one did not. And one had an immediate, significant and long-lasting impact on the direction of French art – although not perhaps the one you might think.

The Thames continued to inspire Turner, but the river was just one of many subjects to which he applied himself. His true love was travel. Whilst the wartime Continent was off-limits he had roamed the length and breadth of Britain – not quite Land's End to John o'Groats, but near enough. Naturally, in the years following the

declaration of peace, he was keen to get back 'on the wing' in Europe. In 1817, he took flight upon his first international trip for fifteen years – a foray to Germany and the Low Countries (present-day Belgium and the Netherlands), including a visit to the battlefield of Waterloo. It was a trip that marked the beginning of an entirely new phase of his life: Turner the European tourist. Without easing up on his domestic journeying, he now factored in near-annual overseas excursions so that most years included an expedition lasting several weeks or months abroad.

Whether one was journeying by sea, river or road, travel in the early nineteenth century was not for the faint-hearted. It required stamina and resilience. There were the perceived perils of substandard accommodation, foreign food and foreign illnesses, not to mention the genuine risk to life and limb in transit. Turner had his fair share of misfortunes. He was 'beset' by bad weather at Calais, 'knocked' out by heat in the South of France and twice stranded in snow amidst the Alps. Along the Rhine he mislaid his 'wallet' of belongings, and he was concerned enough about bandits in Italy to arm himself with a dagger concealed inside an umbrella. The doughty man proved himself equal to all of it. Sometimes in company, but more often as a solo traveller, he successfully planned routes and itineraries, negotiated his way across borders, hired coaches, boats and horses, found lodgings, sustenance and places to paint and to restock artistic equipment, all without proper mastery of any foreign languages. In a relatively short space of time, Turner went from someone who, before the age of forty-two, had only crossed the Channel once, to one of the most widely travelled painters of his generation, and his indefatigable energy and thirst for adventure lasted well into his sixties.

Once again, it is to Turner's sketchbooks that we must turn to recapture the flavour of his European travels. Indeed, of the 280 intact sketchbooks which survive from the artist's studio, around 40 per cent can be assigned to the twenty known tours undertaken in this later phase of his life. The distances involved are staggering. Between 1817 and 1845, Turner covered territory stretching from Copenhagen in the north to Paestum in southern Italy, and from the north-western tip of France to as far east as Vienna. He encountered widely different geographies, from cities and coasts to lakes and

mountains – wonderful landscapes which nourished his inclination for mood and atmosphere. And wherever he went there were rivers – the feature which seemed best to encapsulate the spirit of a country. Particularly during the 1820s and 1830s, he exchanged the Thames for the great waterways of Europe: the cool grandeur of the Rhine; the ancient history of the Tiber; the bustle of everyday life found upon the Seine and Loire; and the picturesque castles and fortresses found along the banks of the Danube, the Meuse and the Moselle.

Travel changes a person. It broadens the mind and alters our perspectives, perhaps for artists more than most. It certainly changed Turner. Already an established master, he could have creditably carried on painting in the same vein, but his European wanderings fundamentally shifted his creative focus. The exposure to sights, sounds and smells so wildly different from those at home was seismic. Every journey resulted in a fresh crop of subjects and a slew of differing pictorial responses, and he even found new ways to refresh familiar themes. All of this brought an aesthetic newness to the second half of his career, tangibly different from what he had been doing before.

One of Turner's most transformative experiences was a tour he undertook of Italy, the country that was considered the artistic equivalent of finishing school. Art was everywhere in Italy and, for scholars of culture, a classical 'Grand Tour' was considered a rite of passage – less a casual indulgence and more an educational imperative. For someone who had made his name by revisiting the classical past, Turner was all but duty bound to go there. He had briefly crossed the Italian border in 1802, dipping a toe into the Aosta Valley, and had it not been for Napoleon, he certainly would have gone back much sooner. As it was, he set out at the end of July 1819, upon a six-month voyage of discovery – to Milan, Venice, Rome, Naples, the Amalfi Coast and finally Florence – a much-delayed odyssey through the country where the past was a physical absolute in the present, and the landscape itself was like an exquisite work of art.

Even more than usual, Turner's itinerary inspired a frenzy of locational sketching. Making up for years lost, or nervous he might never get another opportunity, he seems to have drawn almost continuously – a scrolling scrapbook of views, buildings and people. He made copious notes in galleries, museums, churches and archaeological sites – a bewildering miscellany of sculptures, paintings

and monuments, complete with arcane (to Turner at least) Latin inscriptions. Not a moment can have been wasted. Twenty-three sketchbooks in all were used, roughly one every eight days, the pages crisscrossed and crammed full of information and ideas – far more data than he could reasonably have made use of in a lifetime. Some of it confirmed what he had been schooled to anticipate. Raised on a diet of Italianate landscape, he actively scanned the countryside for echoes of Claude Lorrain, Richard Wilson, Gaspard Poussin and others. But much of Italy was a revelation, not least the light. From Lake Como to the Bay of Naples, Turner had never seen sunlight like this before, golden and buttery. Mere pencil wasn't enough to do it justice. Enthralled and enchanted, he turned to watercolour, trying to capture its essence – the way it heated the blood and dazzled the eyes, bathed the landscape, clarified, intensified, veiled and beguiled. Most of all he stored it in his memory, waiting for the moment when he could unleash it back in the studio.

Great things were anticipated from Turner's Italian tour. The artistic community chattered amongst themselves, speculating about the work that might ensue. Even Constable was intrigued. Nobody knew where the secretive fellow lodged, he gossiped to Farington, but apparently he was 'much occupied in the *Vatican* in drawing Capitals &c, and was very industrious'.[1] Come the spring, the reason for all that Vatican activity was revealed. Like a conquering hero returning from campaign, Turner swept back into the Academy with a large oil loftily titled *Rome, from the Vatican. Raffaelle, Accompanied by La Fornarina, Preparing his Pictures for the Decoration of the Loggia* (fig. 17). Just as the previous year, *England: Richmond Hill* had presented a nationalistic and semi-autobiographical celebration of the River Thames, now the artist offered up a similar-sized panorama of the Tiber, intended as a summation of everything he'd seen and learned in Italy. Completed at speed in the weeks following his homecoming, it was ready in time for the 1820 Exhibition: a tour de force of historical landscape on a grand, resplendent scale.

Rome, from the Vatican is like a fragment of Italy caught on canvas. With a precision to rival even Constable's loving recall of Flatford, Turner recreated the interior of the famous Loggia of Raphael, situated within the Vatican's Apostolic Palace. Courtesy of his sketchbook drawings, he replicated the arcaded corridor

Fig. 17. Turner, *Rome, from the Vatican. Raffaelle, Accompanied by La Fornarina, Preparing his Pictures for the Decoration of the Loggia*, exhibited 1820, oil on canvas.

with painstaking exactitude, from floor tiles to ceiling frescoes, even duplicating the specific decorations from individual pilasters: an impressive feat given that none of his on-the-spot sketches had been labelled according to their locations. Beyond the loggia, the gaze drifts outwards across an equally accurate representation of the city's topography – every tower, dome and rooftop in exactly the right place and proportions, as one would expect from the Royal Academy's Professor of Perspective.

Despite the verisimilitude, *Rome, from the Vatican* is like a dream, a beautiful fantasy where nothing really makes sense: the vertiginous vantage point; the implausible floating table at the front; the anachronistic depiction of Raphael; the statue supposedly come to life (note the empty pedestal on the right where a marble bust of the artist should stand) – the whole effect is disorienting, as though Turner is questioning the very nature of reality. And even as the viewer struggles to make sense of all of this, the eye is drawn to the collection of *objets d'art* strewn across the foreground: paintings, sculptures and architectural plans. Most of these relate to Raphael, but amidst the artefacts one encounters a contemporary palette and brushes, and, of all things, a Turner landscape, improbably propped at the front and inscribed as a view of the 'Casino of Raphael'. The

reference is to a building traditionally believed to have been used by the Renaissance master in the Borghese Gardens.[2] Stylistically reminiscent of Thames works from his own gallery, it is as though Turner has just painted this view of Raphael's studio and then stepped back out of the picture frame.

Today all of this is confusing but its message would have been clearer at the time. During his sojourn in the Eternal City, Turner had been elected as a member of the Roman Academy of St Luke, one of the oldest and most prestigious academies in Europe. His first exhibit back in London was blatantly intended as a kind of pictorial lap of honour from the now double-Academician.[3] As an exercise in drawing parallels – between himself and Raphael, London and Rome, and England and Italy – the composition would have been best understood by his Academic colleagues, people who shared his advanced knowledge of Italian history and culture. The 'picture-within-a-picture' detail is like a footprint, something deliberately left behind as a way to stake his claim upon hallowed artistic territory. It was a gesture of immense self-confidence. By inserting proof of his own genius into such an idealised Italianate image, Turner sought equality with the past and pre-eminence in the present. He was also perhaps turning his face towards the future. European subjects went on to dominate the second half of his career.

Whilst Turner's horizons were widening abroad, Constable's, by contrast, were being condensed – concentrating towards a narrower point of focus according to circumstances at home. It had always been unusual for him to tour for the sake of sightseeing, and he'd never shown much interest in going abroad. But marriage and fatherhood made him even less inclined to leave home. In the summer of 1817, just as Turner was taking off for Europe, Constable was resolutely putting down roots, once and for all transferring his residential allegiance to the capital. He settled in central London, first in Keppel Street, near the British Museum, a time which he later described as his 'five happiest & most interesting years'. 'I got my children and my fame in that house,' he explained, 'neither of which would I exchange with any other man.'[4] Then in 1822 the family moved to Charlotte Street, Joseph Farington's old address, where more fame and more children were to follow. Whilst travel boosted Turner's creativity, it was domestic contentment that nourished Constable's. Just as his

counterpart was striking out in a different – and foreign – direction, Constable doubled down on his credentials as a native landscapist.

These were the years of the Stour six-footers, almost annual compositions between 1819 and 1825, which monumentalised ordinary English scenery and celebrated a settled and sedentary way of life. Capitalising on the success of *The White Horse*, Constable repeated the formula with *Stratford Mill*, a view of anglers beside a riverside paper mill, exhibited in 1820.[5] In the Great Room of the Exhibition, the painting's size may well have dictated a central spot 'on the line', in which case it would almost certainly have been hung on a different wall, but in a corresponding position, to *Rome, from the Vatican*. What the two artists thought of one another's work is unknown but they would have had ample opportunity to compare notes. Once again they were seated together at the king's birthday dinner, just after the closing of the Exhibition. Turner was at the head of the long table, with Constable to his right.[6] Since the artist on Constable's other side was Samuel Lane (deaf and partially mute), it is safe to assume he must have had some conversation at least with Turner – a chance for him to discover more about the other man's recent Italian travels.

The following year, Constable had intended to transfer his allegiance from the Stour to the Thames. Embracing his new identity as a Londoner, he started a painting based upon the recent opening of Waterloo Bridge. He was spending a great deal of time down by the river – so much so that John Fisher deputised his friend to purchase a small rowing boat for him whilst he was there. 'If I had not supposed that your Waterloo would carry you down to Thames frequently,' he wrote, 'I would not have hampered you with the commission.'[7] But it would be a long time before *Waterloo Bridge* came to fruition (see Chapter 9). Constable showed the work in progress to Farington, but the older man considered the change in subject to be a mistake.[8] By 1819, critics had begun to talk about Constable's 'usual style', his 'pleasing works of home scenery', composed of 'the same materials i.e. Water-Mills, Water-Locks, Navigable Canals, and a Flat Cultivated Country'.[9] Farington recommended that Constable, instead of branching out to the Thames, continue along these same lines, repeating the modus operandi of the previous six-footers. Desperate to be accepted as a full Academician – the votes had been accumulating but not in sufficient quantities – Constable heeded his

advice and returned to what was now expected of him: the working life of the Stour. The subsequent composition showed a wagon crossing the mill stream at Flatford. Originally titled *Landscape: Noon*, it would become known to the world as *The Hay Wain* (fig. 18). Ironically, one of the criticisms levelled at it in the press was that the artist should 'vary his treatment of subjects of this kind a little'.[10] Undeterred, Constable produced further river pictures. Over the next few years he painted barges near Flatford Bridge (*A View on the Stour*, 1822), a bargehand opening a lock gate (*The Lock*, 1824) and a barge horse jumping a barrier (*The Leaping Horse*, 1825).

At first sight, nothing could look more English than these rural riverscapes. Stand before a six-footer and you are instantly transported to the Suffolk countryside. And unlike with Turner, it doesn't feel like a dream; you really could be there. Constable built his painted worlds on a granular level, presenting the most trivial things with meticulous care. He revelled in the beauty that hides in plain sight – in ripples of water and in leaves stirred by the breeze, in half-submerged timbers and in mossy, sun-warmed brick. Everything

Fig. 18. Constable, *The Hay Wain*, 1821, oil on canvas.

TURNER AND CONSTABLE

is just so *normal*. The plants are real – weeds and waterside vegetation habitually found growing beside any native pond or stream. His people too are regular folk, not odd-looking figures or legends improbably come to life as Turner was wont to paint.

Such commitment to the commonplace had hitherto held Constable back. On a small scale, the working life of a rural backwater was underwhelming and prosaic. Irrespective of how proficiently it was painted, trying to justify the beauty of a cart to an urban art connoisseur was, on the face of it, an exercise in futility. But paint that cart according to the established principles of Western art, and all of a sudden it was couched in a language that the Academy esteemed. Not only was Constable working on a size to equal that of the Old Masters, he was also actually disguising subtle references to their work within his execution. This was the secret to the success of the six-footers. Whether as a deliberate ploy or not, the scaling up of the Stour prompted Constable to incorporate echoes of epic European precedents – Claudean compositions, Rubenesque motifs and the naturalistic light and colour of the seventeenth-century Dutch School. In place of a classical temple he placed a cottage; instead of a Flemish ferry there was a Stour lighter. His leaping horse owed its monumental solidity to a history of rearing equestrian prototypes, from Uccello through to David. His labourers exert themselves with the physical power of classical heroes, the direct result of years studying musculature in the life class and iconic poses from Old Master prints.[11]

It was a major breakthrough. Constable had made his 'own places' palatable and prestigious. He was no longer just a local artist; he was an intellectual artist of elevated local scenes. He may not have advertised the references quite so blatantly as Turner, but consciously or unconsciously, the connections to the European Old Masters were there, underpinning his work and fortifying his naturalism with academic authority. The result was gains in fame and gravitas, and he also began benefiting from increased notice within the art press. ARAs gained more attention than artists without letters after their name, and ever since *The White Horse*, Constable had become a regular fixture of the reviews (he tended to show the same exhibits from the Summer Exhibition at the British Institution the following January). Critics from the more highbrow papers – the *Examiner* or the *New Monthly Magazine* – liked to bestow praise

in academic terms; that is to say, with reference to the qualitative value of revered precedents. Just as Turner had long been compared to Claude, it became commonplace to sanction Constable's 'truthful', 'fresh' and 'natural' qualities according to the Dutch Old Masters, namely Ruisdael and Hobbema.

A measure of the importance Constable placed upon his six-footers are the accompanying full-size oil sketches he made to assist with the planning and execution of each one. For every large Stour landscape that went to exhibition, the artist made a corresponding six-foot study that never left the studio. Perhaps this fact does not immediately strike the reader as extraordinary? If an artist is creating an important academic picture that he hopes will transform his career prospects why not make a life-size trial run, a bit like a dress rehearsal, to help him do justice to the final production? The answer is that full-scale practice exercises for big oil paintings simply do not exist in the technical history of art. Preparatory material is likely to comprise quick sketches from nature (known in French as *études*), or small painted versions of the concept (an *ésquisse*), designed to guide the evolution of the larger version. There might even be something known as an *ébauche*, a preliminary lay-in on canvas which is intended as the first stage for the composition but sometimes gets left unfinished. To make a large, full-size oil sketch, however, is unheard of: an extreme level of preparation, believed to be virtually unique in the history of painting. It represented an enormous outlay of time, paint, canvas and studio space for something that was never intended to be seen by anyone other than the artist.[12] Indeed, the question as to why Constable made them continues to intrigue art historians to this day.[13]

As ever, Turner becomes an instructive point of comparison. He too made plenty of sketches – the Turner Bequest at Tate Britain is full of oils and watercolours that served a preparatory function of one kind or another – and the reason for their existence is not always clear to us today. There are large oils that appear to have been abandoned in an unfinished state, and others that seem to have been set aside with the intention of returning to them at a later stage. One of Turner's most audacious practices was to take a half-begun work to exhibition and publicly complete it on the walls of the gallery. *Norham Castle, Sunrise* (fig. 39) is probably

an example of a foundational beginning intended for further development in this manner. There are also expressive, gestural studies that seem to encapsulate an experimental freedom; some of his late sea studies fall into this category. But what Turner never did was to paint a full-scale practice run of an exhibition picture. Blessed as he was with confidence and surety of touch, he would have considered such a step an absurdity, a pointless waste of effort and materials. Consider *The Fighting Temeraire* (fig. 38). There is only one known study related to this important work, and whilst it is an equivalent size, the details are extremely rudimentary, with only a passing resemblance to the finished composition.[14] By contrast there are multiple studies associated with the evolution of *The Hay Wain*, including the obligatory full-size study.[15] Less detailed than some of the other six-foot sketches, the trial *Hay Wain* nevertheless represents a compositional template, incorporating all of the main elements evident within the final work. It is not, however, a definitive blueprint. Even within the finished version Constable changed his mind.[16] In the sketch he placed a pony and boy next to the little dog in the foreground. In the actual painting this figurative motif was substituted for a barrel, before being painted out altogether (though shadowy traces known as *pentimenti* are still visible today). This kind of creative vacillation is one explanation (though not the only one) for why the six-foot sketches might exist. Whatever his reasons, they represent one of the most exceptional aspects of Constable's process and reveal a commitment to oil sketching that goes beyond Turner's or any other artist's, before or since.

Mostly on account of the six-footers, the 1820s saw Turner and Constable thrown together on a much more regular basis. Whilst not quite yet up amidst the art-world elite, John Constable, ARA, was significantly more likely to move within the same circles as J.M.W. Turner, RA. For a start they were now geographically closer – Charlotte Street was only a brisk ten minutes' walk from Queen Anne Street. But Constable was also conducting his affairs with a greater seriousness of purpose. Thanks to the move to Charlotte Street he had upgraded his studio space, boasting a new painting room that was 'light – airy – sweet & warm'.[17] He also set up a showroom for receiving potential clients, not unlike Turner's gallery, and employed a studio assistant. In 1824, John Dunthorne's son, Johnny, came to

work for him, doing much the same tasks that William Turner Snr did for Turner: squaring up canvases, setting his palettes, cleaning and varnishing pictures, purchasing pigments, conveying messages, assisting with mounting and framing and so on.[18] All of this equalled a more businesslike approach, in keeping with an artist of his stature. Slowly but surely, Constable began to close the gap in his professional standing, appearing more regularly at exhibition in company with Turner and other Academicians.

A tantalising measure of just how far Constable had risen can be ascertained by an offer extended to him by Martin Colnaghi, a member of a prominent family of art dealers.[19] In July 1821, the summer of *The Hay Wain*, Colnaghi reached out to Constable, asking him to paint a companion piece to one he owned by Turner. Even five years earlier, such an invitation would have been absolutely unthinkable. Nothing further is known about the commission, or why it was (presumably) not completed, but the conceptual link must have been rivers. Given Constable's reputation, the likelihood is that Colnaghi was seeking a large oil of the Stour to pair with a river scene by Turner, probably of the Thames.[20] It's a fascinating moment. Not only does it offer proof that the two artists were now considered equals in the field of modern landscape, but also implicit is the intimation that Turner's work could materially benefit from comparison to Constable's, rather than simply the other way around.

Constable was also beginning to make his presence felt within the Academy, taking a more confident role in the institution's political machinations. Whereas contemporaries including George Jones and Charles Robert Leslie recalled that Turner never let slip anything in praise or denigration of other artists, Constable often gave free rein to his opinions. Despite a supposed aversion to getting 'involved in jarring' and 'mak[ing] one's life uncomfortable', there was a caustic side to his character which he frequently indulged, and during the 1820s he began to try to strengthen his Academy prestige along more partisan lines, gaining supporters, but also making enemies. He called it standing 'on ticklish ground – though that ground is my own'.[21] It wasn't just Turner who received the sharp edge of his tongue. Battle lines of sorts were being drawn with anyone who appeared to him undeserving of the name of landscapist, including many of the premier painters of the day – John Martin, John Glover,

Augustus Wall Callcott – all currently more successful and better known. He detested those artists whose rise he attributed to nepotism – William Daniell and Reinagle, respectively made Academicians ahead of him in 1822 and 1823. A painter he especially deplored was William Collins. Twelve years Constable's junior but – much to his disgust – an Associate five years earlier, Collins transitioned to full Academician within six years, despite being a specialist in scenery that seemed to Constable 'insipid', 'hackneyed' and unrealistic. Although he didn't consider Collins in the same league as Turner, Constable lumped them together for a time, as painters of views he considered unnatural. It was Collins (but possibly also Turner) whom he had in mind when he told Fisher, 'I hear little of Landscape [at the Exhibition in 1821] – and why? The Londoners with all their ingenuity as artists know nothing of the feeling of a country life (the essence of Landscape) – any more than a hackney coach horse knows of pasture.'[22] It was perhaps through publicly airing views like these that Constable fell foul of Turner's temper. In July 1823, he told Fisher he had suffered 'A great row with Turner & Collins'.[23] He seems to have become embroiled in what he called an Academy 'civil war'. 'Collins, & the Sculpture & the portrait painters are for Turner,' he reported, 'but it won't do. He is ruined in art – & he is watchfull & savage.'[24]

Turner's savagery may have been defensive. He was coming under attack from various critical quarters. The bellwether was his European tours, often seen today as dividing the first half of his career from the second. There was before Italy, and there was after, signalling, if not actually effecting, a visual change in his practice. In truth, change may have been creeping in earlier; but put a painting from the 1800s next to one from the 1820s and the chances are there will be a noticeable difference. The later example will be bolder and brighter, the colours richer and more flamboyant, and the complementary contrasts more intense. Above all, there is bound to be a lot of one particular colour – yellow. And not just any yellow but chrome yellow, a gloriously warm and vibrant pigment that incorporated well into both oil and watercolour. Industrially manufactured for artists from 1814 onwards, it was akin to being able to buy a pot of sunshine.[25] Like a window whose shutters have been thrown open to let in the light, yellow streamed into Turner's work. Whether

this was wrought by an Italian epiphany or not, it was the Italian paintings that opened the floodgates, unleashing a golden glow that eventually spread into other subjects. Henceforth, there wasn't a part of his world that might not be touched by a ray of southern sun. It coloured his sight in northern Europe, France and Holland, and even followed him around his expeditions in England.

Turner's proclivity for yellow automatically appeared more exotic when placed in conjunction with Constable's lush greenery. Looking between *Rome, from the Vatican* and *Stratford Mill* in 1820, as an example, would have been an instructive lesson in colour temperature, and perhaps did Constable no harm as a result. His unmistakably English view struck a cooler, fresher chord than the balmy heat of Turner's Italy: a realistic and relieving alternative, like stepping into the shade on a sultry day. By contrast, Turner's 'excessive use' of yellow was mentioned by at least one critic that year who deplored its effect on the walls of the Royal Academy and the way 'it puts everything out of tune that hangs by it'.[26] Preferential murmurings started to emerge. It may even have been Turner to whom Robert Hunt was indirectly referring in his *Examiner* review:

> We shall rouse the jealousy of some professors and of some exclusive devotees of the Old Masters in saying that a *Landscape* [*Stratford Mill*] by Mr Constable has a more exact look of Nature than any picture we have ever seen by an Englishman, and has been equalled by very few of the most boasted foreigners of former days, except in finishing.[27]

It was easy to dismiss Turner's golden colouring as a 'foreign' or alien aberration, especially when compared to the 'natural' colouring of Constable's indigenous landscapes.

Turner was not inclined to be dictated to by the press. He had always been a polarising kind of artist – prone to dividing opinions between reverence and ridicule. But this was only the first instance of criticism against a characteristic that would go on to be one of his most predominant traits: the tip of a very yellow-coloured iceberg. As the years went by, it appeared to many as though Turner was succumbing to the grip of a corrupting influence, analogous to an illness of the body or mind. An obvious example of this arose

TURNER AND CONSTABLE

in 1823 with Turner's second major Italianate landscape oil, *Bay of Baiae, with Apollo and the Sibyl* – a yellow-coloured meditation upon the country's past and present. Whilst some critics described its effects as 'gorgeous', others were suspicious of the 'unnatural' tones.[28] The *British Press* decried the 'glare' and 'meretricious attempt at effect' that made them 'offensive to every man of judgement and good taste'.[29] And when compared to Constable's works – this year represented by *Salisbury Cathedral, from the Bishop's Grounds* and two smaller pictures – the offence was exacerbated. In direct comparison with what it called Constable's 'fresh and powerful transcripts of nature', the *Monthly Magazine* described Turner's 'outrageous' colour and 'visionary absurdities' as 'affectation and refinement run mad'.[30] Even Constable described Turner as 'stark mad – with ability'. He thought the picture seemed painted with 'saffron and indigo'.[31]

As we can see, Constable was not beneath having a cheap dig at Turner's expense. Some of it was sour grapes, stemming from his frustration at constantly being passed over by the Academy. But his comments also betray a tactical willingness to use his contemporary as an object lesson in what *not* to do. If there was critical aversion to bright colours and implausibly fantastical subjects then one way to emphasise his own credibility was by digging in as the opposite camp. By knowingly maintaining his distance from the more con-troversial elements of Turner's art he was strategically enhancing his reputation as a dignified, authentic, home-grown alternative. At the beginning of 1825, he wrote to Fisher, 'My reputation at home among my brother artists [is] dayly gaining ground, & I deeply feel the honour of having found an original style & independent of him who would be Lord over all – I mean Turner – I believe it would be difficult to say that there is a bit of landscape that does not emanate from that source.'[32] That 'original style' was fully in evidence in Constable's latest six-footer, *The Leaping Horse*, whose qualities he catalogued as 'a lovely subject, of the canal kind, lively . . . soothing – calm and exhilarating, fresh – & blowing'.[33] Just as Turner was promoting light as something universal and transforma-tive, Constable was advocating 'freshness' as a form of national health and truth.[34] In the formation of the critical understanding of his style as 'peculiarly English' it is interesting to speculate to what

extent this was self-consciously formulated against Turner's new line in European views, or whether it was unwitting coincidence.[35]

As Constable well knew, Turner that year was exhibiting a large oil, *Harbour of Dieppe*, a painting to which he had appended a French subtitle – *changement de domicile* ('change of address'). Who, or what, was moving from one place to another? Does it refer to the to-ings and fro-ings of the busy harbour scene? Was Turner making a virtue of his own conceptual shift from London to Europe? Or was it the light that had relocated? Whilst there was plenty of journalistic enthusiasm for the work, there was also criticism of its golden colouring, more appropriate for a 'sea port of a southern clime than to one on the northern coast of France' said the *European Magazine*.[36] In his diary for 7 May, lawyer Henry Crabb Robinson bemoaned the 'clothing' of Dieppe in Turner's unlikely 'fairy hues', concluding, 'I can understand why such artists as Constable and Collins are preferred.'[37]

During the years that followed, Turner's perceived chromatic craziness became even more pronounced. In 1826 he exhibited not one but three paintings featuring an unabashed reliance on yellow as the pre-eminent hue. Two were European subjects: one a sunset view of modern Cologne and the other depicting the ancient monuments of the Roman Forum. 'It is impossible there can be a greater contrast of colour than is found between Mr Constable and Mr Turner,' wrote the *British Press*. 'In all,' the paper went on, 'we find the same intolerable yellow hue pervading every thing; whether boats or buildings, water or watermen, houses or horses, all is yellow, yellow, nothing but yellow, violently contrasted with blue . . . we cannot view his works without pain.' The *Literary Gazette* impishly characterised him as swearing fidelity to the 'Yellow Dwarf', an evil Rumpelstiltskin-type figure from a traditional French fairy tale.[38]

Even more difficult for the critics to stomach was when Turner turned his yellow-tinted gaze closer to home. In 1826 and then again in 1827, he returned to familiar territory with pendant views of the Thames, to the west of London. The subject was Mortlake Terrace (fig. 19), an eighteenth-century property on the Surrey side of the river.[39] It may have only been about three miles upstream from Twickenham but this was definitely not the same river he had painted before. Partly because he was now travelling so much, Turner had recently been through his own *changement de domicile*, selling

TURNER AND CONSTABLE

Fig. 19. Turner, *Mortlake Terrace, the Seat of William Moffatt, Esq.; Summer's Evening*, 1827, oil on canvas.

Sandycombe Lodge and moving his father back to Queen Anne Street. Whether this act on some level severed his psychological bond with the area, or whether all his roaming around European rivers had just changed his perspective on his beloved Thames, this portrayal of the river was quite different from that of years ago. His earlier views had brought him closer in line with Constable. The Mortlake paintings flung him entirely in the other direction. Gone was the naturalism of effect and colouring. In its place was the amber glow of Mediterranean climes. In a creative transformation akin to magical realism, Turner glamoured the river into a mirage of gold, complete with light fierce enough to dissolve a solid stone wall, and sloping shadows that carelessly contravened the laws of nature.

Far from being enchanted by the effects, most of the critics declared themselves nauseated. Turner was accused of being afflicted with 'jaundice of the retina' and of making both nature and viewers sick.[40] With distasteful overtones of racism he was accused of spreading

'yellow fever', of being haunted by a 'yellow bonze' and with being a 'cook with a mania for curry'.[41] Stories also began to abound of the negative impact which his xanthous tones had upon other artists. One tale surfaced of Turner having to tone down *Cologne* with 'lamp black' to appease Thomas Lawrence, allegedly dismayed by the dampening effect its aureate glow had on his flanking portraits.[42] Hunt in the *Examiner* stated that the 'flaring yellow' of Turner's 'fine but sometimes mistaken genius . . . has infected many of our Artists'.[43] Even Constable added his two pennyworth. 'Turner never gave me so much pleasure – and so much pain – before,' he told Fisher in 1826. '[He] is too yellow.'[44]

Fortunately for anyone suffering from a case of too much Turnerian yellow, an antidote was on hand: a palliative dose of Constable. His main exhibit for 1826 was *The Cornfield* (fig. 20), an upright landscape of a wooded Suffolk lane which dished up its own serving of yellow – a golden field of wheat ripe for harvesting – but a palatable hue in just the right amount. With its touches of sunlight gilding everything from cow parsley to sheep's bottoms, the painting was widely admired as a 'delightful specimen of genuine English scenery and English atmosphere'.[45] Hunt, in the *Examiner*, lavished praise on its 'sapphire sky and silver clouds, its emerald trees and golden grain, its glittering reflexes of sun-light among the vegetation; in fine, its clear, healthful, and true complexion, neither pale, nor flushed, nor artificial'.[46] He labelled Constable 'not so potent a genius [as Turner]' but one with a faithful, more edifying relationship to his native country.

Of course, Constable would never have dreamed of saturating his landscapes with hues counter to his 'natural painture'. When painting with yellow, in general he preferred more muted pigments: Naples yellow or patent yellow (also confusingly called Turner's yellow but unrelated to the artist).[47] Chrome yellow he deployed sparingly, using it in considered touches, or glazed over or mixed in with other colours, not slathered on as the primary focus.[48] So whilst Turner's colouring was characterised as unhealthy, Constable's was defined as exactly the opposite. Easy to look at and to digest, his English scenery paintings represented wholesome British fare – a therapeutic cure to the spice and saffron served up by Turner. Even Constable himself described *The Cornfield* as 'shaken by a pleasant and healthfull breeze'.[49] He quipped he had applied more 'eye

Fig. 20. Constable, *The Cornfield*, 1826, oil on canvas.

salve' – literally a medical treatment – than he usually 'condescended to give', meaning that he had deliberately made it more palatable for viewers in terms of details and finish.[50]

Whether they dispensed it like medicine or wielded it as a weapon, both artists were acutely aware of the potency of colour, a topic that was gaining traction amongst the scientific community as well as the art world. Just how successfully Constable syndicated green can be judged by looking at George Field's seminal publication, *Chromatography; or a Treatise on Colours and Pigments, and of Their Powers in Painting*, published in 1835. A chemist and colourmaker, Field was well known to both men. In the chapter on greens, he wrote:

The general powers of green, as a colour, associate it with the ideas of vigour and freshness; and it is hence symbolical of youth, the spring of life being analogous to the spring of the year, in which nature is surprisingly diffuse of this colour in all its freshness, luxuriance, and variety; soliciting the eye of taste, and well claiming the attention of the landscape-painter, according to . . . judicious remarks of one of the most eminent of this distinguished class of British artists . . . J. Constable.[51]

Field not only namechecked Constable; he also included an excerpt of the artist's writing as evidentiary proof of the powers of green to instil life and vitality. Compare this to the cautionary note sounded by Field about Turner's favourite colour:

Chrome yellow is a pigment of modern introduction into general use, and of considerable variety, which are mostly *chromates of lead* . . . They are distinguished by the pureness, beauty and brilliancy of their colours, which qualities are great temptations to their use in the hands of the painter . . . In general they do not accord with the modest hues of nature, nor harmonize well with the sober beauty of other colours; hence the opinions of artists vary exceedingly respecting these pigments.[52]

Field does not directly reference Turner here, but he could not have been unaware of the artist's liking for the pigment, or the public vilification received by him as a result.

Acknowledging the criticism he was getting about his colour choices, Turner wrote ruefully to a friend in 1826: 'I must not say yellow, for I have taken it all to my keeping this year, so they say, and so I meant it should be.'[53] Shortly after, he headed off on yet another Continental tour, this time to Normandy, Brittany and the Loire Valley. French subjects were proving immensely popular on the print market and he was off to fill more sketchbooks with potential ideas. Constable, meanwhile, continued to cultivate an identity based upon Englishness. Indeed he became almost reactionary in his insistence upon the moral value of English scenery. In a letter to Fisher he sermonised:

I have a kingdom of my own both fertile & populous – My landscape and my children . . . Am I doomed never to see the living scenes – which inspired the landscape of Wilson & Claude Lorraine? No! but I was born to paint a happier land, my own dear England – and when I forsake that, or cease to love my country – may I as Wordsworth says 'never more, hear Her green leaves russel / Or her torrents roar'.[54]

The artist who openly admired the Dutch for being a 'stay-at-home people' became the most insular and 'stay-at-home' of painters. He never left the country – not once in his entire life. All the same, no man is an island, not even John Constable. Not even the emotional undertow of the Stour could hold him in one place forever and whilst he refused to go to Europe, Europe, in the first instance, came to him. From 1821, a new cast of characters began to enter his world, French ambassadors to the English kingdom he had created.

In the years following the Napoleonic Wars, tourism between France and the United Kingdom flourished. Not only did thousands of British travellers, like Turner, head across the Channel, but French visitors too flocked to England. Milling amongst the crowds for the 1821 Exhibition were a number of French luminaries keen to experience English culture. For the first time in sixteen years, Turner did not actually have anything on display but there were plenty of other interesting things to see. Collins and Callcott were both exhibiting landscapes, Thomas Lawrence (now the Academy's president) was represented by several portraits and the critics paid much attention to paintings by William Etty and William Hilton.[55] But amongst the almost 900 paintings on show that year, the picture that made the biggest impression on them was *Landscape: Noon*, aka Constable's *The Hay Wain*.

Chief amongst the influx of Gallic admirers was Théodore Géricault, the superstar of modern French painting. The special guest of the Academy that year, Géricault was in town following the recent showcasing of his sensational shipwreck painting, *The Raft of the Medusa*, a blockbuster disaster movie of a picture that had thrilled 40,000 Londoners with its monumental size and gruesome, real-life theme.[56] Huge and nightmarish, its portrayal of dead and dying victims made even Turner's maritime disasters look

understated. (Inspired by Géricault's example, Turner would later upscale the size and morbidity of his own shipwreck scenes, starting with a royal commission, *The Battle of Trafalgar* of 1822, and leading up to *The Slave Ship* of 1840.) Géricault's admiration for Constable's work was a most unexpected meeting of worlds. Aside from the fact that more than fourteen *Hay Wains* could fit into the square footage of the vast *Medusa*, tranquil Flatford – a place where it's hard to imagine anything bad happening – looks a million miles away from the hideous tragedy of Géricault's raft.

As far as the British were concerned, *The Hay Wain* wasn't initially considered an especially noteworthy painting – at least nowhere near in proportion to its later fame. It had been placed in the smaller and less prestigious 'School of Painting', not the Great Room, and the reception it received was decidedly mixed. On the one hand, viewers continued to approve of the artist's freshness, naturalistic colouring and realistic elements. Fisher wrote that he was looking forward to seeing it back in Constable's studio, away from the crowds, for 'how can one participate in a scene of fresh water & deep noon day shade in the crowded copal atmosphere of the Exhibition: which is always to me like a great pot of boiling varnish'.[57] On the other hand, a lot of the newspapers homed in on a similar criticism – the 'spottiness' of Constable's brushwork. To aid his depiction of freshness and sparkle, the artist had employed numerous flicks and dabs of white paint across the canvas and the press expressed confused disapproval about this physical 'affectation'. 'A little too spotty,' moaned one reviewer.[58] There are 'scattered and glittering lights that pervade every part', wrote another.[59] Most insulting of all was *Bell's Weekly Messenger*: 'Why the excess of piebald scambling [sic] in the finishing,' they sneered, 'as if a plasterer had been at work where the picture hung, and it had received the spirits of his brush?'[60]

Whilst the British press was unable to accept Constable's maculate brushstrokes for the metaphor they were meant to be, it was precisely these effects which impressed Géricault and his compatriots. They *were* able to make sense of the more painterly elements, which they recognised from their own tradition of *plein air* sketching, but which they had never before seen in such a large finished piece. The idea that the spontaneous qualities of a sketch might be unashamedly incorporated into an exhibition picture was revelatory. Compared

to the smooth uniformity prevalent in French academic painting, Constable's individualistic handling looked original and unaffected, tantamount to a new freedom of expression. The author Charles Nodier expressed it best. Like Géricault, he thought *The Hay Wain* the finest picture in the Exhibition. 'Near, it is only broad daubings of ill-laid colours,' he wrote, 'which offend the touch as well as the sight, they are so coarse and uneven. At the distance of a few steps it is a picturesque country, a rustic dwelling, a low river whose little waves foam over the pebbles, a cart crossing a ford: It is water, air and sky; it is Ruysdael, Wouvermans, or Constable.'[61] It was as if the artist had managed to trap nature itself within the paint.

Much to Constable's surprise, the French reaction to his work slowly snowballed. The following year, a Parisian art dealer called John Arrowsmith (French, despite his Anglo-sounding name) sought him out, and offered to buy *The Hay Wain* as a first foothold for establishing a reputation abroad. He opened negotiations at £70, a price which was less than half of what Constable was hoping for. Stubbornly refusing to be 'knocked down by a Frenchman', he declined.[62] Two years later, with the painting still on his hands, and desperately in need of money, he was rather inclined to reconsider. He finally let Arrowsmith have the painting for £250, along with another six-footer, *View on the Stour near Dedham*, and a sea piece of *Yarmouth Jetty* thrown into the bargain. The works were shipped to Arrowsmith's gallery in Paris and the owner duly reported back that 'no objects of art had ever been more highly praised'.[63] French landscapes at this time tended to be highly formulaic, according to the principles codified by Italian art. What impressed French viewers the most was an artist authentically painting his own world without recourse to trite or artificial idealism. Constable was amused by the thought of his work 'melting the stony hearts of the French painters. Think of the lovely valleys [and] the peacefull farm houses of Suffolk, forming a scene of exhibition to amuse the gay & frivolous Parisians.'[64]

The arrival of *The Hay Wain* in 1824 was like a pebble dropping into a Parisian millpond. The effect was immediate, and rippled through modern French circles with the energy of a shockwave, gathering momentum and turning the artist into something of a cultural phenomenon. In what was described as a 'succès de scandale',

'stony' artistic hearts melted all over the city, alarming the nationalistic journalists who were witnessing the effect. According to reports passed to Constable by friends, the French critics were 'very angry' that French artists might be lured away from the native, neoclassical style of Poussin, David and other greats, in favour of the seductive 'English' look: those rich and true natural effects in which *The Hay Wain* excelled.[65]

At the epicentre of the Constable-quake was another influential figure in the French Romantic movement, Géricault's friend Eugène Delacroix. So inspired was Delacroix by the new aesthetic of *The Hay Wain* that he allegedly went back to his studio and that very night repainted background sections of his current work, *The Massacre at Chios*. One might look in vain for tangible proof of the connection between Constable's verdant scene of calm contentment and the graphic bleakness of Delacroix's large scene of slaughter but the enormity of the encounter was undeniable. It was the handling and colouring that interested the French painter. He wrote in his journal for 19 June 1824: 'Saw the Constables. It was too much for one day. This Constable has done me a power of good.'[66] Years later he would talk more fulsomely about the superiority of the greens. 'The dullness in the green in the verdure painted by other landscape painters is that they tend to use a single tint,' he wrote.[67] The multitude of pigments used in place of a single colour was a lesson that he said applied to all tones. Once again, it is not easy to see that precept in evidence within *The Massacre at Chios*, which is an arid-looking landscape, almost entirely lacking in greens of any description. But if Delacroix was talking about it, others were sure to be listening. His admiration for the Englishman's work went a long way to raising Constable's profile amongst French artists. A few weeks later, it was these two pictures which received the greatest share of the honours at the largest and most prestigious art event in Europe, the exhibition of the Académie des Beaux-Arts, better known as the Salon.

As a celebration of artistic achievement, the Salon was the nominal equivalent of the Royal Academy's Exhibition, but it rather stood in a league of its own; if a sporting metaphor is helpful, it possessed a unique kind of cachet, similar to the modern Olympics. State-run annually, biennially or even more sporadically, it was held in the

grand rooms of the Louvre and dominated opinion and taste in France to a greater extent even than the Academy in Britain.

Constable was embraced at the Salon in a way that had never happened to him at home. 'Look at these English pictures,' visitors were heard to exclaim: 'the very dew is upon the ground!'[68] His six-footers were moved to positions of prominence and Monsieur Constable, 'Peintre de Paysage', was awarded a gold medal of excellence. It was all vindication of his continuing struggles with the Academy and the critics at home. 'English boobies, who dare not trust their own eyes, will discover your merits when they find you admired at Paris,' intuited John Fisher.[69] 'It makes me smile to myself when I think of plain English John Constable who does not know a word of language being the talk & admiration of the French! That he should owe his popularity & his success to Paris!'[70] Constable reported he had 'set all the students in landscape thinking – they say on going to begin a landscape, Oh! This shall be – *a la Constable!!!*'[71] More French exhibitions followed, in Lille (including another gold medal), Douai and the Salon again in 1827, where there was indeed a decided vogue for French landscapes 'à la Constable' – lots of rustic cottages, wagons in ponds and open fields and skies.

In light of his French success, Constable's continued determination not to travel abroad seems nothing short of bloody-minded. Regardless that he was the toast of Paris, irrespective of an offer of accommodation from Arrowsmith, in spite of Fisher offering to accompany him, and even despite the fact his gold medal was to be presented at the Salon by King Charles X, he still adamantly refused to go to France. He was thrilled with the medal, which was 'handsome' and handed over to him in a 'handsome manner' by the French ambassador in London.[72] But he was resolved never to leave England. 'I hope not to go to Paris as long as I live,' he wrote stubbornly.[73] 'I would rather be a poor man here than a rich man abroad.'[74] Careful what you wish for, we might warn him in hindsight. All of a sudden, as quickly and unexpectedly as it had come, Constable's moment of French fame passed. By the end of 1825, he had fallen out with Arrowsmith. And when the French art market, like the British one during the mid-1820s, was hard hit by financial crashes, Arrowsmith and another of Constable's dealers, Claude Schroth, went out of business. Constable's commercial conduit dried

up. He had sold more landscapes in a short space of time than had been purchased by British buyers in years, but now *The Cornfield* was sent back in 1827 from the Louvre unsold.

Constable hadn't been the only successful British painter at the 1824 Salon. In fact, so many of his countrymen were exhibiting that year that it became informally known as the 'Salon des Anglais' ('British Salon'): rather a coup for the national contingent – David Wilkie, William Etty, Copley Fielding and the young Richard Parkes Bonington (British born, though a French resident since 1817). The latter two were, like Constable, awarded medals. Sir Thomas Lawrence, meanwhile, was made a Chevalier of the Légion d'Honneur. British literary and historical subjects were experiencing a vogue amongst French painters and there was widespread approval of the so-called 'British style' in landscape. If only Constable had been more receptive to travel. Perhaps if he had conducted a little in-person networking himself, instead of giving in to xenophobic prejudices, he might have extended his celebrity a little longer. Delacroix, for one, was eager to make his acquaintance. But whilst the French painter came to London in 1825 and met up with Bonington, it seems very unlikely the desired meeting with Constable ever came to pass. It is impossible to imagine Turner squandering an opportunity to capitalise on such an important relationship. In fact, Turner troubled to seek out Delacroix in Paris in either 1829 or 1832. The urbane and dandified Frenchman was not overly impressed with the older artist's appearance. Constable he described as an 'admirable man . . . one of the glories of England'.[75] He recorded Turner as looking 'like an English farmer with his rough black coat and heavy boots, and his cold, hard expression', though he later twinned him with Constable as a 'true reformer' of landscape painting.[76]

Ironically, of all the artists flying the flag for the British School in Paris, the most conspicuous absence *was* Turner. Despite the European outlook of so much of his work – his enthusiasm for Continental landscape and the way his work engaged with and reinforced the pre-eminence of European history and culture – he was never represented at the Salon. He was even *in* northern France in the late summer of 1824 as part of a tour of the Meuse and Mosel rivers. Yet no work of his graced the walls of the 'British Salon'. Why not? It is an anomaly, not easy to explain. French acknowledgement that

TURNER AND CONSTABLE

the English were doing landscape really rather well was becoming widespread, but they were eager to see that excellence extended to their own territories. Stendhal, for example, described Constable 'as true as a mirror; but I would prefer that the mirror were placed [in] front of some spectacular view, like the entry to the valley of the Grande Chartreuse near Grenoble, and not merely in front of a hay cart fording the waters of some sleepy canal'.[77] As the premier British artist responsible for exactly those grander kinds of views, and more besides, Turner might reasonably have been expected to have a significant presence abroad.

Oddly, however, Turner rarely exhibited outside his own country. There were only two occasions in his lifetime when his paintings were seen in European destinations and both times he probably wished he hadn't bothered. The first was a solo exhibition in Rome in 1828 when the resident reaction to a recent batch of Italian-themed paintings was at best incredulous, and at worst vitriolic. A cartoon circulating at the time sums up the worst of it.[78] The details are very crude – a defecating dog maintains he is a painter, the naked figure of Britannia trumpets the name of 'Turner' from her bottom, and the Roman goddess Minerva rejoins 'O charlatan, excrement is not art'. The second occasion was in Munich in 1845. Turner was the only British artist represented at an exhibition called the 'Congress of European Art'. Again, his painting – a German subject titled *The Opening of the Walhalla* – horrified the locals. The Germans were appalled by the loose handling and lack of form and regrettably interpreted it as a satire upon their country. To add injury to insult, the picture (on panel, rather than canvas) was returned to Turner damaged, with additional carriage costs to pay. He apparently fussed over it 'like a hen in a fury'.[79]

There is therefore an interesting paradox in Turner's relationship with Europe. Despite his extensive travels and the European nature of his outlook, his painting had limited appeal abroad during his lifetime. Just at the very time when British art was marking a peak of influence on the Continent, it was Constable who was the more prominent of the two. His in absentia provincialism sent a breath of fresh air into the stale halls of the French Salon and his simple English farmer's cart ultimately went on to pave the way for the modern European avant-garde. To this day, it remains one of the more unlikely developments in Western art history.

SEA AND SKY:
NEW HORIZONS

THE HIGHER CONSTABLE rose, the closer it brought him to Turner. Up until now, the pair had remained largely independent of one another: Turner doing his own thing; Constable doing the opposite and trying to carve out some autonomy as a result. They had very few places in common (Salisbury, the Lake District, Weymouth), and almost no occasions when they had treated the same subjects at the same time. By the mid- to late 1820s, this situation had begun to change. For over two decades, Turner had cultivated mastery of all aspects of landscape and a willingness to go head to head with any major painters, be they British or European, living or dead. As soon as Constable successfully started carving a niche that extended the genre's range beyond his own all-encompassing efforts, it was only a matter of time before he staged a response. Sometimes consciously, sometimes unwittingly, the two artists gradually began to impinge upon each other's territories, and in tackling subject matter that drew them directly into one another's path, it was inevitable they would eventually start treading on one another's toes.

From Constable's perspective, there were signs it was time for a change. Whilst no one ever quite knew what Turner was going to do next, Constable had made his mark as the man who painted rural freshness. Novelty, however, was beginning to border on routine. The critics had begun to anticipate the reliability of his 'peculiar and natural' style as a foregone conclusion.[1] He is 'always pleasant',

wrote the *Literary Chronicle*.[2] By the time of *The Lock* and *The Leaping Horse*, there was talk of 'capital examples' and 'charming specimens'; commentators were confident they could now identify all the 'usual' hallmarks that 'generally' characterised his work.[3] Some of this began to mount up into comments concerning lack of variety. 'There is little in the present performance to mark it from other of Mr Constable's works,' wrote the *Literary Gazette*.[4] He is 'wearisome', concurred the *London Magazine*. 'He seems to have a peculiar affection for the dullest of subjects, and to be unable to quit them.'[5] Even loyal John Fisher tentatively suggested that a little variation wouldn't go amiss. '[James] Thomson you know wrote, not four Summers but *four Seasons*,' he advised. 'People are tired of mutton on top mutton at bottom mutton at the side dishes, though of the best flavour & smallest size.'[6] What is more, as strong as this tried-and-tested formula was, it was still failing to push Constable over the finish line towards full Academic status. French dealers and gold medals were all very well, but they were hollow victories whilst the one thing he really wanted eluded him. With each passing Exhibition season, he remained an Associate, and with each disappointment, his anxiety grew and festered.

Europe, of course, was out of the question, as was any travel for the sake of it. Nevertheless, in his own small way, Constable started to branch out. Prompted by domestic circumstances, a new set of locales began to insinuate themselves within his private life and eventually found their way into his work. Not unlike the effect of Turner's European travels, this refresh broadened Constable's artistic horizons. Literally. His gaze widened – upwards to the skies and outwards to the sea – bringing different flavours and ideas to his practice. It was not always a comfortable experience. So rarely had he strayed beyond his limited repertoire that the profile of these alternative places was sometimes as alien to him as that of any foreign country. But Constable's commitment to empirical exploration was still alive and evolving, and venturing into pastures new helped him to attain deeper insights into the theory and practice of his art. It also brought him into closer alignment with Turner, an artist who had long included the study of seas and skies as part of his signature style.

Pre-eminent amongst the new places in Constable's life was Hampstead. He may have reconciled himself to city living from a

work point of view, but there were conflicting pressures with his home life. Whilst his family brought him great joy, it also added huge anxiety, impacting upon his artistic life. There were the constant low-level anxieties and frustrations any parent can identify with – concerns about earning enough money, and providing for education and welfare – besides which, the sheer fact of having small children around materially affected Constable's ability to work. His offspring were often underfoot, noisy and disruptive, particularly the older boys (their father half-wished he could turn them all into girls). On one occasion they got hold of a broom handle and put a big hole through a canvas. On another they lit a fire in the courtyard at the back of the house and when Constable came out to investigate they drenched him with water. These were not ideal conditions for painting and Constable described them wryly as being like 'bottled wasps on a southern wall'.[7]

More worryingly, the children were often unwell, sometimes seriously so with ailments like whooping cough, scarlet fever and influenza. The eldest, John Charles, was a fragile tot and his recurrent illnesses caused his parents no end of anxiety. Constable's wife too was far from robust. As we know from Turner's poor little sister, the capital could be a deeply unhealthy environment for vulnerable individuals. In any case, Constable had been raised on fresh country air. It was not a surprise he wanted the same for his own brood. In 1819, and then again in subsequent summers throughout the 1820s, he sought rented accommodation outside the city in Hampstead. At this time a pleasant village, situated on heights beside heathland in the northern outskirts of London, Hampstead offered a cleaner, greener environment, much more like the countryside of Suffolk. It became the family's regular out-of-town retreat – what Constable referred to as a 'movable camp'.[8] He kept his London base for work purposes but travelled back and forth as the occasion demanded. Three miles door-to-door, it was convenient but scenic, enabling him for the first time to adequately 'unite a town & country life'.[9]

Although he hadn't migrated to Hampstead specifically to sketch, the fact that he was there for personal reasons seems to have given Constable the opening he needed to connect. With its combination of trees, water, earth and open sky, it was a more familiar kind of landscape to him than the 'brick walls and dirty streets' of the

city,[10] and just as he had previously done in Suffolk, he took his oils outside. Most of the time he looked at subjects near to his front doorstep. Judges Walk was a favourite – a tree-lined path in easy reach of some of the first addresses he rented. Another was Branch Hill pond, a spring-fed pond in a sandy declivity, with a house that looked like a 'Salt box', and a vista stretching north-west across to Harrow.[11] Above all, he loved the half-wild, half-tamed open spaces of the heath. Here he saw quiet moments of everyday life: men digging, livestock grazing and people quietly strolling or going about their business. But the real action was up high. Increasingly Constable directed his gaze upwards, excited by the ever-changing cyclorama taking place above the horizon.

Even at this mature stage in his career, Constable still considered himself to be a student of nature. In Hampstead, he set out to conquer the element of his trade that he had long found the most challenging – the sky. *Only* the sky. Often without reference to buildings, land or even a treeline, Constable embarked upon an extraordinarily focused and intensive form of looking. On at least a hundred separate occasions during 1821 and 1822, he raised his eyes to the skies and captured a painted window of whatever it was he found there. He called this research 'skying', and it was all about specificity: observing, and making sense of what he was looking at. No use doing it on flat grey days, or days of unrelenting blue with not a breath of wind. 'Skying' relied on tangibly distinct features. Clouds were the thing; clouds in all their different formations. From his background in milling and farming he already understood that clouds were not indeterminate and random occurrences. They were phenomena that took shape according to variables in atmospheric conditions. The way they looked had meaning. If he could only intuit the visual patterns, he could read (and by extension, master) the language of the skies. 'That Landscape painter who does not make his skies a very material part of his composition – neglects to avail himself of one of his greatest aids,' he wrote. 'It will be difficult to name a class of Landscape', he went on, 'in which the sky is not the "key note", the *standard of "Scale"*, and the chief *"Organ of sentiment"*.'[12] Intensively studying the skies of Hampstead helped him to hone his skills in this area and recalibrate his landscapes all over. He even overhauled some of his existing Suffolk skies. Following its first

exhibition *The Hay Wain* was allegedly retouched in the studio, with improvements in the billowing clouds and attendant light effects.[13]

Skying was an intellectual exercise as well as an artistic one. There was more to it than simply painting a few oil sketches out of doors. Rather, it represented an integrated 'deep dive' into the topic: *looking* with a view to a profound *understanding*. One way to understand it is to consider it in terms of 'natural philosophy', the pre-nineteenth-century terminology for the empirical study of the natural sciences. It required the same observational rigour. What is more, Constable supported his studies with a background reading list of supporting reference material. One such publication was Alexander Cozens's *A New Method of Assisting the Invention in the Composition of Landscape* (c.1785). This well-known drawing manual offered a simplified 'how-to' guide to creating visually interesting but authentic landscapes, including a designated section concerning skies. Cozens had systematised skies into simplified outlines, and Constable made pencil copies of the etched illustrations, noting the graphic patterning of clouds and the varying distribution of light or darkness therein.

Constable also immersed himself in recent developments in meteorology, familiarising himself with scientific texts such as Thomas Forster's book *Researches about Atmospheric Phenomena* (1813). There has been much discussion about whether he also knew the Latin nomenclature for clouds– cumulus, stratus and cirrus – introduced by the 'father of meteorology' Luke Howard in 1803.[14] In a sense it is a moot point. Even if Constable didn't know these descriptive terms, he understood the overlap between observation and knowledge, and had arrived at a similar level of understanding through his own surveillance. He often accompanied his Hampstead sketches with written descriptions of the conditions under which they had been observed. Consequently they are essays in four dimensions. His clouds have structure and volume, and emerge out of the sky as definite masses of time and space. The 'large climbing clouds' he observed on a 'very hot' morning with a westerly wind on 1 August 1822 may not formally be described as 'cumulus' but there can be no doubt that is exactly what they are (fig. 21): puffy, cauliflower-like heaps of water vapour that build on bright, sunny days, and which may herald a sudden summer shower.

Fig. 21. Constable, *Cloud Study*, 1822, oil on paper laid on canvas.

Unhappily, dark clouds had recently begun to gather in Constable's personal skies: his wife was seriously unwell. Like her mother and her siblings before her, she had begun to show signs of consumption, a condition also known as 'phthisis', 'the white plague' and, eventually, tuberculosis. The scourge of the pre-antibiotic world, this cruel illness was the cause of one in four deaths in Europe during the nineteenth century. There was no known cure. Patients might appear to recover, only to relapse at a later date. Symptoms included fever, chills, night sweats, chest pain, loss of appetite, weight loss and fatigue. Most typically of all, it affected the lungs. There was a persistent wracking cough that caused the sufferer to expectorate mucus or even, alarmingly, blood. It was a terrible and tortuous reality. Within this context, Constable's preoccupation with fresh, clean air became loaded with weightier connotations. He had always prized freshness as a key objective of 'natural painture' but now it began to assume a significance tinged with desperation. Viewed alongside the knowledge of Maria's breathing difficulties, the Hampstead sketches seem to take on a near-obsessive urgency with the elemental quality of oxygen. Brushstrokes flicker across the surface in ways that stir up a sense of life and movement, almost as if the pigment itself were animated by little gusts and breezes of wind. Time and again, sweeping areas of brightness war with swelling dark masses – of cloud,

trees or shadow: a fragile balance preserved by the structure of the composition. It is as though the artist were managing his fears through paint, keeping the darkness at bay with the curative power of good, clean air. Constable's ambition was nothing less than trying to paint his wife well. If only he could breathe health into Maria in the way that he could breathe life into a sketch.

As one of those fascinating comparative exercises which teach us so much about each artist and their mutual frames of reference, it is enlightening to consider Constable's Hampstead sky studies in the context of some near-contemporaneous ones by Turner. Turner would not have disagreed with Constable's premise that the sky played a key role in the emotive power of a view. Most likely he would have laboured the point further. Whether serene, scintillating, sinister or downright scary, Turner's skies tend to be exaggerated, overtly matching the scenery or subject below. He did not require reference material in order to insert a given effect into a composition; he was more than capable of making it up. But when he wanted, Turner could be as meticulous an eyewitness as Constable. For reasons that become immediately obvious, a pertinent comparison to the latter's 'skying' is the *Skies* sketchbook, a bound book containing more than sixty watercolour studies of skies under varying weathers and at different times of day (fig. 22). Like most of Turner's private working material, the book is undated and its geographic locations unspecified (Constable's helpful habit of noting place, time and date is one that later cataloguers might heartily wish Turner had also adopted). However, it is believed to have been in use from around 1817 to 1819 – that is to say, the years immediately preceding Constable's Hampstead sketches.[15]

The timing is particularly interesting, coinciding as it does with a period of unprecedented climatic disruption. In the two or three years or so following the aforementioned eruption of Mount Tambora in 1815 and the ensuing 'Year without a Summer' of 1816, the weather remained unsettled. The dissipating cloud of volcanic dust and ash resulted in atmospheric anomalies, distinctive solar diffusions and abnormally intense and colourful sunsets. These manifestations galvanised Turner's observations in the *Skies* sketchbook. Attuned as he was to subtle changes in colour and aerial constituents, his sketches address an influx of unprecedented

Fig. 22. Turner, *Skies* sketchbook, D12467, CLVIII 19, watercolour on paper.

visual stimuli. One sheet appears to show a distinctive halo around the sun, known as a 'bishop's ring', a phenomenon not documented and named until the later nineteenth century.[16]

Ergo, Constable was not the only painter with a sideline in scientific engagement. Turner too had a scientist's instincts for recording and describing natural phenomena. If anything, however, his inquisitiveness was even more acute. Notwithstanding his limited schooling, he had a magpie-like intellect and science was just another line of enquiry. One way to judge the scope of his interests is to scan the list of his personal possessions. Turner seems to have been interested in *everything*. He owned three telescopes, a pair of table globes and a veritable library of scientific books: a bibliographic reflection of that 'wonderful range of mind' Constable had formerly noted.[17] Amongst the titles were Newton's *Opticks* and Macquer's *Elements of the Theory and Practice of Chemistry*, as well as publications on mathematics, colour theory, geology, physics and architecture. He also associated with members of the scientific community. If we know a man by the company he keeps, Turner knew some of the great minds of the period – Humphry Davy, Mary Somerville, Michael Faraday (the latter also known to Constable).[18] These giants of early nineteenth-century science were engaged in measuring, classifying and interpreting the forces and

energies that shape the world. Their research held immense value to an artist like Turner, fascinated as he was by change and the thoughtful evaluation of man's relationship with nature. It is not clear to what extent he understood that the cause of effects he painted in the *Skies* sketchbook was volcanic activity half a world away. But again, in a sense it doesn't matter. What his sky studies share with Constable's is their intellectual curiosity, their sensitivity to the changing face of nature and an unparalleled ability to chart what was observable.

How the artists chose to deploy what they witnessed was a matter for individual interpretation. Horizontally oriented, with a wide panoramic format and long, low sight-lines, Turner's *Skies* studies have a very different feel from Constable's skylight-like apertures. They are exquisitely vaporous, with an airy, insubstantial quality. Thanks to the use of blurry wash, the specifics of wind, rain, sun and cloud are brushed in with tremendous feeling and spirit; the speed, direction and liquidity of his handling perfectly lends itself to the singularity of the conditions. Yet like Constable's oils, they combine artistry *and* accuracy. Although we are never in any doubt that these are fabrications of watercolour, there is no question that they are based upon direct observation. There is nothing contrived about them. Every page contains a truthful moment. Whilst they might be trickier to describe with meteorological certainty, they are redolent of effects familiar from our own life experiences. And whilst Constable's skies are so precise as to be utterly of the moment, Turner's are unique enough to become entirely universal.

Some of Turner's most convincing skies can be found within the work he did for the commercial trade in topographical views. As the premier landscape and watercolour specialist of the day, he was routinely sought out to provide scenic illustrations that were then engraved and marketed under the profit-making umbrella of the 'Picturesque'. *A Picturesque Tour of* . . . or *Picturesque Views in* or *of* . . ., or some such variation along those lines, was a classic titular starter to a host of nineteenth-century initiatives, and dozens of them featured Turner, as either the solo or headline artist for a series. Some were even instigated by him. Often thematically connected – be it by a county, a country or some other geographical or historical hook – suitable subjects were anything which conformed to the scenic principles of the theory: namely variety, ruggedness, intricacy and naturalness. These

were the kinds of forms and features typically found within rolling hills and valleys, meandering rivers, shady woods, temperate weather, crumbling castles and tumbledown buildings and so on. In short, the characteristic attributes of the Great British countryside. According to the received wisdom of the Royal Academy, this was exactly the kind of thing that represented a lesser field for artistic endeavour. Turner recognised no such limitations. Where others plodded, he excelled, bringing to the job the same ambitions he applied to his oil practice. By matching his facility for watercolour with the merits of his larger work, he eschewed hierarchical prejudices and cornered topographical landscape as an area of outstanding innovation and depth. The nation was one big mine of picturesque potential, and in particular much of his inspiration was water-based: rivers, lakes, canals and, of course, that most enduring motif, the sea. If rural life was Constable's speciality, then the sea was Turner's.

For thirty years or more, it was this kind of work that took up the greater part of Turner's annual agenda. Until 1825, one of his biggest commitments was a project called *Picturesque Views on the Southern Coast of England*. Ongoing since 1811, this pictorial survey of the coast was the brainchild of printmaker brothers William Bernard and George Cooke. Fourteen artists had been employed to produce designs, but it was Turner who made it a popular success. Producing forty designs in total, only he had the vision and skill to combine the small format of topographical watercolour with pictorial effects of the highest quality. His designs contained all the excellences that had propelled him straight to the top of the Academic ladder – originality of composition, narrative complexity and the appropriation of higher visual references. Weaving a virtual voyage between Kent and Somerset, this was something more than vicarious sightseeing. Each of the scenes was crafted as a testimonial to the sea as a natural resource. Provincial locations were portrayed according to their salient specialities: local trades and industries such as oyster dredging in Whitstable, pilchard fishing in St Mawes, boat-building in Teignmouth, even smuggling in Folkestone and sea-bathing in Weymouth (fig. 28). For a project conceived against the backdrop of the Napoleonic Wars, Turner made the picturesque patriotic.

In some ways, the *Southern Coast* represented a contemporary parallel to Constable's River Stour scenery. Just like the Suffolk

six-footers, the illustrations are full of everyday details: places that are recognisable; environmental effects that are convincing; figures who are site-specific, fully integrated within their surroundings and totally true to themselves. But where paintings like *The Hay Wain* credited the countryside as the bedrock of English security, the *Southern Coast* reflected maritime sovereignty. At a time when many rural areas were in crisis and decline, the placid rhythms of Constable's agricultural vision were already nostalgically outdated. Marine matters, by contrast, were right up to the moment. The coastline represented a liminal space – the first and firmest line of defence. Whether from the threat of foreign invasion, the creep of urbanisation and industrialisation or the physical bombardment of wind and waves, the nation's borders were under constant pressure from external forces. By spotlighting the importance of naval and coastal industries, the *Southern Coast* series became a long-form narrative about socio-economic resilience and self-sufficiency: a portrait of an island nation at a critical moment in its history.

In the autumn of 1824 (coincidentally the same time that *The Hay Wain* was in France) Turner was in, of all places, East Anglia. No great surprise in a way. One is hard pressed to find a region of England that Turner didn't explore at some point or other. But he had never been attracted to the east coast before. Famously flat and intensively shaped by human activity, the landscape lacked the visual variety or the cultural heritage of localities he had tended to favour. Why now? It is interesting to muse on whether venturing to the area was in any way a calculated response to his growing awareness of Constable. Had the Suffolk artist's recent success in picturing and promoting his home turf piqued Turner's curiosity towards its picturesque potential? Pure speculation it may be, but Turner *may* have adjusted his own activities according to the recent boom in Constable's reputation. As someone alert to fluctuations within the marketplace, perhaps he felt his fellow landscapist had succeeded in creating a level of demand and interest to which it was worth devoting some of his own attention. It wouldn't be the first time, or the last, that Turner responded reactively to another artist's achievements. But although he was ostensibly in Constable's neck of the woods, the closest he seems to have got to bona fide Constable country was Colchester. Turner preferred to keep his eyes

fixed seawards. In Suffolk and Norfolk, he focused upon the region's maritime locations – places like Orford, Aldeburgh, Lowestoft and Great Yarmouth – where people and coastline were pitted against the stormy power of the North Sea. Some of his sketches evolved into designs for another projected publication, *Picturesque Views on the East Coast of England*. In fairness, this never-to-be-completed idea was more likely to have been conceived in response to William Daniell's *A Voyage around Great Britain*, published between 1814 and 1825, rather than Constable's Stour Valley. But the marine angle made the area freshly relevant. Instead of harmony, Turner revelled in the coast's confrontational tensions: the juxtaposition of lighthouses and wrecked shipping, thriving fishing ports and abandoned ruins, powerful waves and eroded cliffs. Had it been completed, the 'East Coast' scheme would have formed a parallel extension to the *Southern Coast* material.

It is typical of Turner's drive that he should have been simultaneously engaged upon multiple ideas. With many of the topographical projects commissioned by print publishers, one assignment often overlapped with another. We need only look at his 1824 commitments to find a sample cross-section of his relentless schedule. The highest-profile task in hand was finishing a painting by royal command – an epically sized canvas of *The Battle of Trafalgar*, requested by George IV for the State Rooms of St James's Palace. That alone might have been daunting enough for most artists. But Turner had several other jobs on the go as well, all at various stages of completion. These included watercolour commissions for two topographical series, *Views in London and Its Environs* and *Marine Views*, as well as managing a further set of images for *The Provincial Antiquities of Scotland*, now largely at the printmaking stage. He was still engaged upon the *Southern Coast*, but was simultaneously starting to give serious thought to a project for yet another publisher, Charles Heath, a large and ambitious series called *Picturesque Views in England and Wales*.

All of this required a lot of mental energy, as well as physical legwork. Much of the year was spent on field reconnaissance, tramping hither and thither, not just in East Anglia, but also in Yorkshire, Hampshire and Sussex, not to mention a separate body of Continental work gathered on a late summer tour of the Meuse and Mosel rivers.

It was a pace that might have crippled a lesser artist. Small wonder he didn't manage an exhibit for the Royal Academy; he was struggling with his punishing workload. Always busy, always in demand, Turner was forever turning down social invitations; 'no holiday ever for me,' he mourned.[19] It is interesting that it was pressures from work which stopped him exhibiting – so different from Constable's difficulties in balancing career and family. Just the previous year, Constable hadn't managed to get a six-footer to the Royal Academy because his family had all been poorly at the same time. 'My life is a struggle between my "social affections" and my "love of my art",' he later told a customer. 'I dayly feel the remark of Lord Bacon's that "single men are the best servants of the publick".'[20] (Turner's comments concerning the lack of sacrifice to the arts by married men come to mind.) 'I have a wife in delicate health . . . and five [at that point] infant children,' he went on. 'I am not happy apart from them even for a few days, or hours, and the summer months separate us too much, and disturb my quiet habits at my easil.'[21]

Turner's 1824 travels are notable for another reason. They inadvertently brought his professional activities within geographic range of Constable's private ones. Still searching for ideas that might suit one picturesque project or another, Turner had turned from the east coast to the south, and returned to Sussex. As he knew from previous visits, the county offered a compelling diversity of riches. There was the timeless appeal of the South Downs, with its wooded hills and chalk grassland. But there was also the urban face of the coastline, the developing seaside resorts and watering places springing up in response to modern ideas about health and recreation. And, as it turned out, Sussex was where Turner and Constable would go on to share the greatest crossover of subjects.

One such place was Arundel, a town Turner selected to feature in yet another topographical project from this time, *The Rivers of England*.[22] As the title suggests, this series showcased the nation's waterways – each river acting like a mirror to the social, historical or geographical spirit of place. The resulting watercolours are exquisite. The skies are as vivid as those in the *Skies* sketchbook. But instead of relying on loose liquidity, Turner built up a shimmering haze of tiny stippled touches. The effect is like light striking water droplets. The subsequent designs have a sparkling, multi-hued look, as though

TURNER AND CONSTABLE

each vista has been glimpsed through a rainbow. In Arundel, he fix-
ated upon one of his favourite weather effects: the sweeping bands
of rain cast by a passing shower. Though the nominal focus is upon
the distant castle, with the River Arun meandering down to the sea,
the real subject is a violet veil of shadow drawing across the sunlit
valley.[23] Constable too would eventually discover the charms of the
scenery around Arundel's medieval castle, although not for another
decade. For now, it was another Sussex town that brought the two
artists into unexpected alignment – Brighton.

Brighton represents a rare occasion when Turner and Constable
were in the same place at the same time, leading to paintings of the
same subject. Turner was there to finish up the last few designs for
the *Southern Coast* series. The result was a fine plate of Brighton
seafront, as seen from the choppy waters of the Channel.[24] The
prospect was as contemporary and up to date as the slow, drawn-out
process of print publication would allow. Curiously Turner chose to
title it with the town's Anglo-Saxon name, *Brighthelmstone*, rather
than the more common modern contraction 'Brighton'. The old
name forced an ironic acknowledgement of the rapid pace of devel-
opment. Brighton was an urban centre in flux, changing almost as
constantly, Turner suggests, as the tide coming in and out. Thanks
to the clarity of the draughtsmanship – more precisely delineated
than that in *The Rivers of England* – his view contains an enormous
amount of architectural information, all of it concerning the growth
of this fashionable seaside destination. Principal in the centre are
the outlandish contours of George IV's recently completed Royal
Pavilion, cunningly rotated so as to include a frontal view of the
palace's unmistakeable onion domes. Either side of this is a host of
other new buildings, including the distinctive circular structure of
Lamprell's swimming baths, the tall blockiness of the brand new
Albion Hotel and, on the right, the terraced esplanade of Kemp
Town's Marine Parade, still under construction.[25] Meanwhile, the
greatest compositional prominence is reserved for the town's Royal
Suspension Chain Pier. A marvel of modern engineering, the bridge
had been recently opened as a landing place for the Channel crossing
service between Brighton and Dieppe. Reassuringly rigid, the pier
thrusts through the turbulent swell like a welcoming outstretched
arm, ready to steady approaching vessels. The viewer is cast into

the role of a middle-class tourist, arriving by packet boat in order to partake of the health and entertainment facilities the modern resort has to offer.

In an irony of fate, the Constables were at that very time amongst the recent arrivals to Brighton. By now, not even the clear climes of Hampstead were change of scenery enough for Maria. A stronger form of respiratory medicine was recommended – the curative power of sea air. First in 1824, and then repeatedly over the next four years, Constable regularly relocated his family to the town in a desperate annual pilgrimage to chase some colour back into his wife's consumptive cheeks.

Not that they would have met, but Turner's 1824 trip must have coincided with Maria's first stay in Brighton. Since June, she and the children had been installed at an address called Sober's Gardens, in the western part of the town, immediately to the left of Turner's seafront view. Constable himself was probably absent.[26] As in Hampstead, he travelled back and forth to London as work dictated. In any case, the resort was not his kind of place at all. For all the reasons highlighted by Turner's watercolour it was too busy, too modish and too full of city types. He could not hold back his distaste, sending Fisher a snooty description of what he considered to be the vulgarity of the seaside vacationists. 'Brighton is the receptacle of the fashion and offscouring of London,' he griped.

Ladies dressed & *undressed* – gentlemen in morning gowns & slippers on, or without them altogether about *knee deep* in the breakers – footmen – children – nursery maids, dogs, boys, fishermen – *preventive service men* (with hangers & pistols), rotten fish & those hideous amphibious animals the old bathing women, whose language both in oaths & voice resembles men – all are mixed up together in endless & indecent confusion.[27]

He loathed the tumult of traffic and the 'unnatural' appearance of the Marine Parade. Maria's needs, however, trumped his antipathy. 'Piccadilly by the sea-side' it may have been, but at least it was commutable.[28] Parts of it were even paintable. There may not have been trees and fields but Constable liked the 'magnificence of the sea', and the fishermen with their boats, the local equivalent to the rural

labourers and barge hands he was used to seeing in Suffolk. There was also the varying loveliness of the sky, spread before him in even greater uninterrupted immensity than at Hampstead. In other words, as long as he kept his back turned upon Turner's madding, modern sprawl, Brighton became yet another place in which Constable could 'feel' a connection to nature. And where he could feel, he could paint.

To begin with, the emotional response to Brighton was relatively muted. Throughout the autumn of 1824, Constable filled a sketchbook with studies of the 'picturesque' fishing boats and colliers along the shore.[29] His use of the word 'picturesque' is interesting, suggesting he was pandering to commercial principles rather than artistic ones. Subjects of this kind seemed 'hackneyed' to him, 'more fit for *execution* than sentiment'.[30] Full of figurative life and nautical detail, the scenes brought childhood reminders of his father's sea-going vessels at Mistley, but they lack his usual sensory, loving treatment. Executed not in oil, but in monochromatic pencil, pen and wash, they are carefully composed, with a graphic, illustrative quality. Art historian Ian Warrell has convincingly demonstrated that far from being studies in naturalism, they originated in relation to a topographical commission.[31]

Whilst it is unlikely that Constable was aware that Turner was intending to turn Brighton into the latest design for *Southern Coast*, he must have known about the series and the many publications like it. At some point it seems he decided to try and branch out into the picturesque market himself. Whether at his own instigation or at that of his French dealer, Arrowsmith, the idea was mooted for a publication featuring twelve coastal designs, pitched to audiences on both sides of the Channel. Like so many of these sorts of planned projects (Turner's included), it never got as far as the engraving stage. But the work provided an introductory way in to the scenery of Brighton, and left him with a body of compositional ideas ripe for development. The result was Constable's one and only major sea piece.

Despite his initial dismissal of it as a 'dandy jetty . . . with its long & elegant strides into the sea', the subject of Constable's great oil painting was that 'curious specimen of modern ingenuity and scientific art', the Chain Pier (fig. 23).[32] Or at least that is what he titled it. In reality, the pier itself is pushed into the far distance, in favour of a busy strip of shoreline, a turbulent wedge of sea and a

Fig. 23. Constable, *Chain Pier, Brighton*, 1826–27, oil on canvas.

huge expanse of blustery, overcast sky. Unlike the Stour six-footers, this is not a comfortable, soothing piece of landscape. If painting was still 'but another word for feeling' then here Constable seems compositionally and environmentally out of sorts. Rather than a safe haven for disembarkation, the pier looks more like a fence, an artificial boundary which has displaced the native fishermen, pushing them forward and penning them in to an insufficient corner of space which they are forced to share with an assorted jumble of beach users – paddlers, people strolling along the shore, children, someone riding their horse into the waves. Even the bathers seem mildly embattled. Far from sea air bringing health and happiness, there is an inhospitable aura to the scene. The most colourful (and therefore noticeable) figures in the foreground are two women walking by the edge of the water. With their faces hidden by their bonnets, they huddle together, umbrella up like a shield, shoulders hunched against the elements. One can't say they are in danger exactly, but neither do they look completely at ease. Whereas for Turner, modernity was just another part of the inevitable transience of life, for Constable,

it was more troubling: a change, but not necessarily one for the better. Fisher certainly felt the jitters of disquiet. He later wrote to his friend urging him to 'mellow' the picture's 'ferocious beauties'. 'Calm your own mind,' he went on 'and your sea at the same time, & let in sunshine & serenity.'[33]

Serenity, however, was in short supply. Constable conceived the work in 1824 but it took him three years to bring it to fruition.[34] In the intervening period, his relationship with Brighton intensified, crystallising into something complicated by worry. Each visit was prompted by a health crisis: sometimes it was the children, especially John Charles; more often it was his wife. Every yearly return must have felt like a failure of sorts: a sad acknowledgement that the situation was *not* getting any better. One thing that definitely cannot have helped was the arrival of more children. Maria ended up spending over 40 per cent of her married life pregnant. After Isabel she had declared herself content with four children; she didn't really want any more. But the babies kept on coming, each one a drain on her limited reserves of strength. Both the fifth child, Emily, and the sixth, Alfie, were born prematurely. Maria was left 'in a sad weak condition' and had difficulties breastfeeding them.[35] After Alfie's arrival in 1826, Constable wrote to Fisher:

> I have another boy, making my number six, being 3 of each. It is an awfull concern – and the reflection of what may be the consequences both to them and myself makes no small inroad into that abstractedness, which has hitherto been devoted to painting only. But I am willing to consider them as blessings – only, that I am now satisfied and think my quiver full enough.[36]

That was all very well, but they weren't done yet. At the beginning of 1828 there was a seventh and final child, a 'lovely boy', Lionel Bicknell.[37] It proved to be a childbirth too far. Maria was left 'sadly ill at Brighton'.[38] The strain of it all was almost more than Constable could bear.

We can intuit these anxieties within some of the Brighton oil sketches, many of which seem to encapsulate a feeling of escapism tinged with despair. Time and again they show the artist turning his face away from the town, and, in what appear to be brief moments

of respite, gazing along the shoreline towards the horizon. Distant boats and figures serve only to emphasise the loneliness of the view. So much is conveyed by so little. All but devoid of features, the empty landscapes are teeming with the motions of restless sea and sky. Textured smears and encrustations of paint give the wind and surf tangible presence and physicality. Energetic brushstrokes sweep in shafts of light and movement, yet rarely do we see the sun. Storm clouds abound. In the stormiest of these scenes we seem to sense the agitation of Constable's state of mind. Everything is reflected in the paint. Pain and anguish inhabit the lines. One depicts a turbulent sky, with darkened cloud boiling up across the horizon like a pall of smoke.[39] Inscribed on the reverse with 'Sunday 20 July 1828', it seems indicative of the shadow hanging over Constable's life during this summer. Another, not dated, but visceral in its sensibility, shows a blackened wall of rain obliterating the sky. Unlike Turner's rolling rain sheet, which one feels would swiftly sweep past, leaving nothing more than a slight film of moisture upon your eyelashes, Constable's downpour looks like it would knock you off your feet and drench you through. There is heaviness, both in the colour and in the impastoed quantity of the paint. Almost certainly painted in the lid of a painting box, the artist would have had to be sitting still, rooted to the spot with the box stabilised upon his knees.[40] Compare this to Turner's travelling watercolour palettes, lightweight, hand-held objects which lent themselves to ease of movement and swiftness of touch.[41]

Constable exhibited the *Chain Pier, Brighton* first at the Royal Academy in 1827, then again at the British Institution in early 1828. Fisher predicted trouble. By diversifying his practice with such a large and dramatic sea piece, his friend, he felt, had thrown down a gauntlet. 'Turner, Calcott [sic] and Collins will not like it,' he warned.[42] Constable had little respect for Callcott, whom he saw merely as a Turner acolyte, and he absolutely couldn't stand William Collins, whose work he had once caustically described as being 'like a large cow-turd'.[43] Turner, it must be said, was another matter. However much Constable disagreed with his approach, he could not disguise his admiration for the man who had done so much to promote the art of landscape. Turner was one of the few Academicians who believed in the intellectual potential of the genre

as strongly as he did. Considering the prejudice he regularly faced in the Academy (from those who preferred 'the *shaggy posteriors of a Satyr* to the *moral feeling of landscape*', as he acidly put it), he could really have done with lobbying Turner's support.[44] Instead, he was embarking upon actions that could easily be interpreted as provocation. As Anne Lyles has said, it was 'a risky strategy'.[45]

Alas for Constable, the risk did not really pay off. Reviews of the *Chain Pier* were mixed. Complaints were made about the coldness of the colouring, the streakiness of the handling and the artist's neglect of the town. 'Marine subjects are not this gentleman's forte,' wrote *Bell's Weekly Messenger*. 'Whilst Turner, Standfield [sic] and Calcott maintain so much superiority on the ocean, we would rather see this highly gifted artist's productions emanate from some woody dell or meandering streamlet.'[46] Worse came from the the *New Monthly Magazine*. 'This is an attempt by Mr Constable in a new style,' they wrote, 'and we cannot congratulate him on the change.'

> The present picture exhibits the artist's usual freshness of colouring, and crispness and spirit of touch, but it does not exhibit them in connexion with objects to which they are appropriate as they are to green trees, glittering rivulets, and all the sparkling details of a morning scene in the country. Mr Constable's style is rural, and adapted to rural objects almost exclusively.[47]

It seems Turner and co. had nothing to fear from Constable after all.

The change in subject matter also failed to endear Constable to the Academy, alienating, as Fisher had anticipated, its marine painters. When in early 1828 Constable called on Turner to try to canvass his support for election, he was given irritably short shrift. According to Constable, Turner:

> held his hands down by his sides – looked me full in the face (his head on one side) – smiled and shook his head & asked me what I wanted, *angry* that I called on a Monday afternoon. He asked me if I had not a 'neighbour at Hampstead who could help me' – Collins. I told him we were no longer intimate & I know nothing about him – he then held fast the door – & asked many questions – &c.[48]

So no vote from Turner, then. Even worse, his opinion swayed others, one of them being the sculptor Francis Chantrey, whose hypocritical equivocation Constable blamed on Turner. 'I am sorry Turner should have gone growling to Chantr[e]y,' he told Leslie, 'but I recollect that I did not quite like the whites of his eyes – and the shake of his head.'

Perhaps Turner had gone growling to others too. Constable went on to lose by a considerable margin (eighteen ballots to five) to the younger history painter William Etty. It is telling that Etty couched his own account of the election in terms of a naval engagement. 'After combating many hard gales from Cape Difficulty and being nearly upset on Rejection Rock,' he wrote to his brother, 'on nearing land a *Constable* got on board some of the Royal ships, and came out with five or six guns (swivels). But a broadside of eighteen long forties [i.e. eighteen individuals from amongst the forty Royal Academicians] sent him to the bottom.'[49] The marine establishment had seen off the Constable challenge with a coordinated defensive salvo.

Though the general reception of the *Chain Pier* was lukewarm, *The Times* had struck out as a lone voice and described it as one of Constable's best works. The paper dubbed him 'unquestionably the first landscape painter of the day'.[50] Up until now, that title would, by default, have gone to Turner.[51] By dint of his range but also his outward competitiveness, he had cemented a status as peerless amongst his peers. That very year, his entries at the Summer Exhibition had contained two maritime subjects with self-promoting references to other landscapists. The first, *Port Ruysdael*, served as a reminder of Turner's Old Master credentials. The title, colouring and subject invoked the spirit of Jacob van Ruisdael, a seventeenth-century painter from the Dutch School. Tellingly, it was often Constable to whom the papers compared Ruisdael these days. It is tantalising to wonder whether Turner had got wind of Constable's intention to exhibit a sea piece and was playing a tactical game of artistic appropriation. The second was a contemporary allusion: a bright and breezy piece, irreverently titled *'Now for the Painter' (Rope) – Passengers Going On Board*. The wording extended some playful Academy teasing from a previous year between established marine artist, Callcott, and a newcomer to the field, Clarkson Stanfield. Building upon an existing in-joke, Turner cast himself in the role of a figurehead

TURNER AND CONSTABLE

throwing out a tow rope (the nautical term is 'painter') to a smaller vessel following in his wake.

If a starting point for Turner's alleged rivalry with Constable can be detected then it is in the older painter's response to the *Chain Pier, Brighton*. Not only had Constable dipped a toe into marine waters, so to speak, but the *Chain Pier* also represented a deliberate incursion into Turner's client territory. The construction of the Brighton pier had been heavily financed by George O'Brien Wyndham, the wealthy and eccentric third Earl of Egremont, well known as one of Turner's most prominent patrons. To date, fourteen pictures by Turner had made their way into the earl's collection at Petworth House in Sussex. There were none by Constable. Just as Turner speculatively chose subjects to try and draw the eye of royalty, Constable's decision to paint the Chain Pier was nothing less than a blatant attempt to attract the earl's attention.[52] Ultimately, Egremont did buy a stormy sea piece from the 1827 Exhibition but it wasn't the *Chain Pier, Brighton*. Ironically, it was a work by Callcott.[53]

Petworth House held a special place in Turner's heart and personal history. The Old Masters collection had played a pivotal role in his pictorial dialogue with historic artists such as Claude, and although in recent years he had not had much to do with Lord Egremont (there was talk of a rift), he was a long-time favourite of the charismatic earl, and was accustomed to staying in the house as an honoured and privileged guest. Around 1827, Egremont commissioned him to design and paint a quartet of landscapes for the Long Dining Room, a large and opulent chamber also known as the Carved Room after its exquisite limewood decorations by the renowned artist-carver Grinling Gibbons. The room was already magnificently adorned with historic full-length portraits. Now the earl wanted four bespoke canvases to sit directly underneath the portraits, at perfect eye level for his seated dinner guests. Turner obliged with a set of long, low landscapes that, in due course, were installed in situ surrounded with elaborate carved wooden frames. In the process, he defended the territory Constable had been in mind to encroach upon and, in a sense, reclaimed Petworth House as his own.

Though it is safe to assume both the earl and Turner contributed ideas, frustratingly little is known about the circumstances of the Carved Room series. The nitty gritty of whose idea it was, or who decided what should go where, was unfortunately never chronicled.

However, we don't require anyone's say-so on the matter to hypothesise that the commission presented Turner with an opportunity to play Constable at his own game. What is known is that the artist presented Egremont with six ideas for subjects, creating life-size working mock-ups for the earl to choose from. It has been suggested that the very act of making sample studies may have been an 'experimental response' to Constable's custom of producing full-size prototypes for his exhibition six-footers.[54] This seems too much of a stretch. It is highly unlikely that Turner knew what Constable was doing within the privacy of his own studio, and surely he would have dismissed rather than emulated such a labour-intensive sketching habit. The Petworth studies were simply a useful tool to assist in the on-site planning of a rare site-specific job (perhaps even requested by the earl himself).

Three of the proposed designs were views of Petworth Park and lake – the same views, in fact, which could be seen from the Carved Room simply by turning one's head towards the western windows. The remaining ideas touched upon other associations, which, with a bit of detective work, can be read as a deliberate response to Constable. The most obvious example of this is Turner's spectacular version of the Brighton Chain Pier – a sun-drenched answer to Constable's earlier oil with all the key characteristics turned around (fig. 24). Where Constable's colouring had been cold, Turner suffused his with golden warmth, making a flamboyant virtue of the yellow

Fig. 24. Turner, *Brighton from the Sea*, c.1829, oil on canvas.

pigments he was so regularly taunted about. Where Constable's pier had been painted from the shore looking east, Turner's is taken from the sea looking west and includes all the steamboats and other signs of modernity his counterpart had ignored. And where Constable's inhabitants seemed at odds with their environment, Turner's appear peaceably in harmony. One could even fancy that the red-hatted fishermen in the left-hand corner of Constable's work look like they have taken to the water in Turner's. The men are seen returning with their catch, their full basket of silver fish a bountiful treasure compared to the one carelessly tipped over on Constable's beach. Eagle-eyed observers might even note a tiny figure running full pelt towards the end of the pier, a miniscule duplicate of the man sprinting away from the tide in the foreground of Constable's painting, located exactly beneath the same segment of the structure.

Even if it was the earl who had the final say on the subjects, Turner surely had Constable's recent painting in mind when he came to execute his own design, if only to ensure he was doing something different. It is a wonderful example of Romantic subjectivity: how two artists could look at the same subject with remarkably distinct outcomes. Revenge was a dish best served yellow. Hidden in plain sight was proof that anything Constable could do, Turner could do – if not necessarily better (that after all is a matter of personal preference) – then at least bolder, brighter and better remunerated.

Detail of fig. 24,
Turner, *Brighton from the Sea*, c.1829.

Aside from *Brighton from the Sea*, the remaining two subjects put forward for the Carved Room can also be interpreted as having tangential links to Constable. The rejected idea was a sea painting, *A Ship Aground*, now identified as a view of Yarmouth.[55] Whilst there seems no immediate reason to tie this subject with Lord Egremont, there may be a connection with Constable. Prior to taking on the *Chain Pier, Brighton*, the Suffolk artist had found his sea legs (as it were) with some smaller marine-based pictures, including at least three versions of a view of Yarmouth jetty. One of these had been exhibited at the British Institution in 1823. Another had been bought by John Arrowsmith as part of the package deal involving *The Hay Wain*. It certainly seems more than coincidence that the year Constable subsequently exhibited a Yarmouth painting at the Royal Academy, 1831, Turner too showed two pictures conceptually related to his unused Yarmouth study for Petworth: namely, *Fort Viemieux* and *Life-Boat and Manby Apparatus*, the latter a stormy view of Yarmouth jetty from the opposite direction habitually adopted by Constable.[56]

Meanwhile, the fourth design, chosen in favour of *Ship Aground*, was a panel known as *Chichester Canal*. This depicts a navigable shipping lane found around seventeen miles to the south-west of Petworth.[57] Constructed in 1822, the canal had relied heavily on investment from Lord Egremont, and even though he had withdrawn his finances by 1826, it was the site selected to complete the Carved Room series. Can any significance be read into Turner tackling a pictorial trope that Constable had staked his own reputation upon? Whilst there is nothing aesthetically similar to Constable's paintings of the Stour Navigation, prominent in the right-hand foreground of Turner's canal is a small black waterbird. With wings outstretched, it has a similar silhouette and position to the moorhen affrighted in Constable's *Leaping Horse*. One wonders whether this isn't Turner surreptitiously annexing a Constablean motif for those in the know. The main audience for most of his artistic rebuttals was his Academy colleagues. Since so many of these were regularly guests at Petworth House, Turner could not have found a better arena in which to indulge in a spot of quiet counterplay.

The Carved Room refit took three years to fully resolve. Turner carried on tinkering with the Brighton design. Perhaps with Constable still in mind, he returned to the town in 1829, making further studies

of the Chain Pier, some of them from the same angle as Constable's composition.[58] He even began a canvas that adopted the viewpoint more directly. This remained unfinished, although it has been established that it was revisited at some point during the 1840s, after Constable's death.[59] Ian Warrell has suggested this surprising resurrection may have been prompted by the publication of Constable's biography by his artist friend Charles Robert Leslie, in 1842.[60]

As a footnote to Turner's Chain Pier tit-for-tat, it is worth mentioning an amusing incident, also involving Leslie, that took place a few years later. In 1834, Lord Egremont had tried to invite Turner and Constable to stay at Petworth House at the same time. As ever, Turner was too busy to oblige – he was travelling on a 'bookseller's job'. By the time he arrived, Constable had left: an intriguing sliding doors moment of conversations never had. Leslie was still in residence, though, and recorded the following story. Upon discovering Leslie's young son Robert, playing with a toy boat made for him by Constable, Turner muttered, 'Oh, he don't know anything about ships. This is how to do it.' He took the boat from the boy, changed the rigging and refitted it with paper sails made from one of his own sketchbooks.[61] Another Turnerian makeover of a Constable creation.

For the record, as minor as this incident is, the anecdote represents a rare instance of Turner candidly contradicting Constable within someone else's hearing. Irrespective of the fact that he was happy to take on other artists pictorially, verbally Turner kept his counsel. He almost never openly criticised his fellows.[62] Consequently, commentary pertaining to Constable (as on most of his contemporaries) is almost non-existent. Constable, on the other hand, had plenty to say about Turner; and courtesy of his private correspondence, some of it comes across as very barbed, and sarcastic. This situation has made the true nature of their feelings about one another hard to divine. So often the focus has been placed on Turner's combative actions, and Constable's colourful, acerbic statements, to the exclusion of more nuanced and sympathetic interactions. Granted, Constable openly deplored Turner's colouring, but he regularly tempered his criticism with praise. Despite his defeat in the 1828 elections, he remained gracious in his report to Fisher on the Exhibition a few months later. 'Turner has some golden visions – glorious and beautifull,' he wrote. 'They are only visions – yet still they are art – & one

could live and die with *such* pictures in the house.'[63] 'Did you ever see a picture by Turner, and not wish to possess it?' he rhetorically asked Leslie.[64] Similarly, Turner's opinion regarding Constable was not fixed in stone. Whilst he probably actively blocked Constable's election in 1828, a year later the situation looked somewhat different. Perhaps in response to Constable's personal situation Turner seems to have mellowed.

At the end of the year Constable's world had tipped upside down. Maria had finally succumbed to her illness. She died in her husband's arms on 23 November at Well Walk, a Hampstead property Constable had only recently purchased in the futile hope it would be their forever home. He was totally devastated. 'I shall never feel again as I have felt,' he wrote in the immediate aftermath of his grief. 'The face of the World is totally changed to me.'[65] Reeling in sorrow, there was also the shock of becoming the sole parent to seven children under the age of twelve. Then, just eleven weeks after his loss, he was made a Royal Academician, squeaking through the election against Francis Danby by just a single vote. The timing could not have been crueller. Constable had worked so hard and waited so long, and now, just when he was at his unhappiest and most vulnerable, his wish had been fulfilled. 'It has been delayed until I am solitary, and cannot impart it,' he mourned.[66]

Amidst the bittersweet turmoil, there was a small but significant gesture of kindness. Turner called to offer his congratulations. He had been in Italy again for the past five months and arrived back in London just in time for the ballot. It is not known which way he voted. Presumably to begin with he had supported his friend Charles Lock Eastlake, to whom he sent the list of first-round results, but whether he'd plumped for Constable or Danby in the end is not recorded.[67] Regardless, the night the result was announced Turner, accompanied by George Jones, went round to Charlotte Street and paid his respects to his newly elected colleague. Presumably he also offered his condolences. Whatever was said on that occasion is known only to those in the room at the time, but it was clearly a congenial evening. According to Constable, they parted at one o'clock in the morning, 'mutually pleased with one another'.[68] 'Turner's presence was a high compliment,' exclaimed Fisher. 'The great landscape painter by it claimed you as a brother labourer.'[69]

Fig. 25. Turner, *Banks of the Loire*, 1829, oil on canvas.

The picture which had helped finally clinch Constable's election was *The Vale of Dedham*, a large upright canvas which revisited the same small view he had first painted over twenty-five years earlier (fig. 6).[70] As in the earlier study, the compositional source was once

again *Hagar and the Angel* by Claude Lorrain, formerly the treasured possession of Sir George Beaumont. The baronet had bequeathed the painting (along with other works) to the National Gallery upon his death in 1827, and it is likely that Constable's painting was intended as a homage to his late mentor.[71] Interestingly, at the next Exhibition, Turner, newly returned from Europe, also exhibited a painting that contained conspicuous echoes of Beaumont's Claude. His *Banks of the Loire* (fig. 25) perpetuated the vertical format and spatial organisation of Claude's *Hagar*, as well as containing a distinctly Italianate idealisation of the French location.[72] True, if Constable's appropriation was a compliment to a friend, Turner's was more a matter of quiet revenge. In 1815, Beaumont had been openly horrified by Turner's *Crossing the Brook*, a vertical Devonshire landscape visualised according to Claudean principles.[73] By repeating the stratagem Turner was claiming the last laugh against someone who had slighted him for years. But he was also acknowledging a bond between great landscape painters – himself, Claude and, to an incidental extent, Constable. Irrespective of whatever had gone before, Constable was now a Royal Academician. As far as Turner was concerned, there was no greater fellowship.

CHAPTER 8

IN PRINT

S O IT WAS that three months after he had lost Maria, Constable was thrust into the newness of Academician status. It was a distressing and disorienting time. He was still trying to adjust to life as a widower and a single father. To make matters worse, implications surfaced that he did not deserve his recent elevation. The Academy's president, Sir Thomas Lawrence, tactlessly told him he was 'peculiarly fortunate' to have been elected at the expense of 'historical painters of great merit'.[1] Despite all that had been achieved in recent years, institutional prejudice against landscape was still rife. Even whilst Constable was still 'smarting', it was implied in the newspapers that he had bought his election with the money inherited from his recent bereavements (his father-in-law as well as his wife).[2] These imputations chafed a soul already raw with sadness and anxiety. To top it all, he was approached to paint, of all things, a mermaid on a sign for a Warwickshire inn. At over fifty years old, a Salon medallist and a Member of the Royal Academy, such a request was unbelievable. 'This is encouraging,' wrote Constable ruefully, 'and affords no small solace to my previous labours at landscape for the last twenty years.'[3] Poor man. Nobody would have dreamed of asking J.M.W. Turner to paint a pub sign at this or any other point.

Constable's answer was to embark upon a completely different kind of creative project and one designed to cement his reputation for posterity. He moved into the field of printmaking. In doing so, he

deliberately modelled himself on a previous undertaking by Turner. The print market, therefore, is yet another aspect of the two artists' ongoing dialogue. It is another arena where we find them circling around one another, albeit with the usual record of difference and disjuncture, and the odd surprising synchronicity. Turner was a titan of the print world, almost as well known in publishing as he was at the Academy. Constable's involvement was more modest – an isolated interlude – but one loaded with importance. Both men used prints as a tool for disseminating ideas about landscape. With Turner leading out in front and Constable trailing in his wake, both made unique and interesting contributions to the field of printmaking that deserve to be considered alongside their more widely known achievements.

In an era before public collections, relatively few people would have seen works of art in person. Even fewer would have had the means or opportunity to own an original painting. Up until the middle of the century (essentially the end of Turner's lifetime), the primary way the visual arts reached a mainstream audience was through the medium of the reproductive print. Most contemporaries would have been more familiar with a painter's works in the form of black and white engravings on paper, a process which made art more accessible and affordable. From a publicity point of view, there was no more powerful weapon in an artist's arsenal. Engravers therefore played a crucial role in the economics of the art world. As Leslie once wrote, engravers could do without painters much better than the other way around.[4] Although some artists were also printmakers, or vice versa, it more usually formed a separate line of work, requiring years of training and apprenticeship.

A brief word on terminology at this point. 'Engraving' is a catch-all term for a group of historical print techniques that are all intaglio methods – that is to say, a family of processes where the work is made by engraving an image *below* the surface of a metal plate. Each method uses different tools or actions to indent the metal. The basic printing principle, however, is always the same, utilising the forcible pressure of a flatbed press. The plate can be inked up and reprinted multiple times. Smooth, untouched areas of the plate remain white, but any recessed areas – be it line, dot, dash or hollow – hold ink and result in positive black. The wider or deeper the line, the darker the resulting mark.

Intaglio techniques might be used in isolation but could also be combined: the pertinent ones for Turner and Constable being line engraving, etching and mezzotint. A single plate therefore might well intersperse sections of etching (irregular free-form lines, incised by acid) with areas of engraving (flowing curved lines with tapered points, pushed directly into the metal – fig. 26). A distinctive-looking alternative is mezzotint, which requires a completely different mind-set (fig. 27). Unlike the linear processes, which build up darkness through cumulative patterning, mezzotint creates lighter areas out of a default blackness. The engraver works upon a pre-prepared plate, laboriously roughened all over with a serrated tool called a rocker. If printed without any intervention the resulting metal burr holds on to the ink and produces a solid matt black. The trick is to scrape or burnish away the burr in order to create varying degrees of tonal gradation: the smoother the metal, the purer the white. From a reproductive point of view, the choice of technique was often selected according to the medium of the source image. Etching and engraving were understood to mirror the subtle colouring and delicate details of watercolours, whilst mezzotint could better mimic the richness of oil.

In whatever form they chose to proceed, the most proficient engravers could make an astonishing range of marks. They walked a fine line between technical mechanics and artistic sensitivity, but when it was done well, they could use their own medium to evoke the impression of colour and form and bring new levels of perception to an image. Gradations of tone could be suggested by parallel lines, cross-hatching, changing the direction of the lines or using fewer marks altogether. Turner openly acknowledged this kind of graphic expertise when he stated, 'he that impresses the observation or stimulates the Associate idea of a colour individually is the great artist'.[5] No menial copyist could achieve such a feat. John Landseer, a distinguished apologist for the status of his profession, put it best. 'Engraving is no more an art of *copying* painting,' he wrote, 'than the English language is *an art of copying* Greek or Latin . . . its alphabet and idiom, or mode of expression, are totally different.'[6] His preferred term, adopted by Turner, was that of 'translation': translating from 'one language of Art' to another.[7] A print should be judged on its own merits, not merely its approximation to the

Fig. 26. W.B. Cooke, after Turner, *Weymouth, Dorsetshire*, published 1814,
line engraving and etching on paper.

Fig. 27. David Lucas, after Constable, *Weymouth Bay*, published 1830,
mezzotint on paper.

original – on qualitative factors such as the intricacy of the line-work, the luminosity of the highlights or the satisfying contrasts of the shadows. It was barbarous, he believed, to hand-colour an engraving with watercolour: as 'absurd' as colouring a 'diamond'.[8]

Charting the two artists' history with the print industry involves a bit of chronological hopping back and forth. Constable only took it up seriously in his fifties. By contrast, prints were part of Turner's world from the moment he picked up a brush. From his very first paid job (hand-colouring prints when he was ten years old), to reproductive plates still in progress at his death, he racked up almost seven decades of experience with various aspects of the business. Indeed, even if he had never turned out a single oil painting, Turner would still be remembered today as a significant contributor to the print trade. Even by the standards of other successful artists of the day, he was extraordinarily prolific.[9] The statistics speak for themselves. During his lifetime, Turner worked with sixty individual engravers on more than seventy different publishing projects, to produce upwards of 900 prints after his work. Sometimes he was the contractor, sometimes the contractee, and sometimes the inspiration for an entire endeavour. But whatever his level of involvement, he routinely ploughed as much energy into his illustrative output as he did for his exhibition repertoire. Thornbury wrote that Turner 'painted for fame; he engraved for bread'.[10] It was print publishing rather than oil painting that formed the mainstay of his working life, and was his most consistent and reliable source of income. When one takes into consideration the enormous amount of time devoted to the planning, implementation and revision of each endeavour, not to mention the weeks of travel, the thousands of associated sketches, drawings and proofs, and the reams of correspondence flying backwards and forwards between artist, printmakers and publishing houses, it rather begs the question how he managed to get any oil painting done at all.

First and foremost, the publication of reproductive engravings could be a lucrative enterprise. The surest way to transcend the social circumstances of one's birth was through money, and Turner had become an artist in part to do just that. Art for him was a business, and if revenue could be generated several times off the back of a single work then so much the better. This, in a nutshell, was the

beauty of printmaking. It made it possible to turn further profit from an existing commodity. An object lesson of this principle is Turner's marine disaster piece *The Shipwreck*, the first of his oil paintings to be engraved. After debuting in his Queen Anne Street gallery in 1805, the canvas had sold to Sir John Fleming Leicester for 300 guineas (£315).[11] Before the transaction had been fulfilled, however, Turner had been approached by an engraver, his namesake, Charles Turner, who was so struck by the marketability of the dramatic scene that he offered to produce a large version in mezzotint at his own expense.[12] A top-quality reproduction of a popular subject such as this one had the potential to net a printmaker a tidy profit. At least 130 individuals signed up to receive the mezzotint of *The Shipwreck*, which, since the plates were priced between two and four guineas, meant that Charles Turner would have made at least as much as the price of the original painting, if not more.[13] With a subscriber list that read like a 'who's who' of Georgian art and patronage, it was a very significant and free publicity boost for J.M.W. Turner.[14] But it also meant more cash returns. On top of the picture's original sale price, the artist was able to charge an additional twenty-five guineas as a loan fee for the engraver to borrow the picture. Furthermore, he negotiated a deal whereby he was given the chance to purchase any prints he wanted at trade price, for future sale at a mark-up under his own auspices. Aside from the fact that poor Sir John was kept waiting months for his painting, it was a win/win situation.[15] Three lots of income generated out of one picture. To appreciate the savvy of this business model we might remember John Constable, routinely outlaying double the time, effort and resources behind the scenes, into producing a full-size oil sketch for every prospective six-foot subject. Nothing could be further from Turner shrewdly earning profit thrice over from a single, commercially viable picture than Constable effectively producing two paintings for the price of one, never mind that one was surplus to sales requirements and the other was by no means guaranteed to sell.

Turner also exploited printmaking to enhance his reputation. He wanted to be taken seriously as a landscape painter, and so he took steps to promote the genre as a serious discipline, publicising it in such a way that few could doubt its gravitas. From this point of view, the stand-out undertaking of his career was a self-generated

printmaking scheme called the *Liber Studiorum*. Conceived in about 1806, this large and ambitious venture occupied him for the next thirteen years, throughout his thirties and early forties. A remarkable exercise in self-promotion, it harnessed the ability of reproductive engraving to extend the longevity and reach of an image in the wider public domain.

Nothing advertises scholarly sincerity like a Latin title, and the *Liber Studiorum*, or 'Book of Studies', was intended as an educational primer: a manual 'Illustrative of Landscape Compositions'.[16] However, it was a textbook for which there was no text. All the explanation was provided visually, starting with the plates' distinctive 'sepia' look. Turner painted each design in watercolour, using only the brown pigments from his palette – burnt umber, burnt sienna, Indian red.[17] Very different from anything else in his oeuvre, these antique-looking earth tones were then replicated with equivalent inks in mezzotint, a deliberate aesthetic conceit, intended to mimic the style and substance of the *Liber Veritatis* ('Book of Truth'), an acclaimed series after drawings by Claude Lorrain. Whilst the objective behind Claude's book had been to preserve the copyright of his paintings, Turner's was consciously more didactic. Almost as though he were assembling a retrospective catalogue, he put together a selection of images from across his output, carefully chosen to promote the intellectual range and substance of his achievements. Some were based upon pre-existing oils or watercolours; others were created solely for the purpose. One hundred designs were planned. Seventy were completed, plus a frontispiece (fig. 28). Intermittently published between 1807 and 1819, they formed a collectible compendium of the finest assortment of landscape compositions to date.

In the first instance, perhaps the most impressive thing about the endeavour was Turner's own contribution to the reproductive process. He was unusually closely involved, authoritatively stamping his presence at every stage of the plates' evolution. To start with, he etched the outlines of each composition himself, ensuring that every copper plate bore evidence of his hand. And whilst most of the mezzotint work was outsourced to professionals – Charles Turner and several others – Turner supervised their workmanship, editing and refining the tonal effects by marking up progress proofs until he was satisfied with the end result. He even, on occasion, undertook

Fig. 28. *Frontispiece to the 'Liber Studiorum'*, 1812, etched and centre engraved by Turner, engraved by J.C. Easling, etching and mezzotint on paper.

the scraping and burnishing himself. How he acquired the skills is anyone's guess. Aside from the hours of manual rocking required to prepare the plate (typically delegated to junior apprentices), mezzotint is an easier technique to master than line engraving. Turner would have found affinities with the way he had scratched, rubbed or lifted highlights out of wash on white paper for the *Liber* drawings.[18] Still, it was an astonishing accomplishment to have mastered simply as a sideline. The mezzotinting in at least nine of the designs appears to be his sole handiwork, and the quality is indistinguishable from that of the experts, exploiting the rich contrasts in light and dark for the purposes of expression and drama.[19]

The *Liber Studiorum* broke new ground for mezzotint. The medium was most commonly used for modelling form, volume and texture within portraits, but Turner and his collaborators deftly applied it to landscape. Deploying light in different intensities, they spread warmth and mood through the compositions, so that studying the *Liber Studiorum* was like taking a correspondence course in mezzotint,

TURNER AND CONSTABLE

with its special qualities geared specifically towards scenery. And if his objective was to instruct, Turner ended up learning a lot along the way himself. More than twelve years of near-constant print activity not only refined his own technical proficiency, but exponentially increased his understanding of the printmaking process, and his ability to coax a sensitive response out of his engravers.

The *Liber* was also a lesson in landscape. As an aid to pedagogic clarity, Turner categorised the plates, assigning each a classification according to six different landscape types: Architectural; Marine; Mountainous; Historical; Pastoral; and a final classification, 'EP' – essentially an 'elevated' subcategory of the Pastoral (that same synthesis of the classical and the contemporary that he had hit upon with the Thames). With five plates per part, each instalment was crafted to illustrate variety, and whilst the allocation evolved in a more haphazard manner than initially intended, each part contained at least four (and usually five) examples from across the taxonomy. Hence it was possible to find, within one collation, such widely differing sensibilities as a view of 'Marine' vessels becalmed, the 'Historical' story of Rizpah from the Bible, the wild peril of a 'Mountainous' Scottish peat bog, an 'EP' landscape of idealised Italianate scenery and a picturesque 'Pastoral' of real-life soldiers in present-day Sussex.[20] Turner became distressed when dealers broke up complete sets or parts so that individual impressions could be sold separately.[21] As far as he was concerned, it was like ripping out pages of a bound volume: sacrilegious. The book could not be read; the lesson could not be learned.

And what was that lesson? In essence, it was the same message Turner had been promulgating via his exhibition paintings over the years. Viewed holistically, his annual Academy exhibits showcase the same breadth of scope as the *Liber*, sometimes even with a similar mix of offerings featured within the same show. In print, Turner was able to communicate that message more urgently and intensively, filling an important vacuum in the advancement of landscape studies. Marginalisation of the genre was still common within academic circles, particularly of the so-called 'low' forms of scenery. As recently as 1804, Turner had attended a lecture by the professor of painting, Henry Fuseli, in which his colleague had famously repudiated 'the tame delineation of a given spot'.[22] Topography, Fuseli had stated, was a 'kind of map-work', not at all the desirable exercise

of intellectual invention advocated by the Reynoldsian school of thought. The lecture, which was repeated in subsequent years and later also published, blasted 'Views' as the uninteresting 'enumeration of hill and dale, clumps of trees, shrubs, water, meadows, cottages and houses'. In lieu of a professorship in landscape, or any other official outlet through which to propound his arguments, Turner offered up the *Liber Studiorum*. Almost as a direct riposte to Fuseli's insinuations, several plates addressed exactly the branch of landscape he had discredited: specific and recognisable locations such as *Hind Head Hill, The Junction of the Severn and the Wye, St Catherine's Hill near Guildford* and *Pembury Mill, Kent* – proof, in pictorial form, that topography could achieve equal prominence to the supposedly grander scenic modes. In this day and age, Turner was saying, there was no genre more relevant and versatile than landscape. It could be tranquil, tragic or sublimely tempestuous; it could tell a tale or weave a mood; it could reflect life as it is, as it was or as it should be. It could do this without qualitative distinctions between its many faces. The traditional hierarchy of Western art was now obsolete; landscape could do it all.

Generations of artists looked to the *Liber Studiorum* as a source of inspiration. No nineteenth-century practitioner can have been in ignorance of its existence and its devotees included such names as John Sell Cotman, David Cox, John Varley and John Ruskin. For landscape specialists, in particular, it was like the Bible: a sacred book of instruction and best practice – the gospel according to J.M.W. Turner. No wonder Constable sardonically labelled Turner as 'him who would be Lord over all'.[23] He owned a copy of the *Liber Studiorum*. But whilst many of his contemporaries saw it as a definitive statement – the last word in landscape – for Constable it merely sat alongside his own beliefs. He could not ignore such a well-thought-out tribute to British scenery. After all, the *Liber* included several examples of the kinds of subjects Constable was himself trying to dignify: motifs like the *Water Mill*, a composition not unlike *The Hay Wain* with its rustic tableau of tumbledown building, a horse and figure fording the water, and even a little dog standing by edge of the pond.[24] But as far as Constable was concerned, Turner's treatment of these subjects was only superficial, boxed into the category of the 'Pastoral', a trope which did not offer enough room for real

truth or feeling. When he compared his own single-minded pursuit of freshness to 'what greediness of trying every thing has brought *his* very original mind to', he was surely referring to Turner, and what he saw as the sacrifice of quality over quantity.[25] In November 1819, whilst canvassing for support in the run-up to the Academy elections, it must have stung his pride to have been condescendingly advised by the portrait painter Thomas Phillips to study 'Turner's drawing book' (i.e. the *Liber*), in order that he might 'learn how to make a whole'.[26] Constable, as we know, did not go 'running after pictures'. He certainly wasn't going to start taking lessons from Turner at this stage.

It was in 1819 that Turner ceased publishing the *Liber Studiorum*, even though it was incomplete. For all its importance it seems not to have been making him much money.[27] He now had other printmaking projects on the go, including a large number of topographical picturesque commissions. The sheer quality of Turner's watercolour work has already been discussed, but most people would have seen his images only in print form. And what distinguished these prints was the skilled and considered response the artist demanded from his engravers. Turner remained involved at all stages of a print's evolution, and stage proofs were regularly sent to him for editorial comment and alteration. Thanks to his exacting interventions and the evolving versatility of his collaborators, the ensuing prints broke the mould, smashing through the status quo of reproductive standards, and raising the calibre of engraving to new heights. For just a few shillings, it was possible to own an outstanding landscape composition, originating from the mind of a renowned Royal Academician.[28]

In the context of the profitability of British landscape imagery it is worth reminding ourselves of an ugly underlying truth. As with all economies during the Georgian period, the art market in Britain was inextricably fuelled by wealth created by the transatlantic slave trade. A case in point is the series known as *Views in Sussex*, a group of watercolours and related prints which Turner worked on in various stages between 1810 and 1823. The patron for this scheme was John Fuller, a rich landowner and Member of Parliament for East Sussex. He was also a slave owner. An eccentric with a passion for the arts and sciences, 'Mad Jack', as he was known, spent thousands of pounds on self-indulgent hobbies and structures, including an

obelisk, a sugarloaf-shaped folly and an astronomical observatory, designed by the architectural Academician Sir Robert Smirke. During the 1810s Fuller commissioned Turner to make views of his constituency, including some of these buildings and his estate at Rosehill. The ensuing illustrations conformed to all the clichés of commercial picturesqueness. Light and shade dapple the compositions and gently engage the eye in a visual dance through the pleasures of contrast and intricacy. Smoothly undulating grassy slopes are interspersed with tumbling masses of trees, echoed in the sky by billowing clouds and smoke. But as innocuous as these charming images appear, it chills the blood when one remembers that everything about them – the land, the buildings, the engraving and even Turner's handiwork – was paid for by money from Jamaican sugar plantations and rum distilleries.[29] Like most practitioners during this time, Turner was not choosy about the source of his income. By 1811, he had made over £400 working for Fuller, with more to follow.

Fuller was by no means the only client whose prosperity derived from slavery. Other prominent patrons included William Beckford, the Lascelles family of Harewood Hall and even John Julius Angerstein, who profited indirectly from his role as a marine insurer. In taking money from these patrons, Turner was not necessarily different from any other professional painter of the day. No individual operating within the period can be said to be entirely free from the taint of slavery. But Turner's moral choices must be considered more questionable than most. In 1805, he himself had invested money in a Jamaican tontine, a cattle farm that used an enslaved workforce.[30] At best this was thoughtless speculation; at worst, wilful complicity.

Constable seems to have been less financially entangled, but this is because his client list tended to be less illustrious and his sales record so much weaker. Politically he was a stalwart conservative with anti-reform sympathies, as evidenced by his readership of *John Bull*, an ultra-Tory weekly newspaper. This periodical, also a favourite of John Fisher's, was a severe critic of William Wilberforce, Lord Brougham and other abolitionist Whig politicians. Its letters and articles frequently defended the rights of slave owners to compensation and openly questioned the wisdom of extending the abolition of slavery to the colonies.[31] Fisher seems to have agreed. 'The saints will lose us the West Indian Islands,' he wrote to Constable in 1823.[32]

On the other hand, both artists had good friends on the opposite side of the political divide. Back in 1799, Constable's initial introduction to Joseph Farington had been provided by Priscilla Wakefield, a Quaker writer and reformer who was actively involved in anti-slavery campaigning.[33] Turner too had acquaintances who were pro-abolition, notably the liberal Walter Fawkes, who is often credited with playing a part in changing the artist's sympathies. In later life it seems Turner came to adopt a pro-abolitionist stance. But even such a blatantly righteous statement as his 1840 painting *The Slave Ship* may well have had commercial motivations mixed in with its politics.

Fiscal considerations aside, printmaking was an important outlet for artistic expression. Turner, for the most part, preferred linear engraving. It was considered the 'highest style' and it suited the hazy subtlety of his effects. Constable on the other hand, never felt his style was sympathetic to it. Despite being introduced to the rudiments of etching as early as 1797, he had never published anything himself. As his reputation grew, there were a few approaches from engravers asking to reproduce his work. But in 1823, John Landseer had completely killed all feeling and freshness when he had reproduced one of Constable's Suffolk windmills.[34] Similarly, an 1829 engraved reproduction of the *Chain Pier, Brighton* by Frederic Smith had turned out harsh and formulaic.[35] When Edward Finden was subsequently asked to reproduce a view of Warwick for *Landscape Illustrations of the Waverley Novels* (another enterprise dominated by Turner), the engraver found Constable's art 'little fitted for line engraving'. For his part, the artist was also unsure. 'I am fearfull I can accommodate my art as little to his', he told a friend, 'as he can cause his to bend to mine.'[36]

Mezzotint, however, chimed a creative chord. In 1824, Constable had been solicited by Samuel William Reynolds, a mezzotint specialist who had worked with Turner on a couple of plates for the *Liber Studiorum*. In a similar way to that in which Charles Turner had petitioned Turner to reproduce *The Shipwreck*, Reynolds had seen the market potential of *The Lock*, and had reached out to Constable, asking if he could make a reproductive print at his own expense. Agreement was struck and a plate duly begun. In the end the project got no further than the preliminary stages. Despite a 'promising' start, Constable and Reynolds fell out and the plate was abandoned

only half-done. But within the murky depths of the aborted image Constable detected something exciting: hints of sensation, emotion, and chiaroscuro – the very things he was constantly chasing in painting.[37] It awakened an awareness that mezzotint might be worth pursuing at a later date. The medium was well matched to his facture. He liked the way it mimicked the texture and feeling of his brushstrokes. Where Turner's works were so often about airiness and light, Constable's were explorations of solidity and shadow and no other print process could do this justice quite as well as the dense tonality of mezzotint. Somehow, within its velvety richness, Constable sensed it was capable of retaining feeling – that sensory, emotive authenticity he considered so integral to his outlook. When he hit upon the idea of creating a printed record of some of his paintings, it was only ever going to be mezzotint he used for the job.

Unlike Turner, comfortably involved with printmaking for decades, Constable's only sustained venture came about at a particularly fraught juncture in his life. Six months after Maria's death, and three months after his election at the Academy, he was already struggling with the new roles thrust upon him: widower, single father and Royal Academician. To this list he now added print publisher. Anyone of a cautious disposition might suggest the timing was not fortuitous. It might be supposed he had enough on his plate without taking on a large and ambitious project within a completely unfamiliar line of work. But it was precisely to try and reconcile his new identities that Constable turned to printmaking. By the spring of 1829 he had determined to produce a series of engraved reproductions after his work – a semi-autobiographical curation brought together for the purposes of publication. The result was *Various Subjects of Landscape Characteristic of English Scenery*, a series comprising twenty-two mezzotints. More commonly known by its abbreviated title, *English Landscape Scenery*, it was originally published in parts between 1830 and 1832, before being issued in volume form in 1833. Plate by plate those subjects told a story. Some based upon finished pictures, others upon sketches, each one was selected for the part it played within the tale of John Constable. An individualistic blend of memorial and manifesto, it sought to confirm in print what the artist had long been striving for in paint: artistic recognition for the rural landscape of England.

So . . . a series of landscape mezzotints, released in parts, designed to champion its creator and the study of landscape. If any of that sounds familiar then there is good reason. No question that the concept and ambition for *English Landscape Scenery* notionally followed in the footsteps of the *Liber Studiorum*. More openly than on any other occasion, the form and function of Turner's creation begat one by Constable. It went against Constable's usual policy to model himself upon other artists, let alone Turner. In a fit of pique he had once christened the series the 'liber stupidorum'.[38] But jealousy aside, the *Liber* was an authoritative advertisement for the proselytising power of print. Constable wanted to share his beliefs in ways that could not be elucidated in paint alone. What better way than to produce his own version of the most celebrated and influential statement about landscape from recent years? Constable even set out to classify his compositions according to discrete categories, just as Turner had done. Though he ultimately abandoned the idea, early drafts use lettered initials to sort his work according to type; 'p[astoral]', 'f[ancy]', 'L[yrical]' and 'g[rand]'.[39] It is highly unlikely he would have had the confidence to forge ahead if Turner's seminal prototype had not already paved the way.

With little experience or understanding of the practical side of the process, Constable was in no position to commence printmaking alone. He needed an engraver who would be able to offer what Turner's experienced printmakers had done for him – the ability to print like he painted. Over the years Turner had built up a 'school' of associates. Constable found just one: a young man called David Lucas, a mezzotinter who had apprenticed under Samuel Reynolds. Lucas was just starting his career – working for Constable became his first steady employment – but he had the magic touch, translating paint to ink with such skill and sensitivity that it became a voyage of discovery for them both. A 'lovely amalgamation', Constable called it.[40] Lucas *created* Constable in print. He became like the artist's shadow – a dark mirror. But equally and vice versa, Constable *made* Lucas a printmaker, becoming the raison d'être for his finest and most definitive work. The whole was creatively greater than the sum of the parts. Together, the artist and his colour-free counterpart went on to make some of the most charismatic mezzotints ever printed.

As one would expect, Constable's *English Landscape Scenery* covered very different ground to the *Liber Studiorum*. The respective frontispieces are enough to flag the difference. The lead image for the *Liber* is a decorative capriccio designed to symbolise the thematic scope of the contents (fig. 26). With relics of the past side by side with contemporary clutter, it is a glorious artistic miscellany – an imaginary mish-mash of the fantastical and the humdrum: a mythological painting, a Gothic wall, a Roman cornice half-submerged in a river bed, a caduceus a midst some cow parsley, funerary fragments and dead fish, urns and oars, eggs and weeds. It is like looking into the lumber room of Turner's 'wonderful range of mind': the bits and pieces stored in jumbled readiness, awaiting the exercise of his genius. No other artist could claim command of such a vast array of resources. What is missing, of course, is any sense of the artist's individual origins. It would not have occurred to Turner to cite his upbringing as something pertinent to his art.

If the opening illustration to the *Liber* is like looking inside Turner's head, the *English Landscape Scenery* frontispiece speaks straight from Constable's heart (fig. 29). It contains no panoply of elevated references. There is just one leading image: an artist sketching a country lane and a house, which the caption reveals is in 'East Bergholt, Suffolk'. In fact it is a view of Constable's birthplace, the house built by Golding Constable. Beneath the plate is an accompanying inscription – in Latin, naturally: 'This spot saw the day spring of my life, Hours of Joy, and years of Happiness. This place first tinged my boyish fancy with a love of the art, This place was the origin of my fame.' Constable's message could not be clearer. East Bergholt was not just where he had been born. It was the source material for his art – a focused, inward-looking form of expression that relied on nothing more (Constable would like us to believe) than a commitment to looking and an emotional bond to place.

Turner had employed mezzotint in the *Liber Studiorum*, partly because it imparted an aura of historic validity, but also because it was a useful technique for imposing drama and narrative upon already theatrical subjects. Constable, by contrast, was interested in finding visual interest and grandeur in landscapes that were not inherently dramatic. His hunch that mezzotint would suit him was borne out by the way it embodied 'chiaroscuro' – the powerful

Fig. 29. David Lucas, after Constable, *Frontispiece: East Bergholt, Suffolk*, 1831, mezzotint on paper.

striking contrast between light and dark. When he was a young man at the Academy, President Benjamin West had told him always to remember 'that light and shadow never stand still'.[41] Constable would forever equate this advice with the vitality and specificity of the fleeting moment, a vehicle for movement and an allegory of temporality and fragility. He used *English Landscape Scenery* to expound his beliefs concerning what he called the 'chiaroscuro of nature', the artistic effects bestowed by the natural interaction of light and shade.[42] The tonal kinship of mezzotint perfectly fitted that credo. Other intaglio processes could not deliver such punchy contrasts between glittering whites and soft, smoky blacks.

Constable also understood that the duality of light and dark was interlinked – the one depended on the other. Thanks to the medium's reductive modulations it was easier to introduce small touches of the opposite element: tendrils of black creeping through the brightness or highlights piercing the inky gloom.

So, far from being an exercise in imitation, *English Landscape Scenery* was more like a sequel to the *Liber Studiorum*. It was not a discourse about variety, but rather Constable's answer to topics he felt Turner had neglected or misunderstood. If we characterised its subjects according to the *Liber's* landscape types, nearly all of them would fall into one category only, the 'Pastoral'. The overwhelming majority depict agricultural or rural settings. Even here there is limited variation; over half of the book is devoted to Suffolk, and there is no attempt to elevate the scenes according to the usual idealising precedents of the genre. Instead, the locations represent places intimately associated with the author's life, particularly his artistic development and his time as a married man. His objective was not to show breadth of landscape, but rather its varieties of effects; its personal resonance rather than its public applications. And whilst the mezzotint series opened with the artist's birthplace, it ended with a view of Hampstead, with London just visible in the distance.[43] This scene too was captioned in Latin, revisiting that haunting reminder from East Bergholt church about life and death: 'ut umbra sic vita' – life is like a shadow. Hampstead was the place where Maria had died and where she was buried. It was an appropriate way to bookend his life up to this point.

To some extent the whole *English Landscape Scenery* project was an exercise in dwelling upon the past and coming to terms with change. Having never shown much interest in printmaking before, it was an extraordinary volte-face for Constable and it is tempting to see it as a subconscious attempt to impose order on a life recently thrown into chaos. If painting was 'but another word for feeling', then printmaking was a way of coming to terms with those feelings and bringing them back under a semblance of control. The very act of rethinking his landscapes in terms of black and white was like an act of mourning and remembrance. Constable in mezzotint took on a very different look and feel from Constable in paint. When translated into print, the coloured effects from his paintings became

more explicit, often appearing wilder, stormier or more dramatic (fig. 29). The mood was heightened, the sensations more intense. Lucas's 'rich and feeling manner' seemed to ooze emotion, its dark qualities automatically hinting at dark feelings.[44] This was not just a translation of Constable, it was a fiercer and more fervent iteration.

Unfortunately, any creative catharsis was eroded by the practical pressures of the project. The self-financed undertaking caused Constable enormous stress and anxiety. 'Oh for a feather out of Time's wing,' Turner had declared over his work agenda in 1831.[45] Constable would have wholeheartedly agreed with him. 'I feel I have too many ties in life to be happy,' he told Lucas in 1832. 'I often wish I had the wings of a dove – & then I would flee away.'[46] Struggling with grief, poor health and the difficulties of balancing work and children, he became overwhelmed with self-doubt and depression. His correspondence with David Lucas reveals his fluctuating mental state and at no point does one feel sorrier for him than in the letters he wrote during the intensive time leading up to publication. They make for uncomfortable reading. From the beginning of 1830, over the course of some 137 letters, the words 'anxiety' or 'anxious' appear repeatedly, crescendo-ing up to a crisis point of four times in one letter on 25 June 1832. Constable's anxiety is further articulated by a litany of other pessimistic language: distressed, grieved, despair, sad, fear, vexed, perplexed, nervous, disappointed, blighted, hateful, hopeless, worries, painful. He calls the project the work of the devil, conceived 'in evil hour', and says it has been nothing but a 'great interruption of my time and my peace of mind'.[47] Half fearing he might end up in St Luke's (the madhouse that had once hosted Turner's mother), he even began to characterise his mental state in terms of chiaroscuro-like polarities, describing himself as thinking 'too darkly' and being 'desirous of lightening' his mind.[48] By engaging with mezzotint perhaps he was trying to find some light within the darkness. But increasingly it was the darkness that played upon his mind.

One of his most anguished outbursts concerned the print of *The Glebe Farm*, meant as a tribute to his patron the Bishop of Salisbury. Distressed by some of Lucas's additions, Constable declared the plate 'utterly utterly aborted'. In an awful letter of December 1831, he vented his frustration in a rant of disconnected adjectives, amounting at times to an almost nihilistic stream of consciousness.

He said Lucas had achieved nothing less than 'a total absence of breadth, richness, tone, chiaroscuro – & substituting soot, black fog, smoke, crackle, prickly rubble, scratches, edginess, want of keeping, & an intolerable & restless irritation'. He went on: 'I frankly tell you I could burst into tears – never was there such a wreck. Do not touch the plate again on any account . . . I could cry for my poor wretched wreck of the Glebe Farm.'⁴⁹ This barrage of negativity can have been no more pleasant to receive than to write. Lucas was the junior contractor within the partnership and there are times when Constable's tone towards him borders on bullying. He harried him mercilessly for proofs, objected to him taking other commissions and even accused him of being too interested in money.⁵⁰

Truth be told, the working relationship between artist and print-maker was often fraught. More than once Turner had fallen out with an engraver: Frederick Christian Lewis; Charles Turner; and his association with William Butler Cooke had terminated after one of the most acrimonious quarrels of his life.⁵¹ With Turner, however, the problem was nearly always quibbles over money, not artistic differences. When he demanded alterations to a print in progress it was usually with good cause: a tiny, almost imperceptible adjustment, intended to raise the overall standard from good to exceptional. As much as this kind of micromanaging quality control might at times have been rather tough to take, his engravers usually respected his ability to diagnose tonal inaccuracies. Cooke even asked him to assess and correct proofs of work after other artists.

The Constable–Lucas partnership was rather different. Even though *English Landscape Scenery* was a more modest enterprise than many of Turner's projects, it was ambitious enough for Constable, who was managing the whole thing himself with only one printmaker at his disposal. For that reason it was unusually claustrophobic. Lucas was completely at the mercy of the older man's moods and whims. Although, in the main, he liked and respected him, he also found Constable a challenging employer. Just as he fretted about his painting, so it was with printmaking, a far less flexible and forgiving medium. He often changed his mind – sometimes midway through the engraving process. In an 1830 plate, *Stoke by Neyland, Suffolk*, he hit upon the idea of introducing a rainbow at a late stage. A similar afterthought occurred in his large painting *Salisbury Cathedral from the Meadows*

(1831); it is often read as a redemptive symbol of hope. But whilst that was a relatively easy adjustment to effect in oil, it was not so for the mezzotinter working on intractable steel. Lucas was forced to completely scrape away the tower of the church, re-rock the left-hand corner of the plate, reintroduce the building further away from the centre and burnish in a rainbow – all without ruining the work he had already done on the surrounding areas of composition. He did his best, but the ghost of the original concept is still visible in the proofs, a printed version of the *pentimenti* that are such a common feature of Constable's oils.

The artist's most psychologically revealing revision concerned the much-maligned *The Glebe Farm*. In 1832 he instructed Lucas to entirely rework the plate, transforming it from rural cottage to ruined castle – a metaphor for the time, money and energy he felt he had wasted on the venture. He had hoped that the series would promote and legitimise his landscape vision but *The Ruin* represented the collapse of his hopes regarding his legacy. 'This dreadful book', he called it by the end. 'I do consider [it] a heavy visitation, a real curse, upon me for my sins – and that it was the devil himself for first led me *step* by *step* to do it.'[52] Arguably, the project went on to spell ruination for Lucas too. Through no fault of his own, the unpopularity of Constable's prints hampered his career prospects going forward. As a reproductive engraver he would never escape from the monopoly of his association with the older artist. Tragically, when Lucas died in 1881 he was utterly destitute – a resident of a union workhouse in Fulham.

Part of the problem with the *English Landscape Scenery* scheme is that it was not a commercial success. Constable only sold about a quarter of the printed sets – mostly he just gave them away.[53] As his investment in the scheme was financial, as well as emotional, this represented a huge blow. Turner's print projects (aside from the *Liber*) were financed by the publishers, who not only paid for the artist's services but also carried the attendant costs of production, marketing and distribution. If a series ended up a monetary failure – *Picturesque Views in England and Wales*, published between 1827 and 1838, is the most notable example – it was not Turner who bore the losses. Constable, by contrast, had managed and funded every aspect of *English Landscape Scenery* himself, using Maria's inheritance from

Charles Bicknell. As it became clear he would not see a return on his money, he was haunted by the fear that he had squandered his children's birthright.

In an attempt to advertise the series, Constable wrote an 'Introduction' and published it as a prospectus in the *Literary Gazette*. Starting with a poetic quotation from Horace (more Latin), the text went on to explain his motivations for engraving his work.

> The Author rests in the belief that the present collection of Prints of Rural Landscape may not be found wholly unworthy of attention. It originated in no mercenary views, but merely as a pleasing professional occupation, and was continued with a hope of imparting pleasure and instruction to others . . . founded as he conceives it to be in a just observation of natural scenery in its various aspects. From the almost universal esteem in which the Arts are now held, the Author is encouraged to hope that this work may not be found unacceptable, since perhaps no branch of the Arts offers a more inviting field of study than Landscape.[54]

Buy my book, Constable was saying, because it is worthy and will bring you pleasure, not because I need the money. In truth, he felt it beneath him to engage in the disreputable business of 'trade'.[55] Once again, it is almost as though he was consciously crafting an identity in direct opposition to Turner, a man who regularly drew criticism for his acquisitive tendencies. An acerbic article by Edward Dubois in the *Observer*, 22 December 1833, satirised Turner's 'overweening love of filthy lucre'.[56] Yet despite Constable's disingenuous claim that his views had 'no mercenary' impetus, he nonetheless fixed sales at a price equivalent to the *Liber Studiorum*: one to two guineas per part (a set of four or five mezzotints); or five to ten guineas for the full twenty-two (those on India paper were more expensive, as were early, high-quality impressions called proofs).[57] Compare that to Turner's price for the *Liber*, which around this time was one guinea per number (of five plates) or fourteen guineas for the full set of seventy-one. In this sense, Constable had somewhat overpriced himself.[58] In what amounted to a pair of competing vanity projects, he was a less collectible artist, working with an unknown engraver, to produce an unpopular end result. As far as the market

was concerned it did not represent good value for money. By the end of 1834 he estimated he had lost at least £700 on the scheme.[59]

As it happens, both men were left with hundreds of unsold proofs of their respective projects – about seventy of each plate for Turner (though he had ordered a reprint in 1845); many more for Constable.[60] But whilst the *Liber Studiorum* had been acclaimed as a magnum opus, the contemporary reaction to *English Landscape Scenery* was lukewarm at best. As an Academic painter, Constable owed at least some of his success on the strength of his differences with Turner. In print he suffered by comparison. Turner was just too dominant, too self-assured and too prolific. His reputation lay with the *Liber* but his popularity rested with a whole multitude of products, from reproductions of his greatest oils to topographical series and book illustrations for literary works. Whether on copper or steel, in line or in mezzotint, the heights to which he pushed his engravers accounted for a shift in reproductive standards, but his authorial style was so strong that it easily superseded theirs. He set the benchmark for the way a nineteenth-century landscape engraving should look. What is more, with regard to the more challenging aspects of Turner's painting, printmaking calmed his colouring and brought clarity to his forms. As indicated by the critic of the *Literary Gazette*, some people actually preferred him in black and white. 'The pencil of Mr Turner,' they wrote about the *Rivers of England* series, 'appears to infinite advantage, simply rendered in black and white divested of the meretricious display of colours that to our plain view of things do not seem to belong to any or at least to very few of the objects of nature that have met our eye in a general way.'[61]

Where Turner's perceived problems were smoothed out, Constable's seemed to be exacerbated. Forms that looked rough in paint became even less legible in fuzzy mezzotint. Furthermore, the white flicks of his 'snow' were harder to ignore. 'Mezzotint . . . is not well suited to landscape,' wrote the *Spectator* in a review of a couple of the *English Landscape Scenery* plates. 'Least of all is it adapted to represent Constable's effects, except to bring out his faults more strongly; for it makes his cold, dark colours appear blacker, and his scattered lights white; thus exaggerating the raw tone of his later works.'[62] It is noteworthy that the writer went on to bring in Turner as the criterion by which to judge. In an era when consumers prized the lucidity and delicacy

they had come to expect in prints after Turner, the smudgy, smoky qualities of the Constable–Lucas aesthetic flew in the face of public taste and expectations. 'The glowing warmth of Turner's paintings subsides into sober brilliancy in engravings,' declared the reviewer, while 'the crude and cold colouring of Constable translates into harsh blackness and whiteness'.[63]

Looking back retrospectively, viewers familiar with modern photographic art forms are perhaps more forgiving. If one is conversant with Ansel Adams, or the moody vibes of cinematic genres such as film noir, then it is easier to appreciate the beauties of Constable's *English Landscape Scenery*. It might even be argued that its emotive qualities are easier for a contemporary audience to relate to than the antiquated look of Turner's unmistakably period pieces. As the first cataloguer of Constable's published prints wrote, 'The preference of one to the other is a question of personal taste, not of judgement.'[64]

Reproductive engraving suffered a sharp decline in the later nineteenth century. The change was in evidence at one of the most important cultural events of the Victorian era, the Great Exhibition at the Crystal Palace in 1851, the year of Turner's death. Watercolours and reproductive prints were still very much in use as methods of recording the many wonders and products on display, but this unprecedented celebration of industry and manufacturing also witnessed a new phenomenon – the introduction of photography as a means for recording and reproducing works of art. By the twentieth century, when photographic methods had evolved far enough to supply the requisite reproductive volume, engraving began to wane, as did public enthusiasm for it. As Turner's print cataloguer Rawlinson wrote in 1908, 'Photography has killed the beautiful art of Line Engraving in England.'[65]

There is a postscript to this chapter. A fascinating departure from Turner's conventional printmaking exploits was a group of twelve sketch-like mezzotints, speculatively known as the 'Little Liber'.[66] They were never published and very little is known about their purpose, dating or even attribution. But what *is* certain is that they go further beyond the expected limitations of print as a medium for imitation. Austerely atmospheric, they explore the energy of the light–dark tonality much more fully and expressively in mezzotint than in the embryonic watercolours from which they derive.[67] And it

TURNER AND CONSTABLE

is this misty, moody interpretation which comes conceptually closest to the synergy created by Constable and Lucas. The prints are the more fully realised work of art. It is highly unlikely, if not impossible, that these private (and probably earlier) experiments dreamed up by Turner had anything to do with Constable's *English Landscape Scenery*. Nevertheless, they show two very different nineteenth-century masters independently inching towards a similar realisation. Thanks to their shared commitment to the specifics of light, shadow, water and weather, we see them beginning to use printmaking as an original tool for landscape – not just a graphic reproduction, but a standalone work of art.

CHAPTER 9

BROTHER LABOURERS: LATE WORK

O N 1 JANUARY 1830, John Fisher wrote to Constable marking the start of a new decade:

> It is usual among friends to write congratulatory notes at these seasons, so in due form I wish you joy of the new year. And yet I know not why, for it is only to say that we are less young than we were, & have lost since this time last year, a tooth, a friend, or some of our hair.[1]

Around the same time Constable's likeness was captured in an intimate oil by Charles Robert Leslie: the first time his face had been painted for nearly twenty years (fig. 30). Gone is all trace of the handsome young bachelor who made the girls' hearts flutter in East Bergholt. In his place sits a greying, careworn, avuncular-looking man. As Fisher intimated, his hair has indeed receded. He wears the mourning black of a widower – a habit he kept for the rest of his life – and has an abstracted, faraway expression. It is a tender, sensitive portrait, but melancholy. Another drawing from around the same time (this one by Daniel Maclise) hints at ill health and depression.[2] Though absorbed in painting at an easel, Constable has a pinched and haggard look about him; his eyes are heavy, his face is lined.

Turner, respectively fifty-five to Constable's fifty-four, also had loss on his mind. His father had recently died. The garrulous old

Fig. 30. Charles Robert Leslie, *Portrait of John Constable, R.A.*,
c.1830, oil on panel.

gentleman had passed away the previous September and the bereave-
ment had hit the artist hard. 'Daddy' had not just been family but
friend, housemate and assistant, not to mention the man who had
encouraged his career from the beginning. 'My poor father's death
proved a heavy blow upon me,' he told the painter George Jones,
'and has been followed by others of the same dark kind.'[3] Three days
into the new year he scripted a condolence letter to his old friend
Clara Wells, who was mourning her sister, Harriet. Turner tried to
write about the soothing comforts of 'Earthly assurances of heaven's
bliss' but admitted they were 'not known, not felt, not merited by
all'. He signed off with the fervent wish that she would be 'more

successful in the severe struggle [with grief] than I have been with mine'.[4] These are rare flashes of emotion from Turner. Without being as eloquently expressive as Constable, his gloomy words speak to the depth of his sorrow and the disturbance of his mind.

Still the slightly scruffy, eccentric figure he had always been, Turner had no more interest in self-portraiture by this time than Constable. Older and stouter, his appearance lent itself more to caricature than formal representation. Leslie sufficed himself with a written description. Turner, he noted, had:

> a sturdy sailor-like walk. There was, in fact, nothing elegant in his appearance, full of elegance as he was in art; he might be taken for the captain of a river steamboat at a first glance; but a second would find far more in his face than belongs to any ordinary mind. There was that peculiar keenness of expression in his eye that is only seen in men of constant habits of observation.[5]

Something of that piercing gaze was captured in 1838 by John Linnell in the nearest equivalent oil portrait to those late images of Constable (fig. 31). Apparently painted from memory, Turner is similarly depicted in three-quarter-length profile. But where Constable seems lost in thought, Turner looks assessing, even a little fierce. The eyes are alert, but guarded, as if to keep the viewer at arm's length. Despite being one of the most famous, if not *the* most famous British artist of the day, he remained unapproachably enigmatic. Whilst Constable openly displayed the sartorial signs of the great love he had lost, Turner went to great lengths to conceal any suggestion of intimacy and personal feeling. Almost nothing was known about his private affairs, including the fact that he was by now in a committed relationship. Sometime during the 1830s he had entered into yet another secret liaison, this time with Mrs Sophia Booth, a widow with whom he had become intimate during seaside retreats to Margate. The attachment developed into a long-term arrangement, tinged with genuine affection. It brought his feelings for Margate full circle from his childhood, settling into something close to love and domesticity. Perhaps when Turner later claimed that the 'loveliest skies in Europe were found on the Isle of Thanet', he was thinking as much of happy weekend getaways with Mrs Booth as he was of the

Fig. 31. John Linnell, *J.M.W. Turner*, 1838, oil on canvas.

sea view.[6] Constable, incidentally, believed the finest view in Europe was that from his Well Walk drawing room in Hampstead, looking across from Westminster Abbey to Gravesend with the dome of St Paul's in the air.[7] Having traipsed over more of the Continent, Turner was the more qualified of the two to comment.

So, one an open book, the other secretive to a fault. No one looking at their portraits could be in any doubt that these were two very

different personas. Yet let us never forget the significance of Turner and Constable being almost exact contemporaries. As divergent as they were in background and personality, they were approaching the mature years of their lives simultaneously. At almost exactly the same time their works and actions began to reflect the shared experiences common to this particular stage of existence. Both had the attendant health problems usual with age. Both had suffered personal bereavements. As the years went by, the physical toll of the ageing process began materially to affect their practice. Changes occurred too in their mental outlook, as well as in the way their work was perceived by others – all of which inevitably started to impact the style and substance of what they painted.

The discourse about aesthetic lateness isn't simply a matter of dividing up a career into helpfully neat sections. It encompasses ideas about 'late style', a phenomenon whereby artists, writers or composers develop a new creative form or idiom towards the end of their lives.[8] With a creeping awareness of the effects of age and mortality, it may consciously or unconsciously incorporate ideas about death, decline and time running out. It might consolidate a lifetime's themes, or conversely manifest as a time of reactionary and experimental unrest, but it is an inclination that heralds an identifiable change, different from the previously representative oeuvre.

During the 1830s, Turner's and Constable's thoughts turned in parallel towards posthumous reputation and how to shape their individual legacies. A growing sense of mortality shifted awarenesses from past and present towards the future hence. This wasn't a process entirely within their control. If it is only thanks to others that we know what the two men looked like later in life, it is also due to others that they have been remembered as adversaries. Their differences fascinated their contemporaries, and as soon as Constable grew famous enough to be taken seriously as Turner's rival, it became customary to compare them. By the time he was an Academician, that habit had swelled to a compulsion. Among colleagues, critics, friends and the general public, it became a standing practice to identify one as the obverse or alternative of the other. In 1829, for instance, a critic had talked about 'poetry' compared to 'truth', as well as Turner's gold and Constable's silver.[9] In time this tendency hardened into a more confrontational kind of opposition.

The temptation to set them head to head became too much to resist. Entertaining accounts began to emerge of friction, one-upmanship and even animosity. And whilst they contain relatively little detail, it is these stories that have been the most widely circulated: well-worn old chestnuts, repeated and dramatised so often they have passed into legend.

Flying in the face of tradition, a counter-argument can be made. Whilst anecdotal testimony has tended to characterise this as a period of great rivalry, there is evidence that points to the contrary – that Turner and Constable's last shared decade was a time of collegiate friendship and mutual respect. Far from being furthest apart, the 1830s found Turner and Constable in greatest alignment; 'brother labourers', as Fisher had described them.[10]

It is worth remembering that only a small handful of direct interactions between the two protagonists were ever meaningfully documented. As a rule, where records were made, they relate to moments like the 'wonderful range of mind' dinner conversation of 1813 where something colourful was said or done (see Chapter 4). Naturally, the two men crossed paths far more often. After Constable was made an Academician, the regularity of these occasions increased. Becoming one of the 'august forty' (as the RAs were known) immersed him within the same world of institutional responsibility and privilege which Turner had been part of for years. Consequently, by the later stages of their lives they were in each other's company more than ever before. It simply cannot be believed that, during the dozens of occasions they met between 1829 and 1837, they did not have more conversation than was sporadically and selectively chronicled.

What is more, whenever they *were* in a room together, Constable and Turner were more commonly allies than enemies. As associates within an elite fraternity, their professional offices generally had them pulling in a similar direction. Although they never served together on the Council (a rotating body of eight members, plus the president, responsible for the direction and management of all the Academy's business), they attended many General Assembly meetings at the same time, unanimously working towards the goals of the institution to which they had both pledged loyalty. More specifically, they were jointly active in the field of charitable giving – a cause genuinely dear to both their hearts. Both had long been members of

the Artists' General Benevolent Institution (AGBI), an independent committee founded 'to relieve decayed Artists; and to afford assistance to their Widows and Orphans'. United by a humane sympathy for fellow practitioners, they regularly committed time and energy towards helping artists less able to support themselves. Where possible they extended these philanthropic principles within the Royal Academy. Both regularly proposed or seconded the granting of funds to deserving applicants. Indeed, nearly every scrap of business Constable is ever minuted as actioning during his time on the Council was a beneficent act in aid of the needy. Turner, meanwhile, made charitable giving a material part of his last will and testament, first drafted the day after his father's funeral in 1829, with various codicils and revisions through the 1830s and 1840s. His estate was intended to support legacies for the AGBI as well as a charity of his own establishment.[11] The intended recipients were 'poor and decayed male artists being born in England and of English parents only and lawful issue'. Not universally liberal, then. But it shows the kinds of values Turner held as sacred and the exclusivity of the social group with which he most strongly identified.

An illuminating example of a moment which united Turner and Constable during their later years was the demise of Sir Thomas Lawrence. The president's untimely death on 7 January 1830 was sudden, distressing and a huge blow for the art world. Shock waves reverberated around the Academy. Emergency meetings were convened to coordinate the institution's response. As was expected of a new member, Constable had just started a two-year rotation serving upon the Council (replacing Turner, who had just come off it). This meant that Constable's first official duties as an Academician were unfortunately all about death. He was plunged straight into mourning arrangements and funeral minutiae. Coming so soon after his own bereavement, this must have triggered many unhappy memories. He had to attend at least eight meetings within ten days, hammering out details such as the supply of proper mourning garb to in-house servants, and the order of precedence for the cortege. As a Council representative he was obliged to be part of the group that 'respectfully received' Lawrence's casket at Somerset House, where it lay in state in the Model Room, appropriately transformed by candles and black cloth hangings.[12] On the day of the funeral, the

family and other mourners were received for refreshments in the Library and the Great Room, before processing behind the hearse through the January snow to St Paul's Cathedral for the ceremony. It was a dispiriting way to commence his life as an RA.

Turner's involvement in Lawrence's funeral dredged up dark thoughts for him as well. 'We then were his pall-bearers,' he wrote to the absent George Jones. 'Who will do the like for me, or when, God knows how soon.'[13] Since none of the eight individuals listed as carrying the coffin within the newspapers were painters, Turner must have been part of an artists' honour guard appointed to bear Lawrence out of the Academy on his final journey. During the service itself, he was seated between Constable and David Wilkie. The latter became inappropriately animated by the 'fine effect' of the ceremonial dress, the 'sable trappings' and splendid appearance of the city marshal's hat. He whispered loudly: 'Don't you find a cocked hat a very difficult thing to manage in a picture?'[14] Considering the reaction unseemly, Turner 'turned away with disgust'. This caused Constable to reflect approvingly that Turner 'had a great deal of good feeling about him'.[15] Grief had made them both sensitive.

Lawrence's passing gave the two men much pause for thought. After all, he had been fairly near them both in age, being only six and seven years their senior. And as lionised as the portrait painter had been in life, after his death he was found to be deep in debt, with a studio full of unfinished works. A major cause of his insolvency was his collection of Old Master drawings, one of the finest ever assembled. These he had intended to offer to the nation at an advantageous price, but instead the bequest went unfulfilled and the works were sold off to pay his many creditors.

These sad revelations touched a nerve. How short was life; how fickle fame. Turner poured his feelings into a watercolour remembrance of the funeral.[16] A strange scene, full of melancholy tension, it appears to question the paradox between public pomp and pageantry and the fragility of celebrity. Against the solid stone backdrop of St Paul's, the grand carriages and assembled crowds seem but temporary trappings. How long does a person's memory live on, Turner seems to be asking. Only as long as the shadows cast by a pale, wintry sun. Constable tended to talk about 'life being like a shadow'. Turner called it the 'fallacy of hope'.[17]

At the same time as Turner's watercolour was on display at the Exhibition, Constable made his own symbolic gesture. He presented the Academy with a special gift: the palette of Sir Joshua Reynolds.[18] Formerly owned by Sir George Beaumont, it had been bequeathed to Lawrence. After his death, Constable purchased it for twelve guineas from the sale of Lawrence's effects. He donated the object complete with a mahogany case and commemorative inscription honouring all three Academy worthies on a silver plate (the handiwork of David Lucas), thereby cementing his own name with ideas concerning the traditions and continuity of the institution. The new president, Martin Archer Shee, wrote to thank him. He went on: 'I sincerely hope that it may be many, many Years before that which You now so well employ shall become an object of similar veneration, to those who may be anxious to mark their respect for personal and professional worth.'[19]

Not to be outdone, the following year Turner emulated Constable's example. He too purchased a palette, this one formerly used by William Hogarth, and bought from the studio sale of another Academician, John Jackson. If Constable could weave himself a place in Academy history, then so too could Turner. Like his colleague before him, he presented it complete with engraved silver plaque and glass display case, although not before he had ascertained whether he had to fund these things himself. Constable was highly amused when Eastlake was sent as a 'secret' emissary to enquire if the Academy had stumped up for the embellishments. 'I told him no,' wrote Constable to Leslie; 'all the attendant expenses was borne by me – £5 or £6 the plate, the case 3.3.0 0 – he [Turner] will be greatly annoyed by being obliged to take my folly as precedent.'[20] These souvenirs set an interesting example, and one that had enduring longevity. In due course, artists' equipment owned and used by Turner and Constable would eventually enter the Royal Academy collection.[21]

It was not only business happenstance that threw the two men together. Relations genuinely seem to have settled into a friendly understanding, and for the first time in their lives, the pair were actively choosing to mingle with one another. Turner had always done most of his socialising with other artists but Constable less so, sometimes holding himself deliberately and truculently aloof. Now that he no longer felt marginalised, there were a number of

jovial get-togethers, such as one at the end of December 1830 when Constable topped off a day of 'continuous delight' by passing 'the evening with Turner at Mr Tomkisons'.[22] Constable told Leslie he was 'delighted' with his day, 'the relish of which is yet lively in my mind'.[23] Surely many things of interest were said that sadly escaped record. There were also intimate dinners, like the one where Constable noted he 'dined with Jones & Turner, snugly – alone',[24] and a more raucous affair at Shee's with 'a most wretched display' of Academicians in attendance, saved when 'Jones & Turner, came with timely releif [sic], just before dinner was served'.[25]

There were also other signs of fellowship. Provoked by the contemptuous comments of a wealthy visitor to his studio, William Wells, Constable wrote to Leslie concerning his ire:

> I felt annoyed about Mr Wells . . . he wishes Turner & me at the Devil . . . I had 'lost my way' – Turner was 'quite gone' – lost and possessed by a yellow which he could not see himself . . . More self satisfaction in his own opinions of the 'art' of which he knows nothing, I never saw.[26]

The irony is that not so long ago, Constable would have been more likely to join in with this kind of criticism than refute it. Now, he was happy to refer to 'Turner & me' as a pair – the champions of 'poor dear landscape' – coming under attack for the same things.

All of this suggests a level of amicability that has generally been expunged from the usual record. Maybe Turner increased his attentions to Constable because he was an RA. Or perhaps it was because he was a widower. Despite his gruff exterior, Turner possessed a seam of kindness. He had acted in a similar manner to Sir John Soane, spending Christmas Eve with the architect after the tragic loss of his wife in 1815.[27] Whatever the motivation, the early 1830s saw a veritable détente between Constable and Turner which makes subsequent reports of discord all the more questionable.

The idea that the two men were adversaries – if not actually enemies – largely rests upon just two accounts. Both concern the competitive machinations of the Exhibition. Neither originates from the participants themselves. Whilst it is not to be disputed that the incidents took place, questions have been raised in recent years

concerning the spin applied to their telling or interpretation.[28] Context is everything. In the name of historical integrity it is well worth reassessing these two related episodes with an open mind, reinserting frames of reference in order to sort the fact from the friction.

The first alleged altercation took place in the run-up to the 1831 Exhibition. For the second time in his life Constable was taking his turn upon the Selection Committee, a task he must have approached with considerable trepidation. No wonder the job was referred to with gallows humour as 'Hangman'. It involved a tricky mix of curatorship, administration, man management and general troubleshooting. Constable had not had a comfortable time of it during his inaugural outing the previous year, running afoul of the tactical minefield it represented. Things were not much better the second time around. He was given responsibility for hanging the paintings but aspersions were cast against him of favouritism and unfair practice. He was openly accused in the newspapers of deliberately placing other landscapists at a disadvantage. One journalist in particular seemed to have it in for him. Edward Dubois, a wit with a vicious style of criticism, christened him the ' "fell Sergeant", or rather the Constable of the Academy'.[29] He charged him with the 'strangulation' of painters who supposedly posed a threat, mentioning by name exhibitors George Arnauld, C.R. Stanley and F.R. Lee.[30]

As defamatory as these allegations were, none of the purported 'victims' were particularly well known. Dubois, however, had missed a trick. Oddly, the real gossip of the season seems to have passed him by. Within the Academy the rumour was that someone *had* been slighted: an artist much more high profile and newsworthy than the Stanleys, Lees and Arnaulds of the world. At a late stage during the hanging process, Constable had switched the position of his own painting, *Salisbury Cathedral from the Meadows* (fig. 32), with one of Turner's. Either *Caligula's Palace and Bridge* or *The Vision of Medea* had been shunted from a central position, so that the Turner pairing was separated and *Salisbury Cathedral* went in between them.[31] Together these three large paintings occupied nearly three-quarters of one wall's width at the upper end of the Great Room – a highly visible swap.[32] Given Turner's track record, any to-do involving him was bound to set tongues wagging, but the fact that this one had been instigated by Constable was positively inflammatory: a gift to the scandalmongers,

Fig. 32. Constable, *Salisbury Cathedral from the Meadows*, 1831, oil on canvas.

eager to leap upon any hint of conflict between the self-styled leading light of landscape and the main challenger to his throne.

One such individual may have been the artist David Roberts, to whom we owe the account of the affair's fallout. Long after both subjects were dead, he gave the following story to Turner's biographer, Thornbury:

'We had met one night at the General's,' says Roberts, 'shortly after the hanging of the Royal Academy. Constable was, as usual, lavish of the pains he had taken and the sacrifices he had made in arranging the Exhibition. But, most unfortunately, he had, after placing an important work of Turner's, removed it, and replaced it by one of his own. Turner was down upon him like a sledgehammer; it was of no use his endeavouring to persuade Turner that the change was for his advantage, and not his own. Turner kept at it all evening, to the great amusement

of the party; and, I must add, he (Constable) richly deserved it, by bringing it on himself.'[33]

As highly charged as Thornbury makes the situation sound, his summary is toned down compared to Roberts's original journal account, discovered during the 1980s. In this version, still penned at least twenty years after the 1831 event, the language used to describe the encounter is positively vicious. Instead of coming down upon Constable like 'a sledgehammer', Roberts describes Turner as opening 'upon him like a ferret' and 'it was evident to all present [he] detested him'.[34] Constable meanwhile 'wriggled' and 'twisted . . . like a detected criminal' and Turner 'slew him without remorse'. In summary, the gist is far more uncomfortable. Rather than being an amusing case of Turner barracking Constable for the entertainment of others, Roberts portrays it as a hate-fuelled attack which 'all present were puzzled what to do or say to stop'. Furthermore, the author's partisan dislike of Constable is blatant. As (at the time) a youngish outsider, trying to make the transition from set designer to academic artist, Roberts was a great admirer of Turner, whose tradesman's background was close to his own (Roberts's father had been a shoemaker). Constable, by contrast, he labelled 'a conceated [sic] egotistic person' and 'abusive & not sparing of any one else'. He cannot be considered an objective witness.

It seems perfectly plausible that Turner may have communicated *some* reaction to the moving of his works, even if only to save face. He was, after all, a senior member of the establishment with a long-standing history of competitiveness. But there is a vast difference between verbal teasing and verbal assault. Turner's sense of humour tended towards the robust, but the enmity outlined by Roberts seems totally out of character for someone widely renowned for his reticence. And how controversial were Constable's actions anyway? By bumping Turner, Constable has been described as 'overplaying his hand'.[35] But those three large works were always going to be seen together; it was just a question of which went in the centre.

From a curatorial point of view, it is conceivable that Constable's actions were justifiable. There were 192 pictures in the Great Room that year, contributed by 130 artists, including at least 16 Academicians. The 'hangman's' near impossible challenge was to

somehow turn this disparate jumble into a balanced display that attempted to show *everyone* at their best. As if that wasn't difficult enough, Turner's bold aesthetic tended to make the task even harder. Considered visually jarring to contemporaries, it was notorious for 'playing the devil' with whatever was unlucky enough to be hung next to him.[36] The two 1831 exhibits in question were classic examples of this, being grand, mystical and esoteric paintings, entirely dominated by Turner's (now) trademark yellow. The effect of one would have been like a jarring, discordant note amidst a melodious choral hum. Two together would have been untenable, concentrating the impression of filmy yellowness to the point where it skewed the general arrangement of the entire room. Splitting the pair up and neutralising them with something darker and low-toned in the middle made sense, not just for Turner's benefit, so that the pairing 'did not knock each other out',[37] but for the good of the whole hang. At a late stage in the installation process, there may not have been anything else suitably sized other than *Salisbury Cathedral* that could have effectively done the job without disrupting the existing pictorial jigsaw. The displacement was minor and if anything it helped, rather than damaged, Turner's cause. *Caligula's Palace and Bridge* received a very positive reception – a situation that might have been reversed by proximity to *The Vision of Medea*, a painting that was almost universally disliked (as it had been during its first exhibition in Rome in 1828). In all probability, it wasn't so much Constable trying to upstage his rival;[38] it was that he was trying to prevent Turner's works upstaging everyone else.

In retrospect, what seems more interesting than any perceived tactical slight is that Constable was willing, even eager, to place his work in direct contention with two of Turner's big hitters in the first place. If he did indeed orchestrate the juxtaposition, what was he hoping to achieve? Was it, as has been suggested, all part of a plan to endorse the equality of his 'brand' of landscape, 'hauling Constable up alongside Turner to be lauded and berated as his equal'?[39] Or was it less rivalrous than this – more an act of tactical alliance than of opposition?

Constable's work had recently begun to betray new tendencies that could conceivably be described as 'Turneresque'. Attributes such as a more symbolic treatment of landscape; longer, more convoluted

titles for his paintings; poetical extracts appended in the catalogue; and subject matter that echoed Turner's. *Hadleigh Castle*, for example, embodied all of these trends (see the related sketch, fig. 40). A melancholy view of a lonely ruin, it was exhibited in 1829 with verses taken from James Thomson's *Summer*, a well-known point of reference for Turner. The full title – *Hadleigh Castle, the Mouth of the Thames – Morning after a Stormy Night* – has been described as 'Turnerian in its extent and its descriptive information'.[40] It even ventured into territory made famous by the London artist, featuring as it does a view of the Nore anchorage in the Thames Estuary.

Salisbury Cathedral – or the 'Great Salisbury' as the artist liked to call it – was an especially powerful change of pace, moving from the intimate 'natural painture' of Constable's Suffolk rivers to a more staged and monumental treatment of place. The personal references were still there – Salisbury would always be associated with John Fisher and his uncle, the bishop – but it also contained more topical allusions. A conservative traditionalist at heart, Constable was concerned about political reform and its effects upon the social status quo. The lightning storm lashing the cathedral spire is now widely understood to be a metaphor for attacks upon the authority of the Anglican Church.[41] Verging on the sublime, such an imaginative interpretation of weather is not something Constable would have countenanced at an earlier point in his career. Dramatic, complex, heavily weighted with symbolism: it was, in short, a more Turner-like approach to landscape.[42] Turner had employed lightning in *Stonehenge*, a watercolour for *Picturesque Views in England and Wales*, published in engraved form in 1829.[43] With a bolt blasting the Neolithic stones on Salisbury Plain like a symbol of divine retribution, the image includes a shepherd and some of his sheep, killed by a direct strike. A year or so later a companion image of Salisbury Cathedral itself had followed, this time with a hale and hearty shepherd standing guard over his family and flock, as a rainstorm passes overhead.[44] Where Constable's religious edifice appears beleaguered, Turner's stands encircled in light, as though responsible for breaking up the clouds – indicative perhaps of his differing views on political change.[45]

Surely it is telling that Constable chose to bracket *Salisbury Cathedral* with paintings by the one artist whose work had exactly the right combination of qualities to validate and complement his

own? Not only had Turner legitimised landscape as an intellectual pursuit, but he had also brought picturesque subjects front and centre into the Academy, blazing the trail in which Constable now trod. Additionally, his paintings regularly came in for as much critical abuse as Constable's, if not more. The two men's styles may have been very different, but what they had in common was a liberal use of paint and the willingness to explore nature through the materiality of the medium. Since the nineteenth-century preference was for smooth surfaces and fine brushstrokes, any moment when a contemporary viewer became overtly aware of the paint itself – be it the colour, thickness or texture – was generally a problem. It literally interrupted their vision, compromising their ability to accept the artifice of the surface.

Almost from the outset of their careers, both men had been vilified for the formal aspects of their styles, sometimes with idioms that were remarkably similar. The implications tended to veer towards expressions of unhealthiness – things that were painful to the eye, symptomatic of diseases of the body or mind, or marring the complexion of the painted surface with regrettable pockmarks and imperfections. Gradually these had coalesced into repetitive tropes – superficial, pejorative language that ridiculed without meaningful analysis. A broad survey of reviews from 1828 and 1829 alone shows how often these phrases were recycled. Turner's tended to centre around colour (extravagant, tawdry, wild or mad): in particular, satirical synonyms for yellow (mustard, jaundice, fever and so on). Constable's meanwhile had settled upon his tendency to scatter the surface with white highlights ('spotty', 'snow' or 'white-wash'). Intriguingly, one of these expressions was attributed in the papers to Turner himself. In what might easily be another example of spurious pot-stirring the *Athenaeum* and the *London Magazine* named him as the originator of the comment that Constable's effects were like the splashings from a white-washed ceiling.[46] In fact, as we know, this idea had cropped up much earlier, in response to *The Hay Wain* in 1821. Even if Turner had said something of the sort, he wasn't the only one throwing witticisms around in 1829. Constable had no compunction about repeating some of the medically themed hearsay circulating about Turner that year, including a doctor likening one of his pictures to a 'spitting box at a hospital', and Samuel Rogers's rather unkind

comments that 'Turner had more "lucid intervals" than usual' and 'would soon be seen in such "waistcoats" as other people wear' (i.e. instead of a straitjacket).[47]

By 1831, there was an inevitability to the rhetoric. Since *Caligula's Palace and Bridge* and *A Vision of Medea* were prime examples of Turner's yellowness, and Constable's handling of paint in *Salisbury Cathedral* was even more lively and fragmentary than usual, the critical response might have been expected to result in a foregone conclusion. Were Constable's actions an attempt to try to control the response, lending credence to his own technique by optically yoking it to Turner's? If in the minds of others they represented opposite ends of a baffling visual scale, why not close ranks and stand together? It had already been noted in the past that the most obvious foil to Turner's torridness was a cooling breath of fresh air from Constable. Assuming the effect cut both ways, the perfect counterbalance to criticism of Constable's 'snow' and 'cold' was to offset it with an adjacent hit of golden warmth. Reciprocal contrast invited easy, even lazy comparison, but for the sake of strengthening his hand, Constable was perfectly prepared to buy into that dialogue, fighting fire, as it were, with fire (or in this case water). If so, it worked admirably. Addressing the formal qualities of the two men's work, the press went to town with a slew of metaphorical pairings which hitched the artists together as an elemental double act. 'Fire' and 'rain', trumpeted the *Englishman's Magazine*. 'Fire and Water', agreed the *Literary Gazette*: 'the one all heat, the other humidity'.[48] 'If Mr Turner and Mr Constable were professors of geology instead of painting,' the paper went on, 'the first would certainly be a Plutonist, the second a Neptunist.'[49] The *Observer* (Dubois again) considered the pairing a stunt. He described 'Mr Constable's coarse vulgar imitation of Mr Turner's freaks and follies – a mimicry of his extravaganzas, to attract notice, without any of their poetical feeling and clear indication of a masterly genius to repay the attention bestowed'.[50] The general consensus was more generous. 'Who will deny that they both exhibit, each in its own way, some of the highest qualities of Art?' asked the *Gazette*. 'None but the envious and ignorant.'[51] Dubois take note.

Constable was never in a position to hang Turner's work again. He died before his Selection Committee duty came around again. Can anything be read into the fact that even after he was gone, many of

Turner's paintings from the 1840s relied for compositional impact upon the chromatic contrast between tonal opposites – blues, blacks or silvery greys on the one side; reds, yellows and oranges on the other? Some were even conceived in pairs: *War. The Exile and the Rock Limpet* and *Peace: Burial at Sea* (both exhibited 1842); or *Light and Colour (Goethe's Theory)* and *Shade and Darkness – The Evening of the Deluge* (1843). These were examples of thematically linked pendants, designed to be shown side by side. Whether consciously harking back to his late colleague or not, Turner's later colouristic experiments echoed the striking visual impact introduced by putting his paintings next to Constable's. The allegorical comparisons had endured, cropping up in various guises: the need for an umbrella compared to a fire screen when viewing their respective works;[52] or the nicknames of 'Pepper' and 'Mustard' purportedly bestowed by Academy students during the 1830s.[53] Even Leslie ended up equating them as 'Gold' and 'Silver'.[54]

It was Leslie who provided posterity with its best-known anecdote – the famous (or infamous) 'Waterloo Bridge' incident of 1832. Even-handedly told within his *Autobiographical Recollections* (published in 1860), this colourful story unwittingly became the main source for the idea that Turner and Constable were rivals. Nobody else chronicled it, either at the time or subsequently. Were it not for Leslie, we might so easily never have heard of it. Yet, rightly or wrongly, this brief encounter has become the basis for a contentious melodrama.

As told by Leslie, the story concerns events prior to the opening of the 1832 Exhibition. In what was possibly a mischievous bit of scheduling, paintings by Turner and Constable had once again been hung directly next to one another.[55] Turner was showing *Helvoetsluys; the City of Utrecht, 64, Going to Sea* (fig. 33), an understated marine piece in the Dutch style. Constable, meanwhile, had finally submitted *The Opening of Waterloo Bridge ('Whitehall Stairs, June 18th, 1817')*, the seven-foot canvas over which he had been agonising for years (fig. 34). Very different in size, style and subject matter, these two pictures had been placed side by side – a fact that was discovered by the two men on 'Varnishing Day', the time allotted to Academicians for touching up their work prior to opening. Leslie recounted what happened next:

Fig. 33. Turner, *Helvoetsluys; the City of Utrecht, 64, Going to Sea*, 1832, oil on canvas.

Fig. 34. Constable, *The Opening of Waterloo Bridge ('Whitehall Stairs, June 18th, 1817')*, 1832, oil on canvas.

In 1832, when Constable exhibited his 'Opening of Waterloo Bridge', it was placed in the school of painting – one of the small rooms at Somerset House. A sea-piece, by Turner, was next to it – a grey picture, beautiful and true, but with no positive colour in any part of it. Constable's 'Waterloo' seemed as if painted with liquid gold and silver, and Turner came several times into the room while he was heightening with vermilion and lake the decorations and flags of the city barges. Turner stood behind him, looking from the 'Waterloo' to his own picture, and at last brought his palette from the great room where he was touching another picture, and putting a round daub of red lead, somewhat bigger than a shilling, on his grey sea, went away without saying a word. The intensity of the red lead, made more vivid by the coolness of his picture caused even the vermilion and lake of Constable to look weak. I came into the room just as Turner left it. 'He has been here,' said Constable, 'and fired a gun.'[56]

Turner left his red blob sitting there for a day and a half. To all the assembled Academicians it must have looked like a parody of the red highlights Constable was even then applying to his adjacent painting. At the last moment the prankster returned and cleverly fashioned the 'scarlet seal' into a buoy floating in the foreground of his silvery sea.[57]

At face value, Turner's intervention can be read as the supreme example of a strategy that had worked for him for years. Where being noticed at the Academy was everything, he knew how to play the game – how to make his works stand out, how to see off competitors. That small red adjustment is evidence of his visual dexterity – the ability to diagnose the tonal weaknesses of a composition and correct it accordingly. The previous year Constable had used his own cool painting to dampen down one by Turner. This year, the shoe was on the other foot; it was Turner who was in danger of being overshadowed. A small pop of colour was perhaps all *Helvoetsluys* needed to draw the gaze of the viewer so that it could hold its own on the walls next to the more florid *Waterloo Bridge*.

Within the constructed narrative of Turner versus Constable, however, the incident has overwhelmingly been construed as a vindicative piece of trickery: 'a marker of painterly aggression', 'a shot

... out of the water', 'a provocative contrast' designed to 'upstage', or 'a clever, if mean-spirited, visual joke'.[58] Entertainingly reimagined in Mike Leigh's film *Mr Turner* (2014), the performative aspects were strung out as a moment of high tension. From the initial terse warm-up greeting between the two combatants to the subsequent knock-out punch (the red daub actually causes Constable to exit the arena, reeling like a wounded prize fighter), the movie version of the 'Battle of Waterloo' encapsulated a wonderful sense of Turner's brash chutzpah and Constable's nervous inferiority complex.

All of this stems from the interpretation of Constable's enigmatic 'fired a gun' statement as a hostile, militaristic act.[59] Turner's alleged shot has rung out across the centuries like the report from a pair of duelling pistols, or perhaps the boom of a cannon, set off from one of the ships in *Helvoetsluys*. By those interpreting the move as an escalation of the hostilities initiated in previous years, Turner has been understood as wounding *Waterloo Bridge* with a well-aimed snipe. 'Vengeance is mine; I will repay, saith the Lord of All.'[60] And the perceived validation of his revenge was the subsequent slating of Constable's picture by the critics, ultimately leaving it dead in the water. *Waterloo Bridge* was not well received. Even Leslie thought it a 'failure'.[61] The hectic, highly worked surface of Constable's river could not have been more unlike the restrained simplicity of Turner's seascape, and if the latter's red blob or buoy did anything, it perhaps drew even greater attention to the myriad touches for which Constable was by now notorious. When the *New Monthly Magazine* bemoaned the way the artist had 'mingled white and green so confusedly with little blots of red', it was one of thirteen reviews (out of a total of sixteen) that openly complained about the picture's spotted effect.[62]

Whether Turner was truly culpable for the painting's poor reception is highly debatable. Constable was more inclined to blame himself. He had never felt positive about the painting, variously calling it 'a blister', 'an abortion' and his 'Harlequin's Jacket'.[63] Owing to illness he had run out of time, and had been forced to submit it 'scrambling' in a 'sad . . . condition'. He was also unhappy with its installation – not that it was next to Turner, but that it was 'in the traffic between the doors' with 'light of the worst kind'.[64] Referring to the 'retributive' bias of the annual show, he told Leslie he was

reaping his just deserts for the 'hangman' debacle the year before – 'for I played the devil with others'.[65] None of this was helped by a reduction in the allotted time for varnishing and touching up. Constable was still working on it up until the last minute. Personal agitation generally led to an overworked surface, and his red additions were conspicuously frenzied. All this was in stark contrast to Turner's breezy Varnishing Day confidence and insouciance. 'Nothing can reach him,' Constable reflected: 'he is in the clouds.'[66]

Another factor working against Constable was that he was not the only Academician exhibiting a royal bridge opening that year. George Jones and Clarkson Stanfield also had bridge subjects, though theirs depicted a more recent construction, the new London Bridge, opened a few months earlier.[67] Amusingly, Jones's painting had been commissioned by Sir John Soane and featured cameo portraits amidst the crowd, including a profile of a smiling Turner. In this sense, Waterloo Bridge was old news and nearly everyone mistook Constable's subject – his fault for sitting on the subject for fifteen years. Another casualty of the long incubation period was the artist's personal subtext, Constable's metamorphosis from a Suffolk-based painter to a London one. Initiated back in 1819, *Waterloo Bridge* was conceived as a way to translate his interest in the River Stour to the Thames, a waterway with a more distinguished artistic heritage, not to mention a connection by proximity with the Academy at Somerset House. Given its panoramic cityscape and river pageant, comparison was made with Canaletto, but also Turner. Dubois facetiously remarked, 'Mr C appears to think that he is a Turner'; he wasn't, on this occasion, all that far wrong.[68]

Whilst the *Waterloo Bridge* episode has 'passed into art-historical mythology', different readings of the encounter have started to emerge.[69] Prompted in part by the film, and also by recent exhibitions that have reunited the two paintings for the first time since 1832, some scholars have indulged 'heretical' thoughts questioning the efficacy of Turner's blob as a premeditated act of reprisal.[70] Constable's reaction too has been reassessed. In what mood was the 'fired a gun' line uttered: bitter, angry, exasperated or amused?[71] Could it even link back to his own picture? There are celebratory cannon being fired from the bridge in the middle distance. What if Constable was imagining Turner lighting one of these and launching a projectile

of red pigment from Constable's work to his own? And surely it is necessary to recall the friendly fraternising that had recently begun to characterise the two men's social dealings with one another. If the estimated dating is correct, then the aforementioned evening involving Turner, Constable and Jones took place in February 1832, only weeks before the incident. Surely one does not have 'snug' dinners with people one is harbouring a grudge against?

Returning to the source material is essential. Leslie clearly indicates that the spirit in which the red daub moment took place was playful rather than aggressive. 'Turner was very amusing on the varnishing, or rather the painting days, at the Academy,' he wrote, immediately prior to recounting the incident in his memoir. 'I believe', he went on,

> had the varnishing day been abolished while Turner lived, it would almost have broken his heart. When such a measure was hinted to him, he said, 'Then you will do away with the only social meetings we have, the only occasions on which we all come together in an easy unrestrained manner. When we have no varnishing days we shall not know one another.'[72]

This gets to the heart of the matter. Turner's way of claiming comradeship with other painters was to interact with them on Varnishing Days. Surrounded by his brother painters was where he felt socially most at ease. If things were done to other people's pictures they were meant to raise a smile, either from the author or from the assembled company. A final snippet from Leslie (often overlooked) rounds off the account with the wider repartee sparked by Turner's stunt. 'On the opposite wall', says Leslie, 'was a picture by Jones, of Shadrach, Meshach and Abednego in the furnace. "A coal", said [Abraham] Cooper, "has bounced across the room from Jones's picture, and set fire to Turner's Sea." '[73] This is Royal Academy banter – well-meaning, affectionate, bonding, easily misunderstood. Turner too had painted the biblical subject, *Shadrach, Meschach and Abednego in the Burning Fiery Furnace* – a concurrence that was confirmed by George Jones as one of Turner's 'friendly contests'. Describing the cordial circumstances of the competition he went on: 'Our brother Academicians thought that Turner had secretly taken advantage of me and were surprised at our mutual contentment little suspecting

our previous friendly arrangement.'[74] Turner even engineered to swap the positions of the two paintings, giving Jones the more advantageous location. The critic of the *Literary Gazette*, however, chose to interpret this move in relation to Constable. Extending the fire/water metaphor from the previous year, he described Turner's *Fiery Furnace* as judiciously placed opposite *Waterloo Bridge* 'in order to prevent the room from becoming damp'.[75] The whole thing was a confusing web of recondite cross-references and obscure private jokes.

The *Waterloo Bridge* incident therefore can usefully be reframed as a moment of artistic badinage within an equable atmosphere of camaraderie. Rather than the final showdown in an ongoing war of attrition, it should be viewed within the history of practical jokes and hijinks that were part and parcel of the Academy community.[76] So many of these revolved around works being too hot or too cold. Jones once teased Turner that if he did not paint 'some cool and grey pictures the world would say he could not do so', leading Turner to take up the challenge.[77] It wasn't even the first or last time someone engaged in horseplay with Constable. In 1829, sculptor Francis Chantrey had 'interfered' with *Hadleigh Castle*, altering the foreground with a wash of asphaltum (a darkening glaze) in order to warm its coldness.[78] 'There goes all my dew,' Constable had remarked, before undoing the addition. Likewise, in 1835, Edwin Landseer took a peep at Constable's *Valley Farm* and 'could not resist the opportunity of having a good joke, so with three delicate touches of his magic pencil, he transformed [a] white spot . . . into a very pretty and intellectual-looking cat, without offence to any one'.[79] There is even mention (from Thornbury, so perhaps apocryphal) that on one occasion Constable actively licensed Turner's mediation:

'I say, Turner,' cried Constable, 'there is something wrong in this picture, and I cannot for the life of me tell what it is. You give it a look.' Turner looked at the picture steadily for a few moments, then seized a brush, and struck in a ripple of water in the foreground. That was the secret; the picture was now perfect; the spell was completed.[80]

For Turner in particular, teasing denoted professional respect. You knew you were someone if he was 'doing' you; this was less an attack

and more a badge of honour. Time and again we see him jocularly engaging with his peers, particularly a small group of cherished and admired friends and colleagues – Callcott, Stanfield, Jones. The 1832 reaction (if indeed it even referred to Constable and not Jones) was just another instance of this. A splash of red was not just an off-the-cuff reference to *Waterloo Bridge*. It was a nod to one of Constable's habitual tricks of the trade – a device to arrest the eye he might have in turn picked up from Hobbema, or the other Dutch masters. For years a well-placed red accent had helped direct the gaze and intensify the vibrancy of the complementary greens in Constable's exhibition works: in the harnesses of the horses in *The Hay Wain*; the waistcoat of the bargehand in *The Lock*; even the coat of one of the ladies in the foreground of the *Chain Pier, Brighton*. Either, in his stressed condition, Constable failed to get the joke, or it has since been misrepresented. Posterity *expected* and *wanted* a rivalry, and therefore may have engineered one, using this as the basis for something out of nothing.

Fig. 35. Turner, *The Burning of the House of Lords and Commons, 16th October 1834*, exhibited 1835, oil on canvas.

Turner continued to play around with the public twinning of warm and cool visuals. In 1835 he again unleashed fire, first of all this time at the British Institution, with an oil painting based upon a catastrophic conflagration that had recently destroyed the Houses of Parliament (fig. 35). The night the inferno took place – 16 October 1834 – Turner had been an eager onlooker, sketching events from a boat on the Thames. He probably wasn't aware of it but his subsequent painting basically included Constable, who had hurried to the scene in a hackney coach, and watched from Westminster Bridge with his two eldest sons.[81] The trio would have been positioned amidst the thronged crowds massed on the bridge within Turner's picture. Barely indicated but for gestural heads and arms hanging over the parapet, these figures have a vulnerability in their ant-like scale and appearance. Constable made a small sketch of the disaster in watercolour.[82] But the dramatic spectacle of fire and night were more in Turner's line of business, and compared to Constable's static, pedestrian record, his grand reimagining is biblical in its ferocity. Many contemporaries reviewed the disaster in allegorical terms: like an act of divine retribution or self-immolation following the political upheavals of reform.[83] Turner's painting revels in the cataclysmic sense of threat and peril. The end of the bridge is lit up like a touchpaper, as though the fire might burn straight across the river, incinerating everything, and everyone, in its wake. Turner created much of the scene in situ on Varnishing Day, a fact that seems to have added fuel to his reputation as a firebrand. Described as 'a magician, performing his incantations in public', he openly wielded his skills for all to see, and some interpreted his actions and its results with alarm.[84]

Turner also had several fiery scenes at the Academy Exhibition that year. One, *Keelmen Heaving in Coals by Moonlight*, contrasted moonlight with the fires of industry in Newcastle. Another was an alternative version of the *Burning of the Houses of Parliament*.[85] 'We seriously think the Academy ought, now and then, at least, to throw a wet blanket or some such damper over either this fire King or his works,' wrote the *Morning Herald*; 'perhaps a better mode would be to exclude the latter altogether.'[86] By ignoring the rules of conventional picture-making Turner was gaining a reputation as a radical reformer in his own right, an arsonist whose actions could

destroy the very principles of art.[87]

Constable, by contrast that year, was enjoying a rare moment of acceptance. He only had one picture on display, a large upright called *The Valley Farm*. A variant view of Willy Lott's cottage at Flatford, updated from *The Hay Wain* in a less naturalistic, more sentimental style, the picture had sold straight out of the studio, to an illustrious collector of modern British art, Robert Vernon.[88] It earned the artist £300 – more than he'd ever got for a painting before. Like Turner's paintings, *The Valley Farm* was compositionally constructed around a strong contrast between light and dark. But unlike the fantastical intensity of the 'fire King's' chromatic blaze, Constable's brightness was again cool and natural. He felt it 'preserved God Almighty's daylight' – a far cry from the apocalyptic heat of Turner's *conflagration*. Constable claimed (not entirely truthfully) that he had 'passed the ordeal of the Academy, pretty well' and attributed this to the painting's 'ice & snow' which he said was 'proof against the heat of the criticism'.[89] As ever he kept close track of what was going on with Turner. All the man's light effects that year were 'exquisite', he thought, and he was interested to hear Turner had made a second 'House of Lords on fire because he sold the last'.[90]

Constable's comments on Turner could range from caustic to panegyric. In 1832, for example, he had talked sardonically about Turner's 'stagnate sulphur', but also recalled a canal painting 'of singular intricacy and beauty . . . with numerous boats, making thousands of beautiful shapes'.[91] Sadly, the work in question cannot conclusively be identified but according to Constable it was 'I think the most complete work of genius I ever saw.' Praise indeed. His most astute turn of phrase concerns paintings Turner exhibited at the Academy in 1836, notably *Juliet and Her Nurse* (fig. 36), an extraordinary Shakespearean fabrication set in Venice (not Verona, as the *Romeo and Juliet* reference might suggest). By now, Turner had gained his own journalistic bête noire, the ultra-conservative Reverend John Eagles, whose sneering attacks in *Blackwood's Magazine* seem as spiteful and personalised as Dubois's on Constable. Falling back on the usual food and mess clichés, Eagles mocked the 'higgledy-piggledy' construction of Venice and the syrupy look of Juliet, 'steeped in treacle to make her look sweet'.[92] 'A strange jumble', he called it, 'neither sunlight, moonlight, nor starlight, nor firelight.' On this

TURNER AND CONSTABLE

Fig. 36. Turner, *Juliet and Her Nurse*, 1836, oil on canvas.

occasion someone stepped up in Turner's defence. Eagles's review prompted a young John Ruskin to draft an elaborate rebuttal, his first of many writings on the artist. In a 'state of great anger' he readdressed Eagles's criticisms, describing the painting as 'Indistinct with the beauty of uncertain light'.[93] The critical 'heat' was no hotter than Turner was used to handling. 'I never move in these matters,' he confessed to Ruskin – 'they are of no import save mischief.'[94] But, if neither friend nor foe could identify the source of Turner's light, how might it be best understood?

Constable had the answer. It wasn't light at all; it was vapourised colour. 'Turner has outdone himself,' he told a friend; 'he seems to paint with tinted steam, so evanescent and so airy. The public think he is laughing at them, and so they laugh at him in return.'[95]

A typical blend of admiration and mockery, 'tinted steam' is an apposite definition of Turner's nebulous, blurry qualities, but coming as it does from Constable, it seems more than just a throwaway remark. This was a germane choice of words, skewering Turner's originality

as something analogous to but distinct from his own. Indeed, it builds upon the history of the two men's work as elemental powers – one fire and heat, the other water and coolness. Constable's selection of 'steam' as a metaphor suggests Turner had reached a prodigious level of energy within his work. When applied to the watery environment of Venice, the 'heat' of Turner's colours and the forcefulness of his brushwork has led to an alchemical change in reliable reality. Things which should be solid seem to be changing state and evaporating. A firework explodes up from the lagoon with the force of steam from a kettle; the glowing light issuing forth from one side of St Mark's Square looks like it is melting the very fabric of the buildings. It was especially apt for Constable to describe Turner in terms of a modern technology he himself had no interest in depicting. If Constable perceived himself as breathing a new kind of vitality into British landscape through natural freshness, Turner was doing something similar with all the bracing force of a combustion engine. Ultimately, however, they were pursuing the same ends. 'Evanescence' – the quality of fleeting, vanishing impermanence – was highly prized by them both. Turner's recurring theme was the inevitability of one epoch succeeding another. Constable's was consecrating the fleeting moment. Like his counterpart, he understood landscape as uniquely suited to exploring the passage of time. He just expressed it very differently. It is fun to imagine what flowery phrase Turner might have come up with as a rejoinder to 'tinted steam': 'Constable seems to paint with dew-drenched alluvium – so irriguous and so earthy'?

By 1836, a change was afoot. The Royal Academy was on the move. Inspired by the construction of Trafalgar Square, and the recent foundation of a national gallery of art – both memorialising acts concerned with shaping history and British identity – the government had determined to incorporate the Academy within the new National Gallery complex on the north side of the plaza.[96] It was a significant moment, giving the Academy more space and public visibility, whilst also housing it within the same building as the country's first publicly owned art collection. What better time to reflect upon the achievements of the last few decades? Constable's main painting in the same Exhibition as Turner's *Juliet* did just that. Remarking that most Academicians still knew 'as much of landscapes as they do of the Kingdom of Heaven', he used the last

ever Exhibition held at Somerset House to reconsider the role of landscape within the national agenda.[97]

Constable had recently devoted himself to writing landscape into the history books. One way he did that was to pick up where he felt Turner had left off. Aside from the *Liber Studiorum* and his Old Master-themed exhibits, the closest Turner had ever come to a public validation of landscape was within his Royal Academy lectures. As professor of perspective, from 1811 until 1828, he had delivered an annual (or thereabouts) course of six illustrated talks which were meant to provide instruction in the science of geometry and the principles of linear and aerial perspective. With the last lecture in the series, however, Turner had hijacked the podium for his own ends. Titled 'Backgrounds', the talk comprised a discourse on landscape, and the different uses of perspective within the backgrounds and settings of history paintings (Turner adopted a very broad definition of perspective which included the role of light, shade and colour). Praising or criticising a litany of masters from the Renaissance to the recent British school, it owed much to the style and spirit of Reynolds's *Discourses*. He concluded the lecture with something like a call to arms: 'All that have toiled up the steep ascent have left, in their advancement, footsteps of value to succeeding assailants.'[98] According to Turner it was incumbent upon 'concording abilities' that followed to similarly 'fix the united Standard of Arts in the British Empire'.[99]

During the 1830s, Constable took up the baton as one of those 'succeeding assailants'. He prepared and presented his own lecture series, comprising 'a pretty full account of the history of landscape' and its academic value within the history of art.[100] This new occupation earned him no money; it was a true labour of love. But he relished the opportunity to organise and propound his beliefs from an intellectual platform. Variously between 1833 and 1836 he gave ten talks, at the prestigious Royal Institution, as well as other venues in Hampstead and Worcester. Like Turner, he invoked a hallowed chronology of Old Masters including Titian, Claude, Rubens, Rembrandt, Wilson and Gainsborough. Also like Turner, he sought to emulate the didactic gravitas of Reynolds. Unlike Turner, however, Constable's lectures were very well received. As a public speaker he was entertaining and erudite, with a conversational style and impromptu eloquence: the very opposite, therefore, of the former

professor of perspective. Turner was reportedly an execrable lecturer. He frequently confused his notes, lost his place or failed to articulate his words. According to Leslie he had a deep and musical voice but 'was the most confused and tedious speaker I ever heard'.[101]

Delivery aside, Constable also went much further than Turner in publicly establishing a genealogy for landscape, and in stressing its autonomy. He called it 'the child of history'.[102] In other words, whilst it had its roots in history painting, landscape was not an inferior endeavour, but an offshoot which was now independent and superior to its parent. As a visual endorsement of this idea Constable produced a historically themed oil, *Cenotaph to the Memory of Sir Joshua Reynolds* (fig. 37), his most overtly symbolic image to date. Completed in time for the 1836 Exhibition, it is a painting all about looking back in order to look forwards. Set in an autumnal wooded grove, the subject is a tomb-like monument to Reynolds. The memorial was real and, typically for Constable, self-referential, having been erected by his late friend and supporter Sir George Beaumont in the grounds of his Leicestershire home, Coleorton House. Beaumont had died in 1827, but his legacy lived on through his art collection which had formed one of the founding gifts of the National Gallery (including the little Claude painting of *Hagar and the Angel* which had exerted such influence on Constable all those years ago). Constable had manipulated the Coleorton view in order to deliberately incorporate two further features – busts of Michelangelo and Raphael, the two artists whom Reynolds had held up as models of the 'Grand Style' in art. Reynolds had famously finished his fifteenth and final Discourse – the one heard in person by Turner in 1790 – by stating: 'I should desire that the last words which I should pronounce in this Academy, and from this place, might be the name of MICHEL ANGELO.'[103] Since Reynolds's ideas had paved the way for modern artists to aggrandise their own genres, it could be argued that his direct legacy was the rise of Romantic landscape painting in Britain.

If the triumph of nineteenth-century painting was the British landscape school, then Constable and Turner were tacitly its leaders, the modern equivalents to the two Renaissance figureheads. And if Constable liked the symbolism of dual artistic heroes, who could blame him for prioritising one over the other? Thanks to his 1819

Fig. 37. Constable, *Cenotaph to the Memory of Sir Joshua Reynolds*, 1836, oil on canvas.

homage, *Rome, from the Vatican*, Turner had previously established his affiliation to Raphael. Constable, naturally, opted the other way. The function of the stag in the picture, positioned more to the left and looking back at the viewer, has been interpreted as giving visual preference to Michelangelo.[104] This reinforces the painting's associative links with Reynolds and Beaumont, the latter of whom had honoured Reynolds's adulation of the Florentine master by bequeathing to the Academy the 'Taddei tondo', a bas-relief of the Virgin and Child.[105] To date, it remains the only marble sculpture by Michelangelo in Great Britain. As a distant echo of Reynolds, Constable, in what

he called 'the last time in the old house', was trumpeting the names that he felt best celebrated a vital art-historical lineage from past to present.[106] As far as Constable was concerned, landscape had supplanted history painting as the Academy's greatest achievement.

What is so prescient about the *Cenotaph* is the acknowledgment that time is a factor in remembrance and recognition. All the main protagonists were long dead and gone. Constable had written about this idea in the letterpress for *English Landscape Scenery*, arguing that distance lent perspective to understanding.

> Thus the rise of an artist in a sphere of his own must almost certainly be delayed; it is to time generally that the justness of his claims to a lasting reputation will be left; so few appreciate any deviation from a beaten track, can trace the indications of a Talent in immaturity, or are qualified to judge of productions bearing an original cast of mind, of genuine study, and of consequent novelty of style in their mode of execution.[107]

Art that imitated achieved acceptance quickly. Genuinely groundbreaking artists had to trust their work to posterity. More prophetic than he could possibly have known in that moment, Constable's words were about to be proven assuredly true.

CHAPTER 10

ENDINGS . . .
AND BEGINNINGS

O N 25 MARCH 1837, Constable officiated over the last ever life class in Somerset House. Always a popular figure in the Schools, he had relieved Turner by rotation as Visitor in February.[1] To close the final session he made a stirring address to the students, urging them to honour the principles of 'the cradle of British art' in its next home.[2] That he was eagerly anticipating the move to Trafalgar Square can be seen in a sketch he made from memory, mapping out the display and teaching spaces in the new building.[3] On 30 March he attended a General Assembly meeting there and he spent the next day working on his submission for the forthcoming Exhibition. His first painting in the new Academy was to be a novel subject for him, Arundel mill and castle.[4] Even as he added the finishing silvery touches, he felt it was his best picture yet.

It had been a long while since Constable had added anywhere to the list of places he felt able to paint as one of his 'own'. On account of a newly formed friendship with a Sussex namesake, George Constable (no relation), this corner of England had recently opened up a fresh seam of possibilities. The same countryside that had inspired Turner over a decade earlier, it included all the things Constable considered most essential and beloved in landscape – 'woods – lanes – single trees, rivers – cottages – barns – mills and above all such noble & beautifull heath scenery' – all seasoned with the emotional bond of human fellowship.[5] It seemed something of a mental breakthrough.

Having lived for so long in the shadow of the past, his thoughts were now focused on the future. With the Arundel painting close to completion, he put down his tools and went to bed.

Turner, meanwhile, was on the Council, much occupied with the Academy's move. His days were a bustle of domestic arrangements: decisions over new gas lamps and upholstery, tenders and fire irons, even beds and bedding for the live-in porters.[6] There was general anxiety about everything being ready in time. The plastering on the portico was delayed by frost. Braziers were brought in to hasten the drying of the walls in the sculpture gallery. Whether due to cold weather or stress Turner came down with influenza, but rallied in time for a meeting on 4 April. Here it was announced that the rooms vacated by the Royal Academy in Somerset House were finally ready to be officially handed over to their new owners, the Treasury. There were a few other minor bits of business concerning gifts and bequests, before the minutes recorded one final agenda item. The Secretary informed the assembled members that he had 'received notice of the decease of John Constable Esq, RA, (which took place on the 1st [April]) from that gentleman's brother'.[7]

Constable's demise was shockingly unexpected. After spending the day working upon *Arundel Mill and Castle*, he had become suddenly unwell in the night and despite the efforts of his assistant Charles Boner and his children, he died in the early hours of the next day. He was sixty years old. His sudden decline required a post-mortem. When a devastated Leslie saw his friend the next morning he described him 'looking as if in tranquil sleep', a fact which is confirmed by his death mask. Several papers reported the event, including the *Spectator* whose obituary could only sum up the subject's achievements by rehashing the usual references to Turner: 'Constable was the very opposite of Turner; his effects being as cold and watery as Turner's fiery, and his delineations as literal in their fidelity as Turner's are fanciful. Like Turner's however, Constable's paintings are deficient in repose – the prime essential of beauty in a landscape.'[8] Even in death it seemed there was no escaping the binary comparisons.

As to what Turner himself thought, typically nothing is known. It seems the fierier half of British landscape's double act had no more to say on his counterpart's death than he had about his life.

He *was* one of the three Academicians on the Selection Committee for Paintings who accepted and hung *Arundel Castle and Mill* post-humously in the East Room (the Trafalgar Square equivalent of the Great Room) in the 1837 Exhibition.[9] But he was *not* amongst the friends and admirers who, later in the year, subscribed to purchase a work from Constable's studio for the national collection.[10]

Had Constable had any say in the matter, the work chosen to represent him in the National Gallery would almost certainly have been *Salisbury Cathedral from the Meadows*, the painting he believed 'would probably in future be considered his greatest', since it conveyed 'the fullest impression of the compass of his art'.[11] The committee however, could not bring themselves to endorse its dramatic execution and bold handling, still so at odds with public taste and expecta-tions. Instead they plumped for an earlier subject, *The Cornfield*, a painting even Constable had thought was a crowd-pleaser. Heavy on sunny, benign nostalgia, it was a safer, less challenging choice than the dark and moody 'Great Salisbury'.

This decision played a large role in establishing the artist's posthu-mous public image. Broadly speaking, Constable's crowning achieve-ments came to be perceived as his Suffolk landscapes of the 1820s, whilst his later pictures were considered as an abnegation or even a betrayal of his earlier naturalism. As flawed as this view was, it would prove to be incredibly enduring. A hundred and seventy-six years elapsed before *Salisbury Cathedral* entered the national col-lection and received the critical attention it deserved.[12]

The end of Constable's so-called 'late period' (1825–37) marks the beginning of what is generally understood to be Turner's, the final fifteen years of his life from 1836 until his death in 1851.[13] In other words, even as Constable's later works were being quietly side-lined, Turner had not as yet painted his. Tracking backwards from the end of a career immediately throws up an interesting problem. Due to the random finality of death, Constable's 'late period' emerged according to an entirely different set of criteria to that of Turner's. In Constable's case, he died unexpectedly whilst he still had young children and unfulfilled projects. He had no notion his career was about to be truncated, or that his 'late' works *were* his late works. Turner, on the other hand, passed away aged seventy-six, after a long period of decline and infirmity. He was aware of his days being

numbered. Far from relaxing into tranquil retirement, his final years represented an extraordinarily productive period, resulting in some of his most original and controversial works.

Despite a certain shared painterliness of handling, Constable's lateness has been qualified differently from that of Turner. Until recently, the general consensus has been that Constable's earlier work is his most important. At the very moment he achieved academic acceptance he has been judged by posterity as passing his prime, so that his later productions have been described as regrettably conformist and mannered, not representative of the artist's true self. Turner's late paintings, by contrast, are now understood to represent him far more definitively than his earlier productions. Dominated by radical experimentation and the hostility of the critics, his late style is the thing for which he is now most celebrated. What with one is 'a failure of purpose' for the other is 'hailed as a deepening of vision'.[14] To put this simply, there is a notion that Turner only really becomes Turner at the end of his life, whereas Constable becomes less Constable towards the end of his.

What is so fascinating is that their previously parallel timelines cease to appear relevant. As fate would have it, Constable's passing had coincided with the beginning of a new historical era. Just weeks after formally visiting the Royal Academy's new premises, William IV died and was succeeded by his eighteen-year-old niece, Princess Victoria. Whilst Constable would forever remain an artist wedded to the Georgian past, for the last fourteen years of his life, Turner became a Victorian.

As far as posterity is concerned, the distinction is an important one, conceptually pushing Constable back in time, whilst dragging Turner forward into an era that would stretch all the way into the twentieth century. The technological breakthroughs of the Victorian era shaped much of the modern world as we know it today. It was a period of unprecedented urban and industrial growth, which transformed Britain from an agricultural island into a global empire. Canal franchises were taken over by railways; wind power was rendered uneconomic. In the fields, traditional agricultural practices were being retired in favour of mechanised alternatives, and on the waves, sail gave way to steam. And despite the fact that the two artists lived through the same timeline for sixty years, rightly or

TURNER AND CONSTABLE

wrongly they tend to remain associated with these different historical periods. Constable is best remembered for agrarian idylls like *The Cornfield* or *The Hay Wain*. Turner, meanwhile, became better known for paintings where that world has all but vanished. The tranquil traditions of hay carts and horses, windmills and waterways have disappeared in the face of the steam-powered modernity of the Industrial Revolution.

Due to the selectivity of his gaze it becomes easy to forget that Constable belonged to the modern world of steam power and technology. His landscapes of bygone Britain feel as though they date from a different generation. Biographical snippets, however, can be used to link his experience of the industrial nineteenth century to later paintings by Turner. As one illustration, Constable took his two eldest sons to visit a metalworks in Holborn in 1833. He described it as a sight of 'forges – smelting pots – metals – turning lathes – straps & bellows – coals, ashes, dust, dirt, & cinders – and everything else that is agreeable to boys'.[15] Whilst the dynamism of the subject provided no stimulation to his own sensibilities, his vivid word picture might easily be applied to Turner's atmospheric painting of a metal foundry, *The Hero of a Hundred Fights*, reworked from an earlier canvas and exhibited in 1847.[16] Similarly, in 1834 Constable took great interest in a pamphlet arguing for the advantages of the construction of a railroad between London and Bristol. Despite describing it as a potentially 'forbidding' topic, he was impressed with the 'poetical' and 'instructive' content of the prospectus. However, it took an artist of Turner's interests to turn the self-same rail service into a considered pictorial response.[17] His painting *Rain, Steam, and Speed – The Great Western Railway* (1844) featured the newly laid Great Western line to Bristol and Exeter, the first time a train had been made the subject of an academic oil painting. The most conspicuous symbols of modernity absent from Constable's landscapes are steamboats. Merely as an east-coast curiosity he had made a cursory pencil sketch of the *Orwell*, a paddle steamer launched to provide a new packet service from Ipswich to Harwich in 1815.[18] This seems to have been his only pictorial acknowledgement of this particular mode of transportation. In Turner's art by contrast they are everywhere – an everyday sight on British seas and European rivers – in oils and watercolours across the years.

With his 'tinted steam' comment back in 1836, Constable had been astute to label Turner an emissary of the Age of Steam, even though he had not lived long enough to bear witness to his later productions. In particular, given its iconic equivalence to *The Hay Wain*, it seems extraordinary that he never saw Turner's most famous steam-themed production, *The Fighting Temeraire tugged to her last berth to be broken up, 1838* (fig. 38), a painting which is all about the 'evanescence' of life. In 1838, the same year a committee had been formed to erect a monument to Nelson in Trafalgar Square, the *Temeraire*, one of the warships which had played a pivotal role in his most famous victory, was decommissioned from the Royal Navy and sold for parts. In her time, she had been a marvel of British ship building, capable of speed, manoeuvrability and delivering and withstanding enormous firepower.[19] Now she was just an outdated relic, more valuable as a source of timber than as a terror of the seas. She was towed by a couple of steamers to Beatson's shipbreakers'

Fig. 38. Turner, *The Fighting Temeraire tugged to her last berth to be broken up, 1838*, 1839, oil on canvas.

TURNER AND CONSTABLE

yard in Rotherhithe in order to be dismantled, a newsworthy event in its own right. In 1839 Turner immortalised the ship's last voyage in a painting whose fame eventually outstripped that of the subject.

Unlike Turner's more esoteric productions, *The Fighting Temeraire* owes its enduring popularity to the clarity of its visual message. Even without knowing the backstory, the simplicity of the central motif – the old warship towed by the modern steam tug – makes the theme easy to divine. Much has been written about it which need not be repeated here.[20] Over the years commentators have been much exercised as to whether Turner really saw the ship's last voyage, whether the atmospheric conditions are true to the moment or whether the flamboyant fiery sun is rising or setting. Suffice to say, historical accuracy is beside the point. With its composition harmoniously balanced between the warm colours of day and the cool colours of night, this is an artificially constructed painting. It does not take much scrutiny of the details to realise that most of them come from Turner's head. Constable was an artist who really needed to see a thing to paint it. He had so struggled to recall the details of the cart for *The Hay Wain* that John Dunthorne had been required to post a sketch of a vehicle to him in London from East Bergholt.[21] Turner had no such difficulties. It is possible that he saw the *Temeraire* lying in dry dock. Beatson's yard was situated just over the river from a property he owned in Wapping, the Ship and Bladebone inn, and even as a mastless hulk she would have been an impressive sight to behold.[22] But Turner had no more need to witness the *Temeraire* being towed up the Thames than he had to visit ancient Carthage in order to tell the story of Dido and Aeneas. What is more, the painting revisits his ongoing relationship with the Thames as a mirror to the changing face of Britain. Simultaneously an elegy to the Age of Sail and a homage to the Age of Steam, it represents a profound statement about endings and beginnings, about resilience, regeneration and renewal. Whereas the undramatic noonday sun of *The Hay Wain* preserves stability through stasis, the unspecified sunrise or sunset of the *Temeraire* reiterates change. As sure as day follows night, one epoch transitions into another.

An interesting point of comparison to these ideas is the work of one of Turner's closest intellectual acquaintances, Mary Somerville, the 'queen of nineteenth-century science'. Widely acknowledged as

one of the great minds of the age, in 1834 Somerville had written a new kind of science book, *The Connexion of the Physical Sciences*. Within it she explored the idea of reciprocal dependencies between astronomy, physics, chemistry, geography, meteorology and electro-magnetism – brought together within a unified vision of the universe. The true genius of the publication, however, lay in the way she made complex ideas accessible to a non-specialist, general readership. Her analogies came from a similar visual landscape culture to Turner and Constable, where natural and human phenomena were being used to articulate ideas about the cosmic condition. For example, as a way to explain the distribution of sound she employed the metaphor of 'a field of corn agitated by a gust of wind'.[23] A few pages later she went on: 'Anyone who has observed the reflection of the waves from a wall on the side of a river after the passage of a steam-boat, will have a perfect idea of the reflection of sound and light.'[24] These were brilliant strategies, employing sights and sounds so ubiquitous that contemporary readers would have immediately comprehended what she meant. *The Fighting Temeraire* tapped into that same common understanding. Art, Turner believed, could visualise and explain the mysteries of the universe as effectively as science. We might think about it in terms of something Constable said in one of his lectures, given to the Royal Institution in 1836. 'Painting is a science,' Constable had argued, 'and should be pursued as an inquiry into the laws of nature. Why, then, may not landscape painting be considered as a branch of natural philosophy of which pictures are but the experiments?'[25]

No painting embodies that idea more fully than Turner's 1842 oil *Snow Storm – Steam-Boat off a Harbour's Mouth*.[26] Through its novelistic title, the artist claimed that this ambient, swirling canvas depicted his own experience of being tied to the mast of a Harwich steam vessel in the midst of a raging storm. Whether the story is authentic or not – and it certainly sounds mythic – it served its purpose, which was to validate the atmospheric truth of the image by providing evidence of the lengths to which the creator would go to engage with the forces he sought to depict.[27] By capturing the driving movement of wind, sleet and sea spray through the broken and imprecise application of paint, the artist created an empirical simulation of reality. The froth of fractured

colour is idiomatically perfect for the subject matter. Cementing the link between style and subject, this is the mature Turnerian equivalent of 'natural painture'.

Whilst it is debatable that Turner was ever truly tied to a ship's mast in a storm, the painting represents a visceral reminder of the perils faced by sailors during the nineteenth century. If a human story is helpful to drive that point home, a real-life example is that of John Constable's son Charley, who signed up to the merchant navy aged fourteen. The boy had always possessed an adventurous spirit and it seems to have been a trip in a steamer to Gravesend through a heavy sea which inspired his future career choice.[28] In 1835 he had joined an East Indiaman, the *Buckinghamshire*, as a midshipman. Nothing brings a more intimate awareness of the dangers of the 'ruthless sea' closer than reading the letters of his father left fearful at home.[29] With pride and terror intermingled, Constable had to endure Charley's cheerful tidings of storms and heart-stopping near-misses, such as that in September 1835 when he lost his cap and right shoe whilst taking in the topsail during high winds.[30] Or the truly 'frightfull gale' in November 1836 when he witnessed multiple wrecks in the Nore. 'One large ship floated past them bottom upwards,' reported Constable to Leslie, '& after the gale he saw 7 large hulls in tow with steamboats & some on the Goodwins and some on the beach under the Foreland.'[31]

For all its fantastical fury, Turner's *Snow Storm* is observationally spot on. One way to appreciate its accuracy is to apply the 'Beaufort scale', a standardised wind-force scale born from the anxieties and fascinations of an age when wind powered the globe. Developed by an officer of the Royal Navy, Francis Beaufort, in 1805 (the same year as Turner's *The Shipwreck*), and officially adopted for use by the Admiralty in 1838, the scale employed subjective and, to some extent, poetic observations of the wind to evaluate the risk to life and shipping. In lieu of being able to measure the wind itself, a sailor could assign a qualitative number based upon what the wind was doing to a fully-rigged three-masted frigate at sea. Similarly, it is by reading the visible details – the height of the waves, the extent of the spray, the angle of the boat, the colour of the sea – that the viewer can gauge the sublime sense of power and danger implicit in Turner's picture. Where Beaufort used words, Turner used paint, brushstroke-for-brushstroke

matching the energy of the wind as the visual disruptor to what might be considered normal conditions. Hence, we might interpret *Snow Storm* as a Force 11 'violent storm'. To quote the phrasing of the modern Beaufort scale: 'exceptionally high waves; small and medium-sized ships might be for a long time lost to view behind the waves; sea is covered with long white patches of foam; everywhere the edges of the wave crests are blown into foam; visibility affected'.

Visibility was indeed affected. *Snow Storm* represented Turner's most challenging visual image to date. Literally unable to read the surface, the critics reacted with their strongest wave of abuse yet, some of it redirecting the rhetoric they had formerly used to mock Constable. The *Art Union* was typical in its observation: 'Through the driving snow there are just perceptible portions of a steam-boat labouring on a rolling sea; but before any further account of the vessel can be given, it will be necessary to wait until the storm is cleared off a little. The sooner the better.'[31] John Ruskin recorded the hurt reaction of the artist: 'Turner was passing the evening at my father's house on the day this criticism came out: and after dinner, sitting in his arm-chair by the fire, I heard him muttering to himself at intervals, "soapsuds and whitewash! What would they have? I wonder what they think the sea's like? I wish they'd been in it." '[32] If indeed Turner had indulged in the 'whitewash' trope of criticism formerly used to berate Constable, it had come back to bite him with a vengeance.

Snow Storm became one of the paintings Ruskin was roused to defend in his polemical publication *Modern Painters*, an intellectual guide to the rule-breaking aspects of Turner's style. In the first volume, published in 1843, he used it as a key example of Turner's profound ability to depict natural forces: a concept he described as 'truth to nature'. 'Go to nature in all singleness of heart,' he exhorted contemporary artists, 'and walk with her laboriously and trustingly, having no other thought than how best to penetrate her meaning; rejecting nothing, selecting nothing, and scorning nothing.'[33] The one artist whose work might best be said to match these objectives was of course Constable, but probably due to his near-religious veneration of Turner, Ruskin had little time for the Suffolk painter.[34] Turner's art seems to have blinded him to Constable's alternative way of seeing. He dismissed it as 'greatcoat weather and nothing more', the product of an 'industrious and innocent amateur blundering his way to a superficial expression of one or two

TURNER AND CONSTABLE

popular aspects of common nature'.[35] Ruskin's writings on Turner are eloquent and memorable, though inevitably coloured by his personality and upbringing. 'Turner was sent as a prophet of God to reveal to men the mysteries of His universe,' he declaimed, 'standing . . . with the sun and stars given into his hand.'[36] This kind of characterisation is best described as hagiographic. In Ruskin's view Turner was a great and moral figure producing works that were so close to the truth of the Creation that they were almost semi-divine in themselves. One of the reasons Thornbury's 1862 biography was so shocking for its Victorian readership was the stark contrast it presented to Ruskin's adulatory approach. Whilst Ruskin knew Turner quite well, Thornbury had never met the man and his posthumous account relied on secondhand sources. Faced with Turner's secrecy, he sometimes made things up, filling the void with unreliable anecdotes that fabricated a tale of flawed and damaged moral depravity.

In the same year as Ruskin launched *Modern Painters*, Constable received his own literary treatment through Leslie's celebrated biography, *Memoirs of the Life of John Constable Composed Chiefly of His Letters*. In sharp contrast to Ruskin's quasi-deification of his subject, Leslie's book was a gateway piece of life writing, crafting a believable, down-to-earth portrait of a fallible, likeable human being. Where Ruskin sought to elevate his champion above worldly matters, Leslie revelled in them, moulding Constable's life into a story about the 'naturalness' of his art. He played down his academic motivations and heroised him as an underdog, overcoming personal and professional adversity in order to fulfil his destiny. He also gave the man a voice. By publishing many of the artist's letters he made Constable's intentions accessible, well known and eminently quotable. In his own way, however, Leslie was as circumspect as Ruskin, smoothing out the sharper, more acerbic edges of Constable's temperament in order to make him appear closer to a paragon of virtue. When quoting the first 'wonderful range of mind' meeting with Turner, for instance, he tactfully omitted the word 'uncouth' in Constable's impression of his colleague. Thornbury, it is well known, needs to be approached with caution, and Ruskin with a pinch of salt, but even Leslie can't be treated as gospel.

Whether Turner ever read about himself in Leslie's biography is unknown. Surely he cannot have been unaware of it. Did he wonder

who might do the same for him, sensitively and sympathetically? Or did he merely work all the harder to keep his private life private? In old age, Turner was as secretive as ever; paintings and personality alike posed a mystery waiting to be solved. Friends and colleagues began to notice he was looking cleaner and better groomed, but were unaware that it was because he was now, to all intents and purposes, married. Sophia Booth had moved from Margate to take care of him. Using her own money, she rented a riverside house in Chelsea and here the pair cohabited in domestic contentment, man and wife in all but name. As far as the neighbours were concerned, the man who enjoyed painting the Thames from the property's roof terrace was not J.M.W. Turner, RA, but Puggy Booth, a retired admiral. And if Constable had lived and loved like a Jane Austen hero, there is something irresistibly Dickensian about Turner, especially in his twilight years. In so far as his lifestyle flew in the face of Victorian respectability, the 'uncouthness' became even more pronounced.

Whilst Mrs Booth's so-called 'husband' lived in a cosy cottage cleaned 'to a nicety', Turner the famous artist presided over a property that was slowly turning to rack and ruin.[37] Like a tragi-comic mixture of Miss Havisham and Ebenezer Scrooge he had let Queen Anne Street deteriorate into a decaying mausoleum. Poor, faithful Hannah Danby shuffled amidst the squalor, her housekeeping duties now quite beyond her. The roof was leaking, the wallpaper was peeling, it was dirty, damp and cheerless, the very look of the place was 'enough to give a man a cold'.[38] The only suggestion of warmth came from the golden-hued pictures hung or stacked against the walls, a mere fraction of the dozens of canvases unsold or retained after a lifetime of painting. Some, like the large *Battle of Trafalgar* of 1806, dated back decades. Many more were recent: beautiful, bewildering subjects from the 1830s and 1840s, in formats so challenging and incomprehensible that they had alienated the artist from a mainstream audience. Visitors were unlikely to be tempted to buy them now. Once London's finest private showroom, the Turner Gallery was now the worst place imaginable for viewing and storing works of art. Commenting on the famously unstable nature of his colleague's pigments, Constable had once noted how 'some of Turner's best work is swept off the carpet every morning by the maid and put into the dust hole'.[39] The conditions at Queen

Anne Street made that situation even worse. Pictures blocked up broken windows, cats wandered freely over watercolours, pigment flaked off mildewed canvases in lumps and strips. And Turner didn't help either, hoarding his treasures like a miser, buying back certain beloved pictures and rejecting offers to purchase others. An offer of £5,000 was turned down for *The Fighting Temeraire*, an astronomical figure for a landscape of that size (the same price the ship herself had fetched for scrap in 1838 and almost as much as East Bergholt House had sold for back in 1818). He even allegedly refused a complete studio sale: £100,000 for everything in the gallery (over £14 million in twenty-first-century terms).[40] In Turner's mind this was not 'stock' he was sitting on. This was a 'collection', a one-man retrospective, consciously assembled as testament to a lifetime's achievements. Just as he had sought creative autonomy in life, he had no intention of relinquishing that control in death. Even as his gallery rotted and declined around him, he was making plans for its glorious reincarnation and afterlife.

Time and again Turner had witnessed what happened to his peers after they died. There was usually a studio sale through which leftovers were picked over and scattered. The result was a fragmentation of the oeuvre, leaving an artist susceptible to reinterpretation in ways that were unintended. If he was aware of it, Constable was a good example of this. After his death, the Constable children held various sales in order to generate income. Some studio work they sold, some they held on to. The resulting dispersal obfuscated Constable's overall accomplishments, severing connections between different types of work and confusing the canon. An immediate casualty was the historical scope of his art. Courtesy of the efforts of Leslie and others, the artist's story was being told, but in a way that redacted his original intentions. By stressing his originality as an emotional, 'natural' painter, what was being eroded was his links to the academic past. With paintings such as *Cenotaph to the Memory of Joshua Reynolds* no longer in the public eye, Constable was becoming a kind of artistic foundling, cut loose from his art-historical antecedents.

After a lifetime of dialogue with the Old Masters Turner wanted no such rewriting of the record. With more time to muse upon his impending mortality, and in a much stronger position than Constable had ever been to dictate his legacy, he was determined to be the

master of his own destiny. In a final 1848 codicil to his will Turner left all the finished paintings in his gallery to the nation, requesting that they should be kept together and housed within a designated space at the National Gallery. And that wasn't all. There were specific instructions to be followed. More than once Turner had told friends he wanted his body shrouded within his painting *Dido Building Carthage*, wrapped in it like a winding sheet to keep his corpse warm in the grave. As improbable as this sounds, he had been speaking only half in jest. Accompanied by another choice, *Sun Rising through Vapour*, *Dido* went to the National Gallery as part of a named bequest. As a final act of 'compare and contrast' Turner dictated that they should be hung in juxtaposition with the 'Bouillon Claudes', a special pairing of paintings from 1648: *Seaport with the Embarkation of the Queen of Sheba* and *The Mill (or Landscape with the Marriage of Isaac and Rebecca)*. By binding these four works together it was not Turner's earthly remains that were kept warm, but his relationship with Claude Lorrain.

Turner knew exactly what the effect would be of seeing his paintings together with Claude's. In a similar way to Constable's *Cenotaph*, the underlying message is about establishing the pedigree of the modern British landscape school according to the forebears of Western art. At first glance there are the obvious similarities. *Dido Building Carthage* is clearly a Claudean take on a classical history subject, superficially similar to *Seaport with the Embarkation of the Queen of Sheba*. But with slower looking the more profound and interesting differences begin to reveal themselves. Where Claude's light bathes everything in a unifying ambient glow, Turner's is an active force that delivers an emotional punch, directing the viewer's gaze around the canvas and underpinning the narrative. His atmospheric effects are more realistic, and his paint handling more naturalistic. And then there is *Sun Rising through Vapour*, a contemporary sea piece, which shows Turner stepping away from the Italianate model of landscape and engaging with the Flemish and Dutch traditions of painting. Almost like confirmation of Constable's view that landscape was the 'child of history', Turner is revealed as Britain's fresh and modern answer not only to Claude, but also to most of the major European schools of painting.

With his artistic coalition securely indentured, Turner paved the way to the hereafter with a final series of paintings that engaged with

his beliefs about time and history as a cyclical process. For years he had explored the waxing and waning of the human condition, the rise and fall of nations and civilisations, and the way that all things come to an end, only to be replaced by something new. Now, amidst dwindling energies, illness and old age, he painted four last canvases, all Claudean variations revisiting the story of Dido and Aeneas, and submitted them to what he probably realised was his last ever Royal Academy Exhibition in 1850. With titles including *The Departure of the Fleet* and *A Visit to the Tomb*, the quartet focused upon the inevitability of Aeneas's leave-taking from Dido and Carthage and the doom that would follow as a result.[41] It was as though his last word at the Academy was affirmation of his own decline and imminent departure. 'Old Time has made sad work with me,' he told Hawksworth Fawkes. 'I always dreaded it with horror now I feel it acutely.'[42] Waiting in the wings, however, were *Dido Building Carthage* and *Sun Rising through Vapour*. By means of his bequest, Turner had set himself up to rise again in posthumous glory.

Once again there was a sense of one era drawing to a close and another dawning. The burgeoning expansion of the National Gallery meant that Trafalgar Square was not going to be the long-term home the Royal Academy had hoped for. In 1850 a committee concluded it would again have to move to new premises. Meanwhile, 1851 saw the instigation of a new kind of cultural experience, Prince Albert's Great Exhibition of the Works of Industry of All Nations, utterly eclipsing the Royal Academy in significance, size, scope and spectacle. Turner, who witnessed the Crystal Palace being built, described it as a 'Giant'.[43] Shortly after, he made his last appearance at the Academy, as a social guest, not an exhibitor. After over half a century of exhibition dominance, the baton was passing to the next generation. Amongst the exhibits were works by no fewer than three of the grown-up Constable children: Lionel, Alfred and Isabel.[44] The true rising newcomers, however, were John Ruskin's new pet project, the avant-garde circle known as the Pre-Raphaelite Brotherhood. Young, fearless and rebellious, the group included a twenty-two-year-old John Everett Millais, who sketched what must have been one of the last likenesses ever taken of Turner. A typically caricature-like rendering, it shows his stout and curmudgeonly profile: a member of the old guard silently scrutinising the young

bloods taking the establishment by storm. Openly anti-Academic, the Pre-Raphaelites self-consciously rejected the idealising traditions of Sir 'Sloshua' Reynolds and the High Renaissance of Raphael – everything, in fact, venerated by Constable in his *Cenotaph*. Leslie said his friend had almost prophesied the backlash. In 1822, he had predicted, 'The art will go out [and] there will be no genuine painting in England in thirty years.'[45] Leslie went on: 'It is remarkable that, within a few months of the date thus specified, Turner should have died, almost literally fulfilling, as some of his admirers may think, Constable's prophecy.'

It was one of the Pre-Raphaelite Brotherhood, the sculptor Thomas Woolner, who cast Turner's death mask, a disturbingly cadaver-ous-looking effigy compared to Constable's peaceful countenance. The end had finally come in December 1851 after a long period of illness. Turner had lost all his teeth and for months had survived by sucking upon meat and drinking quarts of rum and milk. Stories abound of his dying moments, all of them rich with solar mythology: the enfeebled artist crawling to the window to see the sunlight one last time, and uttering the words 'the sun is god'. George Jones painted Turner's coffin 'lying in state' within his gallery, light appearing to illuminate the dark interior from directly out of the casket. As per his wishes, the funeral was organised by the Royal Academy. In what was an extraordinary marker of upward mobility, the boy who had been baptised in St Paul's, Covent Garden, was interred with honour in St Paul's Cathedral. He was laid to rest in the company of his brother artists, in between Sir Joshua Reynolds and Sir Thomas Lawrence.

One 'brother' not in St Paul's is John Constable. As befitted his life choices, his final resting place was a quieter, less illustrious spot – the graveyard of his local church, St John's in Hampstead. Reunited with his beloved Maria, and in due course, his children, Constable lies in a tomb beneath the trees. Visiting the churchyard today, almost the first thing you see is the name 'Mallord Turner'. A descendant of the artist, Charles Mallord Turner, was a churchwarden of St John's until 1979. He is memorialised with a dedication upon a large eighteenth-century monument near the site's entrance.[46] It's funny how things turn out.

Of course, for an artist, death is not the end of the story. If any-thing, the fictionalised interpretation of their public image intensifies

by virtue of the creations they leave behind. Works are constantly being bought and sold, exhibited, reproduced and copied, criticised, re-examined and reinterpreted. In unforeseen ways they continue to be woven into new contexts. Neither Turner nor Constable could ever have anticipated or imagined how greatly their audiences would expand after their death, or predicted the changing ways their art would be presented and received. The historiography of their after-lives is as fascinating as that when they were alive.[47] It is equally entangled, diametrically different and, to some extent, mutually co-dependent. If posterity has established Turner one way, it has frequently placed Constable another. It is only by comparing the shifting twists and turns of the spotlight that it becomes easier to recognise the arbitrary nature of life beyond the grave.

Turner has always been famous, but although his pre-eminence has remained constant, the nature of his celebrity has undergone significant revision, according to changing tastes. The works revered by his contemporaries are seldom those preferred today. Reinvented according to successive art movements, he has at various times been described as a classicist, a modern Claude Lorrain, a Victorian, a forerunner of Impressionism and the father of abstraction – all of which are both true and erroneous at the same time. Constable, meanwhile, has received an almost complete reversal in his fortunes and is now the recipient of such fame as he could never have antici-pated. He too has been regularly repositioned, contrarily deemed 'the natural painter, the national painter, the Wordsworth of land-scape painting, the proto-Impressionist, the proto-Expressionist, the "innocent" eye who painted only what he saw' and even 'the Anti-Jacobin manipulator who only painted what he wished to be seen'.[48] But whereas Turner's name has become synonymous with art that pushes the boundaries, the overexposure of *The Hay Wain* and *The Cornfield* has caused the radical qualities of his art to be submerged by ideas related to nostalgia and tradition.

One way to chart the evolution of their posthumous reputations is to follow the representation of their sketches within the principal British national collections – the National Gallery, Tate and the Victoria and Albert Museum (V&A). Legacy is directly linked to accessibility. People only judge what they can see. As a result of large bequests from their respective studios, the nation received hundreds

(or in Turner's case, thousands) of preparatory, private and unfinished studies. And over the centuries, public exposure to developmental aspects of their oeuvres has had an unequivocal effect on the way they have been interpreted. Cited as evidence of the artists' truest intentions, they have been hailed as ground-breaking, modern and ahead of their time. The legitimacy of this has been debatable, but there is no denying that Turner and Constable's fame has come to rest almost as heavily upon their sketches as their exhibited or 'finished' pictures.

As far as museums are concerned, the canonical default is the National Gallery, which prides itself upon a 'uniquely coherent narrative of Western European painting'.[49] Since its inception it has evolved to tell a story of art from the thirteenth century to 1900 according to what are considered cultural peaks: representative works from the most important Euro-centric movements by 'masters' of acknowledged 'greatness'. With most of the collection permanently on view, it is like a real-life textbook. And within this cohesively thought-out survey, the era-defining moment for Britain is the Romantic nineteenth century. The main space is a large gallery placed so as to bridge the gap between the glories of the French and Italian eighteenth century and the modern innovations of French Impressionism.[50] Amidst the august company of Gainsborough, Hogarth, Reynolds and Stubbs, Constable and Turner are represented by a selection of their most significant 'masterpieces'. These works can be read as those deemed appropriate to a progressive agenda, building up towards or leading away from a notional career apex. Turner's express his European range and influence. Aside from the companion pieces to the Claudes, the majority are works from the 1830s and 1840s. Constable's, by contrast, are weighted around a mid-career decade of 1816–26. According to the National Gallery, therefore, Constable is an artist who peaked in the early 1820s with his large Suffolk landscapes, whilst Turner's zenith occurred later, with the colourful, hazy paintings of his late period. Their respective summits are signposted by iconically popular pictures, overwhelmingly understood to be *The Hay Wain* and *The Fighting Temeraire*.

Turner, as we know, had always intended to bequeath his finished oil paintings to the nation. He had not, however, made any provision for the rest of the studio. He had also created enormous difficulties

TURNER AND CONSTABLE

for his executors by writing codicils to his will which were confusing and lacked clarity.[51] When the will was contested by some of his cousins, the government was required to step in to sort it all out. A Select Committee was appointed, and in 1856 an Act of Parliament decreed that the financial estate should go to the relatives but that all the artistic works should become national property. Not just the oils but everything – every canvas, watercolour, sketchbook and loose scrap of paper, with no distinction between finished and unfinished. There had never been a gift like it before. With 300 oil paintings, nearly 300 sketchbooks and totals amounting to tens of thousands of individually accessioned items, the museum world was left wondering what on earth to do with this vast amount of unsolicited, uncatalogued and unseen material. In the end, it would take several lifetimes to find a solution.[52] In 1897, the oils moved to the newly created National Collection of British Art (later the Tate Gallery), but it wasn't until the building of Tate's Clore Gallery in 1987 that the works on paper found a permanent home, and the resources to properly document, store and interpret them. And for all his careful forethought, it was precisely because of the Turner Bequest that Turner's reputation ended up escaping the parameters he had tried to impose upon it. Whilst he had attempted to wed himself to the past, subsequent custodians would use the Bequest to unlock different sets of connections.

One of the big ideological shifts occurred with the advent of Impressionism. As the twentieth century dawned, it was no longer Claude Lorrain who was being used to make sense of Turner; it was Claude Monet. Along with Camille Pissarro, the young Frenchman had seen Turner's work in 1870, during his years in exile from the Franco-Prussian War. As far as the British public assumed, when Monet returned to France and painted hazy, colourful visions like *Impression: Sunrise*, or atmospheric smoky train subjects like the Gare Saint-Lazare series, he must have been responding to National Gallery works such as *The Fighting Temeraire* and *Rain, Steam, and Speed*. The first Impressionist exhibition in 1874 had even included an etching after the latter by Félix Bracquemond – not so much a copy as a celebration of its painterly surface and swirling effects. With their love of pure colours on white, their loose brushwork and their unblinking confrontation with the modern world, the French Impressionists

appeared to be speaking a language they had learned directly from Turner. 'It seems to me that we are all descended from the Englishman Turner,' wrote Pissarro. 'He was perhaps the first painter who knew how to make colours blaze out with their natural brilliance.'[53]

It was a moment of patriotic redemption. No longer the regrettable indulgences of an eccentric, ageing talent, Turner's bold chromatic choices and visible brushstrokes were being reclaimed as the raw ingredients for modernity. The very features that had formerly seemed incomprehensible were now being billed as brilliance. He hadn't been mad. He'd just been ahead of his time. This is certainly the message that was promoted in 1906 when a selection of luminous, unresolved landscapes, newly unearthed from the Turner Bequest, were exhibited for the very first time at the Tate Gallery. Even by the standards of Turner's late work these things were a revelation, revealing his ability to think about subjects in terms of broad, almost abstract masses of colour. Works like *Norham Castle, Sunrise* (fig. 39) seemed so self-evidently prophetic of Monet's later colouristic explorations of light

Fig. 39. Turner, *Norham Castle, Sunrise*, c.1845, oil on canvas.

TURNER AND CONSTABLE

and atmosphere that the provenance hardly needed interrogating. 'We have never seen Turner before!' screamed the press.[54]

Rather, they had never been *ready* to see this kind of Turner before. In truth, the link between Turner and Impressionism is not nearly as straightforward as one might think. The Impressionists believed they had reached their understanding about light, colour and modernity independently of Turner's influence. Monet in particular was critical. He did not believe Turner understood colour or shadows correctly. Furthermore, whilst he was familiar with certain pictures during his London years, *Norham Castle* and all of those other impressionistic-looking canvases were still rolled up in the National Gallery's basement. They came from the unfinished items within the Bequest: things that had only been taken to a certain level within completion and were considered, as yet, unfit for public scrutiny. Constable would have called them 'dead horses'.[55] Turner's studio had stabled many 'dead horses', though it is unlikely that he viewed them in quite that light. Unfinished they might have been, but it was possible these embryonic colour lay-ins were exactly the kinds of canvas taken into the Royal Academy and completed on the walls during those performative Varnishing Day appearances. Far from being a modernist essay in formalist light and colour, *Norham Castle* was actually a late reworking of a *Liber Studiorum* motif. It is not known why Turner left it in this state, rather than bringing it up to a point of completion. The issue of finished and unfinished is a complex one.[56] What is indisputable is that it only ever saw the light of day thanks to Monet and his colleagues. It was precisely because the general public had accepted the premise of Impressionism that this kind of picture could now be considered a legitimate candidate for display.

Part of the perceived modernity of Turner's work therefore was due to a paradigm shift in the exposure of unfinished works. On the one hand this helped people to do what the Victorians could not and appreciate the unresolved forms of Turner's late works. On the other it has led us to consider paintings which the artist would never have dreamed of exposing to public scrutiny and ascribe to them anachronistic interpretations. It is not that *Norham Castle* is not an important, meaningful example of Turner's powers. But the simple act of putting it in a frame and hanging it in a gallery changes

its meaning. It is like taking a draft paragraph of prose and reading it out of context, as though it were a poem.

Turner's connection to modern French art only emerged after his death, but as we have seen, Constable was admired by the French during his lifetime. The immediate response to the arrival of *The Hay Wain* in Paris is a matter of historical record. One painter after another rapidly absorbed the lessons of Constable's naturalistic observations and handling. From Géricault, Delacroix and the French Romantics the baton passed to the Barbizon School, an informal group of artists who, between 1830 and 1870, gathered to paint in the Forest of Fontainebleau, near Paris. It is no accident that the English town later twinned with Barbizon is East Bergholt. Like Constable, artists including Paul Huet, Théodore Rousseau, Charles Daubigny, Jules Dupré and Narcisse Diaz sought to capture a realistic likeness of their native landscape. Their preferred subjects were woodland, heathland and rural village communities and they favoured soft, free brushwork in muted earthy greens and browns. From there it was only a short step to the next generation of young artists working *en plein air* – Monet, Renoir, Sisley, Bazille and co.

So whilst on face value alone it looks like it must have been Turner who anticipated Impressionism, it was actually Constable who had the more direct impact. His insistence on capturing a given moment in time closely anticipated the movement's ethos, and by only painting what he could see he provided an important precedent of unidealised landscape. Of course, there were differences. The Impressionist eye was more dispassionate and less selective than Constable's. Those painters were uncompromising in their acceptance of modern life and would never have endorsed the personal emotions driving his work. As a stark illustration of the difference we need only compare the stormy Brighton seascapes, painted against the background of Maria Constable's illness, to Monet's painting of his dying wife, Camille – her pallid face subsumed within the bedsheets as a motif of flickering light and colour. But without an obvious English successor, the closest inheritors of Constable's unique approach to landscape were the anti-establishment painters of the French nineteenth century.

In Britain, that association was retrospectively strengthened by the emergence of previously unseen studies. In 1888, Isabel Constable, the last surviving sibling, gave the remainder of the family's collection to

the South Kensington Museum (later the V&A). Although nowhere near as extensive as the Turner Bequest, this was nonetheless a substantial endowment, comprising three easel paintings, ninety-two smaller oil sketches, two hundred and ninety-seven drawings and watercolours, and three sketchbooks. It proved to be equally revelatory. Just as disclosure of his sketches was changing the way people understood Turner, so the Isabel Constable gift challenged the way the world had previously thought about Constable, lending new appreciation to his working methods in front of the motif. For the first time the full scope of his outdoor oil practice was revealed in all its fresh and Impressionistic-looking glory, confirming for a home audience the international importance of their most British of painters. You can hear the patriotic smugness in discourse from the time: the art critic P.G. Hamerton wrote in 1890 how 'Almost all of Constable's sketches have a French air; the reason being, not that Constable imitated foreign art, for he was British to the backbone, but because he is the father of genuine nature-study amongst French landscape painters, and they have been led into his ways of study, which have now become almost universal amongst them.'[57]

Other revelations to materialise from Constable's studio were the full-size oil sketches painted as trial runs for the exhibition six-footers. Completely unknown during the artist's lifetime – not even Leslie or the Constable correspondence mentions them – their preparatory function was not immediately apparent and for many years they were taken as proof of Constable's progressive instincts. Roger Fry, for example, denounced the exhibition pieces as 'machines' and 'watered down' compromises 'filled with redundant statements of detail'.[58] However, he praised the full-size studies, saying, 'It is to those . . . that we must turn to find the real Constable.' In 1935, a five-and-a-half-foot canvas was bought in good faith by the National Gallery under the erroneous belief it was acquiring Constable's 1829 exhibit, *Hadleigh Castle. The Mouth of the Thames – Morning, after a Stormy Night* (fig. 40).[59] In fact, what the Gallery had purchased was the related full-size sketch. Whilst such a mistake could never have been countenanced in Constable's lifetime, twentieth-century tastes had radically altered expectations. With 'eyes dilated by half a century of impressionism', experts were beguiled by the textured, expressionistic fervour of the palette-knife work and the

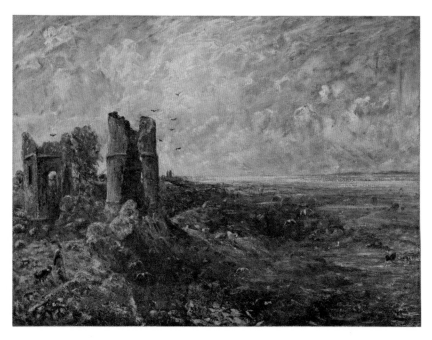

Fig. 40. Constable, *Sketch for 'Hadleigh Castle'*, c.1828–29, oil on canvas.

National Gallery considered the work a welcome addition to its collection.[60] 'We may be proud and thankful,' wrote the director, Charles Holmes, 'that Trafalgar Square now possesses this convincing proof of Constable's . . . modernity and power.'[61] By the time the inaccuracy was discovered, the picture was a beloved fixture of the national collection. Much like *Norham Castle* it can be found today on near-permanent display at Tate Britain, where it is highly prized for its powerful handling and raw emotional quality. Even in this day and age it remains unusual for a historical artist to have unfinished studies framed up and exhibited alongside finished pictures as though they were standalone works of art.

Thus it was that successive generations critically reinvented Turner and Constable, in light of the issues and preoccupations of their own times. Following their reincarnation as proto-Impressionists, in later years they were treated to a different kind of upgrade when modernist essayists such as Clement Greenberg started writing about them in relation to the formalist aesthetics of the early twentieth

TURNER AND CONSTABLE

century. In other words the interest moved from a preoccupation with subject to one of materials and technique. The 'what and the where' became the 'how and the why'. Turner's formerly maligned *Snow Storm – Steam-Boat off a Harbour's Mouth* became a touchstone for the drive towards the language of abstraction.[62] In 1966 the idea hit the mainstream when the Museum of Modern Art in New York put together an exhibition called *Turner: Imagination and Reality*. This was unprecedented: the very first time the gallery had showcased a historical figure who had died over a century earlier. When asked why MoMA, of all places, was preparing a show about a nineteenth-century British Romantic, the director of exhibitions, Monroe Wheeler, replied, 'Because we know a modern painter when we see one.'[63] In other words, it had taken the arrival of twentieth-century art forms for Turner's full genius to be appreciated. In what from a design point of view became an exercise in optics, he was displayed as though he were a contemporary artist. In sharp contrast to the dense picture hang and dark wall colours usual in nineteenth-century displays, at MoMA the paintings were sparsely hung in a single row on light-coloured walls. All this was intended to reinforce the curatorial agenda. With conscious bias, the predominantly late and unfinished works were calculated to align Turner with American abstract expressionism. His art was hailed as the triumph of style over narrative: his most important contribution to aesthetics was regarded as the use of generalised form and colour to capture abstracted states of feeling. In an accompanying essay to the MoMA exhibition, curator Lawrence Gowing described the *Waterloo Bridge* incident with Constable as an example of 'the metaphoric force that colour possessed for English painters, and Turner's way of postponing to the last the translation of colour into form'.[64] Even the catalogue illustrations helped justify the argument. The photographic limitations of colour reproduction made the images look even flatter and more abstract than they appear in real life.

The icing on the cake was the way that Turner was claimed by some of the leading American practitioners of the day. Painter Mark Rothko famously threatened to sue Turner for copyright, joking at the exhibition's opening, 'That chap Turner learned a lot from me!'[65] As one of the foremost abstractionists, he felt an affinity with Turner's immersive and emotional resonances of colour, particularly

in some of the oil or watercolour 'beginnings' where paint had been laid down in contiguous bands of colour. In a gesture that echoed the spirit of Turner's National Gallery tribute to Claude, Rothko bequeathed his black and maroon Seagram murals to the Tate Gallery, welcoming the idea that they would be shown in proximity to the Turner Bequest. This, incidentally, rarely happens. Rothko, who died in 1970, could never have anticipated the opening of Tate Modern. Since 2000, Tate's British collection has been housed at Millbank and the international modern and contemporary collection at Bankside, meaning the two are almost perpetually separated by a couple of miles and on opposite banks of the River Thames.

Whilst Turner was embraced by the 'colour field' abstractionists, Constable's legacy took a different route. His approach was paraphrased by the so-called action painters – artists whose emotional energy was communicated through expressive mark-making. Not for nothing has he since been labelled the 'Jackson Pollock of the 1830s'.[66] And it is this fascination with the physical presence of paint that was so often referenced during the later twentieth century. Characterised by Patrick Heron as a commitment to 'the broken surface', Constable's most revolutionary contribution to art has been identified as the isolation of the individual brushstroke.[67] Disrupting centuries of academic practice, he smashed through the assumption that a painting should act like a mirror. No longer was it needful for paint to form a flawless skin on canvas – a mimetic carapace indistinguishable from reality. Now, brushstrokes could be the most visible part of a painting, even to the point of obscuring the intended subject. Artists who have followed this line of thought – Frank Auerbach, Lucian Freud and Leon Kossoff are just three examples – have tended to relish the hard-won intensity of Constable's facture.[68]

Amidst all of this, the push and pull of comparison continues to play a part. Turner remains a useful point of reference for accessing Constable, and vice versa. Freud explained, 'You can admire Turner enormously, but never be moved by him really. For me, Constable is so much more moving than Turner because you feel, for him, it's truth-telling about the land rather than using the land for compositions which suited his inventiveness.' Auerbach meanwhile is quoted as saying, 'There isn't a Turner that doesn't somehow fly and there isn't a Constable that doesn't burrow.'[69]

　　　　　　　　　　　　　　TURNER AND CONSTABLE

Personal affinities aside, both Turner and Constable have passed into the pantheon of artistic endeavour. So many artists have cited their influence over the centuries – too many to list comprehensively here – or have produced original artworks inspired by individual examples that generalisations become almost pointless. However, certain trends are discernible. Turner has remained a touchstone for artists wielding light and colour (Sean Scully, Olafur Eliasson) as well as cinematographers and filmmakers.[70] There is a long tradition concerning the visible effects of industrialisation and climate change (John Ruskin, James Abbott McNeill Whistler, Emma Stibbon). Above all, his radical reputation has made him a rallying point for experimentation. Art that falls under the banner of his name rarely conforms to comfortable expectations. Instead it challenges viewers to keep faith with the changing modes of present-day practice. There is Turner Contemporary – a spectacular exhibition venue overlooking the seafront in Margate. Opened in 2011, the gallery owes its inception to Turner's biographical associations with the town (the building designed by David Chipperfield Architects was erected on the former site of Mrs Booth's lodging house), but also embodies beliefs about the importance of art as an agent for change and social regeneration. And most famously of all, there is the Turner Prize, since 1984 the British art world's most high-profile annual award. Often associated in the public's mind with provocative contemporary art, this has gained a reputation for sparking controversy and even ridicule. Nevertheless, it has been described as facilitating the engagement with 'new art with an open mind, unencumbered by rancid clichés'.[71] In 2019, a fictionalised imagining of what Turner would have made of it all joked about his reaction to the medium of film installation:

> *Turner*: I've just walked into the bleedin' wall. Why's it so damn dark? Has that wretched Constable fellow been here making a nuisance of himself?[72]

The piece ends with the painter absorbing the gravity of Turner Prize co-winner Lawrence Abu Hamdan's sobering sound pieces and acknowledging the honour of being perennially associated with difficult, important and thought-provoking creations.

Although in nineteenth-century terms it was actually Constable who had the more rebellious outlook, the Turner Prize would make little sense if renamed as the 'Constable Prize'.[73] Whilst Turner's art, particularly his late work, is generally understood as a deviation from pictorial norms, Constable's has become the very definition of tradition. This is not to say he is not significant for modern artists. Many – David Hockney, for one – have emulated his celebration of regionally specific landscape, or his deep and abiding connection to place. But owing to the conventional associations of his most iconic images, Constable is not a plausible standard bearer for abstruse contemporary art.

In particular, it was minimalism that proved to be a bridge too far, as evidenced by a press outburst in 1976. That year, the Tate Gallery hosted a major Constable retrospective (the bicentennial equivalent of one held at the Royal Academy for Turner in 1974–5). Coincidentally, at the same time, the collection displays featured Carl Andre's *Equivalent VIII*, a minimalist sculpture from 1966 comprising 120 firebricks placed in geometric regularity. The work had been on display at least twice since its acquisition by Tate in 1972, but now it suddenly became the focus for a storm of controversy, prompted by a contentious article in the *Sunday Times*.[74] The newspapers condemned the waste of taxpayers' money on a worthless 'pile of bricks' and Tate's judgement became a matter for national debate. The tabloids had a field day – reporters were sent to building sites, asking bricklayers to recreate the piece – but even at government level and within the art press, questions were asked about what should be allowed to be called art. So heated became the antipathy towards Andre's work that it was even vandalised.[75] And there in the background, indirectly fuelling the vitriol, was Constable, whose concurrent exhibition set him up as a paradigm of cultural value. A cartoon in the *Observer* satirised the gulf between the two – Constable's exquisitely painted landscapes and Andre's industrial sculpture, so inanely simplistic that the yokels from *The Hay Wain* could install it.[76] In the words of Briony Fer, Andre's work appeared 'to adopt incomprehensible strategies in order wilfully to confound the common sense and popular taste.'[77] Constable's, by contrast, was everything the public wanted and understood in their art.

As defensive Tate staff contested at the time, all this was simply history repeating itself. Considering the abuse endured by Constable

for his own confounding of nineteenth-century expectations, it was hardly to be wondered at that unconventional art required the test of time to pass into mainstream acceptance. In the meantime, contemporary artists, including minimalist Robyn Denny and figurative sculptor Barry Flanagan (another individual slated by the *Sunday Times* article), were engaging with Constable's legacy within a modern print portfolio entitled *For John Constable*.[78] And in a fascinating continuation of the saga, an intellectual link was later established between Constable and Andre. The *Equivalents* brick series was originally titled after a group of cloud studies by Alfred Stieglitz, an early twentieth-century photographer whose interest in the sky mirrored Constable's.[79] The principle of the argument can even be said to have come full circle. In 2014 the art collector Charles Saatchi, whose own assembly of contemporary art formed a huge national gift in 2010, posited that at least some of Tate's Turners should be sold, shared or traded in order to fund modern and contemporary acquisitions.[81] Whether, as Saatchi's opinion piece stated, the artist would really have been proud 'that he alone had made it possible for his homeland to have the spectacularly good national collection of the world's modern masterpieces it deserves' is debatable. For such a notion to be aired in the press was quite the attitudinal U-turn. Turner, at least, would almost certainly have appreciated the irony.

Clearly there is an object lesson to be learned here, which is that artists are subject to shifting interpretations during and after their lifetimes, and readings of their work can mean quite different things at different moments. Perhaps more than most, Constable and Turner have been susceptible to polarised opinions, ridiculed one minute and revered the next, sometimes for the self-same things. If we are to fully understand their careers it is necessary to interrogate the historical context, rather than subjectively cherry-picking material according to anachronistic methodologies. Ever since the artists found their respective institutional homes – the Isabel Constable gift at the V&A and the Turner Bequest at Tate – the pair have been subjected to more rigorous academic treatment. Aided by technology and the rise of the in-focus exhibition, scholarship has exhaustively explored their social, professional, economic and aesthetic frameworks, leading to a more holistic appreciation of their legacies.

Yet in spite of the best efforts of art historians, a popular dichotomy persists. Turner remains the radical modern and Constable the anti-modern conservative. Conditioned in no small part by the idolisation of *The Hay Wain* and *The Fighting Temeraire*, this perception has proved stubbornly durable. To conclude our tale, as a marker of its longevity, we can follow its existence in the most high-profile arena of all: the court of public opinion.

AFTERWORD: AFTERLIFE

ART HISTORY IS one thing. Turner and Constable, however, are bigger than this. They have become household names. Uniquely amongst British artists, their cultural reach has transcended the realms of art galleries and academia and established them as fixtures within the popular imagination. The everyman's judgement is indicative of their infiltration of the mainstream. Even audiences who claim not to be interested in art might be subconsciously aware of their influence. The seemingly inexhaustible appetite for their paintings means they are perpetually being replayed in the national conscious-ness – repeatedly referenced, reproduced and adapted in ways which keep them more visible than ever before. Aside from the hundreds of non-fiction books devoted to their lives and works, they have inspired plays, poems, books, music and other artworks, and they have even found fame as fictional characters in their own right.[1]

They also, to a large extent, remain shackled together. Like a latter-day Mozart and Salieri, or a forerunner of the Beatles and the Rolling Stones, they seem fated to be remembered in uneasy alliance, each as one half of a rivalrous double act.[2] What is more, as figures invariably described in superlatives, the debate about who is the 'greatest' continues to be played out. In polls and surveys, they are perennially pitted against one another for the notional title of the nation's favourite artist or artwork, edging one another out to come top of the pops on alternate occasions.[3]

In different ways, both too have been used as bastions of Britishness, used to advertise Britain, or stereotypically British things. Constable has been projected onto the facade of the National Gallery; Turner has a rose named after the *Temeraire*. Constable has appeared in the UK passport; Turner is the face of the £20 note; both have been

stamps. Turner paintings have featured in James Bond movies and Sherlock Holmes adaptations, Constable's in episodes of *Doctor Who* and *Harry Potter*. Both have popped up within the absurdist sketches of *Monty Python's Flying Circus*. Rightly or wrongly, they have seeped into the national psyche and become part of a tacit understanding about what it means to be British.

Thanks to his Suffolk showstoppers, John Constable has long been the poster boy for his home county. This happened even whilst he was alive. Much to his delight, he was told by a stranger that the beautiful Dedham countryside they were travelling through was '*Constable's* country'.[4] So it has remained ever since. It is very unusual for the marketing of a geographic region to be so thoroughly associated with the identity of an artist but interest in Constable has been driving tourism in East Anglia since the late nineteenth century. The valleys and villages of the Suffolk–Essex border are 'Constable Country', the place that launched a thousand trips. By 1893, Victorian travel agent Thomas Cook & Son was offering its target middle-class clientele trips to Flatford via the Great Eastern Railway. The excursion was popular with Continental and American tourists but also British day trippers. As a destination it chimed with the company's moralising, temperance values. It wasn't simply a matter of seeing where John Constable came from. It was about the healthful benefits of the countryside and the reminder of simpler (read less socially mobile) times. These qualities, together with the deep satisfaction of recognising Constable's viewpoints, have imparted this part of England with a very special identity.

Over the centuries, steps have been taken to safeguard 'Constable Country', preserving in actuality the qualities that the artist immortalised in paint. In 1970, the Dedham Vale was designated an Area of Outstanding Natural Beauty (today known as a 'National Landscape'). This in effect ensures that 'unspoiled' areas of scenic beauty remain unspoilt, protecting the distinctive characteristics of the terrain. Thanks to Constable this includes natural features like the lowland geography, meandering river and ancient woodland, but also man-made interventions including fields and farmland, mills and villages. Meanwhile, the visitors' oasis at the heart of the region is Flatford, a National Trust stronghold since 1943. Following vital restoration work on Willy Lott's cottage during the 1920s, the building was

presented to the nation. Gradually, after the Second World War, other pockets of Flatford were acquired, bit by bit safeguarding the buildings and sightlines of Constable's most famous paintings. And although the Trust state they do not want to 'fossilise' the artist's landscapes, Flatford has, in essence, become an immersive alternative to *The Hay Wain*.[5] People don't just go there to match up the masterpiece; they want the full picturesque experience. Visitors hope to access the same safe and soothing rhythms the artist sought to capture in his original picture. It is like the touristic equivalent of comfort reading. Stand beside the millpond with your back to Flatford Mill and the feeling is perfection. The pond is a little higher, the trees are more overgrown and there is unlikely to be a fording cart, but otherwise it remains the tranquil tableau of Constable's childhood. If a faint sense of disappointment lingers when you can't see the fields to the right, this is ameliorated by the pristine creaminess of Willy Lott's house and the sunlight sparkling on the surface of the Stour. There will almost certainly be ducks.

Constable's art became part of a halcyon vision of bygone Britain, an antidote to the troubling realities of industrialisation, urbanisation and climate change. And not just 'Constable Country' specifically. As a tokenistic metaphor, Constable *is* country. His name has become synonymous with any mild or tame semi-agricultural (usually south-eastern) area that keys into the populist fiction of the countryside as an idyllic space. *The Hay Wain* and other paintings like it begat a vogue for 'chocolate box' landscapes – a visual iconography composed of rose-strewn cottages, sunny cornfields, country yokels and horse-drawn carts. This kind of quaint rural scenery was considered literally inoffensive enough to put on the lid of a box of Cadbury's but is now more generally used as a pejorative term. We can detect its aesthetics underpinning other fictive idealised locations: the 'perfick' 1950s Kent of H.E. Bates's *The Darling Buds of May*, for example, or the sleepy village of St Mary Mead in Agatha Christie's Miss Marple stories. 'His landscape is just what the English feel nostalgic for,' wrote Robert Hughes, 'as they dodge trucks on the bypass amid the billboards and concrete goosenecks.'[6]

The 'chocolate box' archetype is merely one instance of the way Constable has become subsumed within the national obsession with the good old days. In the world of advertising his work became

ubiquitous with vintage nostalgia and traditionally his paintings have adorned items which are in themselves comfortingly everyday and domestic – tea towels, biscuit tins, table mats and tea caddies. They have been turned into collectibles and sentimental knick-knacks such as thimbles and commemorative plates by ceramicists from Clarice Cliff to Coalport. From the 1930s onwards, Staffordshire pottery company W.H. Grindley specialised in 'Scenes after Constable' earthenware, with the famous paintings transferred onto white plates and tea sets with 'flow blue' glazes – a sort of Anglo alternative to Chinese willow pattern. Similarly, during the 1970s, Broadhurst ceramics made a series of brown ironstone china for the bicentennial of Constable's birth. One can buy a porcelain Willy Lott's cottage or a three-dimensional clay diorama of Flatford, complete with hay wain and little dog. The Constable effect even holds value in the world of real estate. In 2016, the average price of a detached property in Dedham Vale was reportedly 35 per cent above the local average. According to the *Financial Times*, 'Constable country . . . has the sort of character that appeals to those wistful for a traditional English way of life'.[7]

The flip side to all this folkloric fantasising has been the politicising of the myth. 'Parts of south Suffolk and north Essex,' the *FT* article went on, 'have an active UKIP contingent, made more active in the run-up to the EU referendum.'[8] Constable has been commandeered within a reactionary vision where 'good, old England' is in danger of becoming an exclusionary space: an anti-urban idyll, but only for those from the 'right' background. Again, the images most obviously fuelling the ideology are the Flatford pictures. Background placement within films and television series is often judiciously pertinent, ironically deployed to affirm a sense of ultra-nationalism by confirming or subverting the stereotype. Incongruous appearances have included Guy Ritchie's London crime comedy *Snatch* (2000), where *The Hay Wain* is the focal point for a shootout in a dingy back corridor of a dive pub called the Drowning Trout. In the *Harry Potter* franchise, a cheap reproduction of Flatford Mill hangs in the hallway of the ghastly Dursleys' pristine suburban house.

Dystopian twists upon *The Hay Wain* are very effective. Any disruption of the bucolic setting is unsettling and all sorts of jarring things have been dumped into the millpond in the name of satire: cars, shopping trolleys, electricity pylons, skyscrapers and excessive

signage.[9] The experimental 'master of comic disgust' Ellis Sharp used the painting as the starting point for a commentary upon power and privilege in the short story 'The Hay Wain'.[10] Perhaps the most successful example is Peter Kennard's CND takeover. In response to the Ministry of Defence's proposal to house US nuclear cruise missiles in East Anglia, the artist photomontaged three nuclear warheads and a gas mask into the painting – a highly effective and memorable intervention. In real life, the picture has also been the target for high-profile iconoclasm and sporadic acts of vandalism designed to bring media attention to a cause. In 2013, a Fathers4Justice protestor glued a photograph of his son directly onto the picture in the National Gallery. In 2022, Just Stop Oil climate activists glued themselves to the frame and taped posters over the canvas showing an apocalyptic reimagining of the setting.

The Fighting Temeraire too has been used for satirical ends. So often, the ephemeral nature of news means the caricaturists' wit becomes obsolete once the issue has faded from memory, but the significance of Turner's painting remains as clear today as when it was first painted. The jingoistic potency of the imagery, shot through with a poignant sense of futility, has made it a gift for British parody. Since the nineteenth century, illustrators have wrung a lot of mileage from the 'out with the old, in with the new' formula. Easily adaptable to any 'hoary old institution in the process of being dismantled or discarded', the image was appropriated by Matthew Somerville Morgan as a comment upon the disestablishment of the Church of Ireland (1868), as well as by Linley Sambourne in a *Punch* illustration protesting the scrapping of another of Nelson's ships, the *Foudroyant* (1892).[11] In recent years, newspaper cartoonists have grafted British prime ministers into the familiar visuals. During the Iraq War, Steve Bell's *The Fighting Toneraire or 'Thank You for Mentioning the War'* (*Guardian*, 2005) showed a grimacing, wall-eyed Tony Blair as the ineffective battleship was towed away for scrap by the Liberal Democrat leader Charles Kennedy.[12] Political cartoonist for the *Independent* Dave Brown, meanwhile, turned Blair into the tugboat, hauling Sinn Fein's unwilling Gerry Adams to the general election in 2005.[13] A few years later it was David Cameron's turn. A lampoon on the Conservatives' termination of naval shipbuilding in Glasgow and Portsmouth in 2013, *The Fighting Portsmouth: Tugged to Its Last*

Berth to Be Turned into Bagpipes featured a cheery-looking Cameron forging full steam ahead with the policy, whilst the first minister of Scotland, Alex Salmond, basked in blissful contentment with this gift to his nationalist agenda.

Imaginative interactions with Turner continue to circle back to his relationship with maritime history. Almost immediately following its exhibition, *The Fighting Temeraire* became a symbol of indomitable British spirit. Patriotic songs and verses about the ship were popular during the Victorian era, inspired as much by Turner's anthemic painting as the vessel herself.[14] 'Now the sunset's breezes shiver / And she's fading down the river / But in England's song for ever / She's the Fighting Temeraire,' wrote Henry Newbolt in 1897.[15] The picture extended the 'hearts of oak' mythology of the British navy, encapsulating ideas about resolution, courage, grit, endurance and resourcefulness. These sentiments have persisted even to this day, resounding, for example, within the 2012 James Bond movie *Skyfall*. In a film that was all about the transition between one era and another, the juxtaposition of old and new in the *Temeraire* was used to echo the dynamics of the first meeting between 007 and the new MI5 quartermaster, 'Q'. Whilst Q (played by Ben Whishaw) is the master of cyber warfare, it is Bond (Daniel Craig) who is in danger of being retired like an outdated old warship.

It is the sea which has most often provided the theme for a creative post-colonial reckoning with Turner. Artists and writers, especially those with African and Caribbean heritage, have confronted his complicity with, or commentary upon, the transatlantic slave trade. Challenging the conventional white interpretation of the painting *The Slave Ship* as proof of the artist's abolitionist sympathies, creative responses have explored his perceived aestheticisation of suffering, and the reduction of the role of Black Africans to nameless, unseen victims. Notable contemporary artists to explore these ideas include Frank Bowling, Larry Achiampong, Lamin Fofana, the Otolith Group and Ellen Gallagher. David Dabydeen's long narrative poem *Turner* (1995) and Winsome Pinnock's play *Rockets and Blue Lights* (2020) offer powerful retellings of history from the perspective of previously unheard voices.

On a lighter note, the commodification of Turner, like that of Constable, is now so extensive that he has become one of the most reproduced artists in the world. Modern merchandising has made

it possible to superimpose art images onto anything, but Turner's applications have been unusually wide, from low-end kitsch to limited-edition designer luxuries. Depending on one's budget it is possible to purchase Turner flip-flops or Dr. Marten boots; a kitchen clock or a Swatch watch; a canvas tote or a Louis Vuitton handbag. His pictures have inspired everything from fridge magnets to flower bouquets, and paints to carpet colourways. He has been used to advertise Coca-Cola and has even incentivised the field of mixology.[16] Cocktails inspired by him have included a sunset-coloured concoction at the Savoy, a 'Dark and Stormy', and a 'Widow's Kiss', a French drink of Benedictine mixed with Chartreuse and Calvados, purportedly given to widows whose husbands had been lost at sea.[17]

As superficial as all this might appear, it forms a telling part of the artists' legacies, inextricable from their wider stories. To truly appreciate Constable and Turner we need to be always trying to penetrate a little further, to look beyond the stereotypes and the rehashed anecdotes, to reveal a richer, more rounded understanding. One way to do that is to look at them together. History has remembered them as rivals. It would be more accurate to describe them as comrades, brothers-in-arms in the battle of British art. Between them they took on the prejudices of the art world and won status for their chosen field. Together they taught us to look at our lives through the lens of landscape. Their differences are illuminating, indicative of their varying backgrounds and outlooks. But acknowledging their antithetical nature is helpful rather than harmful, bringing us closer to understanding their mutual achievements and legacy. Profoundly different, substantially the same, they spoke the same language – just in very different voices. Turner's art was wide-ranging and universal. He painted great swathes of the world – all over Britain and Europe – and not only its present but also its past, and sometimes he was even reaching towards its future. Constable, by contrast, strove to represent just one small corner of the world. But he did that so fiercely and faithfully that you not only know what it looked like, you can almost smell it, hear it and feel it too. The dynamic duo of landscape painting during its most glorious and influential moment, individually they were great. In tandem they were titans.

Above all, both artists have become part of our lives. Their paintings have become a frame of reference for connecting with the great

outdoors. We get out there and follow in their footsteps, commenting as we go upon Turner skies and sunsets, and Constable clouds or countryside. Up and down the United Kingdom there are views and vistas made famous by one or the other, the scenery signposted by plaques, noticeboards and trails. You can use the what3words digital geocode app to find the viewpoints of Constable's iconic pictures in Suffolk or search more than seventy locations tagged as sites for Turner's. We even seek to bring that outside feeling indoors. Reproductions of their paintings have been decorating our interior spaces for decades, as posters, postcards, pictures and products. And when we choose to adorn our homes with their art it is because we love the way their landscapes make us feel. What is more, we appreciate those things not just for their visual qualities, but also for what they mean to us as humans. Unique yet universal, of their time but also ageless, their art is a reminder of what the natural world makes us feel as individuals, grounding us within life's bigger picture. Ultimately, there is no need to choose between them. As Constable once said about Turner's paintings, 'one can live – and die – with *such* pictures in the house'. We can. We do. We probably always will.

NOTES

Abbreviations used in the notes

B&J	Butlin, Martin, and Evelyn Joll, 1984, *The Paintings of J.M.W. Turner* (New Haven and London: Yale University Press).
Farington diary	Cave, Katherine, Kenneth Garlick and Angus Macintyre (eds), 1978–98, *The Diary of Joseph Farington, 1793–1821*, 17 vols (New Haven and London: Yale University Press).
JCC I	Beckett, R.B. (ed.), 1962, *John Constable's Correspondence: 1. The Family at East Bergholt 1807–1837* (London: Her Majesty's Stationery Office).
JCC II	Beckett, R.B. (ed.), 1964, *John Constable's Correspondence: 2. Early Friends and Maria Bicknell* (Ipswich: Suffolk Records Society).
JCC III	Beckett, R.B. (ed.), 1965, *John Constable's Correspondence: 3. Correspondence with C.R. Leslie, RA* (Ipswich: Suffolk Records Society).
JCC IV	Beckett, R.B. (ed.), 1966, *John Constable's Correspondence: 4. Patrons, Dealers and Fellow Artists* (Ipswich: Suffolk Records Society).
JCC V	Beckett, R.B. (ed.), 1967, *John Constable's Correspondence: 5. Various Friends, with Charles Boner and the Artist's Children* (Ipswich: Suffolk Records Society).
JCC VI	Beckett, R.B. (ed.), 1968, *John Constable's Correspondence: The Fishers* (Ipswich: Suffolk Records Society).
JCD	Beckett, R.B. (ed.), 1970, *7. John Constable's Discourses* (Ipswich: Suffolk Records Society).
Leslie, *Autobiographical Reflections*	Taylor, Tom (ed.), 1978, *Autobiographical Recollections of Charles Robert Leslie* [originally 1860], 2 vols (Wakefield: EP Publishing).
Leslie, *Life*	Leslie, Charles Robert, 1845, *Memoirs of the Life of John Constable*, second edition (repr. London: Phaidon, 1995).
Thornbury, *Life*	Thornbury, Walter, 1877, *The Life of J.M.W. Turner, RA*, second edition (repr. London: Ward Lock Reprints, 1970).

Introduction

1 Leslie, *Life*, p. 178.

1. Background and Beginnings

1 Thornbury, *Life*, p. 7.
2 Ibid., p. 117. John Linnell, *Portrait Study of J.M.W. Turner's Father, with a Sketch of Turner's Eyes, Made during a Lecture*, 1812, pencil on paper (Tate, T03117).
3 Thornbury, *Life*, p. 117.
4 See for example Dr Alun Withey, 'Cuts, Rashes & Chatter! The Pain of the 18th Century Shave!' and 'How Much?! Barbers and the Price of Shaving' blogs, https://dralun.wordpress.com/category/barbers, accessed January 2023.
5 Thomas Rowlandson, after Henry Bunbury, *A Barber's Shop*, c.1780–9, coloured etching with aquatint (Wellcome, 30145i).
6 Thornbury, *Life*, p. 43.
7 See a profile drawing in the *Marford Mill* sketchbook (Tate, D00310, XX 35), and a hidden portrait discovered with X-radiography beneath a landscape oil painting (Tate, N00465); see https://www.tate.org.uk/tate-etc/issue-50-autumn-2020/behind-scenes. There is also a tentatively titled portrait miniature, illustrated in Eric Shanes, *Young Mr Turner* (New Haven and London: Yale University Press, 2016), p. 3, fig. 3.
8 Thornbury, *Life*, p. 4.
9 The 'urban penalty' is a term first used within the study of English demography of the nineteenth century to describe the higher mortality rates found in cities than in rural areas.
10 Thornbury, *Life*, p. 4.
11 Ibid., p. 235.
12 These four watercolours were apparently given to one Mrs Jane Taylor (née Hunt) of Bakewell, Derbyshire. The provenance is recorded in Andrew Wilton, *J.M.W. Turner: His Art and Life* (New York: Rizzoli, 1979), nos 1–4.
13 Both statues are now in the collection of the Bethlem Museum of the Mind. For discussions of these and other artistic depictions of madness see Jane Kromm, *The Art of Frenzy: Public Madness in the Visual Culture of Europe, 1500–1850* (London: Continuum, 2002), p. 87. In 1777, Turner's future colleague John Soane submitted a similar but unrealised design of two female figures for St Luke's Hospital.
14 Information from David Luck, archivist, Bethlem Museum of the Mind, email to author, January 2023.
15 Paul Chambers, 'Bethlem Royal Hospital: Why Did the Infamous Bedlam Asylum Have Such a Fearsome Reputation?', *BBC History Revealed*, April 2020, https://www.historyextra.com/period/victorian/

bethlem-royal-hospital-history-why-called-bedlam-lunatic-asylum/, accessed June 2024.

16 Information from David Luck, archivist, Bethlem Museum of the Mind, email to author, January 2023.

17 Shanes, *Young Mr Turner*, p. 100.

18 Farington diary, 12 November 1798, vol. IV, p. 1090.

19 Constable, letter to William Carpenter, ?summer 1833, JCC IV, p. 147.

20 Thornbury, *Life*, p. 55. Andrew Wilton has suggested that the prolonged relationship may be attributed to Turner's dependence on Monro for his mother's care. See Andrew Wilton, 'Album of Copies of Italian Views for Dr Thomas Monro c.1794–8', April 2012, in David Blayney Brown (ed.), *J.M.W. Turner: Sketchbooks, Drawings and Watercolours*, Tate Research Publication, December 2012, https://www.tate.org.uk/art/research-publications/jmw-turner/album-of-copies-of-italian-views-for-dr-thomas-monro-r1140585, accessed 20 March 2024.

21 See Iain Macintyre and Alexander Munro, 'The Monro Dynasty and Their Treatment of Madness in London', *Neurosciences and History* 3 (2015), pp. 120–1.

22 Chapter IX, 'Two Boyhoods', in John Ruskin, *Modern Painters*, vol. 5 (1860).

23 Ibid., in E.T. Cook and Alexander Wedderburn (eds), *The Library Edition of the Works of John Ruskin* (London, 1907), vol. VII, p. 377.

24 Farington diary, 24 October 1798, vol. IV, pp. 1074–5.

25 Farington diary, 27 March 1811, vol. XI, p. 3900.

26 Ann Constable, letter to John Constable, 26 July 1810, JCC I, p. 47.

27 Quoted in James Hamilton, *Constable: A Portrait* (London: Weidenfeld & Nicolson, 2022), p. 18.

28 These details come from a letter dated 9 July 1816, from Constable's younger brother, Abram, pertaining to the sale of the house. Quoted in JCC I, p. 136. See also the related 1816 advertisement in the *Ipswich Journal*, quoted in Hamilton, *Constable: A Portrait*, p. 25.

29 Leslie, *Life*, p. 3.

30 These pieces of wood have survived and can be found in the collections of Colchester and Ipswich Museums (COLEM:136A).

31 John Constable, *View at East Bergholt over the Kitchen Garden of Golding Constable's House*, c.1812–16, pencil on paper (V&A, 623-1888). Also *Golding Constable's Vegetable Garden* and *Golding Constable's Flower Garden*, both 1815, oil (Colchester and Ipswich Museums).

32 The same view can be seen across two oil paintings, *Golding Constable's Flower Garden* and *Golding Constable's Kitchen Garden*, both 1815 (Colchester and Ipswich Museums, IPSMG:R.1955.96.1 and IPSMG:R.1955.96.2).

33 Constable, letter to John Fisher, 23 October 1821, JCC VI, p. 78.

34 Much of Turner's correspondence was destroyed, notably his letters to Mrs Sophia Booth, Lord Egremont and Walter Fawkes. That which

survives is published in John Gage (ed.), *The Collected Correspondence of J.M.W. Turner* (Oxford: Oxford University Press, 1980). Constable's correspondence and writings were collated in seven volumes and edited by R.B. Beckett during the 1960s.

35 John Constable, *Ann Constable*, c.1800–5 or ?c.1815, oil on canvas (Tate, T03902).

36 Letters from Ann Constable to John Constable, 4 July 1808, p. 26 and undated [1811], JCC I, p. 65.

37 As just one example see letter from Ann Constable to John Constable, 15 March 1810, JCC I, p. 40. Ann concludes her letter, 'You are very seldom absent from the mind of your truly affectionate Mother.'

38 Abram Constable, letter to John Constable, 28 January 1821, JCC I, p. 192.

39 Ann Constable, letter to John Constable, 2 December 1807, JCC I, p. 22. She describes Golding as 'having more apathy than ever – yet good temper'd as usual'.

40 John Constable, *Golding Constable*, 1815, oil on canvas (Tate, T03901).

41 Ann Constable, letter to John Constable, 7 March 1815, JCC I, p. 115.

42 *Landscape with Hagar and the Angel*, 1646 (National Gallery, London, NG 61).

43 Farington diary, 29 June 1799, vol. IV, p. 1568. 'Constable called. His Father consented to his practising in order to profess Painting, – but think He is pursuing a Shadow. – Wishes to see him employed.'

2. The Royal Academy

1 Turner was officially admitted to the Schools of the Royal Academy on 11 December 1789. He began attending the Antique Academy in January 1790.

2 Farington diary, 25 February 1799, vol. IV, p. 1164.

3 Farington diary, 26 September 1798, vol. III, p. 1060.

4 Farington diary, 26 February 1799, vol. IV, p. 1164.

5 Farington diary, 2 March 1799, vol. IV, p. 1166.

6 Turner's study of the *Belvedere Torso* can be found in the collection of the V&A (9261). For a history of the torso and its importance see https://www.royalacademy.org.uk/art-artists/work-of-art/cast-of-belvedere-torso, accessed March 2024.

7 JCC II, p. 22. Constable dated the letter in error 'February 4th, 1799'. Technically speaking he wasn't yet a student but a probationer. He was officially entered into the Schools in March 1800.

8 See Sidney C. Hutchison, 'The Royal Academy Schools, 1768–1830', in *The Volume of the Walpole Society* 38 (1960), pp. 123–91.

9 For discussion of the RA Schools during the period see Annette Wickham, 'The Schools and the Practice of Art', in Robin Simon and Mary-Ann Stevens (eds), *The Royal Academy of Arts: History and Collections* (London: Yale University Press/Royal Academy, 2018), pp. 432–47.

10 Turner, *A Kneeling Male Nude with Upraised Head and Arm in a Landscape Setting*, c.1794–5, black, white and red chalks with stump on laid brown-grey wrapping paper (Tate, D00197); Constable, *Study of a Male Nude Figure, Seated, with His Right Foot on a Round Block and His Head Thrown Back*, c.1800, black and white chalk on grey paper (V&A, 45-1873).

11 Shanes, *Young Mr Turner*, p. 35.

12 Hutchinson, 'The Royal Academy Schools', p. 130.

13 Where records exist, the yearly visitor numbers to the Exhibition are noted in Mark Hallett, Sarah Victoria Turner and Jessica Feather (eds), *The Royal Academy of Arts Summer Exhibition: A Chronicle, 1769–2018*, chronicle250.com. In 1800, for example, there were 59,100 visitors: see Paris Spies-Gans, '1800: The Growing Presence of Female Exhibitors', chronicle250.com/1800, accessed March 2024.

14 For a helpful discussion of monetary values in the long eighteenth century with reference to the production and purchase of cultural items see Robert D. Hume, 'The Value of Money in Eighteenth-Century England: Incomes, Prices, Buying Power – and Some Problems in Cultural Economics', *Huntington Library Quarterly* 77 (December 2014), pp. 373–416, https://hlq.pennpress.org/media/34098/hlq-774_p373_hume.pdf, accessed January 2023. For information on the Vauxhall Pleasure Gardens see https://www.museumoflondon.org.uk/discover/vauxhall-pleasure-gardens.

15 *The Archbishop's Palace, Lambeth*, 1790, watercolour (Indianapolis Museum of Art). Reproduced in Shanes, *Young Mr Turner*, p. 35.

16 *Malmsbury Abbey*, 1792, watercolour on paper (Norwich Castle Museum and Art Gallery). Reproduced in Shanes, *Young Mr Turner*, p. 46.

17 Tate, N00459.

18 Shanes, *Young Mr Turner*, p. 139. *Fishermen Coming at Shore at Sun Set, Previous to a Gale* (cat. 279) was moved after the exhibition catalogue had gone to print. This work has not been seen in public since the mid-nineteenth century but a print after it, *The Mildmay Sea Piece*, appears in Turner's seminal print publication, the *Liber Studiorum*.

19 *The Times*, 3 May 1797, quoted in B&J under no. 3.

20 See Shanes, *Young Mr Turner*, pp. 154–6.

21 Information from RA chronicle. There were 472 artists exhibiting 1,118 works, of whom 13 per cent were Academicians and 87 per cent non-Academicians. Catalogue of the Thirty-First Exhibition of the Royal Academy, 1799, accessible online within *The Royal Academy Summer Exhibition: A Chronicle, 1769–2018*, https://chronicle250.com/1799#catalogue. See Rev. C. Turner (415), D[aniel]. Turner (587) and G[eorge]. Turner (976 and 983).

22 Farington diary, 17 May 1799, vol. IV, p. 1223.

23 Farington diary, 17 May 1799, vol. IV, p. 1229.

24 Ibid.

25 Farington diary, 25 May 1799, vol. IV, p. 1228.

26 Quoted in Shanes, *Young Mr Turner*, p. 163.

27 Ibid., p. 164.

28 Claude Lorrain, *The Father of Psyche Sacrificing at the Temple of Apollo*, 1662–3, and *The Arrival of Aeneas at Pallanteum*, 1675 (both National Trust), see https://www.nationaltrustcollections.org.uk/object/515656 and https://www.nationaltrustcollections.org.uk/object/515654.

29 Farington diary, 8 May 1799, vol. IV, p. 1219.

30 JCC II, p. 23. Constable enrolled in the Life Academy on 19 February 1800, although he didn't receive his official card of admission until 21 June.

31 The picture was described by Joseph Farington as having 'a great deal of merit' but being 'rather too cold'. Farington diary, 6 April 1802, vol. V, p. 1764.

32 John Dunthorne, letter to Constable, 21 March 1802, JCC II, p. 31.

33 Constable, letter to John Dunthorne, 29 May 1802, JCC II, p. 31.

34 Ibid., pp. 31–2.

35 Turner, *Dutch Boats in a Gale: Fishermen Endeavouring to Put Their Fish on Board* (*The Bridgewater Sea Piece*), exh. 1801, oil on canvas, private collection, on loan to the National Gallery, https://www.national-gallery.org.uk/paintings/joseph-mallord-william-turner-dutch-boats-in-a-gale-the-bridgewater-sea-piece.

36 Farington diary, 26 April 1801, vol. IV, p. 1543. Beaumont qualified his comments, saying that he thought Turner's 'sky too heavy and water rather inclined to brown'.

37 Thornbury, *Life*, 1877, p. 8.

38 Shanes, *Young Mr Turner*, p. 5, says the print in question is Elisha Kirkall, after Willem van de Velde the Younger, *Shipping in a Storm*, 1724, coloured mezzotint (British Museum, London), reproduced p. 6.

39 Shanes, *Young Mr Turner*, pp. 226–7. Shanes says there is a marked resemblance to Rosa's *Landscape with St Anthony and St Paul*, 1650s or 1660s, oil on canvas (National Gallery of Scotland, Edinburgh).

40 Farington diary, 29 April 1801, vol. IV, p. 1544.

41 Mark Evans, Stephen Calloway and Susan Owens, *Constable: The Making of a Master* (London: V&A Publishing, 2014), p. 23.

42 In the *Calais Pier* sketchbook, LXXXI–58, D04960 (Tate), Turner annotated a lively drawing of the incident with the inscription 'Our landing at Calais nearly swampt'; Farington, who had also gone to France in 1802, recorded Turner's impressions of his trip on 1 October and 22 November 1802, vol. V, pp. 1890 and 1936.

43 This sketchbook was later titled *Studies in the Louvre*. See David Blayney Brown, 'Studies in the Louvre Sketchbook 1802', October 2009, in Brown (ed.), *J.M.W. Turner: Sketchbooks, Drawings and Watercolours*, https://www.tate.org.uk/art/research-publications/jmw-turner/studies-in-the-louvre-sketchbook-r1129682, accessed 9 February 2023.

44 Château de Malmaison, Paris.
45 Farington diary, 2 September 1802, vol. V, p. 1821.
46 Farington diary, 1 October 1802, vol. V, p. 1890.
47 Edmund Burke, *Philosophical Enquiry into the Origins of Our Ideas of the Sublime and Beautiful* (1756).
48 Farington diary, 21 May 1803, vol. VI, p. 2034.
49 Farington diary, 17 May 1803, vol. VI, p. 2031.
50 See Sam Smiles's essay, ' "Splashers," "Scrawlers", and "Plasterers": British Landscape and the Language of Criticism, 1800–1840,' *Turner Studies* 10.1 (1990), pp. 5–11.
51 This from two separate conversations about 'the different merits of artists': Farington diary, 26 January 1803, vol. V, p. 1967; and 2 May 1803, vol. VI, pp. 2022–3.
52 Farington diary, 23 March 1803, vol. V, p. 1998.
53 Constable's 1803 exhibits were unhelpfully vaguely titled. They were respectively: *A Study from Nature* (59) in the Great Room; *A Study from Nature* (694); *A Landscape* (724); and *A Landscape* (738), all hung in the Library. See Leslie Parris and Ian Fleming-Williams, *Constable* (London: Tate Gallery Publications, 1991), p. 60.
54 See B&J, no. 47.
55 Farington diary, 9 February 1804, vol. VI, p. 2238.
56 Ibid.
57 Farington diary, 10 February 1804, vol. VI, p. 2239.

3. Ups and Downs

1 Farington diary, 30 April 1803, vol. VI, p. 2021.
2 Farington diary, 15 May 1803, vol. VI, p. 2031.
3 Farington diary, 24 December 1803, vol. VI, p. 2202.
4 Farington diary, 1 October 1803, vol. VI, p. 2136. 'Marchant ARA called and spoke of Ts pictures. He said Turner had talent, – that his pictures *are curious*, but bad, and his prices beyond comparison.'
5 Farington diary, 22 May 1804, vol. VI, p. 2328.
6 Farington diary, 1 June 1804, vol. VI, p. 2340.
7 Rising to 400 guineas by 1810. Kenneth Garlick, *Sir Thomas Lawrence: A Complete Catalogue of the Oil Paintings* (Oxford: Phaidon, 1989), p. 20. *Festival of the Macon* is 57½ × 93½ inches. Lawrence used a canvas of 100 × 60 inches for his 'Largest size, whole length', a size for which he was quoting 700 guineas in 1829. See ' "Three-Quarters, Kit-Cats and Half-Lengths": British Portrait Painters and Their Canvas Sizes, 1625–1850', National Portrait Gallery website, https://www.npg.org.uk/collections/research/programmes/artists-their-materials-and-suppliers/three-quarters-kit-cats-and-half-lengths-british-portrait-painters-and-their-canvas-sizes-1625-1850/3.-further-standard-sizes#116, accessed April 2024.

8 Turner, letter to James Wyatt, 21 November 1809, Gage (ed.), *The Collected Correspondence*, p. 36. Turner says his pictures are all three feet by four feet and cost 200 guineas; Leslie, letter to Ann Leslie, 23 May 1837, *Autobiographical Recollections*, vol. II, p. 237, 'Turner desires me to tell E[dward] C[arey] that he cannot undertake a picture of less size than three feet by four, and that his price will be 200 guineas for that size.' Turner was inconsistent, also variously quoting 300 and 350 guineas for this size during the 1830s, but it still remained a modest increase from his starting point of 200. See Evelyn Joll, 'Prices for Turner's Paintings and Watercolours during His Lifetime', in Martin Butlin et al. (eds), *The Oxford Companion to J.M.W. Turner* (Oxford and New York: Oxford University Press, 2001), pp. 239–40.

9 Farington diary, 3 May 1803, vol. VI, p. 2023.

10 Farington diary, 1 April 1804, vol. VI, p. 2287.

11 Farington diary, 26 April 1804, vol. VI, p. 2307.

12 Quoted in B&J, under no. 52.

13 *The Nelson* sketchbook, Tate LXXXIX.

14 Tate, D05456, LXXXIX 9 verso. See David Blayney Brown, 'Diagram of Ship Positions and Notes on the Battle of Trafalgar 1805 by Joseph Mallord William Turner', January 2010, in Brown (ed.), *J.M.W. Turner: Sketchbooks, Drawings and Watercolours*, https://www.tate.org.uk/art/research-publications/jmw-turner/joseph-mallord-william-turner-diagram-of-ship-positions-and-notes-on-the-battle-of-r1139253, accessed 29 March 2024.

15 Tate, N00480.

16 See David Blayney Brown, 'Key to *The Battle of Trafalgar, as Seen from the Mizen Starboard Shrouds of the Victory* 1806 by Joseph Mallord William Turner', April 2006, in Brown (ed.), *J.M.W. Turner: Sketchbooks, Drawings and Watercolours*, https://www.tate.org.uk/art/research-publications/jmw-turner/joseph-mallord-william-turner-key-to-the-battle-of-trafalgar-as-seen-from-the-mizen-r1139293, accessed 14 February 2023.

17 Farington diary, 3 June 1806, vol. VII, p. 2777.

18 *Review of Publications of Art*, 1808, quoted in B&J, no. 58.

19 Constable, letter to John Dunthorne, 23 May 1803, JCC II, pp. 33–4.

20 Leslie, *Life*, p. 15.

21 Constable seems to have muddled the name of the Victory's captain, Hardy, with that of the Temeraire's, Harvey.

22 *The Victory Returning from Trafalgar, in Three Positions*, c.1806, oil on canvas (Yale Center for British Art). B&J, no. 59.

23 Stephen Hebron, Conal Shields and Timothy Wilcox, *The Solitude of Mountains: Constable and the Lake District* (Grasmere: Wordsworth Trust, 2006), p.13.

24 Compare for example Turner's *Crummock Water, Looking towards Buttermere* in the *Tweed and Lakes* sketchbook, 1797 (Tate, D01086) to Constable's *View in the Lake District*, 1806 (V&A, 186-1888).

25 Leslie, *Life*, p. 15.

26 This view was first counteracted in an excellent survey of Constable's Lake District work, Hebron, Shields and Wilcox, *The Solitude of Mountains*.

27 Inscribed on a sketch of Esk Hause. Quoted in ibid., p. xi.

28 Farington diary, 3 April 1809, vol. IX, pp. 3431–2.

29 *St James Chronicle*, 7–9 May 1807. Quoted in Judy Crosby Ivy, *Constable and the Critics, 1802–1837* (Woodbridge: Boydell Press, 1991), p. 63.

30 Farington diary, 6 July 1807, vol. VIII, pp. 3080–1.

31 *Sun*, 27 May 1807. See Martin Postle, '1807: "Boiled Lobsters" and *The Blind Fiddler*', in Hallett, Turner and Feather (eds), *The Royal Academy of Arts Summer Exhibition: A Chronicle*, chronicle250.com/1807, accessed 30 May 2024.

32 Quoted in David Solkin (ed.), *Turner and the Masters* (London: Tate, 2009), p. 155.

33 *Sun*, 17 May 1808. Quoted in B&J under no. 81.

34 See the 1838 engraving after Wilkie's painting by F. Engleheart, https://wellcomecollection.org/works/rb5wm8hm. According to Wilkie's diary, on 18 May 1808 Constable 'stood for his portrait till 10 o'clock', and on 19 May Wilkie 'Went to Turner's Gallery, and admired some of his paintings very much'. Quoted in Allan Cunningham, *The Life of Sir David Wilkie*, vol. I (London, 1843), p. 173.

35 Wilkie's diary, 15 June. Ibid., pp. 177–8.

36 Farington diary, 28 June 1810, vol. X, p. 3677. 'C called. He spoke of His Father still continuing to think that in following painting "He is pursuing a shadow," & sd that were He to be elected an Associate of the Academy it would have a great effect upon His Father's mind by causing Him to consider His situation more substantial.'

37 The painting can still be seen in situ in St James's Church, Nayland.

38 Farington diary, 28 June 1810, vol. X, p. 3677.

39 *Llandaff: The West Front of the Cathedral*, 1795–6, watercolour (Tate, D00686).

40 J.F. Elam, *St Mary's Church, East Bergholt: A Building and Its History* (East Bergholt: East Bergholt Parochial Church Council, 1986), p. 43.

41 See Leslie Parris, *The Tate Gallery Constable Collection* (London: Tate, 1981), under no. 5, published online, https://www.tate.org.uk/art/artworks/constable-malvern-hall-warwickshire-n02653, accessed March 2024.

42 *Petworth, Sussex, the Seat of the Earl of Egremont: Dewy Morning* (Tate, T03880).

43 Quoted in Shanes, *Young Mr Turner*, p. 357, and under B&J, no. 111.

44 Quoted in Ivy, *Constable and the Critics*, pp. 26 and 27.

45 Constable, letter to Maria Bicknell, 12 November 1814, JCC II, p. 136.

46 Joll, 'Prices for Turner's Paintings and Watercolours during His Lifetime', p. 239.

47 Gage (ed.), *The Collected Correspondence*; see Turner's accounts in the *Finance* sketchbook, c.1810 (Tate, CXXII). See Matthew Imms, 'Finance Sketchbook c.1807–14', September 2013, in Brown (ed.), *J.M.W. Turner: Sketchbooks, Drawings and Watercolours*, https://www.tate.org.uk/ art/research-publications/jmw-turner/finance-sketchbook-r1147757, accessed 22 February 2023.

48 Ann Constable, letter to John Constable, 17 July 1810, JCC I, p. 46.

49 See Parris and Fleming-Williams, *Constable*, no. 14, reproduced pp. 74–6.

50 Farington diary, 23 April 1811, vol. XI, p. 3916.

51 B&J, no. 114.

52 *Hastings* sketchbook, CXI, Tate, D07701; see David Blayney Brown, *'Transcript of a Review by John Taylor of "Mercury and Herse" (Inscription by Turner) 1811'*, May 2011, in Brown (ed.), *J.M.W. Turner: Sketchbooks, Drawings and Watercolours*, https://www.tate.org.uk/art/research-publications/jmw-turner/transcript-of-a-review-by-john-taylor-of-mercury-and-herse-inscription-by-turner-r1131188, accessed 23 February 2023. See also Gage (ed.), *The Collected Correspondence*, pp. 48–9, note 3. Gage suggests the review could refer to Turner's latest Academy lecture rather than his painting.

53 B&J, no. 219, *The Wreck of a Transport Ship*, 1810 (Museu Calouste Gulbenkian, Lisbon). See Shanes, *Young Mr Turner*, p. 362.

54 *Sun*, 12 June 1810, quoted in B&J, no. 109.

55 Constable, letter to Maria Bicknell, 6 May 1812, JCC II, p. 66.

56 RA catalogue (258). https://chronicle250.com/1812#catalogue. No actual manuscript of 'The Fallacies of Hope' has ever been found.

57 See Shanes, *Young Mr Turner*, pp. 407–9.

58 B&J, no. 126. See also Andrew Wilton, *Painting and Poetry* (London: Tate, 1990), pp. 64–5.

59 *Repository of Arts, Literature, Commerce*, 12 June 1812, quoted in B&J, no. 126.

60 Farington diary, 10–14 April 1812, vol. XI, pp. 4107–10.

61 Turner, letter to James Wyatt, 13 April 1812, quoted in Gage (ed.), *The Collected Correspondence*, p. 53.

62 Leslie, *Autobiographical Recollections*, vol. II, p. 12.

63 Constable, letter to Maria Bicknell, 24 April 1812, JCC II, p. 65.

64 *Examiner* and *London Chronicle*, quoted in Crosby Ivy, *Constable and the Critics*, p. 66.

65 *London Chronicle*, 11–12 June 1812. Quoted in ibid.

66 Constable, letter to Maria Bicknell, 6 May 1812, JCC II, p. 66.

67 *Examiner*, 16 August 1812, p. 521. Quoted in Ivy, *Constable and the Critics*, pp. 66–7.

4. *Labours of Love*

1 Recollection of Ann Dart, quoted in A.J. Finberg, *The Life of J.M.W. Turner, R.A.* (Oxford: Clarendon Press, 1961), p. 27.

2 'Obituary of James Tibbetts Willmore, ARA', *Art Journal*, 1 May 1863, pp. 87–8.

3 For a full discussion see Ian Warrell, *Turner's Secret Sketches* (London: Tate Publishing, 2012).

4 *Swiss Figures* sketchbook, D04798, LXXVIII 1 (Tate).

5 For example some of the Petworth studies of 1827, and the *Colour Studies (1) and Colour Studies (2)* sketchbooks (all Tate).

6 Thornbury, *Life*, p. 314.

7 D07605-6, *Hasting* sketchbook. See David Blayney Brown, 'A Cure for Gonorrhoea (Inscription by Turner) c.1809–14', April 2011, in Brown (ed.), *J.M.W. Turner: Sketchbooks, Drawings and Watercolours*, https://www.tate.org.uk/art/research-publications/jmw-turner/a-cure-for-gonorrhoea-inscription-by-turner-r1131093, accessed 26 April 2023.

8 Turner, *A Curtained Bed, with a Man and Woman Embracing*, c.1834–6 (Tate, D28846, CCXCI b 42).

9 Leslie, *Life*, p. 3.

10 From *Autobiography and Other Memorials of Mrs Gilbert (Formerly Ann Taylor)*, published in 1874. Quoted in Anthony Bailey, *John Constable: A Kingdom of his Own* (London: Vintage, 2007), p. 20.

11 Constable, *Self-Portrait*, pencil, 1806 (Tate, T03899); Mrs Fisher, wife of the Bishop of Salisbury, to Joseph Farington, Farington diary, vol. IX, p. 3204; Thornbury quoting Trimmer on Constable [written 10 June 1861], Thornbury, *Life*, p. 264.

12 The opening lines of *Pride and Prejudice*, published 1813.

13 Maria Bicknell, letter to Constable, 4 November 1811, JCC II, p. 53.

14 Maria Bicknell, letter to Constable, 22 June 1814, JCC II, p. 126. 'Indeed, my dear John, people cannot live now upon four hundred a year.' See also JCC II, p. 186.

15 Maria Bicknell, letter to Constable, 4 November 1811, JCC II, p. 53.

16 Maria Bicknell, letter to Constable, 17 December 1811, JCC II, pp. 55–6.

17 Constable, letter to Maria Bicknell, 24 December 1811, JCC II, p. 57.

18 JCC II. The correspondence is expertly woven together in an engaging narrative in Martin Gayford, *Constable in Love: Love, Landscape, Money and the Making of a Great Painter* (London: Fig Tree, 2009).

19 Constable, letter to Maria Bicknell, 25 October 1814, JCC II, p. 135.

20 Constable, letter to Maria Bicknell, 25 October 1812, JCC II, p. 90.

21 Constable, letter to Maria Bicknell, 24 November 1813, JCC II, p. 112.

22 Constable, letter to Maria Bicknell, 23 December 1813, JCC II, p. 113.

23 Constable, letter to Maria Bicknell, 23 January 1813, JCC II, p. 103.

24 Maria Bicknell, letter to Constable, 15 November 1814, JCC II, pp. 136–7.

25 Maria Bicknell, letter to Constable, 25 August 1813, JCC II, p. 111.

26 Constable, letter to Maria Bicknell, 28 September 1812, JCC II, p. 87.

27 Constable, letter to Maria Bicknell, 3 May 1813, JCC II, p. 104.

28 Constable, letter to Maria Bicknell, 16 June 1815, JCC II, p. 142.

29 Maria Bicknell, letter to Constable, 28 December 1815, JCC II, p. 163.

30 Constable, letter to John Dunthorne, 29 May 1802, JCC II, pp. 31–2.

31 Constable, letter to John Fisher, 17 November 1824, JCC VI, p. 181.

32 Turner, letter to A.W. Callcott, undated. See Gage (ed.), *The Collected Correspondence*, p. 231.

33 John Soane, junior, letter to his father John Soane, 15 November 1819. Cited in Finberg, *The Life of J.M.W. Turner, RA*, p. 262.

34 Identified by Sam Smiles. See Matthew Imms, 'Tour of the West Country 1813', in Brown (ed.), *J.M.W. Turner: Sketchbooks, Drawings and Watercolours*, https://www.tate.org.uk/art/research-publications/jmw-turner/tour-of-the-west-country-r1148213, accessed 11 April 2024.

35 Constable, letter to Maria Bicknell, [?March 1814], JCC II, p. 120. Constable refers to the book being used 'last summer', i.e. 1813. The sketchbook is in the collection of the V&A. It also, with another sketchbook of 1814, exists as a facsimile reproduction, published in 1973 and 1979, and introduced by Graham Reynolds. Compare with Turner's West Country sketchbooks of 1813 in the Turner Bequest.

36 Unpublished notes courtesy of Anne Lyles. Only around eight of Constable's sketchbooks survive intact.

37 As just one example, one can compare a sketch by Turner of dock leaves in the *Devonshire Rivers, no. 3 and Wharfedale* sketchbook, c.1814–16 (Tate, D09870 CXXXIV 69) to one by Constable in his 1814 sketchbook (V&A): see https://collections.vam.ac.uk/item/O125849/constables-sketchbook-sketchbook-constable-john-ra/?carousel-image=2010EH2759.

38 'Man is like to vanity; his days are as a shadow that passeth away.' Psalms 144:4.

39 V&A 437-1888, detached from the 1814 sketchbook. Reproduced in the facsimile edition as p. 85.

40 Constable, letter to Maria Bicknell, 2 October 1814, JCC II, p. 133.

41 *Landscape: Boys Fishing*, 1813 (Anglesea Abbey, National Trust NT 515780). Due to doubts about this being the original, the painting is listed as 'after John Constable'.

42 Constable, letter to Maria Bicknell, 3 May 1813, JCC II, p. 104. 'My mother has been in town & perhaps I may see her again today.'

43 Turner, letter to James Holworthy, 4 December 1826, quoted in Gage (ed.), *The Collected Correspondence*, p. 102; draft poem in the *Perspective* sketchbook, CVIII 13, quoted in James Hamilton, 'Fishing', in *The Oxford Companion to J.M.W. Turner*, p. 110. The phrase is one used by James Thomson.

44 Reminiscences of Henry Scott Trimmer's son in Thornbury, *Life*, p. 120.

45 Thornbury, *Life*, p. 221; Matthew Imms, '*Young Anglers* c.1808 by Joseph Mallord William Turner', August 2009, in Brown (ed.), *J.M.W.*

Turner: Sketchbooks, Drawings and Watercolours, https://www.tate. org.uk/art/research-publications/jmw-turner/joseph-mallord-william-turner-young-anglers-r1131739, accessed 15 March 2023.

46 Constable, letter to John Fisher, 23 October 1821, JCC VI, p. 77.

47 Turner, letter to John Young, 14 January 1814, Gage (ed.), *The Collected Correspondence,* p. 56.

48 Cat. 148. Royal Collection Trust. See https://www.rct.uk/collection/ 405537/blind-mans-buff.

49 *The Deluge* (Tate, N04493).

50 John Constable, letter to Maria Constable, 24 October 1819, JCC II, p. 254.

51 Ann Constable, letter to John Constable, 10 November 1811, JCC I, p. 69.

52 Ann Constable, letter to John Constable, 8 January 1811, JCC I, p. 54.

53 Ann Constable, letter to John Constable, 30 November 1812, JCC I, p. 87.

54 Ann Constable, letter to John Constable, [4 January 1811], JCC I, pp. 52–3.

55 Abram Constable, letter to John Constable, 10 March 1815, JCC I, p. 118.

56 Thornbury, *Life,* p. 121.

57 Ibid.

58 Ibid., p. 122. *Crossing the Brook,* exhibited 1815 (Tate, N00497).

59 A little-known miniature of Evelina by an unknown artist is reproduced in Franny Moyles, *The Extraordinary Life and Momentous Times of J.M.W. Turner* (London: Viking, 2016), ill. 34, between pp. 290 and 291.

60 Thornbury, *Life,* p. 122.

61 Farington diary, 4 November 1812, vol. XII, p. 4249.

62 John Fisher, letter to Constable, 14 June 1813, JCC VI, p. 21.

63 See for example, William Elmes, *Jack Frost Attacking Bony in Russia, November 1812,* hand-coloured etching on paper (British Museum, 1931,1114.331).

64 Farington diary, 24 May 1813, vol. XII, p. 4355.

65 23 April 1813, Royal Academy Council minutes.

66 Farington diary, 28 June 1813, vol. XII, p. 4381.

67 Constable, letter to Maria Bicknell, 30 June 1813, JCC II, p. 110.

68 Hamilton, *Constable: A Portrait,* p. 61.

69 James Hamilton, ' "I Dined with Jones & Turner, Snugly – Alone": The Friendship of Turner and Constable, Brother Labourers', *Turner Society News* 138 (autumn 2022), p. 16.

70 John Gage asks this same question in his book *J.M.W. Turner: A Wonderful Range of Mind* (New Haven and London: Yale University Press, 1987), p. 21.

71 The Gainsboroughs were owned by Henry Scott Trimmer's grandfather, Joshua Kirby. Trimmer's recollections in Thornbury, *Life,* p. 248.

72 See Farington diary, 8 April 1813, vol. XII, p. 4328.

73 Minutes of Royal Academy Council meeting for 29 March 1813, p. 31 (Royal Academy archive).

74 Farington diary, 29 June 1813, vol. XII, p. 4382.

5. *Rivers of England*

1 Attributed to the Greek philosopher Heraclitus of Ephesus.

2 *Studies for Pictures: Isleworth* sketchbook, D05520, XC 21 (Tate). See David Blayney Brown, '*Study for "Dido and Aeneas"* 1805 by Joseph Mallord William Turner', August 2007, in Brown (ed.), *J.M.W. Turner: Sketchbooks, Drawings and Watercolours*, https://www.tate.org.uk/art/research-publications/jmw-turner/joseph-mallord-william-turner-study-for-dido-and-aeneas-r1129831, accessed 20 July 2023.

3 Constable, letter to Maria Bicknell, 4 May 1814, JCC II, pp. 121–2.

4 Quoted in Parris and Fleming-Williams, *Constable*, p. 22.

5 Ruskin, 'Modern Painters', vol. V; Cook and Wedderburn (eds), *The Library Edition*, vol. VI, 1, p. 377.

6 Thornbury, *Life*, p. 32.

7 Ibid., pp. 44 and 64.

8 Tate, D00684, XXVII W.

9 For example, *The Thames near Walton Bridges*, 1805, oil on mahogany veneer (Tate, N02680).

10 Compare Constable, *Barges on the Stour, with Dedham Church in the Distance*, c.1811, oil on paper laid on canvas (V&A, 325-1888).

11 Constable, letter to John Dunthorne, 4 [March] 1799, JCC II, pp. 22–3.

12 David Hill, *Turner on the Thames* (New Haven and London: Yale University Press, 1993), p. 40.

13 For a summary see Michael Rosenthal and Anne Lyles, *Turner and Constable: Sketching from Nature* (London: Tate, 2013).

14 David Blayney Brown, 'Sketchbooks Used at Isleworth, Hammersmith and along the River Thames c.1804–14', December 2009, revised by Matthew Imms, September 2016, in Brown (ed.), *J.M.W. Turner: Sketchbooks, Drawings and Watercolours*, https://www.tate.org.uk/art/research-publications/jmw-turner/sketchbooks-used-at-isleworth-hammersmith-and-along-the-river-thames-r1129934, accessed 27 June 2023.

15 See the *Studies for Pictures: Isleworth* sketchbook (Tate). The sketch with the adjacent pressed leaf can be found on D05543, XC 35.

16 See also Jan Siberechts, *A View from Richmond Hill*, 1677 (Tate, T15998).

17 See David Blayney Brown, '?*Sketch for "Dido Building Carthage"* 1805 by Joseph Mallord William Turner', August 2007, in Brown (ed.), *J.M.W. Turner: Sketchbooks, Drawings and Watercolours*, https://www.tate.org.uk/art/research-publications/jmw-turner/joseph-mallord-

william-turner-sketch-for-dido-building-carthage-r1129817, accessed 14 April 2024. The painting is in the collection of the National Gallery, London (NG498).

18 Quoted in Catherine Parry-Wingfield, *J.M.W. Turner and the 'Matchless Vale of Thames'* (Twickenham: Turner's House Trust, 2020), p. 20.

19 *The Stour Valley and Dedham Village*, 1814 (Museum of Fine Arts, Boston). This painting was a wedding present for a neighbour, Philadelphia Godfrey, who was moving to Wales.

20 Abram Constable, letter to John Constable, 12 March 1815, JCC I, p. 120.

21 Constable, letter to Maria Bicknell, 19 October 1815, JCC II, p. 156.

22 Constable, letter to Maria Bicknell, 16 August 1816, JCC II, p. 196.

23 Constable, letter to Maria Bicknell, 24 March 1816, JCC II, p. 183.

24 Turner, letter to James Holworthy, 31 July 1816, Gage (ed.), *The Collected Correspondence*, p. 67.

25 *Yorkshire 2* sketchbook, CXLV (Tate). See for example, David Hill, '*Orton and the Lune Valley from Orton Scar* 1816 by Joseph Mallord William Turner', April 2009, in Brown (ed.), *J.M.W. Turner: Sketchbooks, Drawings and Watercolours*, https://www.tate.org.uk/art/re search-publications/jmw-turner/joseph-mallord-william-turner-orton-and-the-lune-valley-from-orton-scar-r1201776, accessed 20 July 2023.

26 Turner, letter to James Holworthy, [postmarked] 11 September 1816, Gage (ed.), *The Collected Correspondence*, p. 70.

27 Tate, N00499.

28 Leslie, *Life*, p. 62. Pencil drawings of children and family life include *A Baby, Probably Maria Louisa Constable*, 1819 (V&A, D.235-1888), as well as several in the British Museum.

29 Leslie, *Life*, p. 64.

30 *Fifth Plague of Egypt*, 1800 (Indianapolis Museum of Art); *Ships Bearing up for Anchorage ('The Egremont Seapiece')*, 1802 (Tate, in situ at Petworth House), and *Sun Rising through Vapour*, 1807 (National Gallery, London). In general, Turner's canvas sizes in his own gallery tended to be smaller than six feet, whilst those at the Academy were often bigger.

31 David Blayney Brown, '*Study for "England: Richmond Hill, on the Prince Regent's Birthday"* c.1815–18 by Joseph Mallord William Turner', July 2011, in Brown (ed.), *J.M.W. Turner: Sketchbooks, Drawings and Watercolours*, Tate https://www.tate.org.uk/art/research-publica tions/jmw-turner/joseph-mallord-william-turner-study-for-england-richmond-hill-on-the-prince-regents-r1131654, accessed 19 July 2023.

32 Composed in 1819, the poem was not published until 1839 in *The Poetical Works of Percy Bysshe Shelley* (London: Edward Moxon), edited by Mary Shelley.

33 Farington diary, 7 July 1819, vol. XV, p. 5386.

34 Turner, letter to Abraham Cooper, 7 August 1821, Gage (ed.), *The Collected Correspondence*, p. 86.

35 *Entrance of the Meuse: Orange-Merchant on the Bar, Going to Pieces; Brill Church bearing S.E. by S., Masenslyus E. by S.*, 1819 (Tate, N00501).
36 Farington diary, 2 May 1819, vol. XV, p. 5359; Constable, letter to Maria Constable, [?21 May] 1819, JCC II, p. 249.
37 Respectively, *New Monthly Magazine*, 1 June; *Literary Chronicle*, 29 May; and *Literary Gazette*, 3 July. See Ivy, *Constable and the Critics*, pp. 81–3.
38 *Examiner*, 27 June 1819, p. 413. Quoted in Ivy, *Constable and the Critics*, p. 82.

6. Foreign Fields

1 Farington diary, 9 January 1820, vol. XVI, p. 5450.
2 See Nicola Moorby, 'Turner's Sketches for Rome, from the Vatican: Some Recent Discoveries', *Turner Society News* (spring 2011), pp. 6–9.
3 Turner's honorific appears in the RA catalogue for 1820.
4 Constable, letter to John Fisher, 7 October 1822, JCC VI, p. 99.
5 National Gallery, London (NG6510).
6 See Farington diary, 3 July 1820, vol. XVI, p. 5533.
7 John Fisher, letter to Constable, 6 August 1821, JCC VI, p. 72.
8 Farington diary, 21 November 1820, vol. XVI, p. 5582.
9 For example, *Champion*, 7 March 1819, and *Literary Gazette*, 20 March 1819, both quoted in Ivy, *Constable and the Critics*, p. 80.
10 *Repository of Arts*, June 1821, p.367, quoted in Ivy, *Constable and the Critics*, p. 89.
11 Constable's assimilation of the Old Masters was comprehensively explored in a 2014 exhibition at the V&A, *Constable: The Making of a Master*.
12 Sarah Cove has suggested he painted them pinned to the wall to save on stretchers. See 'The Painting Techniques of Constable's "Six-Footers"', in Anne Lyles (ed.), *Constable: The Great Landscapes* (London: Tate Publishing, 2006), p. 56.
13 Charles Rhyne, 'The Remarkable Story of the "Six-Foot Sketches"', in Lyles (ed.), *Constable: The Great Landscapes*, pp. 42–9.
14 *Steamer and Lightship; a Study for 'The Fighting Temeraire'*, c.1838–9, oil on canvas (Tate, N05478).
15 *Full-Scale Study for 'The Hay Wain'*, c.1821, oil on canvas (V&A, 987-1900).
16 For a full account see Lyles (ed.), *Constable: The Great Landscapes*, pp. 140–5.
17 Constable, letter to John Fisher, 31 October 1822, JCC VI, p. 100.
18 Constable often mentions Johnny Dunthorne in the journal he kept for Maria's interest in 1824 and 1825: see JCC II, pp. 313–422. An indication

of jobs Turner's father did for him can be found within their letters: see for example Gage (ed.), *The Collected Correspondence*, pp. 108–10.

19 M.L. Colnaghi, letter to Constable, 17 July 1821, JCC IV, p. 153.

20 James Hamilton has assembled a potential list of Turner oils owned by Colnaghi. See ' "I Dined with Jones & Turner, Snugly – Alone" ', p. 19.

21 Constable, letter to John Fisher, 1 April 1821, JCC VI, p. 65.

22 Ibid.

23 Constable, to John Fisher, 3 July 1823, JCC VI, p. 122.

24 Constable, to John Fisher, 5 July 1823, JCC VI, p. 125.

25 Joyce H. Townsend, *How Turner Painted: Materials and Techniques* (London: Thames & Hudson, 2019), p. 112.

26 Annals of the Fine Arts, quoted in B&J, no. 228, p. 124.

27 *Examiner*, 15 May 1820, p. 316. Quoted in Ivy, *Constable and the Critics*, p. 84.

28 See B&J, under no. 230.

29 *British Press*, 5 May 1823, quoted in B&J, under no. 230.

30 *Monthly Magazine*, LV, 1 June 1823, p. 439, quoted in Ivy, *Constable and the Critics*, p. 101.

31 Constable, letter to John Fisher, 9 May 1823, in JCC VI, p. 116.

32 Constable, letter to John Fisher, 23 January 1825, JCC VI, p. 191.

33 Constable, letter to John Fisher, undated [early April 1825], JCC VI, pp. 197–8.

34 For a discussion of the frequent use of 'fresh' as an adjectival description of Constable's work see Mark Hallett, '1825: Fresh', in Hallett, Turner and Feather (eds), *The Royal Academy of Arts Summer Exhibition: A Chronicle, 1769–2018*, chronicle250.com/1825, accessed 30 May 2024.

35 For example see *London Magazine*, June 1824, p. 669, quoted in Ivy, *Constable and the Critics*, p. 106.

36 *European Magazine*, May 1825. Quoted in B&J, under no. 231.

37 Henry Crabb Robinson, *Diary, Reminiscences and Correspondence*, 1869, ii, p. 294. Quoted in B&J, under no. 231.

38 Quoted in B&J, under nos 232 and 233.

39 Also *The Seat of William Moffatt; Esq., at Mortlake, Early (Summer's) Morning*, 1826, oil (Frick Collection, New York).

40 Quoted in B&J, under no. 239, and in Gage (ed.), *The Collected Correspondence*, p. 99.

41 Ibid.

42 Ruskin spread the story, having apparently been told it by George Jones. B&J under no. 232. Analysis of *Cologne* by paintings conservator Rebecca Hellen has revealed evidence to support the story. See Rebecca Hellen, ' "Unfinished Productions": History and Process in Turner's 1820 Port Scenes of Dieppe, Cologne, and Brest', in Susan Grace Galassi, Ian Warrell and Joanna Sheers Seidenstein (eds), *Turner's Modern and Ancient Ports: Passages through Time* (New Haven: Yale University Press, 2017), pp. 117–18.

43 *Examiner*, 8 July 1827, p. 418. Quoted in Ivy, *Constable and the Critics*, p. 124.

44 Constable, letter to John Fisher, 26 April 1826, JCC VI, p. 220.

45 *Literary Chronicle and Weekly Review*, 6 May 1826, quoted in Ivy, *Constable and the Critics*, p. 118.

46 Robert Hunt, *Examiner*, 2 July 1826, quoted in ibid., p. 119.

47 Turner used these pigments too but in earlier works – rarely after chrome yellow was available. Townsend, *How Turner Painted*, p. 112.

48 See Sarah Cove, 'Constable's Oil Painting Materials and Techniques', in Parris and Fleming-Williams, *Constable*, especially p. 506. There is a bladder of chrome yellow in Constable's metal paint box (Clark Institute, Williamstown): see Lyles (ed.), *Constable: The Great Landscapes*, fig. 86, p. 196.

49 Constable, letter to John Fisher, 8 April 1826, JCC VI, p. 216.

50 Ibid., p. 217.

51 George Field, *Chromatography; or a Treatise on Colours and Pigments, and of Their Powers in Painting* (London, 1835), p. 123.

52 Ibid., p. 77.

53 Turner, letter to James Holworthy, [postmarked] 5 May 1826, quoted in Gage (ed.), *The Collected Correspondence*, p. 100.

54 Constable, letter to John Fisher, 9 May 1823, JCC VI, p. 117.

55 See Catherine Roach, '1821: John Constable, John Martin, and the Ecosystem of Exhibitions', in Hallett, Turner and Feather (eds), *The Royal Academy of Arts Summer Exhibition: A Chronicle, 1769–2018*, chronicle250.com/1821, accessed 30 May 2024.

56 See Christine Riding, 'The *Raft of the Medusa* in Britain: Audience and Context', in Patrick Noon (ed.), *Constable to Delacroix: British Art and the French Romantics* (London: Tate Publishing, 2003).

57 John Fisher, letter to Constable, 19 July 1821, JCC VI, p. 70.

58 *Magazine of the Fine Arts*, I, 1821, p. 113. Quoted in Ivy, *Constable and the Critics*, p. 89.

59 *Literary Gazette*, 2 June 1821, p. 346. Quoted in Ivy, *Constable and the Critics*, p. 90.

60 *Bell's Weekly Messenger*, 28 May 1821, p. 165. Quoted in Ivy, *Constable and the Critics*, p. 89.

61 Charles Nodier, *Promenade from Dieppe to the Mountains of Scotland* (Edinburgh, 1822), p.49. [Translated from *Promenade de Dieppe aux Montagnes de l'Écosse*, 1821.] Quoted in Ivy, *Constable and the Critics*, pp. 93–4.

62 Constable, letter to John Fisher, 17 April 1822, JCC VI, p. 91.

63 John Arrowsmith, letter to Constable, 19 June 1824, JCC IV, p. 184.

64 Constable, letter to John Fisher, 8 May 1824, JCC VI, p. 157.

65 Constable's journal, 7 July 1824, JCC II, p. 356; and Constable, letter to John Fisher, 18 July 1824, JCC VI, p. 167.

66 Cited by Beckett in JCC IV, p. 183.

67 Journal of Eugène Delacroix, 23 September 1846, cited in Hamilton, *Constable: A Portrait*, p. 237.
68 Constable, letter to John Fisher, 17 December 1824, JCC VI, p. 185.
69 John Fisher, letter to Constable, 10 May 1824, JCC VI, p. 158.
70 John Fisher, letter to Constable, 31 May 1824, JCC IV, p. 162.
71 Ibid.
72 Constable, letter to John Fisher, undated [?April 1825], JCC VI, p. 197.
73 Constable's journal, 22 June 1824, JCC II, p. 340.
74 Constable, letter to Francis Darby, 24 August 1825, JCC IV, p. 100.
75 Quoted in Hamilton, *Constable: A Portrait*, p. 237.
76 Journal of Eugène Delacroix, quoted in *The Oxford Companion to J.M.W. Turner*, p. 75; cited in Hamilton, *Constable: A Portrait*, p. 238. For a slightly different translation, see Bailey, *John Constable*, p. 314.
77 Stendhal, 27 October 1824. Quoted in Charles Harrison et al., *Art in Theory 1815–1900* (Oxford: Wiley-Blackwell, 1998), p. 35.
78 Reproduced in Andrew Wilton, *Turner in His Time* (London: Thames & Hudson, 1987), ill. 220, p. 158.
79 Tate, N00533. See B&J, under no. 401.

7. Sea and Sky: New Horizons

1 *European Magazine*, I, September 1825, p. 85. Quoted in Ivy, *Constable and the Critics*, p. 115. 'Peculiar', in the sense of unique, is a word that crops up repeatedly with reference to Constable and his work.
2 *The Literary Chronicle and Weekly Review*, 20 August 1825, p. 542. Quoted in Ivy, *Constable and the Critics*, p. 115.
3 *Morning Chronicle*, 5 May 1825: 'The composition has all the pleasing peculiarities of this artist's style.' Quoted in Ivy, *Constable and the Critics*, p. 112; *Sun*, 4 May 1824: 'Constable has a Landscape, which has all that vivid aspect that generally marks his productions.' Quoted in Ivy, *Constable and the Critics*, p. 106.
4 *Literary Gazette*, 11 June 1825, p. 379. Quoted in Ivy, *Constable and the Critics*, p. 114.
5 *London Magazine*, III, September 1825, p. 67. Quoted in Ivy, *Constable and the Critics*, p. 115.
6 John Fisher, letter to Constable, 13 November 1824, JCC VI, p. 180.
7 Constable, letter to John Fisher, 7 October 1822, JCC VI, p. 99.
8 Constable, letter to John Fisher, 26 August 1827, JCC VI, p. 230.
9 Constable, letter to John Fisher, 28 November 1826, JCC VI, p. 228.
10 Constable, letter to Maria Bicknell, 12 November 1814, JCC II, p. 136.
11 See for example, Constable, *Hampstead Heath, with the House Called 'The Salt Box'*, c.1819–20, oil on canvas (Tate, N01236).
12 Constable, letter to John Fisher, 23 October 1821, JCC VI, pp. 76–8.
13 Lyles (ed.), *Constable: The Great Landscapes*, p. 142.

14 There have been a number of studies exploring Constable's knowledge of meteorology: John E. Thornes, *Constable's Skies* (Birmingham: University of Birmingham, 1999); Mark Evans, *Constable's Skies: Paintings and Sketches* (London: Thames & Hudson, 2018), pp. 8–13; Nicholas Robbins, 'John Constable, Luke Howard, and the Aesthetics of Climate', *Art Bulletin* 103.2 (June 2021), pp. 50–76.

15 Ian Warrell, *Turner's Sketchbooks* (London: Tate Publishing, 2014), p. 100; David Blayney Brown, *J.M.W. Turner: The 'Skies' Sketchbook* (London: Tate Publishing, 2016), p. 3.

16 Natalia Bosko, 'Exploration of the Sky: The *Skies* Sketchbook by J.M.W. Turner', *Journal of the Royal Astronomical Society of Canada* 113.4 (August 2019), pp. 141–2.

17 For the inventory of Turner's library and his possessions see Wilton, *Turner in His Time*, pp. 246–8.

18 James Hamilton, *Turner and the Scientists* (London: Tate Gallery, 1998).

19 See various letters in Gage (ed.), *The Collected Correspondence*, eg. nos 107, 110, 116, 135, 148.

20 Constable, letter to Francis Darby, 24 August 1825, JCC IV, p. 100.

21 Ibid.

22 Turner, *Arundel Castle, on the River Arun*, for *The Rivers of England*, c.1824, watercolour (Tate, D18140).

23 Turner created two watercolours: a view from the banks of the river, *Arundel Castle, on the River Arun, with a Rainbow*; and one from afar, *Arundel Castle, on the River Arun* (both Tate). Only the latter was engraved. See Alice Rylance-Watson, '*Arundel Castle, on the River Arun* c.1824 by Joseph Mallord William Turner', March 2013, in Brown (ed.), *J.M.W. Turner: Sketchbooks, Drawings and Watercolours*, https://www.tate.org.uk/art/research-publications/jmw-turner/joseph-mallord-william-turner-arundel-castle-on-the-river-arun-r1146206, accessed 10 November 2023.

24 Turner, *Brighthelmstone, Sussex*, from *Picturesque Views on the Southern Coast of England*, 1824–5, watercolour (Royal Pavilion & Museums, Brighton).

25 See Ian Warrell, 'In Pursuit of Originality in Brighton', in Shân Lancaster (ed.), *Constable and Brighton: Something Out of Nothing* (London: Scala, 2017), pp. 47–9.

26 Ibid., p.44. Warrell says it seems likely Turner's visit fell between those of Constable.

27 Constable, letter to John Fisher, 29 August 1824, JCC VI, pp. 170–2.

28 Ibid., p. 171.

29 Ibid.

30 Ibid.; and Constable, letter to John Fisher, 17 November 1824, JCC VI, p. 182.

31 Warrell, 'In Pursuit of Originality in Brighton', pp. 50–5.

32 Constable, letter to John Fisher, 29 August 1824, JCC VI, p. 171; E.W. Brayley, *Topographical Sketches of Brighthelmston and its Neighbourhood* (1825), quoted in https://www.brightontoymuseum.co.uk/index/ Category:Chain_Pier, accessed 16 November 2023.

33 John Fisher, letter to Constable, 7 December 1828, JCC VI, p. 241.

34 Warrell, 'In Pursuit of Originality in Brighton', p. 57.

35 Constable, letter to John Fisher, undated [?early April 1825], JCC VI, p. 197.

36 Constable, letter to John Fisher, 28 November 1826, JCC VI, pp. 227–8.

37 Constable, letter to John Fisher, 11 June 1828, JCC VI, pp. 236–7.

38 Ibid.

39 *Seascape Study: Boat and Stormy Sky* (Royal Academy, 03/830).

40 In a letter of 5 January 1825, Constable told Fisher he had painted a dozen Brighton oil sketches 'in the lid of my box on my knees as usual'. JCC VI, p. 189. One of Constable's sketching boxes is in the Constable family collection, illustrated in Parris and Fleming-Williams, *Constable*, fig. 166, p. 501.

41 There are two known palettes of this kind. One is in a private collection, illustrated in Nicola Moorby and Ian Warrell (eds), *How to Paint Like Turner* (London: Tate Publishing, 2010), p. 33; the other is in the Royal Academy of Arts (03/7072).

42 John Fisher, letter to Mary Fisher, 11 April 1827, quoted in JCC VI, p. 230.

43 Constable, letter to John Fisher, undated [early April 1825], JCC VI, pp. 197–8.

44 Constable, letter to Robert Charles Leslie, 21 January 1829, JCC III, p. 19.

45 See Anne Lyles, ' "Turner, Calcott and Collins Will Not Like It": Constable, Brighton and the Sea', in Christine Riding and Richard Johns (eds), *Turner and the Sea* (London: National Maritime Museum, 2013), pp. 160–1.

46 *Bell's Weekly Messenger*, 17 February 1828, p. 55 [British Institution review]. Quoted in Ivy, *Constable and the Critics*, p. 125.

47 *New Monthly Magazine*, September 1827. Quoted in Ivy, *Constable and the Critics*, p. 124.

48 Constable, letter to Robert Charles Leslie, 5 February 1828, JCC III, p. 13.

49 William Etty, letter to his brother Walter. Quoted in JCC III, p. 15.

50 *The Times*, 11 May 1827. Quoted in Ivy, *Constable and the Critics*, p. 122.

51 Thomas Lawrence for example had described Turner in 1808 as 'indisputably the first landscape painter in Europe'. Quoted in Michael Levey, *Sir Thomas Lawrence* (New Haven and London: Yale University Press, 2005), p. 328, n. 6.

52 Warrell, 'In Pursuit of Originality in Brighton', pp. 57–8.

53 *Heavy Weather Coming On, with Vessels Running to Port*, reproduced in Riding and Johns (eds), *Turner and the Sea*, no. 62. See Warrell, 'In Pursuit of Originality in Brighton', p. 63.

54 Warrell, 'In Pursuit of Originality in Brighton', p. 63.

55 Tate, N02065. Ian Warrell (ed.), *J.M.W. Turner* (London: Tate Publishing, 2007), pp. 119–20.

56 B&J, no. 341.

57 Tate, T03885 (in situ at Petworth House).

58 Warrell, 'In Pursuit of Originality in Brighton', p. 64.

59 Tate, N01986. Warrell, 'In Pursuit of Originality in Brighton', pp. 65, 69. Joyce Townsend has identified the presence of yellow barium chromate, a pigment that wasn't available until 1843.

60 Warrell, 'In Pursuit of Originality in Brighton', p. 69.

61 Robert Charles Leslie, *A Waterbiography* (1894), p. 57. Quoted in Anthony Bailey, *Standing in the Sun: A Life of J.M.W. Turner* (London: Sinclair-Stevenson, 1997), p. 259.

62 Both Charles Robert Leslie and George Jones testify to this in their autobiographical recollections.

63 I've here conflated two slightly different versions of the same quotation. Beckett transcribed Constable's original letter to John Fisher, 11 June 1828, as 'one could live with *such* pictures in the house'. See JCC VI, p. 236. In Leslie's biography it is 'one could live and die with such pictures'. Leslie, *Life*, p. 142.

64 Quoted in JCC IV, p. 312.

65 John Constable, letter to Golding Constable, 19 December 1828, JCC VIII, pp. 80–1.

66 Leslie, *Life*, p. 147.

67 Turner, letter to Charles Lock Eastlake, [16 February 1829], Gage (ed.), *The Collected Correspondence*, p. 124.

68 Constable, letter to John Chalon, 11 February 1828, JCC IV, p. 277.

69 John Fisher, letter to Constable, 11 February 1829, p. 243.

70 National Galleries of Scotland, Edinburgh, NG 2016.

71 See Parris and Fleming-Williams, *Constable*, under no. 169, p. 311.

72 See Ian Warrell, *Turner Inspired: In the Light of Claude* (London: National Gallery, 2012), pp. 99 and 110–11.

73 Tate, N00497. See B&J, no. 130.

8. *In Print*

1 Leslie, *Life*, p. 148.

2 Constable, letter to Charles Robert Leslie, 5 April 1829, JCC III, p.20; *Morning Chronicle*, 16 April 1829, quoted in Ivy, 1991, pp.14 and 132.

3 Constable, letter to Charles Robert Leslie, 21 January 1829, JCC III, p. 18.

4 Leslie, *Autobiographical Recollections*, vol. I, p. 216.

5 Quoted in John Gage, *Colour in Turner: Poetry and Truth* (London: Studio Vista, 1969), p. 196.

6 John Landseer, *Lectures on the Art of Engraving* (London, 1807), p. 177. Landseer presented a copy of his lectures to Turner.

7 Ibid., p. 178. See also Gage, *Colour in Turner*, pp. 50–1, and Anne Lyles and Diane Perkins, *Colour into Line: Turner and the Art of Engraving* (London: Tate Gallery, 1989), p. 11.

8 Landseer, *Lectures on the Art of Engraving*, p. 180.

9 As a useful comparison, James Hamilton gives the example of Edwin Landseer, an artist with a similar length of career and level of success, who supplied 434 subjects with 126 engravers – that is, twice the number of engravers to make half the number of print subjects, compared to Turner. James Hamilton, *A Strange Business: Making Art and Money in Nineteenth-Century Britain* (London: Atlantic, 2015), p. 215.

10 Thornbury, *Life*, p. 185.

11 A guinea was a 'gentleman's pound' or twenty-one shillings.

12 Lyles and Perkins, *Colour into Line*, p. 42.

13 The price of this mezzotint varied depending on the quality of the paper.

14 See David Blayney Brown, '*List of Subscribers (Inscriptions by Turner)* c.1806–7 by Joseph Mallord William Turner', catalogue entry, December 2005, in Brown (ed.), *J.M.W. Turner: Sketchbooks, Drawings and Watercolours*, https://www.tate.org.uk/art/research-publications/jmw-turner/joseph-mallord-william-turner-list-of-subscribers-inscriptions-by-turner-r1139155, accessed 27 September 2023.

15 In the end, Leicester never received the painting but swapped it for an alternative subject.

16 The wording is taken from the blue paper wrappers that enclosed each published part of the *Liber Studiorum*. See Lyles and Perkins, *Colour into Line*, cat. 40, p. 51.

17 Joyce Townsend, *Turner's Painting Techniques* (London: Tate Gallery, 1996), pp. 376, 377; Gillian Forrester, *Turner's 'Drawing Book': The Liber Studiorum* (London: Tate Gallery, 1996), pp. 18–19.

18 Townsend, *How Turner Painted*, pp. 34–5.

19 Matthew Imms, '*Liber Studiorum*: Drawings and Related Works c.1806–24', January 2010, in Brown (ed.), *J.M.W. Turner: Sketchbooks, Drawings and Watercolours*, https://www.tate.org.uk/art/research-publications/jmw-turner/liber-studiorum-drawings-and-related-works-r1131702, accessed 11 October 2023.

20 *Calm, Rispah, Peat Bog, Scotland, Bridge and Goats* and *Winchelsea, Sussex*. All plates from Part 9 of the *Liber Studiorum*, published in April 1812. See Forrester, *Turner's Drawing Book*, pp.103–8 and 166, and Matthew Imms, '*Liber Studiorum*: Drawings and Related Works c.1806–24', accessed 3 October 2023.

21 W.G. Rawlinson, quoted in Forrester, *Turner's Drawing Book*, p. 27.

22 Henry Fuseli, 'Lecture IV – on Invention', 1804. See Ralph N. Wornum (ed.), *Lectures on Painting by the Royal Academicians: Barry, Opie and Fuseli* (London: Bohn, 1848), p. 449.

23 Constable, letter to John Fisher, 23 January 1825, JCC VI, p. 191.

24 *Water Mill*, engraved by Robert Dunkarton, 1812. See Forrester, *Turner's Drawing Book*, no. 37, p. 97.

25 Constable, letter to John Fisher, 17 November 1824, JCC VI, p. 181.

26 Farington diary, 1 November 1819, vol. XV, p. 5422.

27 See Forrester, *Turner's Drawing Book*, pp. 20–1.

28 The prices for a serial part of the *Southern Coast* (which included three full-page plates and two vignettes) were variously 12s. 6d. for royal quarto on Whatman; 18s. for imperial quarto on Whatman; and £1. 10s. for imperial quarto on India. Turner was paid £7 10s. per watercolour, later rising to £10.

29 For an exploration of the links between slavery and the fabric of Britain's built and natural landscapes see Victoria Perry, *A Bittersweet Heritage: Slavery, Architecture and the British Landscape* (London: Hurst, 2022).

30 See Sam Smiles, 'Turner and the Slave Trade: Speculation and Representation, 1805–40', *British Art Journal* 8.3 (winter 2007–8), pp. 47–54.

31 See for example *John Bull*, 22 June 1828, p. 196. The slave trade in Britain was abolished in 1807 but British colonial slavery not until 1837.

32 John Fisher, letter to Constable, 12 December 1823, JCC VI, p. 145.

33 See 'John Constable: Tottenham Connections', https://www.turnerin tottenham.uk/priscilla-wakefield.html, accessed April 2023.

34 John Fisher, letter to Constable, 30 June 1823, JCC VI, pp. 120–1. John Landseer, after Constable, *A Windmill at Stoke, Suffolk*, 1814, etching and engraving on paper (V&A, 342A-1888), published in Peter Coxe's *The Social Day*, 1823. See https://collections.vam.ac.uk/item/ O1243102/a-windmill-at-stoke-suffolk-print-john-landseer.

35 *View of Brighton with the Chain Pier* (British Museum, 1841,1113.204).

36 Constable, letter to John Martin, 26 November 1830, JCC V, pp. 87–8.

37 Constable, letter to John Fisher, 23 January 1825, JCC VI, p. 191.

38 Constable, letter to David Lucas, 12 March 1831, JCC IV, pp. 344–5.

39 Andrew Wilton, *Constable's 'English Landscape Scenery'* (London: British Museum, 1979), p. 9.

40 Constable, letter to David Lucas, 16 December 1834, JCC IV, p. 416.

41 Leslie, *Life*, p. 11.

42 Constable uses this term frequently. The full title for the letterpress of *English Landscape Scenery* is 'Various Subjects of Landscape, Characteristic of English Scenery, Principally Intended to Display the Phenomena of the Chiar'Oscuro of Nature: From Pictures Painted by John Constable, R.A.', see JCD, p. 7.

43 *Vignette: Hampstead Heath, Middlesex*, published 1832.

44 Constable, 'Introduction' letterpress to *English Landscape Scenery*, JCD, p. 9.

45 Turner, letter to Sir Walter Scott, 20 April 1831, Gage (ed.), *The Collected Correspondence*, p. 143.

46 Constable, letter to David Lucas, 27 April 1832, JCC IV, p. 372.

47 Constable, memorandum listing all the problems he had encountered, written on the back of a prospectus. JCC IV, p. 405.

48 Constable, letters to David Lucas, undated, JCC IV, p. 395 and 12 March 1831, JCC IV, pp. 344–5.

49 Constable, letter to David Lucas, 4 November 1831 [Beckett suggests it should be December], JCC IV, pp. 360–1.

50 See Wilton, *Constable's 'English Landscape Scenery'*, p. 10. See for example, Constable, letter to David Lucas, undated [December 1834], JCC IV, p. 414.

51 For the letters regarding the disagreement between Turner and Cooke see Gage (ed.), *The Collected Correspondence*, pp. 104–6.

52 Constable, letter to David Lucas, undated, JCC IV, p. 395.

53 Estimated by Beckett, JCC IV, p. 414.

54 Letterpress to *English Landscape Scenery*, first published in the *Literary Gazette*, 1833, JCD, pp. 8–9.

55 Constable, memorandum, JCC IV, p. 405.

56 Quoted in Ivy, *Constable and the Critics*, p. 182; For further comments see also Thornbury, *Life*, p. 184.

57 A letter from Constable to Martin Colnaghi, 23 March 1833, suggests that by 1833 he had reduced the price by three guineas. See JCC IV, pp. 161–2.

58 Turner, letter to R. Griffin & Co., undated [but suggested date of ?1836], Gage (ed.), *The Collected Correspondence*, p. 164.

59 Constable to David Lucas, undated [December 1834], JCC IV, p. 414. He says his 'unfortunate book' is 'a dead loss of at least £600' with another £100 at Sparrow's (the printer's).

60 Matthew Imms, '*Liber Studiorum*: Drawings and Related Works c.1806–24', January 2010, in Brown (ed.), *J.M.W. Turner: Sketchbooks, Drawings and Watercolours*, https://www.tate.org.uk/art/research-publications/jmw-turner/liber-studiorum-drawings-and-related-works-r1131702, accessed 19 October 2023.

61 *Literary Gazette*, 24 September 1825, cited in Ian Warrell, ' "The Wonder-Working Artist": Contemporary Responses to Turner's Exhibited and Engraved Watercolours', in Eric Shanes, *Turner: The Great Watercolours* (London: Royal Academy, 2000), p. 41.

62 *Spectator*, 10 January 1835, pp. 43–4, quoted in Ivy, *Constable and the Critics*, p. 197.

63 Ibid.

64 Andrew Shirley, *The Published Mezzotints of Lucas after Constable* (Oxford: Clarendon Press, 1930), p. 1.

65 W.G. Rawlinson, *The Engraved Work of J.M.W. Turner*, vol. I (London: Macmillan, 1908), p. lxvii.

66 See Lyles and Perkins, *Colour into Line*, p. 58.

67 For the watercolours see Matthew Imms, 'Watercolour Designs for the "Little Liber" or "Sequels to the *Liber Studiorum*" c.1823–6', November 2011, in Brown (ed.), *J.M.W. Turner: Sketchbooks, Drawings and Watercolours*, https://www.tate.org.uk/art/research-publications/jmw-turner/watercolour-designs-for-the-little-liber-or-sequels-to-the-liber-studiorum-r1133274, accessed 12 April 2024.

9. Brother Labourers: Late Work

1 John Fisher, letter to Constable, 1 January 1830, JCC VIII, p. 120.

2 Daniel Maclise, *John Constable*, c.1831, pencil (National Portrait Gallery, London, NPG 1456).

3 Turner, letter to George Jones, [22] February 1830, Gage (ed.), *The Collected Correspondence*, no. 161, p. 137.

4 Turner, letter to Clara Wells, 3 January 1830, Gage (ed.), *The Collected Correspondence*, no. 159, p. 135.

5 Leslie, *Autobiographical Recollections*, vol. I, pp. 204–5. Leslie had attempted a profile portrait of Turner during his student years at the Royal Academy, though he felt he had 'failed' in the likeness (Charles Robert Leslie, *J.M.W. Turner*, 1816, pencil, National Portrait Gallery, London, NPG 4084).

6 John Ruskin, 'Fors Clavigera, vol. I', Cook and Wedderburn (eds), *The Library Edition*, vol. XXVII, p. 164.

7 Constable, letter to John Fisher, 26 August 1827, JCC VI, p. 231.

8 Theories about late style have permeated discussions about culture across all art forms. Notable studies include those by the German philosopher Theodor Adorno, who wrote about the last works of Beethoven, and more recently, Edward Said, whose book *On Late Style* (New York: Pantheon, 2006), published posthumously, examined amongst others Mozart, Thomas Mann and Beethoven. Other figures discussed with reference to a defined late style include Shakespeare, Liszt and Bach. In art history, meanwhile, notable studies or exhibitions have variously looked at Titian, Matisse and Rembrandt. Important contributions to the field have been Sam Smiles, *The Late Works of J.M.W. Turner: The Artist and His Critics* (New Haven and London: Yale University Press, 2020), and Anne Lyles, *Late Constable* (London: Royal Academy, 2021).

9 *London Magazine*, III, June 1829, in Ivy, *Constable and the Critics*, p. 135.

10 John Fisher, letter to Constable, 11 February 1829, p. 243.

11 Nicholas Powell, 'Will and Bequest', in *The Oxford Companion to J.M.W. Turner*, p. 382.

12 Royal Academy Council minutes, vol. VII, 1824–32. See the records for 8–20 January 1830, pp. 322–35.

13 Turner, letter to George Jones, [22] February 1830, Gage (ed.), *The Collected Correspondence*, p. 137.

14 Leslie, *Autobiographical Recollections*, vol. I, p. 176.

15 Thornbury, *Life*, p. 126.

16 See Nicola Moorby, '*Funeral of Sir Thomas Lawrence: A Sketch from Memory* exhibited 1830 by Joseph Mallord William Turner', May 2011, in Brown (ed.), *J.M.W. Turner: Sketchbooks, Drawings and Watercolours*, https://www.tate.org.uk/art/research-publications/jmw-turner/joseph-mallord-william-turner-funeral-of-sir-thomas-lawrence-a-sketch-from-memory-r1133879, accessed 27 November 2023.

17 Turner uses this term repeatedly, most notably as the title for his manuscript poem, 'Fallacies of Hope'.

18 Minutes of the meeting of the Academy Council of 25 June 1830.

19 Martin Archer Shee, letter to Constable, 21 June 1830, JCC VIII, p. 286.

20 Constable, letter to Charles Robert Leslie, 26 September 1831, JCC III, p. 47.

21 The Royal Academy of Arts owns an oil-smeared palette used by Constable, given by his daughter Isabel in 1886 (03/4285), as well as two watercolour palettes owned by Turner, given by Hilda Félicité Finberg in 1940 (03/7070 and 03/7072).

22 Constable, letter to Charles Robert Leslie, 29 December 1830, JCC III, p. 34. Beckett transcribed the name of the third party as 'Tomlinson' but Leslie said 'Tomkison'. James Hamilton has since confirmed this was Thomas Tomkison of 55 Dean Street, Soho, near Charlotte Street, a piano manufacturer whom Turner had known from boyhood and was an active collector of his watercolours. See Hamilton, *Constable: A Portrait*, p. 341.

23 Ibid.

24 Constable, letter to David Lucas, undated [possibly February 1832], JCC IV, p. 366.

25 Constable, lettter to Charles Robert Leslie, undated [possibly spring 1833], JCC III, p. 100.

26 Constable, letter to Charles Robert Leslie, 3 April 1833, JCC III, pp. 97–8.

27 Helen Dorey, *John Soane & J.M.W. Turner: Illuminating a Friendship* (London: Sir John Soane's Museum, 2007), pp. 9, 30. Eliza Soane had died in November 1815. At the same sale from which he had purchased Hogarth's palette in September 1831, Turner had bought a portrait sketch of her and presented it to Soane in honour of his recent knighthood.

28 See for example Jacqueline Riding, '1832: Shot out of the Water?', in Hallett, Turner and Feather (eds), *The Royal Academy of Arts Summer Exhibition: A Chronicle*, chronicle250.com/1832, accessed 30 May 2024; David Blayney Brown, ' "Fire and Water": Turner and Constable in the Royal Academy, 1831', *Tate Papers* 33 (2020), https://www.tate.org.uk/research/tate-papers/33/fire-water-turner-constable-royal-academy, accessed 5 December 2023; and James Hamilton, ' "I Dined

with Jones & Turner, Snugly – Alone": The Friendship of Turner and Constable, Brother Labourers', *Turner Society News* 138 (autumn 2022), pp. 12–26.

29 *Morning Chronicle*, 8 February 1832, talking retrospectively about the 1831 hang. Quoted in Ivy, *Constable and the Critics*, p. 157. For Dubois's reputation see ibid., p. 15.

30 *Observer*, 1 May 1831, repeated in the *Morning Chronicle*, 2 May 1831. Quoted in Ivy, *Constable and the Critics*, p. 149. See also Leslie Parris, Conal Shields and Ian Fleming-Williams (eds), *John Constable: Further Documents and Correspondence* (London: Tate Gallery, 1975), p. 174.

31 Tate, N00512 and N00513; B&J, nos 337 and 293.

32 *Morning Post*, 2 June 1831. Quoted in Ivy, *Constable and the Critics*, p. 154.

33 Thornbury, *Life*, pp. 228–9.

34 See Helen Guiterman, ' "The Great Painter": Roberts on Turner', *Turner Studies* 9.1 (1989), pp. 2–9.

35 Brown, ' "Fire and Water" '.

36 W.P. Frith, *My Autobiography and Reminiscences* (London, 1889), pp. 89–90. See also general discussion in Bailey, *Standing in the Sun*, p. 293.

37 Brown, ' "Fire and Water" '.

38 Ibid.

39 Amy Concannon, '1831: Turner and Constable as "Fire and Water" ', in Hallett, Turner and Feather (eds), *The Royal Academy of Arts Summer Exhibition: A Chronicle*, chronicle250.com/1831, accessed 30 May 2024.

40 Hamilton, *Constable: A Portrait*, p. 318.

41 First suggested by Leslie Parris. See Anne Lyles, 'Sublime Nature: John Constable's Salisbury Cathedral from the Meadows', in Nigel Llewellyn and Christine Riding (eds), *The Art of the Sublime*, Tate Research Publication, January 2013, https://www.tate.org.uk/art/research-publications/the-sublime/anne-lyles-sublime-nature-john-constables-salisbury-cathedral-from-the-meadows-r1129550, accessed 5 December 2023.

42 Amy Concannon has noted that had any attempt been made to unpick their meanings in 1831, parallels could have been drawn between Constable's cathedral and Turner's *Caligula's Palace and Bridge*, a commentary on hubris and transience. Concannon, '1831'; Brown, ' "Fire and Water" '.

43 *Stonehenge*, c.1827, watercolour (Salisbury Museum).

44 *Salisbury, Wiltshire*, c.1828, watercolour on paper (Salisbury Museum), published in 1830. See Eric Shanes, *Turner's England, 1810–1838* (London: Cassell, 1990), p. 186: 'the complementary nature of their imagery is so marked that it is difficult to believe that the two watercolours were not conceived as a pair'.

45 See Timothy Wilcox, *Constable and Salisbury: The Soul of Landscape* (London: Scala, 2011), pp. 148–9. Wilcox describes the distant cathedral as 'ringed in a halo of light'.

46 *Athenaeum*, 20 May 1829, p. 315; *London Magazine*, III, June 1829, pp. 604, 606–7. Quoted in Ivy, *Constable and the Critics*, pp. 134–5. See also Beckett's comments in JCC III, p. 21.

47 Constable, letter to John Fisher, 4 July 1829, JCC VI, p. 248; Constable, letter to Charles Robert Leslie, ?May 1829, JCC III, p. 22.

48 *Englishman's Magazine*, June 1831, p. 323; *Literary Gazette*, 14 May 1831. Both quoted in Ivy, *Constable and the Critics*, pp. 150–1, 153.

49 Some scientists believed that rocks were formed by the crystallisation of water (Neptunists) whilst others saw them as the result of the solidification of magma (Plutonists). See Leo Costello, 'Power, Creativity and Destruction in Turner's Fires', *Interdisciplinary Studies in the Long Nineteenth Century* 25 (2017), https://19.bbk.ac.uk/article/id/1588, accessed 29 May 2024.

50 [Edward Dubois], *Observer*, 29 May 1831. Quoted in Ivy, *Constable and the Critics*, p. 152.

51 *Literary Gazette*, op. cit.

52 'FUSELI, when he was going to see a picture of CONSTABLE'S, who is fond of rainy effects, called for his umbrella: when going to see one of TURNER'S we might ask for a fire-screen.' *Spectator*, 21 November 1835, p. 1116. Quoted in Ivy, *Constable and the Critics*, p. 210.

53 [Edward Dubois], *Observer*, 24 May 1835. Quoted in Ivy, *Constable and the Critics*, p. 202.

54 Mary Leslie, 'Lecture', inserted in a grangerised copy of C.R Leslie's memoir (Yale Center for British Art, New Haven, Connecticut). Quoted in Brown, ' "Fire and Water" '.

55 With thanks to Mark Pomeroy, archivist at the Royal Academy of Arts, for his unpublished notes on the Hanging Committee expenses from this year. The artists who incurred the most expenses were those who did the greater amount of work, i.e. the main rooms of oil paintings. In 1831, this was Edwin Landseer, William Daniell and Richard Cook.

56 Leslie, *Autobiographical Recollections*, I, p. 202.

57 Ibid.

58 Michael Rosenthal, 'Turner Fires a Gun', in David Solkin (ed.), *Art on the Line: The Royal Academy Exhibitions at Somerset House 1780–1836* (New Haven, CT: Yale University Press, 2001), p. 148; David Solkin, *Turner and the Masters* (London: Tate Publishing, 2009), p. 189; Richard Johns, 'Contested Waters', in Riding and Johns (eds), *Turner and the Sea*; Riding, '1832: Shot out of the Water?'.

59 Leo Costello, for example, talks about Turner's 'oft-cited attack' and Constable's 'violent metaphor of Turner's brush as an instrument of destruction'. See Costello, ' "This Cross-Fire of Colours": J.M.W. Turner

and the Varnishing Days Reconsidered', *British Art Journal* 9.3 (2010), pp. 56–68.

60 Constable had sardonically labelled Turner 'him who would be Lord over all'. Constable, letter to John Fisher, 23 January 1825, JCC VI, p. 191.
61 Leslie, *Life*, p. 177.
62 *New Monthly Magazine*, 1 June 1832, p. 255. Quoted in Ivy, *Constable and the Critics*, p. 161.
63 Constable, letters respectively to John Fisher, 19 November 1825, JCC VI, p. 207; to David Lucas, 28 February 1832, JCC IV, p. 367; and to Charles Robert Leslie, 4 March 1832, JCC III, p. 64.
64 Constable, letter to Charles Robert Leslie, 24 April 1832, JCC III, p. 68.
65 Ibid.
66 Constable, letter to Charles Robert Leslie, 27 April 1832, JCC III, p. 69.
67 George Jones, *The Opening of London Bridge, 1831*, 1832, oil on canvas (Sir John Soane Museum, P247), https://collections.soane.org/object-p247.
68 *Observer*, 27 May 1832. Quoted in Ivy, *Constable and the Critics*, p. 160.
69 Lyles, *Late Constable*, p. 39.
70 Riding, '1832: Shot out of the Water?'. See also Maurice Davies and Annette Wickham, *'He Has Been Here and Fired a Gun': Turner, Constable and the Royal Academy* (London: Royal Academy, 2019).
71 In a fascinating plenary lecture given by Jacqueline Riding at the Courtauld Institute of Art in 2017, she demonstrated through vocal inflection the range of meanings and intention behind the phrase 'He has been here and fired a gun.'
72 Leslie, *Autobiographical Reflections*, I, pp. 202–3.
73 Ibid.
74 See B&J, no. 346. Also George Jones, *Recollections of J.M.W. Turner*, quoted in Gage (ed.), *The Collected Correspondence*, p. 5.
75 *Literary Gazette*, 19 May 1832, p. 314. Quoted in Ivy, *Constable and the Critics*, p. 160.
76 W. Cosmo Monkhouse makes this point in *Turner* (London, 1879), p. 100.
77 Jones, *Recollections of J.M.W. Turner*, quoted in Gage (ed.), *The Collected Correspondence*, p. 4.
78 Leslie, *Life*, p. 151.
79 Reported in *Literary Gazette*, 13 June 1835, p. 380. See Ivy, *Constable and the Critics*, pp. 203–4.
80 Thornbury, *Life*, pp. 327–8. See also Monkhouse, *Turner*, pp. 100–1.
81 Leslie, *Life*, p. 203.
82 Constable, *The Houses of Parliament on Fire*, 1834, pen and ink and watercolour on paper (Sterling and Francine Clark Art Institute, Williamstown, MA).

83 Caroline Shenton, *The Day Parliament Burned Down* (Oxford: Oxford University Presss, 2012).

84 E.V. Rippingille, 'Personal Recollections of Great Artists', quoted in B&J, under no. 359.

85 *The Burning of the Houses of Lords and Commons, 16 October 1834*, 1835 (Cleveland Museum of Art).

86 *Morning Herald*, 2 May 1835, quoted in B&J under no. 364.

87 See Costello, ' "This Cross-Fire of Colours" ', pp. 56–68.

88 Robert Vernon (1774–1849) later presented a gift of 166 pictures to the National Gallery.

89 Constable, letter to Charles Boner, 14 March 1836, JCC V, p. 197. Despite his self-congratulatory tone, *The Valley Farm* had been widely criticised in the papers with all the usual slurs: 'shower of sleet', 'cold, wiry, chalky look', 'white . . . from a dredging box', etc. See Ivy, *Constable and the Critics*, pp. 199–204.

90 'Turner's light, whether it emanates from the sun or the moon, is exquisite.' John Constable, letter to George Constable, 6 June 1835, JCC V, p. 22; Constable, letter to Charles Boner, 14 March 1836, JCC V, p. 197.

91 Constable, letter to Charles Robert Leslie, 17 December 1832, JCC III, pp. 84–5; Constable, letter to Charles Robert Leslie, 14 January 1832. JCC III, pp. 57–8.

92 Quoted in B&J under no. 365. See also Ian Warrell (ed.), *J.M.W. Turner*, no. 107, p. 152.

93 See B&J under no. 365. The article remained unpublished, though Ruskin later expanded upon it in *Modern Painters*. The text appears in Cook and Wedderburn (eds), *The Library Edition*, vol. III, pp. 635–40.

94 Turner, letter to John Ruskin, 6 October 1836, quoted in Gage (ed.), *The Collected Correspondence*, pp. 160–1.

95 John Constable, letter to George Constable, 12 May 1836, JCC V, pp. 32–3.

96 See Caroline Knight, 'The Buildings', in Simon and Stevens (eds), *The Royal Academy of Arts: History and Collections*, pp. 36–7.

97 Constable, letter to David Lucas, 28 September 1835, JCC IV, p. 423.

98 Lecture 6, quoted in Shanes, *Young Mr Turner*, p. 386.

99 Ibid.

100 John Constable, letter to George Constable, 12 May 1836, JCC V, pp. 32–3.

101 Leslie, *Autobiographical Recollections*, p. 205.

102 Lecture 1, 'The Origin of Landscape', from Leslie's notes on the lectures given at the Royal Institution in 1836, in JCD, p. 40.

103 Sir Joshua Reynolds, 'Discourse XV', 10 December 1790, in Helen Zimmern (ed.), *Sir Joshua Reynolds' Discourses* (London: Walter Scott, 1887), p. 300.

104 Anne Lyles, '1836: "The Last Time in the Old House"', in Hallett, Turner and Feather (eds), *The Royal Academy of Arts Summer Exhibition: A Chronicle*, chronicle250.com/1836, accessed 30 May 2024.

105 Constable had written an article on Beaumont's gift for the *Athenaeum*, 3 July 1830. See JCD, pp. 79–80.

106 John Constable, letter to George Constable, 12 May 1836, JCC V, p. 32.

107 Letterpress to *English Landscape Scenery*, JCD, p. 10.

10. Endings . . . and Beginnings

1 John Constable, letter to George Constable, 17 February 1837, JCC V, p. 37.

2 See JCD, pp. 76–7.

3 Constable, *A Recollection of the New Royal Academy*, 1837, pen and brown ink on paper (Yale Center for British Art).

4 Constable, *Arundel Mill and Castle*, 1837, oil on canvas (Toledo Museum and Art Gallery).

5 John Constable, letter to George Constable, 17 February 1837, JCC V, p. 37.

6 Royal Academy Council minutes, vol. VII, 1832–8.

7 Royal Academy Council minutes, 4 April 1837, vol. VII, p. 304.

8 *Spectator*, 8 April 1837, pp. 331–2. Quoted in Ivy, *Constable and the Critics*, p. 229.

9 The other two were William Etty and William Hamilton. The painting is listed in the catalogue as no. 193 by 'The late J. Constable, RA'.

10 Ian Fleming-Williams and Leslie Parris, *The Discovery of Constable* (London: Hamish Hamilton, 1984), pp. 8–10.

11 Leslie, *Life*, p. 203.

12 The painting was acquired by Tate in 2013 and was the subject of a comprehensive research project led by Amy Concannon: see https://www.tate.org.uk/research/in-focus/salisbury-cathedral-constable, accessed December 2023.

13 These timeframes are adopted from Tate's 2014 exhibition, *Late Turner: Painting Set Free*, and Sam Smiles, *The Late Works of J.M.W. Turner* (London: Paul Mellon Centre for British Art, 2020), as well as the Royal Academy's 2021 exhibition, *Late Constable*.

14 William Vaughn, 'Constable's Englishness', *Oxford Art Journal* 19.2 (1996), p. 23.

15 Constable, letter to Charles Robert Leslie, 20 January 1833, JCC III, p. 90.

16 *The Hero of a Hundred Fights*, c.1800–10, reworked 1847 (Tate, N00551). See also David Blayney Brown, Amy Concannon and Sam Smiles, *Turner's Modern World* (London: Tate Publishing, 2020), pp. 34–7.

17 Constable, letter to John Britton, 2 February 1834, JCC V, p. 85.

18 Constable, *The Steamship (The Orwell)*, c.1815, pencil on paper (private collection, on long-term loan to Gainsborough's House).

19 For details on the ship's construction see Sam Willis, *The Fighting Temeraire: Legend of Trafalgar* (London: Quercus, 2009), pp. 97–107.

20 For detailed discussions see Judy Egerton, *Turner: The Fighting Temeraire (Making and Meaning)* (London: National Gallery, 1995), and Willis, *The Fighting Temeraire*, pp. 261–81.

21 Abram Constable, letter to John Constable, 25 February 1821, JCC I, p. 193.

22 Inherited from his uncle in 1820, this establishment, frequented by dock workers, was run by tenants, but Turner maintained an association with it until the 1840s. See David Meaden, 'J.M.W. Turner, Artist and Publican?', British Library blog, February 2022, https://blogs.bl.uk/untold-lives/2022/02/jmw-turner-artist-and-publican.html, accessed June 2023.

23 Mary Somerville, *The Connexion of the Physical Sciences* (1843; eighth edition, London, 1849), p. 143.

24 Ibid, p. 153.

25 Also quoted in Leslie, *A Life*, p. 274.

26 The painting's full title is Snow Storm – Steam-Boat off a Harbour's Mouth Making Signals in Shallow Water, and going by the Lead. The Author was in this Storm on the Night the 'Ariel' left Harwich.

27 So entrenched is this episode in British folklore that in 2007 the artist Bob and Roberta Smith (the pseudonym of Patrick Brill) tried to restage it off Brighton beach using a home-made raft. Brill explained: 'I am interested in Turner's processes, and the notion of tying yourself to a mast to experience a storm at sea. It is a bit like the crucifixion.' Quoted in James Hall, 'A Sublime Roller Coaster Ride through Art History, *Tate Etc.* (2009), https://www.tate.org.uk/tate-etc/issue-17-autumn-2009/sublime-roller-coaster-ride-through-art-history, accessed 30 May 2024.

28 JCC V, p. 176.

29 John Constable, letter to George Constable, 12 September 1835, JCC V, p. 27; Constable, letter to Charles Robert Leslie, undated [?1835], JCC III, p. 129.

30 Constable, letter to Charles Robert Leslie, 14 September 1835, JCC III, p. 130.

31 Constable, letter to Charles Robert Leslie, ?early November 1836, JCC III, pp. 142–3.

32 For this and other citations see B&J, no. 398.

33 Quoted in B&J, under no. 398.

34 John Ruskin, 'Preraphaelitism', 1851. Cook and Wedderburn (eds), *The Works of John Ruskin*, vol. 12, p. 339.

35 Christiana Payne has suggested Ruskin's words may represent an unconscious echo of Constable's last lecture on landscape painting, given in 1836 and published in Leslie's *Life*. Christiana Payne, 'Constable, Ruskin and the Pre-Raphaelites', *British Art Journal* 16.1 (2015).

36 Appendix to *The Two Paths* (1859), from Cook and Wedderburn (eds), *The Works of John Ruskin*, vol. 16, p. 415. See https://www. lancaster.ac.uk/fass/ruskin/empi/notes/hcons03.htm, accessed December 2023.

37 John Ruskin, *Modern Painters*. Cook and Wedderburn (eds), *The Works of John Ruskin*, vol. 3, p. 254. Quoted in Robert Hewison, *Ruskin, Turner and the Pre-Raphaelites* (London: Tate Gallery, 2000), p. 14. Hewison notes that this 'hyperbole' was dropped from later editions.

38 David Roberts. Quoted in James Hamilton, *Turner: A Life* (London: Hodder & Stoughton, 1997), p. 303.

39 Munro to the painter Frith. Quoted in William Powell Frith, *My Autobiography* (London, 1887), p. 90. For further descriptions of Queen Anne Street see Thornbury, *Life*, pp. 317–23.

40 Constable, letter to Charles Robert Leslie, [early November 1836], JCC III, p. 143. Constable was referring here to Turner's paintings in the collection of John Sheepshanks. This transcription follows that of James Hamilton which differs slightly from Beckett's: see Hamilton, *Constable: A Portrait*, p. 25 and n. 54.

41 See Smiles, *The Late Works*, p. 188.

42 See B&J, nos 429–32.

43 Turner, letter to F.H. Fawkes, 27 December 1850, Gage (ed.), *The Collected Correspondence*, p. 224.

44 Turner, letter to F.H. Fawkes, 31 January 1851, Gage (ed.), *The Collected Correspondence*, p. 227.

45 Respectively L.B. Constable, *On the Coast of Cornwall* (13) and *Entrance to Looe Harbour, Cornwall* (1039); A.A. Constable, *A Fishermen's Cottage* (564); and I. Constable, *Flowers* (567). The three are listed in the catalogue index as living together at 16 Cunningham Place, St John's Wood.

46 Leslie, *Autobiographical Recollections*, vol. I, p. 201.

47 Charles Mallord Turner (1903–1979). In 1982 his wife paid for the funerary vault of Thomas Gardner, Helen Gates and William Gates to be restored in his memory.

48 Two excellent publications for understanding this phenomenon are Fleming-Williams and Parris, *The Discovery of Constable*, and Sam Smiles, *J.M.W. Turner: The Making of a Modern Artist* (Manchester: Manchester University Press, 2007).

49 Ivy, *Constable and the Critics*, p. 13.

50 National Gallery's acquisition policy, November 2012, https://www.nationalgallery.org.uk/media/16208/acquisitions-policy_2012.pdf.

51 Traditionally, and at the time of writing, Room 34, a large gallery on Level 2.

52 For a detailed account of the legal interpretation of Turner's will, see Nick Powell, 'Will and Bequest', in *The Oxford Companion to J.M.W. Turner*, pp. 382–4.

53 For the subsequent movements of the Turner Bequest see Powell, 'Will and Bequest'. Also Ian Warrell, 'Turner's Legacy: The Artist's Bequest and Its Influence', in Katharine Lochnan (ed.), *Turner, Whistler, Monet* (London: Tate Publishing, 2004), pp. 67–73.

54 Cited in John House, 'Tinted Steam: Turner and Impressionism', in Lochnan (ed.), *Turner, Whistler, Monet*, p. 45.

55 Cited in Warrell, *J.M.W. Turner*, under no. 165, p. 228.

56 See Constable's journal of 1825, JCC II, p. 397.

57 See Smiles, *The Late Works*, pp. 226–38.

58 Cited in Fleming-Williams and Parris, *The Discovery of Constable*, p. 89.

59 Roger Fry, *Reflections on British Painting* (1934). Cited in Fleming-Williams and Parris, *The Discovery of Constable*, p. 124.

60 See Fleming-Williams and Parris, *The Discovery of Constable*, pp. 124–5.

61 Kenneth Clark, 1944, quoted in ibid., p. 124, n. 19.

62 Inconsistencies in the picture's provenance eventually revealed the error. In 1960, the finished *Hadleigh Castle* resurfaced from a private collection and was bought by Paul Mellon.

63 In 2003, Kirk Varnedoe, former curator of the Museum of Modern Art, New York, and professor of history of art at Princeton University, used the painting as the starting point for a series of lectures and a publication entitled *Pictures of Nothing: Abstract Art since Pollock* (Princeton, NJ: Princeton University Press, 2006).

64 Cited in Smiles, *J.M.W. Turner: The Making of a Modern Artist*, p. 202.

65 Laurence Gowing, *Turner: Imagination and Reality* (New York: Museum of Modern Art, 1966), p. 45.

66 Remembrance by Norman Reid, director of the Tate Gallery. Quoted in Smiles, *The Late Works*, p. 4.

67 Cited in Sarah Cove, 'The Painting Techniques of Constable's "Six-Footers"', in Lyles (ed.), *Constable: The Great Landscapes*, p. 61.

68 Patrick Heron, 'Constable: Spatial Colour in the Drawings', in Charles Leggatt et al., *Constable: A Master Draughtsman* (London: Dulwich Picture Gallery, 1994), p. 45.

69 https://www.tate.org.uk/art/artworks/constable-salisbury-cathedral-from-the-meadows-t13896/in-depth-salisbury-cathedral-from-the-meadows/legacy-influence, accessed January 2024. See also L. Whiteley, 'Constable et le salon de 1824', in *Constable: Le Choix de Lucian Freud* (Paris: RMN, 2002), pp. 47–51, and 'Conversation entre Lucian Freud et William Feaver' in the same catalogue, also published in English as *Lucian Freud on John Constable with William Feaver* (London: British Council, 2003).

70 Tim Adams, 'Frank Auerbach: Turner, Constable and me', *Observer*, 21 September 2014.

71 See *Legacies: J.M.W. Turner and Contemporary Art Practice*, exhibition guide, New Art Gallery, Walsall (2017), https://thenewartgallerywal-

sall.org.uk/wp-content/uploads/2017/05/EXHIBITION-GUIDE-WEB-SITE.pdf; Jonathan P. Watts, 'Into the Light with J.M.W. Turner', *Tate Etc.* (25 June 2019), https://www.tate.org.uk/tate-etc/issue-32-autumn-2014/light-jmw-turner, both accessed January 2024.

72 Richard Cork, "The Turner Prize: Everyone's a Winner", *Tate Magazine* 2 (November/December 2002).

73 Will Gompertz, 'Will Gompertz Resurrects Turner for a Tour of the Art Prize in His Name', BBC News (28 September 2019), https://www.bbc.co.uk/news/entertainment-arts-49820595, accessed January 2024.

74 Sam Smiles has pointed out that it would make less sense named after any other British artist of the period: Smiles, *The Late Works*, p. 2.

75 Colin Simpson, 'The Tate Drops a Costly Brick', *Sunday Times*, 15 February 1976. The term 'pile of bricks' was coined by the *Evening Standard*. See Briony Fer, 'The Modern in Fragments', in Francis Frascina et al., *Modernity and Modernism: French Painting in the Nineteenth Century* (New Haven and London: Yale University Press, 1993), pp. 37–42.

76 An irate visitor threw blue dye over the piece.

77 'Trog', 'And I Say the Tate Gallery Is That Way', *Observer*, 22 February 1976.

78 Fer, 'The Modern in Fragments', p. 37.

79 Published by the Bernard Jacobson Gallery to coincide with the Tate's exhibition. Nineteen artists were invited to contribute prints. Editions are held by Tate and the V&A.

80 *Equivalents*, exhibition selected by Steven Claydon and held at the Firstsite gallery, Colchester, 2012.

81 Charles Saatchi, 'A Legacy That Turner Would Have Approved Of', *Guardian*, 14 February 2012. See also https://www.charlessaatchi.com/a-legacy-that-turner-would-have-approved-of, accessed January 2024.

Afterword: Afterlife

1 Turner features in novels *The Dark Clue* by James Wilson (2002), *Will and Tom* by Matthew Plampin (2015) and *The Green Lady* by Sally Bayley (2023). Constable, meanwhile, is a main character in *The Year without Summer* by Guinevere Glasfurd (2020) and *Between Painting Room and Paradise: A Savage Fate* by James Armstrong (2021). Theatrical productions include Rebecca Lenkiewicz's *The Painter* (2011, with Toby Stephens in the title role as Turner at the Arcola Theatre) and Michael Brunström's surreal Fringe comedy, *The Hay Wain Reloaded* (2016).

2 References are too numerous to list here, but one article which explores the appeal of their oppositions is Sebastian Smee, 'One Rivalry Changed the Landscape in English Art', *Washington Post*, 17 January 2019.

3 For example in a 2005 poll organised for BBC Radio 4's *Today* programme to find the 'nation's favourite painting', *The Fighting Temeraire* took first place, with *The Hay Wain* second, and in 2015, Turner topped a BBC survey of the 'nation's favourite artist'. Conversely in an online vote by Samsung in 2017, *The Hay Wain* beat *The Fighting Temeraire* (though Banksy's *Girl with Balloon* won overall).

4 Constable, letter to David Lucas, 14 November 1832, JCC IV, p. 386.

5 Keith Turner, *Constable Country* (Swindon: National Trust, 2000), p. 22.

6 Robert Hughes, 'Art: The Wordsworth of Landscape', *Time*, 25 April 1983.

7 Nicola Davison, 'Picture-Perfect Homes in "Constable Country" Come at a Premium', *Financial Times*, 17 June 2016.

8 Ibid.

9 See for example a four-minute animation from 1970 by Derek Phillips, an amateur filmmaker who made more than forty animated shorts as 'an outlet to his unique blend of caustic wit, philosophical enquiry and pessimistic atheism'. His *For Your Pleasure* is available to view at https://player.bfi.org.uk/free/film/watch-for-your-pleasure-1970-online, accessed 30 May 2024.

10 Ellis Sharp, *Dead Iraqis: Selected Short Stories* (Nottingham: New Ventures, 2009).

11 Rakewell, 'Star Turner – The Fighting Temeraire, from Biscuit Tin to Banknote', *Apollo*, 22 February 2020. See https://www.apollo-magazine.com/fighting-temeraire-turner-banknote/, accessed January 2024.

12 *Guardian*, 26 April 2005.

13 *The Fighting Derry Air: Tugged to Its Last Berth to be Turned into Ballot Boxes*, 2005. I'm grateful to Pieter van der Merwe for bringing this to my attention.

14 Collated within an appendix by Willis, *The Fighting Temeraire*.

15 Ibid., p. 316.

16 *Masterpiece*, Coca-Cola global advertising campaign, 2023.

17 During a Tate Britain exhibition, *Turner, Whistler, Monet* in 2005, the Savoy Hotel offered cocktails based upon each artist's work: *The Art of the Cocktail* (London: Ilex Press, 2019), p. 63; Frick Collection, 'Cocktails with a Curator', 2020, YouTube. In a nod to Constable's European impact, the *White Horse* episode of the latter featured a blend of French Dubonnet and English gin.

SELECTED BIBLIOGRAPHY

Bailey, Anthony, 2007, *John Constable: A Kingdom of His Own* (London: Vintage).

Beckett, R.B. (ed.), 1962, *John Constable's Correspondence: 1. The Family at East Bergholt 1807–1837* (London: Her Majesty's Stationery Office).

Beckett, R.B. (ed.), 1964, *John Constable's Correspondence: 2. Early Friends and Maria Bicknell* (Ipswich: Suffolk Records Society).

Beckett, R.B. (ed.), 1965, *John Constable's Correspondence: 3. Correspondence with C.R. Leslie, RA* (Ipswich: Suffolk Records Society).

Beckett, R.B. (ed.), 1966, *John Constable's Correspondence: 4. Patrons, Dealers and Fellow Artists* (Ipswich: Suffolk Records Society).

Beckett, R.B. (ed.), 1967, *John Constable's Correspondence: 5. Various Friends, with Charles Boner and the Artist's Children* (Ipswich: Suffolk Records Society).

Beckett, R.B. (ed.), 1968, *John Constable's Correspondence: The Fishers* (Ipswich: Suffolk Records Society).

Beckett, R.B. (ed.), 1970, *7. John Constable's Discourses* (Ipswich: Suffolk Records Society).

Beevers, David (ed.), 1995, *Brighton Revealed: Through Artist's Eyes c.1760–c.1960*, exh. cat. (Brighton: Royal Pavilion, Art Gallery and Museums).

Berger, Susanna, 2012, ' "When Sobriety and Taste Were Cast to the Winds": A Study of George Walter Thornbury's "The Life of J.M.W. Turner, RA" ', *British Art Journal* 12.3, pp. 81–8.

Bindman, David (ed.), 2008, *The History of British Art 1600–1870* (London: Tate Publishing).

Broughton, Trev Lynn, 2010, 'Life Slips: Work, Love and Gender in John Constable's Correspondence', *Studies in the Literary Imagination* 43.1, pp. 27–47.

Brown, David Blayney, Amy Concannon and Sam Smiles (eds), 2014, *Late Turner: Painting Set Free*, exh. cat. (London: Tate Publishing).

Brown, David Blayney, Amy Concannon and Sam Smiles (eds), 2021, *Turner's Modern World*, exh. cat. (London: Tate Publishing).

Butlin, Martin, and Evelyn Joll, 1984, *The Paintings of J.M.W. Turner* (New Haven and London: Yale University Press).

Cave, Katherine, Kenneth Garlick and Angus Macintyre (eds), 1978–98, *The Diary of Joseph Farington, 1793–1821*, 17 vols (New Haven and London: Yale University Press).

Clarkson, Jonathan, 2010, *Constable* (London: Phaidon).

Cook, E.T., and Alexander Wedderburn (eds), 1903–12, *The Library Edition of the Works of John Ruskin*, 39 vols (London: George Allen).

Costello, Leo, 2010, ' "This Cross-Fire of Colours": J.M.W. Turner and the Varnishing Days Reconsidered', *British Art Journal* 10.3, pp. 56–68.

Costello, Leo, 2017, 'Power, Creativity and Destruction in Turner's Fires', *Interdisciplinary Studies in the Long Nineteenth Century* 25.

Dabydeen, David, 1995, *Turner: New and Selected Poems* (London: Jonathan Cape).

Davies, Maurice, and Annette Wickham, 2019, *'He Has Been Here and Fired a Gun': Turner, Constable and the Royal Academy* (London: Royal Academy).

Dorey, Helen, 2007, *John Soane & J.M.W. Turner: Illuminating a Friendship*, exh. cat. (London: Sir John Soane's Museum).

Egerton, Judy, 1995, *Turner: The Fighting Temeraire (Making and Meaning)*, exh. cat. (London: National Gallery).

Evans, Mark, 2018, *Constable's Skies: Paintings and Sketches* (London: Thames & Hudson).

Evans, Mark, Stephen Calloway and Susan Owens, 2014, *Constable: The Making of a Master*, exh. cat. (London: V&A Publishing).

Fenton, James, 2006, *School of Genius: A History of the Royal Academy of Arts* (London: Salamander Press).

Fer, Briony, 1993, 'The Modern in Fragments', in Francis Frascina et al., *Modernity and Modernism: French Painting in the Nineteenth Century* (New Haven and London: Yale University Press).

Field, George, 1835, *Chromatography; or a Treatise on Colours and Pigments, and of their Powers in Painting* (London: Charles Tilt).

Finberg, A.J., 1939, *The Life of J.M.W. Turner RA* (Oxford: Clarendon Press).

Fleming-Williams, Ian, and Leslie Parris, 1984, *The Discovery of Constable* (London: Hamish Hamilton).

Fleming-Williams, Ian, Jane McAusland, Anne Lyles and Patrick Heron, 1994, *Constable: A Master Draughtsman*, exh. cat. (London: Dulwich Picture Gallery).

Forrester, Gillian, 1996, *Turner's 'Drawing Book': The Liber Studiorum*, exh. cat. (London: Tate Publishing).

Freud, Lucian, William Feaver et al., 2002, *Constable: Le Choix de Lucian Freud*, exh. cat. (Paris: RMN).

Frith, William Powell, 1887, *My Autobiography and Reminiscences* (London: Richard Bentley and Son).

Gage, John, 1969, *Colour in Turner: Poetry and Truth* (London: Studio Vista).

Gage, John (ed.), 1980, *Collected Correspondence of J.M.W. Turner* (Oxford: Clarendon Press).

Gage, John, 1987, *J.M.W. Turner: A Wonderful Range of Mind* (New Haven and London: Yale University Press).

Galassi, Susan Grace, Ian Warrell and Joanna Sheers Seidenstein, 2017, *Turner's Modern and Ancient Ports: Passages through Time*, exh. cat. (New Haven and London: Yale University Press, in association with the Frick Collection, New York).

Garlick, Kenneth, 1989, *Sir Thomas Lawrence: A Complete Catalogue of the Oil Paintings* (Oxford: Phaidon).

Gayford, Martin, 2009, *Constable in Love: Love, Landscape, Money and the Making of a Great Painter* (London: Fig Tree).

Gayford, Martin, and Anne Lyles, 2009, *Constable Portraits: The Painter and His Circle*, exh. cat. (London: National Portrait Gallery).

Gowing, Lawrence, 1966, *Turner: Imagination and Reality*, exh. cat. (New York: Museum of Modern Art).

Guiterman, Helen, '1989, "The Great Painter": Roberts on Turner', *Turner Studies* 9.1, pp. 2–9.

Hallett, Mark, and Sarah Victoria Turner (eds), 2018, *The Great Spectacle: 250 Years of the Royal Academy Summer Exhibition*, exh. cat. (London: Royal Academy).

Hamilton, James, 1997, *Turner: A Life* (London: Hodder & Stoughton).

Hamilton, James, 1998, *Turner and the Scientists*, exh. cat. (London: Tate Publishing).

Hamilton, James, 2014, *A Strange Business: Making Art and Money in Nineteenth-Century Britain* (London: Atlantic).

Hamilton, James, 2022, *Constable: A Portrait* (London: Weidenfeld & Nicolson).

Hamilton, James, 2022, ' "I Dined with Jones & Turner, Snugly – Alone": The Friendship of Turner and Constable, Brother Labourers', *Turner Society News* 138, pp. 12–26.

Hebron, Stephen, Conal Shields and Timothy Wilcox, 2006, *The Solitude of Mountains: Constable and the Lake District* (Grasmere: Wordsworth Trust).

Herrmann, Luke, 1990, *Turner Prints: The Engraved Work of J.M.W. Turner* (Oxford: Phaidon).

Hewison, Robert, Ian Warrell and Stephen Wildman, 2000, *Ruskin, Turner and the Pre-Raphaelites*, exh. cat. (London: Tate Publishing).

Hill, David, 1985, *Constable's English Landscape Scenery* (London: Guild Publishing).

Hill, David, 1993, *Turner on the Thames* (New Haven and London: Yale University Press).

Hoock, Holger, 2010, ' "Struggling against a Vulgar Prejudice": Patriotism and the Collecting of British Art at the Turn of the Nineteenth Century', *Journal of British Studies* 49.3, pp. 566–91.

Hutchinson, Sidney C., 1960, 'The Royal Academy Schools, 1768-1830', *Volume of the Walpole Society* 38, pp. 123–91.

Ivy, Judy Crosby, 1991, *Constable and the Critics, 1802–1837* (Woodbridge: Boydell Press).

Joll, Evelyn, Martin Butlin and Luke Herrmann (eds), 2001, *The Oxford Companion to J.M.W. Turner* (Oxford: Oxford University Press).

Lancaster, Shân (ed.), 2017, *Constable and Brighton*, exh. cat. (London: Scala).

Landseer, John, 1807, *Lectures on the Art of Engraving* (London: Longman, Hurst, Rees and Orme).

Leslie, Charles Robert, 1845, *Memoirs of the Life of John Constable*, second edition (repr. London: Phaidon, 1995).

Lochnan, Katharine, 2004, *Turner, Whistler, Monet*, exh. cat. (London: Tate Publishing).

Loukes, Andrew, 2014, *Constable at Petworth*, exh. cat. (Petworth: Bexley Printers).

Lyles, Anne (ed.), 2006, *Constable: The Great Landscapes*, exh. cat. (London: Tate Publishing).

Lyles, Anne, and Matthew Hargreaves, 2021, *Late Constable*, exh. cat. (London: Royal Academy).

Lyles, Anne, and Diane Perkins, 1989, *Colour into Line: Turner and the Art of Engraving*, exh. cat. (London: Tate Publishing).

Monkhouse, William Cosmo, 1879, *Turner* (London: Sampson Low).

Moorby, Nicola, 2011, 'Turner's Sketches for "Rome, from the Vatican": Some Recent Discoveries', *Turner Society News* 115, pp. 4–10.

Moorby, Nicola, and Ian Warrell (eds), 2010, *How to Paint Like Turner* (London: Tate Publishing).

Moyles, Franny, 2016, *The Extraordinary Life and Momentous Times of J.M.W. Turner* (London: Viking).

Noon, Patrick (ed.), 2003, *Constable to Delacroix: British Art and the French Romantics*, exh. cat. (London: Tate Publishing).

Parris, Leslie, and Ian Fleming-Williams, 1991, *Constable*, exh. cat. (London: Tate Gallery).

Parris, Leslie, Conal Shields and Ian Fleming-Williams (eds), 1975, *John Constable: Further Documents and Correspondence* (Ipswich and London: Tate Gallery and Suffolk Records Society).

Parry-Wingfield, Catherine, 2012, *J.M.W. Turner, RA: The Artist and His House at Twickenham* (London: Turner's House Trust).

Parry-Wingfield, Catherine, 2020, *J.M.W. Turner and the 'Matchless Vale of Thames'* (London: Turner's House Trust).

Paulson, Ronald, 1982, *Literary Landscape: Turner and Constable* (New Haven and London: Yale University Press).

Payne, Christiana, 2015, 'Constable, Ruskin and the Pre-Raphaelites', *British Art Journal* 16.1, pp. 78–87.

Pinnock, Winsome, 2021, *Rockets and Blue Lights* (London: Nick Hern Books).

Powell, Cecilia, 1987, *Turner in the South: Rome, Naples, Florence* (New Haven and London: Yale University Press).

Rawlinson, W.G., 1908–13, *The Engraved Work of J.M.W. Turner, RA*, 2 vols (London: Macmillan).

Rees, Ronald, 1976, 'John Constable and the Art of Geography', *Geographical Review* 66.1, pp. 59–72.

Reynolds, Graham (intro.), 1979, *John Constable's Sketch-Books of 1813 and 1814, Reproduced in Facsimile* (London: Her Majesty's Stationery Office).

Reynolds, Graham, 1983, *Constable's England*, exh. cat. (New York: Metropolitan Museum of Art).

Riding, Christine, and Richard Johns, 2013, *Turner and the Sea*, exh. cat. (London: National Maritime Museum).

Riding, Jacqueline, and Andrew Loukes, *Mr Turner: An Exhibition*, exh. cat (Petworth: Bexley Printers).

Rosenthal, Michael, 1987, *Constable* (London: Thames & Hudson).

Rosenthal, Michael, 2006, 'Constable and Englishness', *British Art Journal* 7.3, pp. 40–5.

Rosenthal, Michael, and Anne Lyles, 2013, *Turner and Constable: Sketching from Nature*, exh. cat. (London: Tate Publishing).

Rowell, Christopher, Ian Warrell and David Blayney Brown, 2002, *Turner at Petworth*, exh. cat. (London: Tate Publishing in association with the National Trust).

Shanes, Eric, 1990, *Turner's England, 1810–38* (London: Cassell).

Shanes, Eric, 2000, *Turner: The Great Watercolours*, exh. cat. (London: Royal Academy).

Shanes, Eric, 2015, 'Sacrificing Symmetry: Turner and the Inner Room Display at the Royal Academy in 1811', *British Art Journal* 16.2, pp. 70–5.

Shanes, Eric, 2016, *Young Mr Turner* (New Haven and London: Yale University Press).

Shenton, Caroline, 2012, *The Day Parliament Burned Down* (Oxford: Oxford University Press).

Shirley, Andrew, 1930, *The Published Mezzotints of David Lucas after John Constable, RA* (Oxford: Clarendon Press).

Simon, Robin, and MaryAnn Stevens (eds), 2018, *The Royal Academy of Arts: History and Collections* (London: Yale University Press/Royal Academy).

Smiles, Sam, 1990, ' "Splashers", "Scrawlers" and "Plasterers": British Landscape Painting and the Language of Criticism, 1800–40', *Turner Studies* 10.1, pp. 5–11.

Smiles, Sam, 2007, *J.M.W. Turner: The Making of a Modern Artist* (Manchester: Manchester University Press).

Smiles, Sam, 2007, 'Turner and the Slave Trade: Speculation and Representation, 1805–40', *British Art Journal* 8.3, pp. 47–54.

Smiles, Sam, 2020, *The Late Works of J.M.W. Turner: The Artist and His Critics* (New Haven and London: Yale University Press)

Smith, Greg, 2018, *The Emergence of the Professional Watercolourist: Contentions and Alliances in the Artistic Domain, 1760–1824* [originally 2002] (London and New York: Routledge).

Solkin, David (ed.), 2001, *Art on the Line: The Royal Academy Exhibitions at Somerset House 1780–1836*, exh. cat. (New Haven and London: Yale University Press).

Solkin, David (ed.), 2009, *Turner and the Masters*, exh. cat. (London: Tate Publishing).

Somerville, Mary, 1849, *The Connexion of the Physical Sciences*, eighth edition (London: John Murray).

Taylor, Tom (ed.), 1978, *Autobiographical Recollections of Charles Robert Leslie* [originally 1860], 2 vols (Wakefield: EP Publishing).

Thornbury, Walter, 1877, *The Life of J.M.W. Turner, RA*, second edition (repr. London: Ward Lock Reprints, 1970).

Thornes, John E., 1999, *John Constable's Skies: A Fusion of Art and Science* (Birmingham: University of Birmingham Press).

Townsend, Joyce H., 2019, *How Turner Painted: Materials and Techniques* (London: Thames & Hudson).

Townsend, Joyce, 1996, *Turner's Painting Techniques* (London: Tate Gallery).

Tromans, Nicholas, 2007, *David Wilkie: The People's Painter* (Edinburgh: Edinburgh University Press).

Turner, Keith, 2000, *Constable Country* (Swindon: National Trust).

Vaughn, William, 1996, 'Constable's Englishness', *Oxford Art Journal* 19.2.

Vaughn, William, 1999, *British Painting: The Golden Age* (London: Thames & Hudson).

Vaughn, William, 2002, *John Constable* (London: Tate Publishing).

Warrell, Ian (ed.), 2007, *J.M.W. Turner*, exh. cat. (London: Tate Publishing).

Warrell, Ian (ed.), 2012, *Turner Inspired: In the Light of Claude*, exh. cat. (London: National Gallery).

Warrell, Ian, 2012, *Turner's Secret Sketches* (London: Tate Publishing).

Warrell, Ian, 2014, *Turner's Sketchbooks* (London: Tate Publishing).

Wilcox, Timothy, 2011, *Constable and Salisbury: The Soul of Landscape*, exh. cat. (London: Scala).

Willis, Sam, 2009, *The Fighting Temeraire: Legend of Trafalgar* (London: Quercus).

Wilton, Andrew, 1979, *Constable's 'English Landscape Scenery'* (London: British Museum).

Wilton, Andrew, 1979, *J.M.W. Turner: His Art and Life* (New York: Rizzoli).

Wilton, Andrew, 1987, *Turner in His Time* (London: Thames & Hudson).

Wilton, Andrew, 2006, *Turner as Draughtsman* (Aldershot: Ashgate).

Wilton, Andrew, and Rosalind Mallord Turner, 1990, *Painting and Poetry*, exh. cat. (London, Tate Gallery).

Zimmern, Helen (ed.), 1887, *Sir Joshua Reynolds' Discourses* (London: Walter Scott).

Online sources

Alfrey, Nicholas, 2020, 'John Constable and Paul Huet: Marsh and Flood', *Tate Papers* 33, https://www.tate.org.uk/research/publications/tate-papers/33/john-constable-paul-huet-marsh-flood.

Brown, David Blayney, 2020, ' "Fire and Water": Turner and Constable in the Royal Academy, 1831', *Tate Papers* 33, https://www.tate.org.uk/research/tate-papers/33/fire-water-turner-constable-royal-academy.

Brown, David Blayney, and Matthew Imms (eds), 2012, *J.M.W. Turner: Sketchbooks, Drawings and Watercolours*, Tate Research Publication.

Concannon, Amy (ed.), 2017, *In Focus: Salisbury Cathedral from the Meadows*, Tate Research Publication, https://www.tate.org.uk/research/in-focus/salisbury-cathedral-constable.

Hallett, Mark, Sarah Victoria Turner and Jessica Feather (eds), *The Royal Academy of Arts Summer Exhibition: A Chronicle, 1769–2018*, chronicle250.com.

Lyles, Anne, 2013, 'Sublime Nature: John Constable's *Salisbury Cathedral from the Meadows*', in Nigel Llewellyn and Christine Riding (eds), *The Art of the Sublime*, Tate Research Publication, https://www.tate.org.uk/art/research-publications/the-sublime/anne-lyles-sublime-nature-john-constables-salisbury-cathedral-from-the-meadows-r1129550.

Myrone, Felicity, 2020, ' "No Mercenary Views"? Constable's English Landscape', *Tate Papers* 33, https://www.tate.org.uk/research/tate-papers/33/no-mercenary-views-constable-english-landscape.

ILLUSTRATIONS

1. Turner, *Self-Portrait*, c.1799, oil on canvas, 743 × 584 mm. Photo: Tate.
2. Ramsay Richard Reinagle, *John Constable*, c.1799, oil on canvas, 762 × 638 mm. © National Portrait Gallery, London.
3. John Wykeham, *26 Maiden Lane, London, J.M.W. Turner's birthplace*, 1852, watercolour on paper, 355 × 222 mm. © The Trustees of the British Museum.
4. Constable, *Golding Constable's House, East Bergholt*, c.1811, oil on millboard laid on panel, 181 × 505 mm. © Victoria and Albert Museum, London.
5. Johann Heinrich Ramberg, engraved by Pietro Antonio Martini, *The Exhibition of the Royal Academy 1787*, published 1787, hand-coloured etching and engraving, 322 × 491 mm. Classic Image / Alamy.
6. Constable, *Dedham Vale*, 1802, oil on canvas, 435 × 344 mm. © Victoria and Albert Museum, London.
7. Turner, *The Festival upon the Opening of the Vintage of Macon*, 1803, oil on canvas, 1825 × 2744 mm. Sheffield Museums Trust.
8. Turner, *The Battle of Trafalgar, as Seen from the Mizen Starboard Shrouds of the Victory*, 1806, reworked 1808, oil on canvas, 1708 × 2388 mm. Photo: Tate.
9. Constable, *His Majesty's Ship 'Victory', Capt. E. Harvey, in the Memorable Battle of Trafalgar, between Two French Ships of the Line*, 1806, watercolour on paper, 420 × 584 mm. © Victoria and Albert Museum, London.
10. Constable, *The Church Porch, East Bergholt*, 1810, oil on canvas, 445 × 359 mm. Photo: Tate.
11. Turner, *Snow Storm: Hannibal Crossing the Alps*, 1812, oil on canvas, 1460 × 2375 mm. Photo: Tate.
12. Constable, *Flatford Mill from a Lock on the Stour*, c.1811, oil on paper laid on canvas, 260 × 355 mm. Royal Academy of Arts.
13. Turner, *Frosty Morning*, 1813, oil on canvas, 1137 × 1746 mm. Photo: Tate.

14. Turner, *The River Thames with Isleworth Ferry*, 1805, pencil and watercolour on paper, 258 × 366 mm. Photo: Tate.
15. Constable, *The White Horse*, 1819, oil on canvas, 1314 × 1883 mm. The Frick Collection.
16. Turner, *England: Richmond Hill, on the Prince Regent's Birthday*, 1819, oil on canvas, 1800 × 3346 mm. Photo: Tate.
17. Turner, *Rome, from the Vatican. Raffaelle, Accompanied by La Fornarina, Preparing his Pictures for the Decoration of the Loggia*, exhibited 1820, oil on canvas, 1772 × 3353 mm. Photo: Tate.
18. Constable, *The Hay Wain*, 1821, oil on canvas, 1302 × 1854 mm. National Gallery, London.
19. Turner, *Mortlake Terrace, the Seat of William Moffatt, Esq.; Summer's Evening*, 1827, oil on canvas, 921 × 1222 mm. Andrew W. Mellon Collection, National Gallery of Art, Washington.
20. Constable, *The Cornfield*, 1826, oil on canvas, 1430 × 1220 mm. The National Gallery, London / Presented by subscribers, including Wordsworth, Faraday and Sir William Beechey, 1837.
21. Constable, *Cloud Study*, 1822, oil on paper laid on canvas, 305 × 508 mm. Yale Center for British Art, Paul Mellon Collection, B1981.25.144.
22. Turner, *Skies* sketchbook, D12467, CLVIII 19, watercolour on paper, 125 × 247 mm. Photo: Tate.
23. Constable, *Chain Pier, Brighton*, 1826–7, oil on canvas, 1270 × 1829 mm. Photo: Tate.
24. Turner, *Brighton from the Sea*, c.1829, oil on canvas, 635 × 1320 mm. Photo: Tate.
25. Turner, *Banks of the Loire*, 1829, oil on canvas, 713 × 533 mm. Worcester Art Museum, 1940.59.
26. W.B. Cooke, after Turner, *Weymouth, Dorsetshire*, 1814, etching and engraving on paper, 148 × 184 mm. Yale Center for British Art, Paul Mellon Collection, B1977.14.6589.
27. David Lucas, after Constable, *Weymouth Bay*, published 1830, mezzotint on paper, 143 × 445 mm. Yale Center for British Art, Yale University Art Gallery Collection, B1994.4.1181.
28. *Frontispiece to the 'Liber Studiorum'*, 1812, etched and centre engraved by Turner, engraved by J.C. Easling, etching and mezzotint on paper, sheet 292 × 448 mm. Yale Center for British Art, Paul Mellon Collection, B1977.14.8095.
29. David Lucas, after Constable, *Frontispiece: East Bergholt, Suffolk*, 1831, mezzotint, sheet 298 × 445 mm. Yale Center for British Art, Yale Art Gallery Collection, Gift of Mrs. John Archer Gee for History of Art (History of Prints), B1994.4.1184.
30. Charles Robert Leslie, *Portrait of John Constable, R.A.*, c.1830, oil on panel, 182 × 137 mm. Royal Academy of Arts.

31. John Linnell, *J.M.W. Turner*, 1838, oil on canvas, 460 × 384 mm. © National Portrait Gallery, London.

32. Constable, *Salisbury Cathedral from the Meadows*, 1831, oil on canvas, 1537 × 1920 mm. Photo: Tate.

33. Turner, *Helvoetsluys; the City of Utrecht, 64, Going to Sea*, 1832, oil on canvas, 914 × 1220 mm. Tokyo Fuji Art Museum / Bridgeman Images.

34. Constable, *The Opening of Waterloo Bridge ('Whitehall Stairs, June 18th, 1817')*, 1832, oil on canvas, 1308 × 2180 mm. Photo: Tate.

35. Turner, *The Burning of the House of Lords and Commons, 16th October 1834*, exhibited 1835, oil on canvas, 920 × 1231 mm. Philadelphia Museum of Art.

36. Turner, *Juliet and Her Nurse*, 1836, oil on canvas, 880 × 1210 mm. Foto Diego Spivacow. Gentileza Colección AMALITA.

37. Constable, *Cenotaph to the Memory of Sir Joshua Reynolds*, 1836, oil on canvas, 1320 × 1085 mm. The National Gallery, London.

38. Turner, *The Fighting Temeraire tugged to her last berth to be broken up, 1838*, 1839, oil on canvas, 907 × 1216 mm.

39. Turner, *Norham Castle, Sunrise*, c.1845, oil on canvas, 908 × 1219 mm. Photo: Tate.

40. Constable, *Sketch for 'Hadleigh Castle'*, c.1828–9, oil on canvas, 1226 × 1673 mm. Photo: Tate.

INDEX

candidature for Associate Royal
 Academician, 36, 37, 38–9
character, 11, 96, 212, 219, 220,
 232–4, 254
childhood home in Maiden Lane,
 7–9, 8, 12, 13, 16, 108
children and grandchildren, 79,
 96–7, 120–1
class and status, 27, 53
commercial activities, 35, 38, 40,
 42, 53–4, 68–9, 86, 93, 164–5,
 189–90, 205, 206
on the Committee of
 Arrangement, 127
comparisons with Constable,
 1–4, 127–8, 143, 213–15, 268,
 273
Constable's critiques of, 46–7,
 49, 105, 143
Constable's knowledge of, 38, 45
in contemporary culture, 273–4,
 277–9
critiques of, 141–2
death, 258
death of his father, 210–12
early artistic talent, 9–10, 11, 12,
 14
family background, 5–6, 10–11
fascination with the Thames,
 104, 107–10, 113–14, 126–7
friendship with Walter Fawkes,
 97, 98
gifts to the Royal Academy
 collection, 218
health, 214
intellectual curiosity, 163–4
Italian tour, 131–4
knowledge of Constable, 124–5,
 166–7
late life, 217, 245–6, 254–5
late period, 245–6, 256–7
legacy and posthumous
 reputation, 214, 255–6,
 258–64, 266–74, 279–80
love of fishing, 91, 109

in Margate, 212–13
meetings with Constable, 99–
 101, 135, 139, 215, 218–19
as a member of the Roman
 Academy of St Luke, 134
Monro's patronage of, 14–15, 24
move to Harley Street, 55
name, 5, 45, 50
patrons, 38, 41, 177
phrase 'white painter' and, 54
poetical epigraphs, 72–4, 97
politics, 101, 196–7
portraits, 212, 213, 257–8
printmaking, 186, 189–96, 204,
 207
as professor of perspective, 68,
 102, 133, 239, 240
public profile, 52, 55, 57, 69–70,
 100
Queen Anne St house, 68, 96,
 114, 139, 145, 190, 254–5
the RA's move to Trafalgar
 Square, 244
relationship with Constable, 1,
 3–4, 141
relationship with his father, 11
relationship with his mother,
 11–13
relationship with Sarah Danby,
 78–9, 80, 97
relationship with Sophia Booth,
 97, 212, 254, 269
rivalry with Constable, 3–4, 28,
 63, 177, 178, 179, 180–2, 215,
 219–34, 267
rivalry with David Wilkie, 61–3
as a Royal Academician, 45
second homes in London, 109
Self-Portrait, 1, 2, 78
sketchbooks, 77–8, 80, 86–7,
 88, 89, 110–12, 113, 130–2,
 162–3, 168, 259–60, 261
socio-historical contexts, 4, 93–4,
 117–18, 125–6, 129, 195–7,
 246–8